THE ETCHINGS OF
SALVATOR ROSA

RICHARD W. WALLACE

THE ETCHINGS OF SALVATOR ROSA

PRINCETON UNIVERSITY PRESS

PRINCETON, NEW JERSEY

0691039356 T

1001107289

Copyright © 1979 by Princeton University Press

Published by Princeton University Press,
Princeton, New Jersey
In the United Kingdom: Princeton University Press,
Guildford, Surrey

Library of Congress Cataloging in Publication
Data will be found on the
last printed page of this book

This book has been composed in Linotype Granjon

Clothbound editions of
Princeton University Press books are printed on
acid-free paper, and binding materials are
chosen for strength and durability

Printed in the United States of America
by Princeton University Press,
Princeton, New Jersey

FOR KATE, DAVID, AND MARIA

CONTENTS

PREFACE AND ACKNOWLEDGMENTS

A great many people and institutions deserve my thanks for the help they have given me in the course of preparing this study. Many years ago the late Professor Erwin Panofsky encouraged me in my choice of Rosa as a subject for my doctoral thesis and gave me invaluable help with the early stages of my research. Professor John Rupert Martin acted as my thesis advisor for Princeton University's Department of Art and Archaeology and was, and has continued to be, unfailingly generous with his advice and help.

I am particularly grateful to Dr. Luigi Salerno, the dean of contemporary Rosa studies, who has welcomed me during my visits to Rome and opened doors that without his help would have remained closed. Dr. Michael Mahoney, the expert on Rosa's drawings, has been equally helpful, generously sharing information that has been of the greatest use to me. Working on the same subject with these two scholars has been for me a great pleasure and a very rewarding experience in cooperative scholarship, and it is especially gratifying to know that our work has helped to restore Rosa to his rightful place as one of the most interesting and original artists of his time.

Mrs. Katharina Mayer Haunton of P. & D. Colnaghi & Co. helped me greatly with technical questions and with my catalogue, and I am very grateful to her and to Mr. Arthur Driver of Colnaghi's for their generosity and patience in letting me study their prints and draw upon their extraordinary resources and expertise. Mr. Andrew Robison and Mr. Christopher White have given me excellent advice on the arrangement and nature of my catalogue, and Mr. John Sunderland of the Courtauld Institute has offered a number of valuable suggestions for the chapter on the influence of Rosa's etchings.

Dr. Anthony Oldcorn of Brown University provided invaluable assistance with Italian translations, and Dr. Katherine Geffcken of Wellesley College has helped me enormously with the translation of the Latin inscriptions.

I am very much indebted to my editor, Miss Harriet Anderson of Princeton University Press, for her help and patience in dealing with the difficult editorial problems this book presented.

Much of my work has been done in the Department of Prints and Drawings of the Museum of Fine Arts, Boston, which has

an outstanding collection of Rosa's etchings. I am very grateful to Miss Eleanor Sayre and to her splendid staff for their unfailing patience and helpfulness during the many pleasant hours I have spent with them. I owe thanks also to the direction and staffs of the Gabinetto Nazionale delle Stampe, Rome; the Albertina, Vienna; the Department of Prints and Drawings of the British Museum; the Print Department of the Bibliothèque Nationale, Paris; the Departments of Prints and of Drawings of the Metropolitan Museum of Art, New York; and the Rijksprentenkabinett, Amsterdam.

Special thanks must be given to Principe Ladislao Odescalchi of Rome, who very generously allowed me to study his magnificent collection of Rosa drawings at length and to have them photographed. I am also most grateful to Principe Urbano Barberini of Rome for introducing me to Principe Odescalchi and for letting me study and have photographs made of the Rosa drawings in his collection.

In the course of my studies I have been the fortunate recipient of a number of grants without which my work would not have been possible. A grant from the Mead Fund of the Department of Art and Archaeology, Princeton University, allowed me to buy photographs for my thesis and a Fulbright Fellowship furthered research for it in Rome. A Fellowship from the American Council of Learned Societies and a summer stipend from the National Endowment for the Humanities advanced my work in Rome on the present study. In addition Wellesley College has been extremely generous in its support, granting me one of its generous early leaves and providing funds to help defray the costs of buying photographs and preparing the typescript.

Finally, I am most grateful both to my colleagues in the Wellesley College Art Department and to my own family for their patience and understanding in bearing with the often tyrannical demands my research has made on me.

R.W.W.

February 5, 1977

Wellesley College
Wellesley, Massachusetts

Acknowledgment for Photographs

The photograph for each work listed as belonging to a museum or a collection was supplied by the proprietor. Acknowledgment for the rest is made as follows:

For Catalogue Illustrations
6a, 25a, 40a, 49a, 95a, 96a	Odescalchi
52a, 57a, 77a, 80a	Rome, Principe Urbano Barberini

For Comparative Illustrations
9, 22-23	Alinari/Scala
17	Frick Reference Library

CATALOGUE

ILLUSTRATIONS

COMPARATIVE
ILLUSTRATIONS

INTRODUCTION

Salvator Rosa did well over one hundred etchings, most of which were extensively printed and widely circulated in his lifetime. In letters to his friend Giovanni Battista Ricciardi, Rosa said that they were so much in demand that everyone was making pilgrimages to see them, and that they were being collected as far away as Paris and Flanders.[1] Although it would be naive to trust Rosa's own word completely in these matters, for he was not given to understatement, his remarks find support in G. B. Passeri's life of the artist: Passeri says that there is no need to describe the etchings in detail since they are so readily available that everyone can see them easily.[2]

In addition, a great many impressions were pulled from Rosa's plates after his death, a practice that was continued by the Calcografia Nazionale in Rome, where the plates are preserved, up until some ten years ago. Many of Rosa's prints, chiefly the small figure prints or *Figurine* as he called them, were so widely copied and forged that they are among the most imitated prints in the history of graphic art. As a result, impressions from worn plates and imitations are very common and have tended to interfere with the full appreciation of his considerable merits as a print maker, much as the vast number of spurious paintings attributed to him have, at least until recent years, clouded his reputation as a painter. Because of these considerations I have tried to cite the most commonly encountered copies as fully as possible and above all have attempted to provide in the catalogue entries, detailed technical descriptions which I hope will be in some measure useful in assessing the quality of various impressions.

[1] De Rinaldis, p. 145, no. 110 bis, dated September 16, 1662: "Le stampe son venerate e richieste, ed a quest'ora pellegrinano per tutto...." Limentani, 1950, p. 125, no. xxxii, dated July 1662: "I due rami grandi riuscirno assai bene, et a quest'hora sono in Fiandra e Pariggi assieme con tutto il resto...." [Throughout the notes Italian orthography follows the source quoted.]

[2] Passeri, p. 399: "Stimo non sia necessario il descrivere le istorie e le proprie fantasie, che rapresentò in quelle sue carte, perche sono cose che vanno in giro, e ciascheduno può sodisfarsi compitamente;..." This is echoed by De Dominici, iii, p. 247: "Non ci par necessario lo stendere qui un Catalogo delle Stampe di Salvatore, poicchè essendo fatte pubbliche, anche con la moltiplicità delle copie assai bene imitate in Francia, può il curioso facilmente soddisfarsi col vederle." See aslo Rotili, Ch. 1, "Fortuna critica," especially pp. 10-13.

Rosa was very much a *peintre-graveur*, for whom etching provided the attraction of a medium different from painting but one that could be quite easily managed by the experienced artist without the need for laborious technical training and practice. He did not, however, simply subordinate etching to painting but gave it equal and sometimes even superior status and used it with great independence and freedom of invention. To be sure he did simply reproduce in etching several of his most important pictures, but by far the greatest number of his prints are original as etchings. He also developed a number of his most interesting, successful, and even most ambitious compositions first as etchings and then either turned them into paintings, as the *Jason and the Dragon* [118], *Glaucus and Scylla* [101], and the *Crucifixion of Polycrates* [111], or planned to if the occasion arose, as in the case of the *Fall of the Giants* [115], and the *Rescue of the Infant Oedipus* [116].

It also seems very likely that Rosa intended his larger prints to be framed in some manner and hung much like paintings, since most of them were done as matched pairs and relate best visually when seen from some distance, especially the largest of them, the *Death of Atilius Regulus* [110], with the *Polycrates*, and the *Giants* with the *Oedipus*. The latter pair in particular have the scale, sweep, and breadth of monumental paintings, with the *Giants* being the graphic equivalent of a Roman High Baroque ceiling painting.

In addition, the *Figurine* etchings were probably also intended, at least in part, to stand as corrections and improvements of the coarser, more *bamboccianti*-like staffage figures of his earlier landscapes, just as his etchings in general were meant to declare the superiority of figural composition over landscape.

Rosa's etching style seems to have evolved quite naturally out of his painting and drawing styles and the habits of his hand. To be sure, his prints fall clearly within prevailing Italian graphic traditions of the period, and in doing them he used the kinds of shading lines, hatchings, contour lines, dottings, and so on, that were the common coin of contemporary graphic practice. The specific influence of Jusepe de Ribera, Annibale Carracci, Giovanni Benedetto Castiglione, Stefano della Bella, and Pietro Testa can also be noted in a number of his prints, but it would be a mis-

take, in my opinion, to place too much emphasis on these influences in determining his etching style. Instead, as a number of comparisons in the text indicate, the translation of a drawing or painting into an etching seems to have been accomplished without a conscious attempt to achieve a specific etching style as such. Obviously the closest parallels are between his etching and his drawing styles, and fortunately a great many of the preparatory studies for his prints, large and small, early and late, are preserved. As a result, it is possible to trace with some precision just how the two styles are related and are modified to meet various kinds of aesthetic demands and choices.

The relation of his etching style to his painting style is more complex since his pictures are usually distinguished by a wide and rich range of chiaroscuro—dark, somber tonalities, shadows of varying degrees of opacity, and varied highlights, effects that are not so easy to achieve in etching, in which the white of the paper tends to be the dominant tone. Rosa was obviously interested in exploring the tenebrist effects of his painting style in etching—his earliest print, the *Male Nude* [1], has very pronounced contrasts of light and dark, and many of the *Figurine* show him experimenting with a wide variety of chiaroscuro and even nocturnal effects. His larger prints also often achieve quite striking and effective contrasts of light and shadow; but the variety and range of chiaroscuro that they show in general is surprisingly limited, and they tend to be basically quite uniform in tone despite the fact that they often differ radically in subject matter, content, and mood. This limitation seems to have been deliberate on Rosa's part and imposed for a variety of reasons, artistic and philosophical. Like most Italian print makers of the period, he avoided elaborate technical solutions and used a straightforward etching procedure—all of his etchings are done with single-stage biting, very often with slight changes made by burnishing or by the addition of drypoint to reenforce lines and shading, to tone portions of the plate left unetched, and to make modest alterations, often in connection with burnishing. Given this procedure, it would be difficult in any case to create a very rich or complex variety of light and dark effects, but in his large etchings Rosa deliberately renounced a number of the devices that he had used earlier in the *Figurine* and the Triton

Group prints to achieve subtler and more complex effects of light and shadow. Instead the larger prints are in general done with a conservative handling of the needle which, together with single stage biting, results in prints that are often disappointingly even and sometimes bland in tonality and that fail to exploit one of Rosa's greatest strengths as a painter, his forceful, rich, and dramatic chiaroscuro. Only in his late prints, especially the *Giants* [115] and *Oedipus* [116] did he experiment with more varied and complex effects of light and shadow.

To say that Rosa was a *peintre-graveur* is to tell only part of the truth. He was also a *peintre-graveur-publiciste par excellence* whose motives for doing the etchings were not limited to purely artistic considerations. Etching provided him with an art form that would circulate widely, publicizing his art and proclaiming his most cherished artistic ideas and principles. Rosa was not only always eager for publicity but very dependent on it because of his unusual attitudes towards artistic freedom, his refusal of traditional patronage, and his insistence on working essentially as a free agent, painting what he chose and then submitting it to the art-buying public.

The etchings also provide a kind of capsule summary of Rosa's art in general, both its strengths and weaknesses. In them one sees the fundamental tensions and conflicts that were typical of Rosa's style, especially the conflict between the spontaneous and romantic side of his creative personality and the demands he imposed on himself to be a serious painter of learned philosophical themes and *cose morali*. In his paintings the former side is most clearly expressed in his dramatic landscapes; the latter in his history pictures, which are often rather heavy-handed in their insistent pedantry and stiff in execution. In his etchings an analogous dichotomy exists between the free *capriccio* qualities of the earlier prints, especially the *Figurine* [6]-[87], and the Triton Group prints [91]-[98], and many of the later, larger prints which deal with serious subjects and are usually much less varied and interesting in graphic terms. His etchings in general are a direct reflection of his almost obsessive desire to be known as a figure painter rather than a landscape artist. All but a very few of them are figure prints with, at the most, very limited landscape elements. Ironically, many of them demonstrate

that his critics were right, that he did have difficulty in drawing the human figure, in rendering anatomy accurately, and in disposing forms fluently in space. And as the two small landscapes [4] and [5] and the *Rescue of the Infant Oedipus* [116] indicate, he was capable of creating splendid landscape etchings, and missed a marvelous opportunity by refusing to do them. But it should be added that this kind of tension, stress, and uneasiness is of fundamental importance to Rosa's art. It is at the root of the sense of disquiet and urgency that is one of the most fascinating and attractive aspects of his style.

None of Rosa's etchings is dated, so that establishing a chronology for them and tracing their development is difficult, especially since the evidence of their style alone is often inconclusive. Fortunately he did refer to a number of them in letters to Ricciardi, references which are of central importance in establishing a basic chronological framework into which most of the etchings can be fitted, with varying degrees of certainty and precision, by an evaluation of documentary evidence, style, technique, and even subject matter and content. It should be stressed, however, that an attempt at a comparative dating of prints that are separated from each other in execution only by a matter of a few years or even a few months is risky, and that the outline proposed in this book is meant to serve simply as a general guide to Rosa's development as an etcher rather than as a comprehensive scheme. I am well aware that some of the arguments proposed here could be turned around and used to justify quite different conclusions; and when this is the case, I have tried to consider these alternative possibilities.

The arrangement of this book is somewhat unorthodox for a study of prints. Instead of the usual brief introduction with extensive catalogue entries, the material seemed to warrant an extensive text which could deal with broad issues and developments in a continuous, unified fashion. The catalogue entries are limited to technical questions and are intended to be useful working guides for the detailed investigation of individual prints. The descriptions of technique are extremely detailed but it has been my experience that such description provides the most reliable data for assessing the quality and freshness of various impressions.

THE ETCHINGS OF
SALVATOR ROSA

CHAPTER I

THE EARLY PRINTS

c. 1635 – 1645

The earliest known reference Rosa made to etching is in a letter dated December 30, 1651, to Giovanni Battista Ricciardi. In it the artist mentions two unidentified plates that had apparently been given their design by Rosa, sent to Ricciardi, and then returned to Rosa to be etched.[1] The offhand way in which the artist refers to the plates suggests that the etching process was not unfamiliar to him, and it seems very likely that Rosa had done at least five etchings by this time.

The first of these, the *Male Nude* [1], can probably be dated as early as the second half of the 1630s. As far as I have been able to discover, it exists in only one impression. It bears the artist's monogram in the lower right and the lettering style is very much like that which appears in other Rosa prints. This is, however, hardly sufficient evidence for a convincing attribution since such monograms and signatures were so often forged on spurious Rosas that they are all too often grounds for suspicion.

The way the figure is modeled is somewhat unusual in comparison with Rosa's other etchings; but the drawing, treatment of anatomy, the strongly bitten lines, the extensive use of broken contours, the screen of parallel lines which produce a peculiar, nocturnal effect behind the figure, and the quick, sharp strokes and free scribbled coils and squiggles that form the foliage are all features that are characteristic of his etching style, especially in his early prints. In addition the print is clearly an almost exact translation into etching of a red chalk drawing now in the Teyler Museum, Haarlem [1a]. The drawing is one of a group of five very similar male figure studies in the Teyler Museum done in

[1] De Rinaldis, p. 27, no. 13: "I due rami, che si tornano in mio potere dal vostro per intagliarsi, si faranno, ne credete che mi dimentico le cose vostre massime donde si tratta di cose di dipendono da me." Also cited in Salerno, 1963, p. 95. The letter was written from Rome to Ricciardi, who was certainly in Pisa at the time although the letter is not specifically addressed so. One of these prints is probably also referred to in a letter of some two weeks later: "Il rame è in mio potere, ma è ben dovere che non è fatto ancora; subito che sarà finito ve lo farò avisato." (Limentani, 1950, p. 86, no. XI, dated January 14, 1652.) Bozzolato, pp. 5, 15, associates this letter with the plate for the *Shepherd* [98].

red chalk with occasional wash.[2] They are typical of Rosa's early drawing style and were once part of the Livio Odescalchi collection in Rome, a provenance which lends strong support to their attribution to Rosa.[3] All seem to be studies from the life and one of them (C 12) even shows the etching figure drawn from another point of view. All are somewhat cautious in execution and restrained in the handling of the red chalk, a medium with which Rosa never seems to have felt comfortable and which he tended to use conservatively even later in his career when most of his pen and wash drawings are marvels of dashing execution.

These drawings, similar in being studies of male nudes in academic poses, are awkward in the handling of anatomy and stiff in execution, strongly suggesting the work of a relatively inexperienced artist still in training. They do in fact show interesting similarities to the red chalk drawings of Aniello Falcone, the Neapolitan battle painter with whom Rosa studied and worked during the 1630s, and to those of Andrea de Leone, Rosa's fellow student under Falcone during those years.[4] It is especially relevant to this discussion that both Falcone and Leone were famous for their academic drawings of nudes from the life.[5]

Moreover, in the handling of the human figure and in basic feeling, the Teyler Museum drawings show strong similarities to the figures in one of Rosa's earliest known paintings, the *Coral Fishers*. This picture was almost certainly done in Naples and can be dated to about the middle of the 1630s (Fig. 1).[6] One of the Teyler Museum drawings (I 17) seems to have been used as the model for the figure second from the left in the painting, and a figure in another drawing (C 11) shows considerable resemblance to the half-reclining figure with his back turned in the left foreground of the picture.

The *Coral Fishers* is also clearly similar to the paintings of Falcone and to the most Falcone-like of Rosa's own paintings, the *Battle Scene*, now in the collection of W. Mostyn Owen, which is signed and dated 1637.[7] It is noteworthy that the *Battle Scene* develops even further the *bamboccianti* qualities seen in much of Falcone's art; but while Falcone treats his soldiers and men in armor in a way that is reminiscent of the *bamboccianti* painters' direct and unheroic realism, and like them makes use of a generally Caravaggian chiaroscuro, his figures usually have a kind of sprightliness that makes them significantly different from those seen in most of the paintings of the *bamboccianti*. Rosa's figures, on the other hand, especially in the *Coral Fishers*, seem to exhibit a more direct influence of the *bamboccianti* in their humble and even coarse realism, and in their unaffected

[2] The others are I. 17, pen and brown ink, brown wash over red chalk, 95 x 66 mm.; C. 11, red chalk, 114 x 91 mm.; C. 12, pen and brown ink, brown wash over black chalk, 71 x 141 mm.; I. 16, pen and brown ink, brown wash over red chalk, 96 x 67 mm. See Mahoney, 1973, no. 50; and Mahoney, 1977, 2.2, 2.1, 2.4, 2.5.

[3] See Mahoney, 1965, pp. 383-89; Mahoney, 1973, introduction and nos. 49, 50; and Mahoney, 1977, pp. 17-30.

[4] Especially the Falcone drawing of a half-length nude youth in Madrid, National Library, no. 7904 (red chalk), and two Leone drawings of male nudes in Naples, Museo di Capodimonte, nos. 687, 688 (red chalk heightened with white). For the latter two see W. Vitzhum and R. Causa, *Disegni Napoletani del sei- e settecento*, Rome, Palazzo Barberini, December 1969-January 1970, p. 14, nos. 17, 18. See also M. Soria, "Andrea de Leone, a Master of the Bucolic Scene," *Art Quarterly*, XXIII, 1960, pp. 23-35, and Mahoney, 1977, pp. 42-47, 131-44.

[5] De Dominici (III, pp. 73-74) says of Falcone, "Studiava Aniello continuamente il naturale, tenendo in casa sua l'accademia del nudo dall'-Autunno per tutta la primavera; Laonde molti giovani, ed anche Pittori, conoscendo il di lui valore del disegno, massimamente nelle Battaglie, vollero essere suoi Discipoli, alcuni de' quali divennero poi famosissimi. ..." He says of Andrea de Leone (III, pp. 80-81), "...fu molto studioso del disegno, e massimamente del nudo: E infatti vanno a torno molte sue accademie assai ben disegnate, come altresì molte teste, e parte del corpo a somiglianza del maestro [Falcone], che simil faceva...." See also Vitzhum and Causa, *Disegni Napoletani*, pp. 13-14, no. 15; F. Saxl, "The Battle Scene Without a Hero," *Journal of the Warburg and Courtauld Institutes*, III, 1939-1940, pp. 70-87; M. Soria, "Some Paintings by Aniello Falcone," *Art Quarterly*, XVII, 1954, pp. 3-15; and R. Spear, *Caravaggio and His Followers*, Cleveland, 1971, pp. 90-91, no. 25, for a survey of the most important information and bibliography on Falcone.

[6] Salerno, 1963, p. 114, no. 1. For other early Rosas of a similar kind, see Salerno, 1970, pp. 61-62, figs. 33, 34, 35.

[7] Salerno, 1963, p. 114, no. 2a. See also Langdon, "Rosa: Paintings," no. 2.

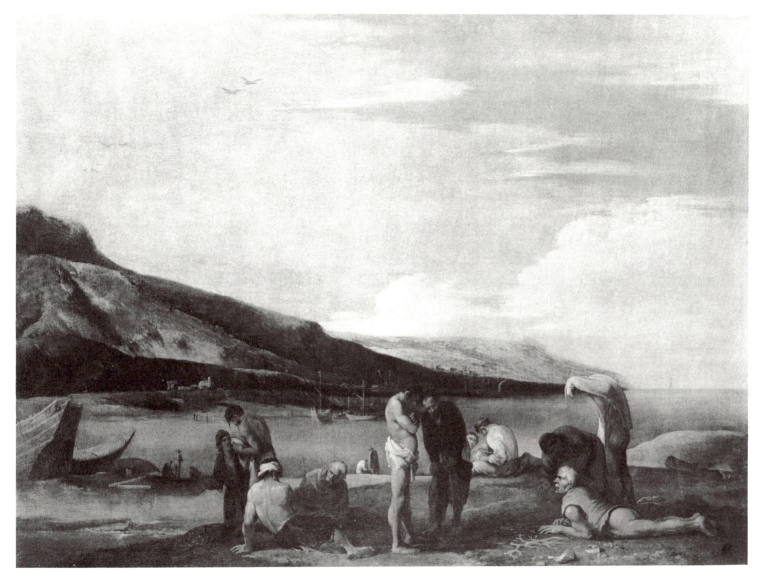

1. Rosa, *Coral Fishers*, painting. Columbia, South Carolina, Columbia Museum of Art,
 Samuel H. Kress Collection

postures which have the hangdog, downtrodden quality so often seen in Van Laer's or Cerquozzi's figures. They are, in fact, very like the figures in Rosa's own *Bambocciata*, done probably about 1639.[8] The standing figure in the right foreground of that picture is, in effect, a clothed version of the central nude in the *Coral Fishers*.

Rosa first went to Rome in 1635, and although Baldinucci says that he fell ill immediately and soon returned to Naples, it seems more likely that, as Passeri indicates, he stayed in Rome for several years, returning to his native city only for a visit during 1638. In any case, he clearly came into direct contact with the *bamboccianti* painters and their art during this period; Passeri even says that during his early Roman years Rosa did "many small pictures with little figures wonderfully touched with lovely colors and in good taste, but of low subjects such as rogues, lime kiln workers, and sailors."[9] Or even if Baldinucci is right about Rosa's early return to Naples, it seems very probable, given the great popularity of Van Laer's and Cerquozzi's art in Rome in the 1630s, that some of it migrated to Naples as well and was known either through paintings or engravings. According to De Dominici, for example, Viviano Codazzi, when he arrived in Naples from Rome about 1635, brought with him one of his own architectural view paintings with figures by Cerquozzi.[10]

For all of these reasons it seems plausible that the preparatory drawing [1a] for the *Male Nude* etching [1] can be dated to the latter half of the 1630s, although this does not necessarily mean that the etching itself was done then. But stylistic and technical considerations indicate that it is certainly the earliest of Rosa's own etchings and was probably done not long after the drawing. As mentioned earlier, the modeling of the figure is rather different from that seen in Rosa's developed etching style. It is clumsier and less confident although it does have a kind of naive vigor and forcefulness. Every aspect of the drawing, from its contours to its distribution of light and shade, is followed so faithfully in the etching as to suggest a hand not fully confident in the management of the needle. There is little variety in the nature and graphic weight of the etched line so that the strokes that model the body are very similar in feeling to the lines that form the setting. This, in combination with a kind of *horror vacui* gives much of the print a pronounced surface web of a uniform graphic weight and what might be called graphic weave. As a result the spatial difficulties of the drawing become even more evident in the etching, and the figure tends to take on pattern-like juxtapositions of forms and silhouettes, as for example in the hip foiled against the arm, or the arm against the background screen of lines. In some places the modeling system itself contributes to this flattening out of masses, as in the figure's lower right leg where the strokes cut across, and in effect carve away, the roundness of the leg's contour. It is interesting that these graphic solutions, especially the juxtaposition of brightly lit areas against graphically saturated darks, produce an unusual, nocturnal effect that is strikingly reminiscent of Caravaggio's *tenebroso*. This is another reason for dating the etching to Rosa's early career when he was most directly influenced by the Caravaggian tendencies that permeated Neapolitan painting at that time and that can be seen in the work of his closest artistic associates there, Falcone, Ribera, and Fracanzano, and in the *bamboccianti*.

Despite its awkward qualities the print has a kind of rude vigor and forcefulness. This is seen in the firmly stroked lines of the etching, especially the chisel-like strokes that model the body, and in the free calligraphic coils of the foliage. Most striking of all is Rosa's graphic boldness in translating the light-dissolved contours of the drawing into similar kinds of broken, and what might be called negative, contours in the etching; in a number of places, such as the figure's right knee, upper right leg, right

[8] Salerno, 1963, p. 114, no. 2b.

[9] Baldinucci, 1773, p. 6; Passeri, p. 387, "...figurine piccole, e tele non molto grandi, toccate mirabilmente con tinte grate e di buon gusto; ma di soggetti vili cioe baroni, calcare, e marinari." It is difficult to be sure of precise dates for Rosa's movements during this period, and there are conflicts in dating among the sources and authorities. It is clear however that he went to Rome in 1635, returned to Naples either shortly thereafter or in 1638, and then left Naples permanently in 1638 to go to Viterbo and then to Rome. For a summary of these questions see Salerno, 1963, pp. 91-92, and Mahoney, 1977, pp. 50-54.

[10] De Dominici, III, p. 203. See also E. Brunetti, "Situazione di Viviano Codazzi," *Paragone*, July 1956, pp. 48-69; and R. Longhi, "Viviano Codazzi e l'invenzione della veduta realistica," *Paragone*, November 1955, pp. 40-48.

hip, right arm, and left forearm, the contour lines are broken or simply omitted so that contours are completed by the implied continuation of the contour lines adjacent to the gap and by the negative definition provided by lines and strokes behind the contour. Broken contours are of course very common in 17th century Italian etchings, which so often strive for forceful light effects, and negative contours are not exceptional; they can be seen to a limited degree in the etchings of Parmigianino, Giovanni Benedetto Castiglione, and Pietro Testa, among others, and play a very important role in the etchings of Stefano della Bella. In addition it is an approach that is not uncommon in engravings of the period and can be seen very strikingly in the engravings of Francesco Villamena, to cite just one example. Still, Rosa's use of negative contours here, and even more in many of his later *Figurine* etchings of 1656-1657, is quite bold in the context of the graphic techniques of his time.

Many of the graphic qualities of the *Male Nude* [1] can be traced, in my opinion, to the influence of the etchings of Ribera, whose prints would undoubtedly have been those most familiar to the young Rosa and probably also the most appealing to him because of his close association with the Ribera circle in Naples. It is significant in this context that of all of Rosa's paintings the *Male Nude* is closest to the early *Prometheus*, the most emphatically Riberesque of all of his pictures (Fig. 2).[11] Rosa's use of Ribera's prints as models may also explain, at least in part, the

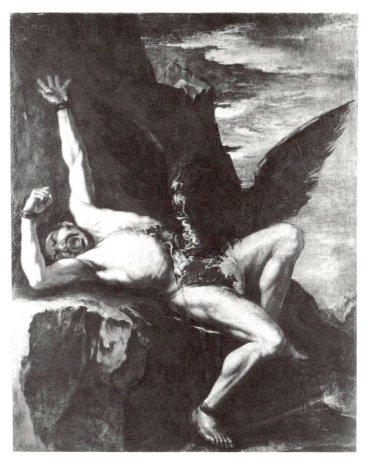

2. Rosa, *Prometheus*, painting. Rome, Galleria Nazionale d'Arte Antica

[11] Contrary to most scholarly opinion (Ozzola, pp. 43-45; H. Voss, *Die Malerei des Barock in Rom*, Berlin 1924, p. 572; Passeri, p. 388; Salerno, 1963, p. 147; Mahoney, 1977, pp. 44, 176-77) and in agreement with Kitson, no. 113, I am convinced that the Palazzo Corsini picture can be identified with the famous painting sent by Rosa from Naples to Rome and exhibited there, probably in 1638, with great success. Passeri's identification of the picture as a Tityus is almost certainly incorrect since his rather detailed description of it fits the story of Prometheus but not that of Tityus. Rosa's *Prometheus* shows a striking resemblance to Ribera's *Tityus*, now in the Prado, Madrid. See E. Trapier, *Ribera*, New York 1952, p. 79, no. 50 and Brown, pp. 125-26, fig. 32. On p. 137 of his excellent and most useful catalogue, Dr. Brown notes the clear influence of Ribera's pen style on Rosa's early drawings and feels that a Rosa preparatory drawing for the *Prometheus*, which he illustrates as fig. 40, seems to follow the Ribera *Tityus* specifically. See also pp. 166-67, no. 20.

boldness with which he approached what was probably his first venture into etching.

A comparison of Rosa's *Male Nude* with Ribera's two versions of *St. Jerome Hearing the Trumpet* (Fig. 3), the *St. Peter*, or even the two *Grotesque Heads*, reveals a number of important similarities of etching style and technique.[12] All of these prints use firmly stroked, strongly bitten lines which usually have a single-directional thrust and are frequently placed parallel to one another. This is seen most notably in the shaded areas of the nude bodies or of the drapery, areas which are almost always composed of systems of regular parallel lines sometimes crossed by equally regular lines of crosshatching. This is supplemented with short, emphatic strokes, curved and straight, in both the Rosa and the Riberas. Although Ribera tends to handle his modeling scheme with greater consistency and clarity than Rosa, whose approach is somewhat cruder, the basic logic of the two approaches is very similar. In addition, the contour lines which define the nude bodies in the Ribera *St. Jerome* prints have the rather stiff, wiry, angular qualities seen in Rosa's *Male Nude*, and the way that Rosa foils brightly lit and essentially unmodeled contours against a background screen of lines has interesting parallels in both versions of the Ribera *St. Jerome*, especially Bartsch 5 (Fig. 3).

Ribera does not use broken or negative contours as daringly as Rosa does, but restrained versions of this device do occur in the wings of the angel in the *St. Jerome Hearing the Trumpet*, Bartsch 4, and also along the left shoulder of *St. Jerome Hearing the Trumpet*, Bartsch 5 (Fig. 3), and at the left shin of *St. Jerome Reading*, Bartsch 3. In the last two, very faint contour lines do exist but because of their delicacy do not read as defining the contour. The Rosa *Male Nude* and the Ribera etchings also share a similar calligraphic freedom in the treatment of certain areas of the background and setting. This is seen in the quickly scrawled coils and squiggles and quick, sharp strokes used to define foliage by both artists, and in the zigzag shading lines in the background areas, as in the rocky zones behind the figures

[12] Bartsch, xx, 5, 4, 7, 8, and 9 respectively. Brown, nos. 4, 5, 6, 10, 11.

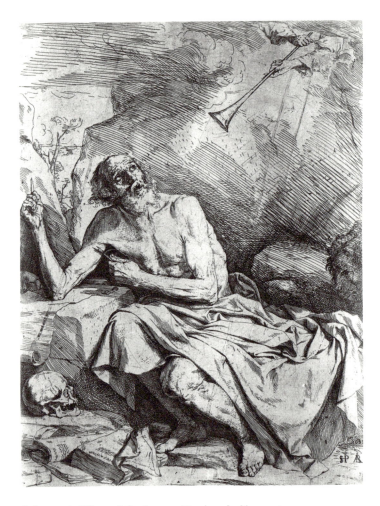

3. Jusepe de Ribera, *Saint Jerome Hearing the Trumpet*, etching. Amsterdam, Rijksprentenkabinet

in the two *St. Jerome Hearing the Trumpet* prints, and in the rocky foreground areas of Rosa's *Male Nude*.

Two other Rosa etchings can be dated early, the *Praying Penitent in a Wilderness* [2], and the *Landscape with a Figure* [3]; they were probably done not long after the *Male Nude* [1], possibly about 1640.[13] Bartsch does not mention them, but they are listed by Nagler (92, 93), and impressions of both, although somewhat rare, are much more common than those of the *Male Nude*. It seems quite likely that a relatively limited number of impressions were pulled from the plates since all the prints I have seen have square corners.[14] There are no preparatory drawings now known for them, and their style presents rather special problems since graphically they are among the most spontaneous prints Rosa ever did. The way he handled the needle in each, especially in the *Landscape with a Figure*, suggests that he was experimenting with the freedom of the etching technique virtually for its own sake, an approach that is very unusual in the scope of his graphic oeuvre.

However, it does seem reasonable to think that they were done at approximately the same time and were probably intended to be a matched pair. They are the same size and similar in subject (a solitary figure in a wilderness), in the consequent use of extensive landscape elements, and in general compositional arrangement and graphic density. Matched pairs of etchings are common in Rosa's oeuvre, in fact almost all of his later prints

with the exception of the *Figurine* series were so conceived. The most important similarities of this pair are a rapid calligraphic handling of foliage and free zigzag strokes to model and shade rocks, features of an approach that is rather rare in his other prints, which sometimes use one or even both of these devices, but never so extensively. This approach is the more evident in the *Landscape with a Figure* [3], in which the modeling of the rocks seems random, almost careless, so that the rocks have little of the solidity and substance that is typical of the rocks in Rosa's other landscapes. The foliage too has been rendered with a greater graphic independence from organic arboreal structure than is seen in almost any other print, drawing, or painting by the artist. Because of this freedom of execution, both prints have a certain muddiness of line in graphically functional terms, a tendency to superimpose strokes in a fluid and painterly way so that in many places lines and hatchings become blurred and lack functional distinctness in relation to the forms they describe. This is seen the more emphatically in the *Praying Penitent* [2], in the way the shading lines of his belly or at his right hip have a scrawled existence independent of the underlying forms so that there is little clear separation between his belly and the rock, or between his thigh and the drapery behind it. In general much of the lower half of his body and its drapery tends to intermingle and blur together with the rock. In the *Landscape with a Figure* there are passages in the foliage in which leaves are freely scribbled on top of leaves, forming a tangled web whose calligraphic energy is dominant over a clear description of leafy structure. All of these qualities stand in contrast to Rosa's later prints which move progressively in the direction of a greater functional clarity of modeling line, a more orderly control of stroke, and a clearer separation of forms.

It is possible to argue that these two prints could have been dashed off as quick sketches at almost any time during the artist's activity as an etcher and that their very freedom is a strong argument for placing them late, rather than early in his oeuvre. But the fact that their freedom is accompanied by signs of graphic ineptness suggests that this dash may well be the product of inexperienced bravado rather than of virtuoso assurance.

[13] In the Arts Council Catalogue (Wallace, "Rosa: Etchings," no. 80) I tentatively associated these two prints with the two plates mentioned by Rosa in a letter of December 30, 1651 (see n. 1 above). I also argued there (nos. 93, 94) that although Rosa's two small landscape etchings [4], [5] had much in common with his style of the 1640s, they should probably be dated near the Triton Group prints [91]-[98] of 1660-61 because of what I felt at the time was their stylistic and technical virtuosity. After seeing these prints in the context of the Arts Council exhibition and discussing them with Mrs. Helen Langdon there, I changed my mind in favor of the early dating proposed here. I am also much persuaded by the discussion of these prints by Rotili, nos. 4, 7, 8, 9.

[14] For a discussion of the significance of the condition of the plate corners in many of Rosa's smaller etchings, see the introduction to the catalogue.

An even more important argument for dating them early is that both prints have much in common with the early *Male Nude* [1], although they also show clear indications of graphic advances over that print. Despite the freedom of execution of the *Praying Penitent* and the *Landscape with a Figure*, their contour lines, especially in the figures but also in the rocks, have a kind of stiff, rather tense angularity that is much like that seen in the *Male Nude*. One senses an unfluent dis-ease in the hand that moved the needle in these passages, something that is not inconsistent with and may help to explain the combination of extravagance and awkwardness seen in other portions of the matched pair.

As in the *Male Nude* both prints tend to rely extensively on web-like screens of lines and strokes to cover large portions of the plate's surface area, with the calligraphic treatment of foliage and the zigzag strokes in the rocky areas being quite similar in all three prints, although carried out with greater dash in the *Praying Penitent* and *Landscape with a Figure*. And like the *Male Nude*, the matched pair show a tendency toward a flattening out of forms and a patternization of lights against darks. But they do not share the pronounced *horror vacui* of the *Male Nude* and their relatively greater openness and luminosity suggest that they were done by a more experienced etcher who had enough discretion to know when to put the needle aside. In addition, the artist in the *Praying Penitent* used quick, sketchy drypoint to fill out the rock at the lower right side of the print, and also to create a light tonal screen at the upper right, an approach which indicates an advance in graphic sophistication over the *Male Nude*.

It should also be noted that the rather taut, inhibited modeling of the body of the *Male Nude* has, in the *Praying Penitent*, given way to a kind of modeling which, because of its complexity, variety, and liveliness, makes the figure of the penitent, chiefly the lower portions of his body, fit into its setting with greater fluency and suppleness than does the *Male Nude*. This again suggests that the *Praying Penitent* falls later in date in Rosa's etched oeuvre.

It is noteworthy that the *Praying Penitent* is even more Riber-esque than the *Male Nude* and is closely based on the Ribera *St. Jerome Hearing the Trumpet*, Bartsch 5 (Fig. 3), discussed earlier. It also shows a strong resemblance to Rosa's own painting *S. Nicolo da Tolentino* now in Fabriano, a picture of the later 1630s which clearly derives from Ribera's hermit saints.[15] In addition to the emphatic similarities to the Ribera print in composition and in facial and figure types, the Rosa also makes extensive use of very free zigzag strokes to model and shade rocks, and places a brightly lit figure against a darker rocky background sprouting foliage. The way the penitent's upper left arm is foiled against a dense screen of closely woven etched lines is strikingly similar to Ribera's handling of similar passages in both of his *St. Jerome Hearing the Trumpet* etchings. But Rosa here makes a significant departure from the approach seen in Ribera's prints and his own *Male Nude*. The *Male Nude* follows, albeit somewhat roughly, Ribera's precise, almost engraving-like modeling system for the human figure, contrasting this, just as Ribera does, to an extremely free and sketchy handling of the background zones. In the *Praying Penitent*, however, although Rosa is clearly following Ribera in his treatment of background areas, he abandons Ribera's carefully controlled modeling of the figure in favor of a much more painterly approach. This again suggests that the *Praying Penitent* is the product of a more assured and independent hand than is the one that did the *Male Nude*.

The *Praying Penitent* and the *Landscape with a Figure* do not seem to have been intended to play an important public role, as Rosa's later etchings were. Neither is signed, and judging from the relatively small number of impressions that survive, all with square corners, they were much less extensively printed and circulated. It is probably best to regard them as essentially free, experimental etchings done before Rosa decided to use the etching medium as a way of making important artistic statements.

The same seems to be true of two rare etchings, *Landscape with Herdsmen* [4], and *Landscape with Figures and a Hill*

[15] Salerno, 1963, pp. 31, 141. The print is also quite close to the very Riberesque Rosa drawing of a penitent saint now in the British Museum (Cracherode F.f. 2-175). See [3].

[5], which were probably done not long after the *Praying Penitent* and *Landscape with a Figure*, about 1640-1645.[16] That the two belong together is indicated not only by their very similar styles, but also by the British Museum's curious impression, which was made by placing the lower edge of the smaller plate at the upper edge of the larger one and running them through the press on one sheet.

Unlike the *Landscape with a Figure* [3], both of these small landscape prints have the breadth, sweep, and concern with light, and atmospheric effects to be seen in Rosa's landscape paintings. They are the only true landscape etchings by the artist that I know. Their tiny size, light, sketchy execution, and extreme rarity indicate that Rosa did not intend them to be taken seriously as important prints. He probably dashed them off with his great facility for rendering landscape. And since he thought of his etchings as demonstrations of his prowess as a figure painter and as a means of countering what he regarded as the popular misconception of his art as being primarily landscape painting, he would hardly have given much attention to landscape prints, especially during the mature phases of his career as an etcher.

This attitude was, in my opinion, very unfortunate since these two etchings are among the most interesting he ever did. More than any other of his prints they show a keen sensitivity to the subtlest effects of light, atmosphere, and distance as seen in the glimmerings of light and reflections on water, the penetration of light into foliage, the atmospheric veiling of distant forms, and the resultant convincingness of placement of forms in space. More than any other of his etchings, they achieve remarkably subtle tonal effects. In this they come closest to the etchings of Claude Lorrain, which they resemble in many ways.[17] It is clear that Rosa was in fact influenced by Claude, especially during his early years in Florence, 1640-1645, and did a number of Claude-like landscapes and harbor scenes which are among his finest

works. A particularly striking example of this phase of his painting, the Modena *Erminia* of 1640, shows strong similarities to both of the small landscape prints in mood, composition, effects of light and atmosphere, and in the treatment of rocks, trees, and water.[18]

Given this interest in Claude's paintings, it seems very likely that Rosa would also have found Claude's etchings appealing. And although there are important differences between these two Rosa etchings and Claude's landscape prints, they all have in common a basic delicacy of mood and execution, a concern with refined nuances of light, atmosphere, and tone, and similar ways of using fine, curving, coiling, and interlaced etched lines to create sensitive effects of organic, growing life in trees and foliage.

[18] Salerno, 1963, p. 116, no. 11; Langdon, "Rosa: Paintings," no. 5. See also Langdon, "Rosa and Claude," pp. 779-85, for an extended discussion of Claude's influence on Rosa's paintings.

[16] See n. 13 above.

[17] Rotili, pp. 52-54 and nos. 8, 9, suggests that Rosa may also have been influenced by the landscape etchings of Filippo Napoletano. This seems plausible, although it strikes me as a less clear association.

CHAPTER II

THE *FIGURINE*

SERIES

c. 1656–1657

The best known of Rosa's etchings and among the best known of his works in general are the 62 small figure etchings of soldiers, male genre figures, and women, which the artist himself referred to simply as *Figurine* [6]-[87].[1] One index of their popularity relative to his other etchings is that they were copied, imitated, and forged much more often than his other prints, so often that it is almost impossible to keep track of all the later variations, some of which can be found in almost every print room in the Western world.[2]

In recent articles in the *Burlington Magazine* Mr. John Sunderland has shown that Rosa's *Figurine* were evidently very much in vogue in 18th century England, where Rosa enjoyed a popularity that amounted almost to idolatry. Not surprisingly, the soldiers of the series were singled out for special attention and given a romantically biased and inaccurate identification as *banditti*. They had a considerable influence especially on John Hamilton Mortimer and on a number of other etchers and engravers of his circle, an influence that is seen most directly in Mortimer's etchings of *banditti*, which are clearly inspired by Rosa's prints and in many instances modeled directly on specific *Figurine*.[3] Mortimer even did an etched portrait of Rosa which gives a marvelously romantic visual expression to the then current myth that Rosa had spent part of his life with the *banditti* of the Abruzzi and that his etchings of them were done from the life (Fig. 4).[4]

The attempt to link Rosa's personal life with the most romantic aspects of his art seems to have had an irresistible appeal for his admirers. The earliest instance is found in the mid 18th century biography by Bernardo De Dominici, who claims that during the revolt of Masaniello in Naples in 1647 Rosa left Rome to

[1] Limentani, 1953, p. 53, no. 3, dated October 14, 1656.

[2] Imitations, derivations, and copies of the *Figurine* are listed in the catalogue as [131]-[144].

[3] Sunderland, "Mortimer and Rosa," 1970, pp. 520-31, and "Legend and Influence," pp. 785-89. See also *Mortimer A.R.A.*, pp. 35-39, nos. 51-75.

[4] Sunderland, "Mortimer and Rosa," fig. 48; *Mortimer A.R.A.*, p. 26, nos. 29, 30. For a fuller discussion of the popularity of Rosa's *banditti* in 18th and 19th century England, see Ch. VII below.

4. John Hamilton Mortimer, *Salvator Rosa*, etching. By Permission of the Trustees of the British Museum

return to his native city and fight with the mythical *Compagnia della Morte*, a group of artist-patriots who painted by day and fought the Spanish oppressors by night.[5]

Lady Morgan, who in 1824 published the most colorful of Rosa's biographies, picks up and adds both to the *Compagnia della Morte* legend and to the myth of Rosa's life with the *banditti*. In one of the *Figurine* prints of a group of warriors and genre figures [59], she sees a self portrait of Rosa and writes about it in a passage typical of her style:

> There is one engraving which, though evidently done *a colpo di pennello*, seems so plainly to tell the story of the wandering artist's captivity, that it may, as an historic fact, if not as a *chef d'œuvre* of the art, merit a particular description. In the midst of rocky scenery appears a group of banditti, armed at all points, and with all sorts of arms. They are lying, in careless attitudes but with fierce watchfulness, round a youthful prisoner, who forms the foreground figure, and is seated on a rock, with languid limbs hanging over the precipice, which may be supposed to yawn beneath. It is impossible to describe the despair depicted in this figure: it is marked in his position, in the droop of his head, which his nerveless arms seem with difficulty to support, and in the little that may be seen of his face, over which, from its recumbent attitude, his hair falls in luxuriant profusion (and the singular head and tresses of Salvator are never to be mistaken). . . . [6]

Although the accounts of Rosa's life and art given by 18th and 19th century Romantic writers are filled with similar kinds of romantic exaggerations and distortions, they very often point to a larger truth. This is that Rosa was surprisingly romantic in the 18th and 19th century sense. He could, for example, strike a Byronic pose and paint himself as a somber bravo in a way that makes Mortimer's and Lady Morgan's versions of his life with

[5] De Dominici, III, pp. 225-26.
[6] Lady Morgan, I, p. 81.

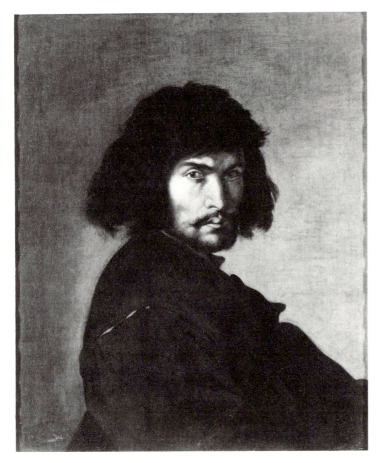

5. Rosa, *Self Portrait*, painting. Courtesy of the
 Detroit Institute of Arts

the *banditti* seem almost believable (Fig. 5).[7] And on a more serious level his artistic personality anticipated in a remarkable way many of the qualities of the Romantic genius. He was restless, filled with malaise, at odds with the society which he felt failed to understand him and which he savagely attacked in seven of the most important satires written in the 17th century.[8] He seems to have seen himself as set apart from and superior to ordinary men because of his creative capacities, a view that has its most significant expression in his revolutionary attitude toward patronage. Unlike other Italian artists of this period he insisted on complete freedom to create as his own remarkable spirit moved him and he refused to be bound by the dictates of a commission. In what Francis Haskell calls "an astonishingly early claim of the painter's complete dependence on inspiration," Rosa wrote to the important collector and patron of the arts, Don Antonio Ruffo of Messina, that Ruffo would have to bear with him since he painted only when carried away by the transports of enthusiasm and could use his brush only when he felt himself rapt.[9] And to his friend Ricciardi, whom he felt was trying to tell him how to paint, Rosa wrote haughtily, "To painters of my condition and extravagant genius it is necessary to leave everything after the measurements free. . . ."[10]

[7] The painting is now in the Detroit Institute of Arts (no. 66.191). It is particularly noteworthy in this context that there is a version of this picture in the Palazzo Chigi Saracini, Siena (Salerno, 1963, p. 116, no. 13), in which the figure is shown drawing a sword, with a drum, smoldering fuse, gun, trumpet, and banner in the background. I have not seen the Siena picture in many years, but I am now inclined to think that it follows the Detroit picture and may be by another hand. The military equipment must, in any case, have been added by someone else since it is poorly painted and the parry-ring of the sword is on the wrong side.

[8] The standard edition of the satires is found in Cesareo. The basic study of Rosa's satires is Limentani, 1961, Ch. v, pp. 113-244, "Salvator Rosa." For the satire *Invidia*, see also Limentani, 1957, pp. 570-85.

[9] From a letter of April 1, 1666, published by Ruffo, p. 180: "...è forza il lasciarmi trasportar da gl'impeti dell'entusiasmo ed esercitare i pennelli solamente in quel tempo che me ne sento violentato." See Haskell, p. 22. My English translation is based on his. See also Salerno, 1963, pp. 24-26, "Il rifiuto del mecenate."

[10] De Rinaldis, p. 165, no. 131, dated June 21, 1664: "...ai pittori della

In the light of these attitudes it is not surprising that his favorite way of dealing with the public was to display his paintings in his studio for the *cognoscenti* and prospective clients to look over and perhaps to buy. Even under these circumstances his touchy pride was easily offended, and there are many anecdotes in Passeri, Pascoli, and Baldinucci about his insulting behavior toward his visitors, many of them rich and powerful, whom he felt had overreached themselves in their comments or requests or who had tried to haggle about prices. As a corollary to this system of selling his pictures, he realized the value of publicity and of keeping his name before the public. Much of his flamboyant and eccentric personal behavior such as his treatment of his customers was probably to some degree directed to this end.[11]

His satires were also, at least in part, motivated by a desire to shine in the public eye. He succeeded in this more fully than he planned since these bitter satirical attacks on contemporary society and on certain clearly recognizable individuals embroiled him in controversies that were certainly well publicized but also painful and even dangerous. In Rome they earned him many enemies who irritated him for years with their attacks and schemes against him, attacks which he often answered with further satires, both literary and pictorial, and with more rude behavior.[12]

But perhaps his most effective way of bringing his art to the public's attention was his assiduous use of the big public exhibitions, *mostre*, held twice a year in Rome, one at the Pantheon on March 19, the other at S. Giovanni Decollato on August 29. Other artists used the exhibitions to publicize themselves, but Rosa seemed to have been especially keen in this matter.[13] He was always on the lookout for new and unusual subjects, especially those that had never been done before so that his pictures would be sure to attract attention by their novelty, and a number

of his letters refer triumphantly to the success of the works he displayed, a success he often seems to have measured chiefly in terms of the publicity that they created.[14] On a number of occasions he used these exhibitions to reply to his enemies and critics, much as he used his satiric poems in counterattack. Once he gleefully exhibited a painting, *Il Sasso*, now lost, that showed nothing but a large rock, the point being, as he made savagely clear in the satire *Invidia*, that his enemies could break their teeth criticizing it.[15] Another time he exhibited what turned out to be the most notorious of his satires, pictorial or literary, a Fortune shown pouring out gifts of wealth and favor upon brute beasts draped in clerical robes, a clear allusion to Alexander VII Chigi's nepotism.[16] Only the intervention of the Pope's brother saved him from probable imprisonment.

He seems usually, in short, to have been in the thick of things, dashing himself against the rocks of what he felt was a corrupt society unable to understand or appreciate his genius. Some of this was a calculated pose, intended to attract attention to himself and his work, but at root it seems to have been a perfectly genuine expression of his deeply felt conviction that he was a uniquely gifted, inspired artist who should be permitted to follow his own creative enthusiasm free of the restrictions and restraints that the usual forms of patronage imposed.[17] And as he so shrewdly realized, the only way he could follow his own genius' dictates and not starve to death was to break free of traditional modes of commercial support and build a reputation as an independent and self-sustaining artist. It was a revolutionary attitude for the

mia condizione e genio stravagante, è forza dalla misura in poi lasciare il resto in libertà...."

[11] Haskell, p. 22.

[12] Limentani, 1961, especially pp. 193-211.

[13] Haskell, pp. 126-27.

[14] De Rinaldis, p. 141, no. 107, dated July 29, 1662; p. 144, no. 110 bis, dated September 16, 1662; pp. 18-19, no. 8, dated May 12, 1651; p. 31, no. 18, dated March 23, 1652; pp. 209-10, no. 175, dated September 15, 1668; Cesareo, II, p. 70, no. LXX, dated April 1, 1651; p. 72, no. LXXII, dated April 18, 1651; p. 80, no. LXXIX, dated Pentecost 1651. See also pp. 96-97, no. XCII, dated August 17, 1652, and p. 98, no. XCIII (1652, not dated), for similar proud references to the attention attracted by the Corsini *Battle*, which, however, was not actually displayed at a *mostra*.

[15] Limentani, 1961, pp. 199-200, *Invidia*, vv. 538-43, 547-49.

[16] Salerno, 1963, p. 122, no. 36. Now in the J. Paul Getty Museum, Malibu, California.

[17] Haskell, p. 22.

period, and Haskell goes so far as to say, "[Rosa] created an image of the artist which was to be fully appreciated only by the Romantics of the 19th century. In his own day he stood alone."[18]

Rosa clearly intended his etchings to play an important role in creating and proclaiming this image, and it is particularly noteworthy that he, unlike many Italian printmakers of the period, refused to associate himself with any publisher. The only name or signature that appears on his etchings is his own.

An emphatic statement of many of these views is seen in his ambitious *Genius of Rosa* etching of c. 1662 which can be taken as a kind of allegorical self-portrait [113].[19] The inscription is the key to the print's meaning: "Ingenuus, Liber, Pictor Succensor, et Aequus, / Spretor Opum, Mortisque, hic meus est Genius. Salvator Rosa." This can be translated roughly as "Sincere, free, fiery painter and equable, despiser of wealth and death, this is my genius. Salvator Rosa." Rosa's name is here part of the declaration of genius rather than simply a signature as in his other prints that include inscriptions, where "Salvator Rosa" is followed by "Inv. scul." or "Inv. pinx. scul."

Sincerity is personified in the figure of the woman with a dove to whom the genius of Rosa gives his heart. Liberty behind crowns him with a cap of liberty. *Pittura*, with a panel and brushes, Satire, related to the inscriptions "fiery," and Stoic Philosophy, relating to the "equable" of the inscription, all confront the genius in hortatory poses. The genius spurns the cornucopia of wealth which is carelessly overturned, and seems unaware of the funereal sarcophagus and cypress trees behind. What is perhaps most relevant to this discussion is that Rosa referred to himself as "Pictor Succensor," "fiery painter," and shows his genius crowned not with the usual laurel crown of epic endeavor, but with bacchic ivy, the same plant that crowns the figure of Satire. Obviously Rosa was aware that as a lively satirist the poetic crown most suited to his genius was one of ivy, the symbol of fame appropriate to *poeti allegri*, and *poeti ditirambici*. In addition, it seems very likely that Rosa meant the ivy crown to reflect his

own unusual ideas about genius. By crowning his genius with the sacred ivy of Bacchus, the god of inspired fervor, Rosa stated his belief in the intuitive, inspired, and mysterious qualities of his own genius.

But it is important to see that a wreath of laurel, the sacred plant of Apollo, also one might say crowns the inscription. The laurel crown seems to have been intended to serve two purposes. One was to declare that the Dionysiac qualities of his genius existed side by side with Apollonian ones and that the fieriness and inspired freedom of his genius were kept in check and balanced by a Stoic equilibrium, the latter symbolized by the figure of Stoic Philosophy holding the balance. As the inscription states, Rosa considered himself not only "fiery" but "equable." The other purpose of the laurel crown is to provide a proud reference to his abilities as a learned painter of grand and noble subjects and erudite philosophical themes, all of which called for the display of the human figure in significant action. The issue of figure painting was an especially touchy one with Rosa, who was deeply resentful of the fact that his reputation rested chiefly on his landscapes. He missed no occasion to stress that he considered his figure compositions to be the only ones that really counted, and always showed large, complex allegories, mythologies, or histories in the two great *mostre* in Rome mentioned earlier. He wrote Ricciardi in exasperation, ". . . I am delighted that these pictures of mine are going to the bad, so that people will forget that I ever painted landscapes."[20]

It seems reasonable to think that Rosa intended the *Genius* etching to be, among other things, a kind of *pronunciamento* that his real genius lay in depicting the human figure. And it is no accident that all of his other etchings of note, except the *Oedipus*, are concerned almost exclusively with figures and contain only minimal landscape backgrounds. As Rosa was well aware, these works as etchings would circulate widely, thus providing him with an ideal means of publicizing himself as a figure artist. This was, I believe, his chief motive in doing the etchings.

The *Figurine* seem to have been the earliest of the prints that

[18] *Ibid.*, p. 23.
[19] For a full discussion of the *Genius* etching and a complete documentation of the ideas presented here, see Ch. V below and Wallace, "Genius," pp. 471-80.

[20] De Rinaldis, p. 191. See also Haskell, p. 143.

were intended, by reaching a large public, to serve this purpose. They can be reliably dated, since on October 14, 1656, Rosa wrote to Ricciardi, whom he often consulted for advice on subject matter and literary questions, asking him for an inscription dedicating a *libretto* of 25 of the *Figurine* to Rosa's friend and most avid collector, Carlo de' Rossi.[21] The dedication was in fact made, and it is seen in the title page [6]; and although Rosa mentioned only 25 *Figurine* in his letter, his request must have come before the series, which as generally known comprises 62 prints, was finished. It is, of course, possible that only 25 prints were done in 1656 and dedicated to De' Rossi as a *libretto*, and that the remaining 37 were done at some later, undetermined time. But strong evidence that all the *Figurine* etchings were done as part of a single campaign is found in a *libretto* in the Gabinetto Nazionale delle Stampe in Rome containing 51 first states, many of them printed before Rosa's monogram and final touches of drypoint were added to the plates.[22] This strongly suggests that the whole series, or most of it, was run off in first-state form before the final impressions were pulled and that a reasonable date for the whole series would therefore be from late 1656 probably to sometime in 1657.

[21] Limentani, 1953, p. 53, no. 3: "Ho intagliate da 25 figurine d'aquaforte, e le vorrei dedicare ad [un] mio amico qui in Roma al quale professo qualche sorte d'oblighatione trovandolo sempre pronto ad ogni mia necessità col core, e con la borsa apperta, ond'io... li vorrei dedicare questo libretto;..." Rotili, pp. 79-80, nos. 22, 23, and p. 160, follows my observations (Wallace, "Rosa: Etchings," nos. 82, 83, this catalogue [47], [80]) in seeing several of the *Figurine* as being earlier than the others but dates them about 1651. He also (p. 80, no. 83 and p. 160) follows Tomory, no. 10, in thinking that the *Figurina* with the herm of Diana of Ephesus [71] may have been intended to be a separate frontispiece for the *Figurine* prints that have women subjects, with that separate series having, as Tomory suggests, allegorical significance. As I have already observed (Wallace, "Rosa: Etchings," no. 91), I find Tomory's interpretation unconvincing, based as it is on the contention that the principal figure in [71] is female or at least androgynous. It seems very unlikely that this print, or any other print in the *Figurine* series or in the series as a whole, has any allegorical meaning. They are, as Rosa declared in his frontispiece, simply *capricci*, and as such were undoubtedly meant to be free of the encumbrance of specific meaning.

[22] See the introduction to the catalogue.

The dedicatory page exists in more versions than any other print by Rosa, versions that are quite helpful in following Rosa's thinking not only about this print but about the *Figurine* series as a whole.[23] In the first state of the dedicatory page, now preserved as a unique impression in the Gabinetto Nazionale delle Stampe [6/I], the inscription is written in with pen in Rosa's own hand, and this print also shows the interesting iconographical feature of a bellows fully etched before it was subsequently burnished down in the final state so that only the snout could be seen. The inscription in its final form reads, "Salvator Rosa Has Ludentis otij Carolo Rubeo Singularis Amicitiae pignus D.D.D." ("Salvator Rosa dedicates these prints of playful leisure to Carlo de' Rossi as a pledge of outstanding friendship.") This phraseology is a succinct boiling down of an elaborate and involved text which Ricciardi proposed in response to Rosa's request for the inscription. Ricciardi's suggestion was "Friendship also has tablets of its laws, and these it hides in minds more than on bronze engravings. Salvator Rosa dedicates these bronze tablets to Carlo de' Rossi the sweetest of friends so that the tablets which a playful hand carves may earnestly testify to those laws which a genius ["unus Genius"] has written in a sincere heart."[24] It is interesting that Ricciardi's closing lines with a reference to the sincere heart of Rosa's genius adumbrate several of the *concetti* of the *Genius* etching, done some six years later, which shows Rosa's genius handing over his heart to a personification of Sincerity.

It is also interesting that the youthful figure of the dedication print bears a strong resemblance to the genius figure in idealized facial type, in the way the head is turned to show a classical profile, and even in the full and rakish headdress, although in this case it is of plumes rather than ivy. Furthermore this figure, in gesturing toward the inscription block, points directly to Salvator Rosa's name as if to identify himself. For all of these reasons

[23] See [6], [7], and [8] for the various versions of the dedication page.
[24] Limentani, 1953, p. 38: "Habet et tabulas legum suarum amicitia,/ illasq. sculptura plusquam aenea/ in animas celat./ SALVATOR ROSA/ has aeris tabulas/ CAROLO RUBEO/ amicorum suavissimo/ D.D.D./ ut istae quas ludens incidit manus/ serio testentur illas quas unus Genius/ genuino scripsit in corde."

and those that follow, I find it plausible to consider this youthful figure to be in the nature of an allegorical self-portrait much as the genius figure is.

In addition, as Nancy Rash Fabbri has shown in a recent article, this figure is very clearly based on Ripa's description of *Capriccio*:

> A young boy, dressed in various colors, wearing a hat, on which there are various feathers, similar in color to his clothes. In his right hand he holds a bellows, in his left a spur.
>
> People who are called "capricious" are those whose actions are governed by ideas which differ from the ordinary ideas of men, but who change from one idea to another of the same kind; and, by way of analogy, ideas that in painting, music or elsewhere appear out of the ordinary are termed "caprices." Inconstancy is shown in the age of the child, variety in the diversity of colors.
>
> The hat with the various feathers shows that this extraordinary variety of actions have their seat chiefly in the fantasy.
>
> The spur and bellows show that the capricious man is ready to praise other people's virtue or to prick their vices.[25]

In the etching the spur was omitted and in the final state the bellows burnished out, probably because Rosa realized that they would be both iconographically heavy and visually awkward.

The figure in the background is clearly intended as a personification of Envy, who is traditionally shown as a dessicated crone with withered breasts and snaky hair, and Fabbri has pointed out that the frontispiece shows close connections with Rosa's satire *Invidia*, which was written in 1653. The poem is a typically bitter attack on the vice of Envy and in large measure a response to the jealousies, intrigues, and rumors that were directed against Rosa, especially in the early 1650s shortly after he returned to Rome from a nine-year stay in Florence.[26] As Fabbri has observed, the poem opens with a scene which is remarkably close to the etching, a vision of the artist in which Envy bars his way as he tries "to inscribe his name on a plaque in the Temple of Immortality." But, as she also points out, the roles are reversed in the print, the personification of *Capriccio*, which Fabbri interprets specifically as the artist's fantasy, triumphs over Envy and looks down at her from above, proudly pointing to his name already recorded on the tablet. This interpretation makes it clear that Rosa intended the *Figurine* prints to be *capricci* and saw them as a response to the envious accusations and slanders of his detractors. Since he was especially sensitive about his role as a figure painter, it seems very likely that he intended the series to show not only that he could draw the human figure but that he could draw it in almost every conceivable kind of pose, costume, and grouping, with an assurance, dash, and caprice that would mark him as a master of the genre.

It is also possible, in my opinion, to extend the interpretation of the frontispiece somewhat. On the most obvious level it should be stressed that Rosa, through the allegorical personification of himself, declares his friendship for De' Rossi, here engraved on lasting stone, and boldly defies Envy to interfere with or threaten that friendship. His affirmative gesture toward the block and the defiant look he directs toward Envy may also be a manifestation of the idea expressed by Ripa that the capricious person praises virtue and scorns vice. I think that Rosa intended the frontispiece to have a larger significance as well. It is clear that he spent

[25] Fabbri, pp. 328-30. Ripa, 1630, pp. 95-96: "Giovanetto vestito di varij colori, in capo porterà un cappelletto simile al vestimento, sopra il quale vi saranno penne diverse, nella destra mano terrà un mantice, e nella sinistra un sperone. Capricciosi si dimandano quelli, che con Idee dall'ordinarie de gl'altri huomini diverse fanno prendere le proprie attioni, mà con la mobiltà dall'una all'altra pur del medesimo genere, e per modo d'Analogia si dicono capricci le idee, che in pittura, ò in musica, ò in altro modo si manifestano lontane dal modo ordinario: l'inconstanza si dimostra nell'età fanciullesca, la varietà nella diversità de i colori. Il cappello con le varie penne mostra che principalmente nella fantasia sono poste queste diversità d'attioni non ordinarie. Lo sperone, e il mantice mostrano il capriccioso pronto all'adulare l'altrui virtù, ò al pungere i vitij."

[26] See n. 12 above. Rosa also apparently had in mind doing a picture *Invidia*. See De Rinaldis, p. 64, no. 44, dated February 21, 1654, p. 70, no. 46, dated May 1654, and pp. XLVII-XLVIII.

considerable time and effort mulling over the form, both visual and symbolic, that the dedicatory page would take. In addition to the two states already mentioned there is also a splendid drawing for the etching which shows important variations of its own [6a], and also two *rovesci* [7], [8], preserved in the Calcografia Nazionale in Rome, that is etchings done on the reverse sides of plates for other Rosa etchings.[27] One of the *rovesci* seems to be the earliest expression of Rosa's thinking about the dedication page [7]. It shows the allegorical Rosa defying Envy and pointing to a large panel on which is represented a female figure holding a brush and a staff covered with vine leaves and tendrils. The fact that the allegorical Rosa here points to the painting rather than to the inscription block is another reason for believing that the artist intended the etching series to have a significance larger than specified in the dedication, that he meant it to be a kind of programmatic statement about his art and artistic principles in general, especially his commitment to figure art. This is borne out by the iconography of that panel, since the figure who holds the brush can be identified as *Pittura*. She is, first of all, a clear variation on the Ripa figure of *Arte* who holds in one hand a stake twined with young plants symbolizing the art of agriculture and in the other hand a brush and chisel for the arts of painting and sculpture.[28] Rosa has modified this personification by removing the chisel from one hand and by transforming the generalized plant into vine leaves and tendrils which have a bacchic significance, making her into a figure that has very close iconographic parallels to the *Pittura* of the *Genius* etching [113], who is also clearly associated with a panel, brushes, and bacchic ivy. Most important of all, the staff covered with vine leaves has an exact parallel in Rosa's satire *Pittura*, in which the personification of *Pittura* carries just such a thyrsus-like implement "quella Verga sua cinta di Pampino"; and in the satire the staff has the kind of bacchic significance that has already been discussed in connection with the *Genius* etching. *Pittura*, after

haranguing the artist-protagonist of the poem to be a fiery, satirical, moralizing painter in such verses as "Up, up! awaken men's spirits, and kindle their ire; and with a heart filled with noble daring rebuke and reprehend these wicked artificers," touches him on the head with the thyrsus with the result that: "From that moment on it is as if my internal fibers were afire, and as if the furies all united were encamped within my heaving breast."[29]

This bacchic symbolism is rudimentary here in comparison with the highly evolved iconographical statement made in the *Genius*, and it was soon abandoned in the later versions of the frontispiece. But I believe that Rosa, in giving the *Pittura* of this trial proof a thyrsus had in mind the ideas that were to be fully developed some six years later in the *Genius* print; that is that his art was closely associated with moralizing, poetic, satirical concerns and also that the bacchic qualities of inspired fervor and ardent freedom of creativity were important attributes of his kind of painting. Most specifically, I think he meant this version of the page to state that the prints of the *Figurine* series had these bacchic qualities, which together with their more modest corollaries of dashing imagination and bravura invention are central to the whole concept of the *capriccio*. And just because he abandoned this particular version of the dedication page does not mean he abandoned its *concetto* vis-à-vis the prints themselves; after all 25 of them must have already been done by the time he began working on the dedication page. Instead the same ideas are expressed in the final state of the frontispiece through the use of the *capriccio* iconography, in the confrontation of the al-

[27] See [6], [7], and [8] for a detailed description of the drawing and the *rovesci*.

[28] Ripa, 1630, pp. 61-63, "Arte."

[29] Cesareo, p. 227, vv. 109-17: "Sù sù desta gli spirti, e l'ire accendi;/ E pieno il cor d'un nobile ardimento/ Questi artefici rei sgrida, e riprendi./ Così diss'ella; e sù l'estremo accento/ Con quella Verga sua cinta di Pampino/ Toccommi il capo, e dileguossi in vento./ Da quel momento in quà par che m'avvampino/ Le fibre interne, e che le furie unite/ Ne l'agitato sen tutte s'accampino." The thyrsus is used as an attribute of "Poema satirico," by Ripa (1630, p. 578) and was associated with fiery satire by Rosa in the satires *Tirreno* (vv. 106-8, 520-22) and *La Babilonia* (vv. 406-8); Cesareo, I, pp. 369, 391, 341 respectively. See also Ch. V below on the *Genius of Rosa* etching.

legorical Rosa with the vice of Envy and by the inscription which implies that the series was dashed off.[30]

In addition to these iconographical considerations, Rosa was certainly familiar with the *capriccio* and *capriccio*-like prints of such artists as Jacques Callot (Fig. 6), Abraham Bosse, Stefano della Bella, and Teodor Filippo de Liagno (Fig. 7), to cite the most interesting representatives of this tradition, and the prints of Callot and especially Liagno seem to have had considerable influence on Rosa's conception of the *Figurine* series.[31] Moreover, the etchings that follow the *Figurine* next in date in Rosa's etched oeuvre are a group of battling tritons prints and the *Piping Satyr* [91]-[95], all of them related to well-established *capriccio* types within the 17th century *capriccio* tradition.[32] But Rosa, more than

any other printmaker of the period, seems to have realized the possibilities of the *capriccio*, that it could allow the artist to display his imagination and invention in the most direct way possible, without the intervention of traditional subject matter, and that, because of the great freedom and spontaneity of the etching medium itself, the *capriccio* could permit the printmaker fully to express the individuality and graphic inventiveness of his hand as well. The *capriccio* was thus perfectly suited to Rosa's intense drive for originality and it offered him a unique opportunity for a proud statement of his own personal creativity in both conception and execution, mind and hand.

As if to demonstrate his mastery of the human form in all of its possible manifestations, Rosa did figures in seated, kneeling, reclining, crouching, standing, and walking positions, turned in almost every conceivable relationship to the viewer, full face, profile, back turned, three-quarter view, or lost profile. He did women, male genre figures, and soldiers—single figures, pairs, and groups of three or four—sometimes nude and sometimes garbed in a kaleidoscopic array of costumes ranging from armor to oriental turbans.[33] Some figures rest quietly and some gesture violently, some are shrouded in melancholic isolation and others are engaged in vivid interchange with their fellows.

This broad range of solutions seems especially imaginative and various when compared with the graphic traditions in the genre that preceded the *Figurine* and in which they had their roots. Prints of this sort, showing single figures or groups of figures in a variety of poses, costumes, and activities, seem to have been quite popular from early in the history of graphics. As early as

[30] Ricciardi, in his proposal for the inscription, seems to have had capriciousness even more emphatically in mind, saying that the prints were done with a playful hand. Passeri (p. 399) says of the etchings: "...palesò il valore del suo bel genio, il furore del suo spirito sollevato, e la prontezza della sua mano ardita, mostrando capriccio nell'invenzione, stravaganza negl'abiti, e nei costumi delle figure, e maniera disciolta,..."

[31] *Varie Figure di Jacopo Callot* (J. Lieure, *Jacques Callot*, Paris, 1924, I, 201-13, 403-5); *Capricci di Varie Figure di Jacopo Callot* (Lieure, I, 214-63, 428-77); *Les Geuex* (Lieure, I, 479-503); *La Noblesse* (Lieure, I, 549-60); *Les Fantasies* (Lieure, 1372-85). The print illustrated here is from the *Varie Figure* (Lieure, I, 210). Abraham Bosse, *Figures au naturel tant des vetements que des postures des Gardes Françaises du Roy Tres Chrestien* (G. Duplessis, *Catalogue de l'œuvre de Abraham Bosse*, Paris 1859, 1332-40); *Le jardin de la noblesse française* (Duplessis, 1031-1318). Stefano della Bella, *Caprice faict par de la Bella* (A. De Vesme, *Le Peintre-Graveur Italien*, Milan 1906, 104-16); *Diversi capricci fatti per S. D. Bella* (De Vesme, 128-51); A series without title (De Vesme, 156-64); *Dessins de quelques conduites de troupes* (De Vesme, 252, 254, 260); *Diverses figures et griffonments* (De Vesme, 459-81); Liagno (Bartsch, XVII, 2-13). A frontispiece was added to the series some ten years after Liagno's death which has as its title: *Capricci et habiti Militari di Philippo De Liagno Napolitano. Novamente dati in luce da Giuseppe de Rossi in Roma 1635.* The print illustrated here is Bartsch 10. See also A. Calabi, pp. 85-100, "Il Capriccio." See also Kitson, nos. 110-12, for Liagno, or Filippo Napoletano as he was often called. For the influence of Callot and Liagno on Rosa's *Figurine*, see Salerno, 1970, pp. 38-39, and Rotili, pp. 51-55, 74.

[32] By Oduardo Fialetti, Bartsch XVII, 24-29; by Fialetti after P. Giancarli, Bartsch XVII, 44-64; by Giovanni Benedetto Castiglione, Bartsch

XXI, 15-18; and by Stefano della Bella, De Vesme, 102, 103, 150, 418, 464, 719, 984, 1016, 1021, 1028, 1037. See also Calabi, pp. 98-99. For some general remarks on the origins of the *capriccio*, see Crispolti.

[33] Rosa's interest in exotic types in the *Figurine*—vaguely oriental, Slavic or Turkish—was also undoubtedly stimulated by his knowledge of similar figures and types as they appear in Callot's etchings (Lieure, *Callot*, I, 206, 207, 211-13); della Bella's (De Vesme, 181-92 and the series *Cavaliers nègres polonais et hongrois pièces rondes*, De Vesme, 270-80); Castiglione's oriental heads (Bartsch XXI, 32-53); and in a number of Liagno's figures.

6. Jacques Callot, from the *Varie Figure* series, etching. Rome,
Gabinetto Nazionale delle Stampe (F.C. 120650)

7. Teodor Filippo de Liagno, *Soldier*, etching. Rome, Gabinetto
Nazionale delle Stampe (F.N. 4451)

the Quattrocento for example, this tradition is represented by the familiar series of prophets and sybils, and the so-called Tarocchi cards.[34] Other manifestations of this taste are found in the numerous prints of wandering vendors or street types which range in date from the 1460s up to Bosse's *Les Cris de Paris*, Francesco Villamena's *Figure della Strada*, Annibale Carracci's *Le Arti di Bologna* and beyond, even well into the 19th century in England with the *Cries of London* series.[35] Apostle, saint, and evangelist series such as those by Parmigianino and his circle, Marcantonio Raimondi, Callot, or Agostino Carracci, to cite only a few examples, can be included in this tradition.[36]

Of course the prints most directly related to the *Figurine* thematically are the various soldier, *landsknecht*, and exercise-of-arms prints that seem to have been popular from early in the history of printmaking. Several particularly interesting early examples are the print of an archer by Lucantonio degli Uberti and the prints that include the warrior heroes Achilles (Fig. 8), Troilus, Pyrrhus, and Theseus, a group which Hind dates about 1500 and attributes to an uncertain school. Similar figures occur frequently in the prints of Urs Graf, Albrecht Altdorfer, Wolf Huber, Lucas van Leyden, Albrecht Dürer, and Jacques de Gheyn,[37] and it

seems reasonable to think that even if they were not directly known by Rosa, they certainly must have fed into the print tradition represented by Callot, Liagno, della Bella, and Bosse, with which he was undoubtedly familiar.

Closely related to many of the figure ideas of the series already outlined here are the countless costume books of the 16th and 17th centuries which show similar types of figures displaying a variety of outfits, costumes, and modes of fashion. The prints of Bosse, Buytewech, and Goltzius show particularly strong connections with these costume books, and those of Callot, Liagno, and della Bella are also clearly related to them.[38]

A great many more examples could be cited but suffice it to say that the prints of this figure tradition—even those by Callot, della Bella, and Liagno that were identified specifically as *capricci*, and even those that fall in date well into the Baroque period—are almost always more restrained, conservative, and traditional than the Rosa *Figurine*, and in general show less variety of pose, gesture, and grouping. As a general rule they show a figure or perhaps several figures conservatively posed and essentially self-contained. There is little sense of the strong compositional, gestural, psychological, and often verbal bonds that link so many of Rosa's figures. These prints, their figures and compositions, seem complete in themselves, finished entities, closed statements. There is little of the strange feeling that seems to cling to Rosa's figures that they are in some way curiously incomplete parts of a larger whole, that they are participating somehow in an unperceived narrative or drama. Despite these differences it seems an inescapable conclusion that this figure tradition and representative prints from it, especially those by Callot, Liagno, and della Bella, played an extremely important

[34] Hind, 1938-1948, III, pl. 219-63; IV, pl. 320-93; I, pp. 153-81, 221-47. See also Petrucci, 1956, VI, pp. 89-97, "Figure della strada: I venditori ambulanti di Roma."

[35] Petrucci, *ibid.* For Villamena, see Petrucci, Ch. V, pp. 81-87, "Figure della strada: I ritratti in piedi del Villamena." The Annibale prints exist in a number of editions. That listed by Bartsch XIX, 117-57, is under Mitelli. For Bosse, see Duplessis, *Bosse*, 1341-52.

[36] Parmigianino, Bartsch XVI, 8, 9; Master F. P., Bartsch XVI, 1-13; Andrea Meldolla, Bartsch XVI, 24-53; Marcantonio Raimondi, Bartsch XIV, Ch. IV, "Sujets de Saints et Saintes," Ch. V, "Les Petits Saints de Marc Antoine"; Callot, Lieure, *Callot*, I, 1297-1312; Agostino Carracci, Bartsch XVIII, 48-89.

[37] For the early prints, see Hind, 1938-48, I, p. 214, D.III.5; III, pl. 310; I, pp. 282-83, F. 8-12; IV, pls. 465-66. The print illustrated here is I, p. 282, F. 8; IV, pl. 465. E. Major, E. Gradmann, *Urs Graf*, Basel, 1942, nos. 120, 123, 124, and frontispiece. H. Voss, *Albrecht Altdorfer und Wolf Huber*, Leipzig 1910, pl. 3, 4, 21, 51-53, 55-57. F.W.H. Hollstein, *The Graphic Art of Lucas van Leyden*, Amsterdam n.d., p. 103, B. 140; p. 104, B. 141; p. 105, B. 142. V. Scherer, *Dürer*, Klassiker der Kunst series, IV, Stuttgart, Leipzig n.d., p. 93, B. 88; p. 100, B. 82; p. 108, B. 87. For

Jacques de Gheyn: F.W.H. Hollstein, *Dutch and Flemish Etchings, Engravings and Woodcuts ca. 1450-1700*, Amsterdam n.d., VII, p. 135, no. 143; p. 137, no. 145; pp. 178-79, nos. 353-64.

[38] See R. Colas, *Bibliographie générale du costume et de la mode*, Paris 1933, II, "Table Methodique," pp. 1-2, 6-7, 24, 37-38, 40-41. For Goltzius, see Hollstein, *Dutch and Flemish*, VIII, pp. 87-95. For Buytewech, see E. Haverkamp Begemann, *Willem Buytewech*, Amsterdam, 1959, figs. 23, 42-44.

8. Italian, c. 1500, *Achilles*, engraving. Rome,
Gabinetto Nazionale delle Stampe (F.N. 72322)

role in Rosa's basic conception of the *Figurine* and were a major stimulus to his undertaking the series. They provided a typological model and precedent, as it were, and formed a well-established graphic tradition within which he could work his own distinctive variations and inventions.

However, the chief source for the *Figurine* was Rosa's art itself as it already existed at the time the series was begun. Figures and groups very much like the *Figurine* appear even among the earliest of his paintings and drawings such as the bambocciantesque *Coral Fishers*, his earliest known picture (Fig. 1). Very similar kinds of *bamboccio*-like figures and figure groups appear in the landscapes, harbor scenes, and battle pictures. These works were the most important part of his early production, especially in the 1640s when he was working in Florence, as seen in the splendid *Marina delle Torri* now in the Galleria Pitti, Florence (Fig. 9).[39] Although the impact of the *bamboccianti* painters' homely realism moderated during this Florentine period, it is still clearly evident in the pictures done then. In 1649 he returned to Rome where his contact with the art of the Roman grand manner seems to have been an important stimulus in his drive toward becoming a painter of large history pictures. Although he continued to do landscapes after his return to Rome he did so reluctantly, complaining frequently to Ricciardi about the public taste for them. And in general the kinds of figures that peopled these later landscapes tend to take on some of the qualities of his large figure pictures. The *bamboccio*-like figures of his earlier landscapes are corrected as it were and given a new look, although they are not completely exorcised. They become more dignified in bearing and dress, often being clothed in vaguely classical garb, and are frequently made to participate in some biblical or classical story, such as *Pythagoras and the Fishermen* or the *Preaching of St. Anthony* (Fig. 10).[40] Despite these changes, something of the original *bambocciant* flavor lingers in most of these pictures although Rosa himself does not seem to have been aware of it.

Not only was Rosa, during the later phases of his career, uneasy

[39] Salerno, 1963, p. 108, no. iv; Langdon, "Rosa: Paintings," no. 18.
[40] Salerno, 1963, p. 124, nos. 44, 42.

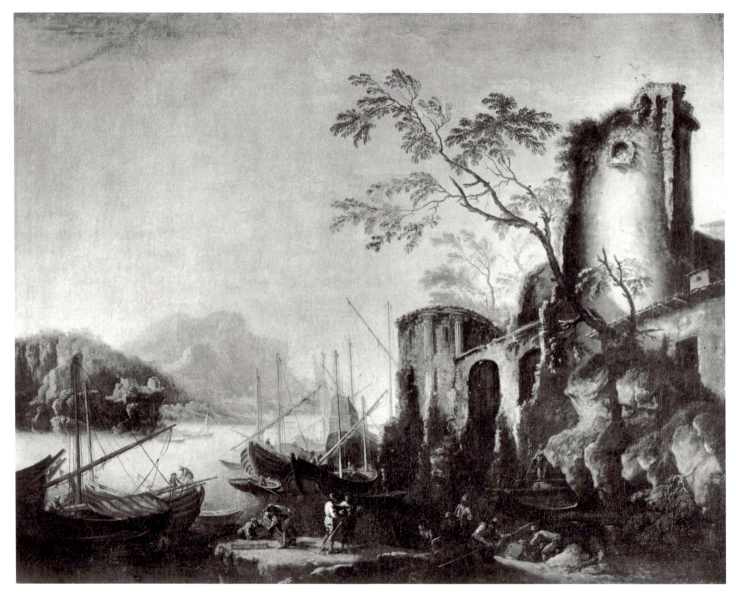

9. Rosa, *Marina delle Torri*, painting. Florence, Palazzo Pitti,
Galleria Palatina (Alinari/Scala)

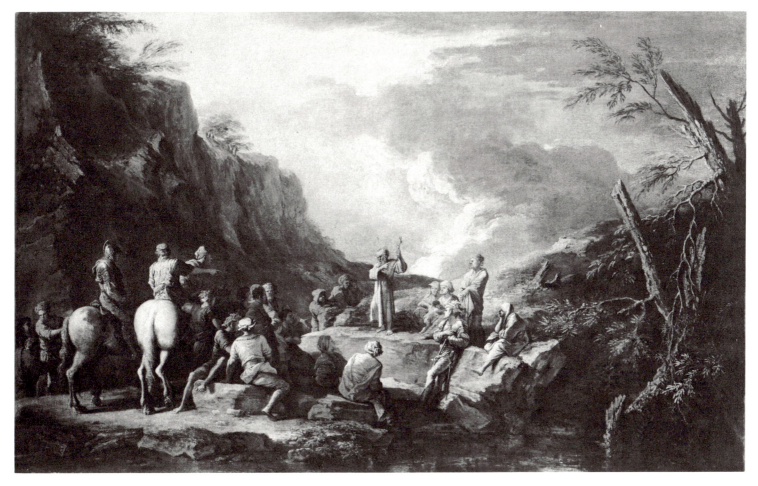

10. Rosa, *The Preaching of Saint Anthony*, painting. London, Sotheby Parke Bernet

and resentful that his reputation was based chiefly on his landscape paintings but he was embarrassed about the bambocciantesque qualities of much of his earlier art. He even declared as much in his third satire, *Pittura*, which was written in Florence, probably around 1645. It contains a violent attack on the coarse realism and subject matter of the *bamboccianti* painters; and it is also, as Limentani in *La Satira nel Seicento* puts it, a solemn repudiation of that aspect of his early style and a pledge to dedicate himself to high art.[41]

The *Figurine* series can be seen as a similar kind of repudiation of the style of the *bamboccianti* and as a revision and correction of his earlier figures. Like the figures in his later landscapes, the *Figurine* etchings make a point of shunning the coarse realism of the *bamboccianti* tradition although, like the figures in the later landscapes, they retain something of a *bamboccio*-like feeling. However the *Figurine* in general, even the genre figures, have a studied control and dignity of pose, and a largeness of gesture, often rhetorical, that make them differ significantly from Rosa's earliest bambocciantesque genre figures and also from many of the figures in the early landscapes. It is tempting in this context to think that Rosa's theatrical experience played a role in shaping the often extravagant and—to modern eyes at least—theatrical postures and gestures of his *Figurine* although it must be noted that such postures and gestures are very common in Baroque art in general. In addition, he took pains to clothe the *Figurine*, including many of the genre figures, in unusual, exotic, and archaic garments and in vaguely classical and deliberately archaic armor, costumes that place them at a picturesque remove from the world of ordinary appearances and give them a kind of romantic idealism.[42]

This sense of remoteness is greatly enhanced by the fact of their being cut off from any kind of apprehensible setting. They look as they do because they derive from the drawn and painted figures whose purpose it was to populate Rosa's landscapes, harbor scenes, and battles and to give these settings life and vivacity by their energetic and varied postures, gestures, and groupings. The *Figurine* are in a sense extracts from the paintings. It is as if Rosa decided to isolate these figures from the context that brought them into being in order to elevate them to the status of complete works of art in themselves. It is, once again, a typical assertion on Rosa's part of the superiority of the figure over landscape. But the *Figurine* do not seem to be completed works of art in themselves. They are quite unlike the self-contained figures of Callot, Liagno, della Bella, and the earlier representatives of this graphic figure tradition. Because they have been cut off from this larger context, their postures and gestures, the direction of their attention, their psychological thrust, make it seem as if an important part of their existence lies outside the edges of the etchings. They seem to carry with them by implication something of a larger environment of which they were originally a part.

In analogous fashion they very often have the air of being participants in some larger narrative or drama which the viewer thinks he senses but cannot grasp. Unlike the other representatives of this figure tradition they seem to be closely associated with words. A number of them are shown speaking and emphasizing their words with gestures. Many more seem about to speak or to have just finished speaking. And as Giulio Carlo Argan has observed, we tend to look at figural prints differently than we look at paintings; we are inclined to read them much as we would the printed page rather than to contemplate them as we

[41] Limentani, 1961, p. 163.

[42] Mr. Helmut Nickel, Curator of Arms and Armor at the Metropolitan Museum of Art, New York, has very kindly informed me that only one of the *Figurine* etchings [52] shows historically correct armor and that "all the others are either ingeniously but heavily romanticized versions of classical armor with Renaissance additions and interpretations, or . . . vague renderings of foot soldiers' armor of the middle and second half of the 16th century." In view of Rosa's pedantic fussiness in matters of historical accuracy—he wrote Ricciardi, for example, that he had studied

"Choul" (Guillaume du Choul, *Discours su la castrametation et discipline militaire des Romains*, Lyons 1555, and other editions), in order to be as rigorous as possible in doing the armor for his *S. Torpè* (see Salerno, 1963, p. 57, pp. 99-100, p. 145)—it seems quite likely that this inaccuracy was deliberate and intended to create a sense of archaic remoteness (De Rinaldis, p. 221, no. 186, dated August 17, 1669). For other references to Rosa's insistence on scrupulous accuracy, see Baldinucci, 1773, pp. 75-76; Limentani, 1961, p. 173; Limentani, 1950, p. 141, no. 40, dated October 23, 1666.

do paintings. As a result the figural print has much in common with the printed book.[43] These considerations, taken together with the fact that Rosa apparently intended the *Figurine*, or at least some of them, to be bound together in *libretto* form, help to explain some of the curious, incomplete narrative qualities that the *Figurine* seem to have.[44] For the 17th century viewer, the experience of looking through a *libretto* of these prints must have had something in common with a reading of the romances of chivalry that enjoyed a tremendous popularity in the late 16th century and throughout the 17th century. Rosa even mentions reading one of them himself in a letter to Ricciardi.[45] These romances, both serious epics based chiefly on Tasso and satirical parodies in a mock epic vein such as Alessandro Tassoni's *La Secchia Rapita* or the *Malmantile Racquistato* by Rosa's friend Lorenzo Lippi, are filled with knights and warriors, heroes, heroines, and even genre figures and common soldiers.[46] And since they are inevitably based on the romantic adventures of a bygone time, chiefly the Middle Ages, they have something of the remote, exotic, and archaic flavor of many of Rosa's *Figurine*, especially of course his soldiers with their archaic armor. The organization of these *romanzi* also has something in common with Rosa's *Figurine* as bound together in *libretto* form, their plots are basically a straightforward, linear sequence of events or vignettes.

The satirical approach to the epic tradition found in the mock epics may have served to some degree as a stimulus to Rosa in doing his own satire on warfare, *La Guerra*. It is, however, far from a humorous or burlesque treatment of the theme but is instead a bitter denunciation of the pointless bloodshed of warfare. It is tempting to think that there might be some direct connection between the satire and the *Figurine* since they were both produced at almost the same time; however, not only are the two entirely different in basic tone and mood but the poem is purely rhetorical in approach, a dialogue between two characters, Autore and Timone, and lacks entirely the rich and varied *dramatis personae* of the epics, mock epics, and the *Figurine*.[47]

There is in fact no narrative to which the *Figurine* belong; they do not illustrate any text that I have discovered. As a result they remain elusive and fugitive, implying more than they state and evoking a larger context that seems to hover just beyond the range of the viewer's comprehension. Consequently the *Figurine* in general and the soldiers in particular have an air of mystery, conspiracy, and what might be called a romantic incompleteness. Being incomplete these etchings can serve as a kind of *tabula rasa* upon which the Romantic imagination can wander fancy free, spinning out its fantasies. It is not surprising, for example, that in the 18th century Rosa's soldiers were transformed into *banditti*, that Lady Morgan could impose a completely fictional biography of Rosa on one of his prints, or that Mortimer could portray him as one of his own *banditti*. Rosa's prints were not only widely known in the 18th century, both in the originals and in copies after them, but many of these prints were also bound together in *libretto* form.[48] The implied narrative qualities of the *Figurine* so bound seem to have been especially attractive to Mortimer—and to Robert Blyth, who did a number of etchings after Mortimer's paintings and drawings—since many of Mortimer's *banditti* prints have titles which fall into a kind of storybook sequence, as "Going Out in the Morning," "Banditti Taking His Post" (Fig. 26), "Banditti on the Lookout," "Killing an Enemy," "Stripping the Slain," "Returning Wounded from Battle," and so on.[49]

[43] G. C. Argan, "Il valore critico dell'incisione di riproduzione," *Marcatre*, I, April, 1966, pp. 19-22.

[44] As quoted in n. 21 above, Rosa, in asking Ricciardi for a dedication inscription for the series, referred specifically to them as being in *libretto* form. De Dominici, III, p. 247, calls the *Figurine* "il bel libro di Soldatini e altre figurette." Giuseppe de Rosis, in a letter to Don Antonio Ruffo dated June 2, 1663, referred to "il libro delli soldatini" (Ruffo p. 168).

[45] Limentani, 1953, p. 58, no. 6, dated August 11, 1668. For this epic and mock-epic tradition in Italian 17th century literature, see A. Belloni, *Il Seicento*, Storia Letteratura d'Italia, Milan, n.d., Chs. III, IV.

[46] For Tassoni, see Belloni, *Il Seicento*, pp. 242-52; for Lippi, pp. 279-82 and De Rinaldis, pp. XVII-XVIII.

[47] Tomory, no. 10, suggests a direct connection between *La Guerra* and the *Figurine*.

[48] Sunderland, "Mortimer and Rosa," pp. 520-21.

[49] *Mortimer A.R.A.*, pp. 34-39, nos. 51-75.

For all these reasons the *Figurine* inspire fantasy more than do the other figure prints in the graphic tradition which preceded them. Callot's and Liagno's figures are essentially *capricci* of fanciful costumes and exotic types; it is hard to conceive of an 18th century Romantic, no matter how heated his imagination, being able to spin much of a yarn around them. But in Rosa's *Figurine* the qualities of the *capriccio* go much deeper and the etchings are for the reasons I have tried to suggest, much more fundamentally mysterious and fantastic. In this they anticipate many of the qualities of Giovanni Battista Tiepolo's *Capricci* and *Scherzi* (Fig. 25), perhaps the most capricious and fantastic prints ever done in this tradition and also the most tantalizing and elusive in meaning. It is revealing that Tiepolo modeled several of his prints on Rosa's and that many of the figures in his *Capricci* and *Scherzi* show great similarities to Rosa's *Figurine*.[50]

There are also interesting connections among these qualities of fantasy, mystery, and incompleteness, and the notion of obscurity which played an extremely important role in Romantic thinking and art theory, especially in England. Edmund Burke, perhaps the most influential writer of the time on these matters, felt that obscurity contributed greatly to that most desirable of all things in art, the sublime, by inducing feelings of awe and terror.[51] As an artistic principle, obscurity seems to usually have been applied to landscapes, where of course Rosa got very high marks, partly because his landscapes had, or were imagined to have, a great many caves, grottoes, chasms, torrents, precipices, forests, and of course *banditti*. If Rosa's Romantic admirers were attracted by these qualities of obscurity in his landscapes, this probably helps to explain, at least in part, the popularity that his *banditti* etchings seem to have enjoyed. It is amusing and also revealing that Rosa enthusiasts were so intrigued by his grottoes and his *banditti* since the *banditti* partake of the *capriccio* tradition, the earliest manifestations of which were evidently the *grotteschi* or grotto work of antiquity and the Renaissance.[52]

It seems likely that Rosa intended the *Figurine* to be imagi-

native, inventive, and capricious in style and execution as well. Just as they display a greater range of postures, gestures, groupings, and psychological interplay than any of the other prints in the tradition that preceded them, so too do they show a greater range of techniques in the handling of contour lines, modeling systems, hatchings, strokes, dots, and especially light effects than do any of the earlier prints in this graphic figure tradition. This is not to say that Rosa invented these techniques as such although some of them, such as the negative contour which I will discuss later, are in fact rather unusual for the time. But these techniques are found to varying degrees and in varying mixtures in Italian 17th century graphics in general. In fact Rosa's etching style and technique show close connections with the free, quick, light-filled etching style that was begun by Parmigianino. That artist's approach was picked up and developed to a limited degree by Annibale Carracci and more so by Guido Reni, Simone Cantarini, and Giulio Carpione, to name only a few of the most important printmakers. Variations are found in the work of Ribera, Pietro Testa, and Giovanni Benedetto Castiglione, all of whom influenced Rosa's style and technique to some degree.

Other prints of the period show a greater complexity of technique, such as those by Orazio Borgiani, or, most interesting in the scope of this study, some of those by Giovanni Benedetto Castiglione or Stefano della Bella. But these prints are usually relatively large, complex, and ambitious graphic statements, unlike the prints of the small figure tradition which I have outlined. And it is important to remember that Rosa was achieving this variety and richness within the narrow confines of small compositions done in single stage biting. One biting, varying amounts of drypoint, and occasional burnishing out were the only devices he used, but with them he was able to achieve a remarkably broad range and variety of graphic effects in the *Figurine* without sacrificing spontaneity and directness of execution.

Since a considerable number of preparatory drawings for the *Figurine* survive and since in almost every case the etching follows the drawing closely, it suggests that all of the *Figurine* etchings probably had such preparatory studies. It is also very interesting that the drawings go through a pronounced evolution

[50] See Ch. VII below. [51] See Ch. VII below.

[52] Crispolti, col. 104.

from a careful and conservative execution to a very bold one, an evolution that has certain interesting but complex parallels in the prints themselves. Although the etchings follow the drawings closely and although the drawings are the same size as the etchings, only one of the studies that I know was actually scored for transfer onto the plate, a drawing at Windsor for a soldier group print [47], [47a]. It is done in pen, brown ink, and brown wash with traces of red chalk and washed red chalk, and it is surprisingly cautious in execution. The contours are carefully and rather stiffly drawn with thin, spidery pen lines and the shadows are done with precisely managed washes. This is especially remarkable since by this late date Rosa was already the master of a brilliant and dashing pen and wash technique, and it suggests that Rosa deliberately shifted to a more restrained and conservative approach in beginning the *Figurine*, the first of his prints intended to play an important public role and to be extensively printed and circulated. Despite the unusual qualities of the drawing there can be little doubt that it is by Rosa. The handling of the drapery and anatomy is especially characteristic of him, the face is a very typical Rosa physiognomy, and the additions in red chalk to the shadow behind the figure's left leg indicate that the drawing is in fact preparatory to the etching rather than a copy after it. Its restraint of execution combined with the fact that it is unique in being scored for transfer strongly suggests that it is for one of the earliest, and perhaps the earliest, of the *Figurine* etchings, done when the artist was proceeding cautiously on what was his first attempt at printmaking on an ambitious scale.

The print follows the drawing so closely that many of the qualities of stiffness in the preparatory study are repeated in the etching, as seen especially in the rather awkward contour lines of the face, arms, hands, fingers, and drapery. Despite this the lines are strongly stroked and emphatically bitten, producing an effect of considerable graphic weight. A similar kind of rough and awkward vigor is seen in the shading and modeling of the etching as well. The figure is modeled, rather harshly, with straightforward systems of firmly stroked parallel lines and crosshatching that reproduce the tonal effects of the drawing

quite carefully. However, despite the strength of the modeling strokes themselves they are usually quite cautiously disposed at the edges of the forms, concentrated at the contours, so that large, unmodeled light areas are vividly set off against darks, creating pronounced pattern and silhouette effects. This tendency toward patternization is much enhanced by the rough screen of parallel lines and crosshatching of the background. Since the lines that form the screen are carried all the way across the print's surface and are of essentially the same graphic weight as the lines of the foreground, the screen tends to read as a plane which comes forward visually, compressing and flattening the forms in front of it even more and giving great stress to the two-dimensional surface of the print.

This dark background and the pronounced contrast of light and dark in other parts of the print produce the effect of a strong raking light and a strangely nocturnal quality that is reminiscent of the *Male Nude* [1]. The print also has a pronounced negative contour at the left shoulder of the background figure that is very similar to like contours seen in the *Male Nude*. In fact almost all of the graphic qualities of this *Figurine* are much like those seen in all three of Rosa's earliest prints, the *Male Nude*, the *Praying Penitent in a Wilderness* [2], and the *Landscape with a Figure* [3]. The exception is the deliberateness of stroke of the *Figurine*, which is quite different from the free, painterly handling of the *Praying Penitent* and the *Landscape with a Figure*, although very similar to the approach used in the *Male Nude*. As has already been mentioned in connection with the drawing, this conservatism can probably be explained as the result of Rosa's conscious restraint of hand in beginning a series of etchings that for the first time in his career were intended to circulate widely.

In all other graphic features the four prints are very much alike. They all have rough, vigorous, strongly stroked, and deeply bitten lines. Contour lines in all of them are similar in having a stiff, rather tense, somewhat awkward angularity. All show a tendency to cover large portions of the print's surface with a web of lines of a basically uniform graphic weight, and to varying degrees all tend to flatten forms and create pattern-like juxtaposi-

tions of lights against darks. In this *Figurine* [47] as in the *Praying Penitent*, the *Male Nude*, and even the *Landscape with a Figure*, the contrast between lights and darks is often rather stark and unmodulated.

There are a number of other *Figurine* which in my opinion can be dated early because they share many of the graphic qualities of [47] and were done from preparatory drawings very similar to the Windsor study for that print. None of these drawings is scored, however, with the result that the flow of line in the etchings after them is more confident and less inhibited than in [47]. The drawing for the soldier group [52], [52a], for example, has almost all of these qualities discussed in connection with the drawing for [47], and like it has significant *pentimenti* that indicate it was in fact preparatory to the print and not done after it. The print itself is very similar to [47] in its vigorous, strongly stroked, deeply bitten line, its forceful, regular modeling scheme, its strong contrast of lights against darks producing powerful raking light and nocturnal effects, and its pronounced negative contours. There is, however, a measure of stylistic development beyond [47] in the print, not only in its greater fluency of line but also in its more consistent modeling scheme, which distributes modeling lines and hatchings more comprehensively over the forms instead of concentrating them at the contours as in [47]. A slight amount of dotting is even used to help model the armor of the central figure and the figure to his left. As a result the forms seem to occupy space more convincingly as masses, and the pattern-like qualities seen in [47] and in the three early prints are less pronounced, although the foreground rock does read quite emphatically as a silhouette, especially at the right side. Especially noticeable in this print is the way the artist rejects the flat, space-compressing background plane of parallel lines seen in [47] in favor of an opening up of the background at the upper left.

There are other prints that can be grouped early because of very similar considerations of etching style and the style of their preparatory drawings. These prints also show Rosa trying to achieve a greater variety of etching possibilities than is seen in [47] or the three early etchings. For example, in an exotic group [77], [77a], he experimented with the long, vertical, parallel modeling and contour lines that are characteristic of the etchings of Jacques Callot. He also added small dots to the back of the principal figure's robe to make the modeling of the drapery more subtle and to suggest something of the texture of the cloth. And after a first state impression was pulled, he applied a fine web of drypoint lines to the already etched plate in the areas of the principal figure's cap and left shoulder and sleeve to render with greater suavity the tonal and modeling transitions there. In addition he was clearly aware of the problems created by making the background screen lines of the same strength as the foreground lines and decided to modulate this effect by lightening them, possibly by burnishing the plate after the lines were bitten or possibly by somehow inhibiting the biting of that portion of the plate.

Or in the etching of a pointing figure [80], the preparatory drawing for which is typical of those for the early *Figurine* [80a], he used considerable dotting to model the figure's left leg; and after the first state [80/I] was pulled, he reworked the plate with extensive drypoint along the central fold of drapery that hangs down in front of the figure [80/II]. In comparison with the first state of the print, the drypoint in the finished state modifies the strong contrast of light and dark in this area, models the drapery more subtly, and places it more convincingly in depth by reducing a tendency seen in the first state—a tendency of the brightly lighted fold to come forward visually so that it reads as being in the same plane as the figure's left leg. It is an interesting evolution away from the more straightforward and often ruder juxtaposition of lights and darks typical of his early prints and one that looks forward to developments in the later *Figurine*. In this print, and another early *Figurine*, a walking genre figure [78], the preparatory drawing for which is typical of those for the early *Figurine*, he also broke away entirely from the use of background screens of lines and allowed the figures to stand against a simple, unworked background.

Another of the *Figurine*, a sleeping soldier [57] shows many of the qualities that are characteristic of the early *Figurine* but is more confident and flexible in the management of both the etching needle and the pen and wash technique used in its prepara-

tory study [57a]. In this print Rosa not only varied the placement of lines in the background screen to avoid the flat planarity of [47] but he also made the background lines consistently lighter than those of the foreground. He accomplished this not by staged biting but by the relatively simple expedient of applying varying degrees of pressure to the etching needle, barely scratching through the ground at the upper left, and by going over some of the darker passages several times with the etching needle, reinforcing lines and shading before biting the plate. It is a sign of his relative inexperience as an etcher that these darker areas were often worked too much with the needle so that the acid, in biting places where so much copper was exposed, bit more strongly than he intended, causing plate breakdown and blurred lines.

Any attempt to establish a chronological sequence of stylistic evolution within a large group of etchings all done within a year or two of one another is risky, but the particular combinations of stylistic features that I have used to characterize the early *Figurine* and their drawings do distinguish them from other prints in the series which are, in my opinion, stylistically and technically more advanced and therefore later. It would, however, be a pointless and certainly inaccurate overrefinement to try to establish any kind of precise order of development for the *Figurine*, aside from this rough division into earlier and later etchings, especially since in doing them Rosa chose to be deliberately capricious and inconsistent in style and technique and experimented with an extremely wide range of graphic solutions.

In addition to purely graphic advances, there are also remarkable differences between the drawings for the early *Figurine* and those that are preparatory to the later etchings. In general, the later drawings are so much more forceful and assured than those for the early *Figurine* that it is hard to believe that they all could have been done within a few years of each other. But as noted earlier, Rosa had in fact been doing a large number of even more vigorous drawings for many years before this. As a rule the preparatory studies that show the greatest mastery and confidence in the handling of the pen and wash technique, such as the study for the soldier group [40], [40a], are for the etchings

that are graphically the most confident, subtle, and complex. Not only is this drawing particularly bold in its dashingly executed *pentimenti*, but the print itself shows considerable independence from its preparatory study, especially in its background areas, which were apparently designed directly on the plate without benefit of a drawing, an approach which is a far cry from the careful duplication in etching of timid drawings seen in the earlier *Figurine*. In addition [40] has a number of graphic qualities which are, in my opinion, quite characteristic of the later *Figurine* and which are also seen to varying degrees and with differing emphases in the soldier groups [64] and [49], a single standing soldier [25], an exotic warrior [30], and a female nude [81], to choose several of the most telling examples. It is noteworthy that all of these prints have preparatory studies which are in general stylistically typical of those for the later *Figurine*, as [49a], for example, or [25a]. In the later prints the etched line is usually lighter, finer, more cleanly stroked, and done with a greater freedom and assurance of hand than in the earlier examples. Contour lines tend to be more suave and more fluent than in the earlier *Figurine*, and shaded areas are often more transparent and more subtly and regularly formed. The modeling of figures in the later prints is often more consistent and comprehensive than in the early *Figurine*, so that the patternizing effect of the early examples gives way to solutions in which forms are more convincingly modeled as three dimensional entities and have a more believable existence as masses occupying space. The play of light and shadow is generally more subtle and varied. It should be observed, however, that despite the greater sophistication of later *Figurine* in purely graphic terms, they nevertheless often exhibit a fundamental awkwardness in the drawing of the human figure, the treatment of anatomy, and the placement of forms in space.

In addition to the handling of the etching technique in the later prints, generally more polished and assured, a number of subtle graphic devices are introduced into many of them, devices which show the artist experimenting with an increasingly widened range of graphic possibilities to produce varied and complex etched solutions. For example, both the exotic warrior [30]

and another exotic type, a bowman [79], show regular systems of traditional hatching and crosshatching, executed with great regularity and blended together with a varied assortment of dots, flicks, and short quick curving strokes to model forms subtly and to suggest textures of flesh, leather, cloth, fur, and armor. Interesting and sophisticated variations on the negative contour idea are seen in the soldier group [64], an exotic warrior group [70], and especially [49]. In [64] the contour of the foreground figure's back is created by foiling an unmodeled area of white against a lightly worked background of parallel strokes supplemented with a variety of secondary strokes, straight and curving, between them, producing a soft fuzzy transition between light and shadow at that point. Or in [70] the principal figure's left arm is set off against varied and vigorously executed crosshatching, creating a vibrant light effect at the contour which enlivens that side of the figure and enhances the vivid raking-light qualities of the whole print. A particularly subtle variation on the negative contour is seen in [49]. The modeling of the torso of the foreground figure with a great variety of dots, flicks, and short strokes produces a smooth sculptural rounding of the form which is especially appropriate since the figure is based on the Belvedere torso. And by using a delicately dotted negative contour foiled against a light screen of background lines the artist is able to retain the closed sculptural contour of the back while at the same time suggesting that it is affected by the light of this very luminous print.

The most complex of all of the *Figurine* in technique is undoubtedly the female nude [81]. Almost no hatching is used to model the figure, delicate passages of dots and short strokes are used both to create smooth modeling transitions and to suggest the softness and skin texture of the nude female body. Rosa is at his most imaginative here in his use of variations of the negative contour, as seen at her shoulder, where the background foil consists of a variety of straight and curving lines, at her waist where this is supplemented by light dotting at the edge of her body, and especially at the crossing of her right leg over her left where the background foil is made up simply of a very light dotting. This effect is repeated with the addition of a very light

contour line where her knee is foiled against the rock. Below that the contour of her calf is dissolved into a series of short dashes, the stroked direction of which serves to imply the roundness of her leg. The background foliage is treated with a similar delicacy, giving the whole print a feathery softness and gentle, high-key luminosity.

The great range and subtlety of the graphic solutions of many of the later prints is often accompanied, as seen in the prints already discussed, by a greater range and variety of light effects, atmospheric effects, and spatial relations than is found in the early *Figurine*. For example, the knight in armor [24]—like a number of other later *Figurine* such as a seated soldier [12], a standing soldier [13], a sleeping soldier [27], a seated knight [32], a soldier group [58], or a female genre figure [84]—also shows Rosa experimenting with more sophisticated variations on the pronounced chiaroscuro and nocturnal effects seen in a number of his early prints. The sleeping soldier [27], an interesting variation on the earlier sleeping soldier [57], shows many of the qualities of style that I have discussed as being typical of the later prints. Above all the etched line is lighter, finer, more cleanly stroked, and done with a greater freedom, confidence, and flexibility of hand. Contour lines are smoother and more fluent, and systems of hatching and crosshatching more regular, more subtly gradated in tone, and in general more transparent. As a result the figure is more comprehensively and smoothly modeled as a three-dimensional form and seems to exist within the nocturnal atmosphere of the print rather than standing out before it as the figure in the earlier print does. The background forms of the later etching—the trees, foliage, and clouds—are done in a more sketchy and impressionistic manner than the figure itself, causing them to be read as being farther back in space, more blurred by atmosphere than is the figure. This is in marked contrast to the handling of the background figure in the earlier print [57], which is done with lines of essentially the same graphic weight and clarity as the chief figure so that it tends to come forward in space.

There is as well considerable variation in the kinds of nocturnal effects seen in these later prints. The sleeping soldier print can

be considered a genuine night scene, but in the two etchings of knights in armor [24] and [32], the figures are enveloped in the deep shadows of grotto-like settings. The standing soldier [13] is, on the other hand, set off against the storm-darkened sky, an effect often seen in the *Figurine* and in Rosa's art in general. A particularly inventive and technically rather difficult touch is found in [32] where the shadowed face of the seated knight is etched completely black. Much as in the case of [27] as compared to [57], the figures in [12], [13], [24], and [58], because of the more subtly modulated tonal effects of the prints, seem to blend in smoothly with their dark ambiances in contrast to the earlier dark prints such as [47], [52], or [57] in which abrupt juxtapositions of intense lights and saturated darks tend to contrast and separate forms and their settings. A particularly interesting method of achieving this kind of atmospheric blending is seen in [13] and [58], in which the screens of parallel lines of the somber sky, instead of keeping to the background as they do in the other etchings, are made to intervene between foreground and background shapes. In [13] these lines overlap and veil the low rise of ground behind the warrior and in [58] they veil the figure farthest in depth, shrouding these forms in semi-darkness. It is a logical, albeit more ambitious development of the screening effect seen in the lower portion of the tree in [27], and as in [27] the sense of atmospheric blurring is enhanced in both prints by the use of sketchy, impressionistic strokes to describe these background shapes.

Analogous graphic methods are used to produce varied atmospheric and light effects and complex adjustments in the placement of forms in space in a number of other later *Figurine* as well, as in [50], [54], [59], [64], or [70]. Obviously these prints with their relatively large groups of three or more figures could accommodate these rather complex graphic variations especially well. But even many of the prints with single figures in this series show Rosa experimenting with analogous kinds of atmospheric and light effects in their settings and backgrounds. In [79] this can be seen in the broken, sketchy treatment of the background tree stub and foliage, in [30] the exotic warrior stands in front of what seems to be a distant battle veiled in smoke and haze roughly and impressionistically sketched, in [35] there is a distant view of a landscape with a tower etched with dotted, light-dissolved lines.

Many of the *Figurine* also show what might be called a decorum of style and technique, that is style and technique chosen for their fitness to form, subject matter, and expression. This is something that is seen more consistently in the later *Figurine* than in the earlier ones, and it once again indicates that in the series the artist was deliberately seeking ever greater varieties of imaginative and expressive graphic possibilities. For example in three prints of idealized female nudes [81], [82], and [86], the style and execution of the figures is appropriately polished and suave. The classicizing, sculpture-like drapery of [82] derives much of its smooth harmonious rhythm from the measured flowing strokes which define and model it. Two women of a homelier sort, the two female genre figures [83] and [84], are more roughly etched in an appropriately homelier style, and the modeling lines, hatchings, strokes, and dots which define them are more irregular in feeling, flow, placement, and rhythm. In general the genre figures of the *Figurine* series, prints such as [66], [67], [69], [74], or [75], tend, by comparison with the soldier *Figurine*, to be done in what might be called a more pedestrian style, one that makes use of straightforward rather uniform lines of relatively little variety or subtlety. In some cases however, such as [66] or [69], these lines have considerable energy and velocity. The soldier figures are often, but not always, done with a greater variety of lines, dots, and strokes than are the genre figures and their often complex graphic systems frequently have a nervous, charged quality that is not usually seen in the graphically more sober and stolid genre figure etchings.

The *Figurine* also show considerable variety among themselves in the way style and technique are adjusted, modified, and adapted in order to express most appropriately different kinds of motion and emotion. In [50], for example, a moody, pensive print, the etching style, although subtly charged with tense, vibrating graphic qualities, is nevertheless quite restrained and subdued in its broader and more obvious characteristics and given over to a careful description of forms as seen at rest, systematically modeled

and rich in textures. In [54] on the other hand, free, hasty, slashing lines play an extremely important expressive role in contributing to the extroverted, bursting quality of the composition and in accentuating its swirling, spiraling energy. Similar kinds of choice and adjustment of style and technique to suit a variety of moods, emotions, and movements can also be seen in a number of the other *Figurine*, as for example [24], [30], [59], or [64], to choose several restrained etchings, or [12], [13], [51], or [62], to cite more vigorous prints. In many of these *Figurine*, modeling lines are carefully integrated with the composition as a whole and, as in [54], often play an important role in organizing and energizing the composition.

Given the complexity, variety, and range of graphic and formal solutions seen in the *Figurine*, it is more difficult than in the case of Rosa's five early prints to establish what influences may have been at work on them. Moreover most of the features of style and technique found in the *Figurine* were used to varying degrees and in varying mixtures by so many of the printmakers of the time that it is difficult to limit a given feature of style and technique to a sufficiently small number of artists to make a convincing argument for the influence of a particular artist, print, or group of prints on the *Figurine*. Still, it does seem reasonable to think that the early *Figurine*, which have so many qualities in common with Rosa's three early prints, also show something of a lingering influence of Ribera's etchings. This is evident in the firmness of stroke with which the early *Figurine* were done and to some measure in the forceful contrasts of light and dark they exhibit, the latter being transmuted in several of them into somber, nocturnal effects much like those seen in the *Male Nude*.

But the sources for Rosa's use of pronounced and even nocturnal chiaroscuro effects in the *Figurine* are more complex. Not only do they, like his earliest prints, reflect his own predilection for similar qualities in many of his paintings and drawings but it seems very likely that this taste was reinforced by Rosa's demonstrated strong interest in the etchings of Giovanni Benedetto Castiglione, who, more than any other Italian etcher of the period, experimented with a great range of dark, gloomy,

nocturnal effects, many of them Rembrandt-like in feeling.[53] In the course of producing these effects Castiglione also frequently set off bright, unmodeled white contours against complex foils of freely scribbled, web-like lines, an approach that may have encouraged Rosa in his experiments with elaborate negative contour effects in the *Figurine*. The knight in armor [24] is especially reminiscent of Castiglione's prints, both in its nocturnal effects and also in the finespun, scribbly filagree of etched line with which the principal forms and especially the background are modeled and shaded. It is also tempting to think that the suave dotting techniques used to model flesh and suggest skin texture in a number of the *Figurine* such as the female nude [81] may be, at least in part, derived from the analogous dotting solutions seen in certain of Castiglione's prints such as the *Genius* or more especially the *Melancholia*. But this technique, like almost all of those used in the *Figurine*, was so widely practiced in Italian baroque prints that there is no reason why there need be a direct connection between Rosa and Castiglione in this particular. In fact Rosa's female nude [81] shows a striking resemblance to Annibale Carracci's print *Magdalen*, Bartsch 16 (Fig. 11), which not only provides an important model for the figure and her posture, but also makes use of a very similar kind of subtle dotting to model forms and also, most important, to create negative contours which are remarkably like those seen in Rosa's figure.

Bartsch and Ozzola note the influence of Pietro Testa's prints on Rosa, an influence that is most evident, as I shall demonstrate later, in Rosa's larger prints. In addition Pettorelli makes similar observations, and points out that Rosa's use of long, flowing, weighty drapery in his etchings has much in common with Testa's handling of drapery in his prints, a comparison that applies to many of the *Figurine* as well as to the larger etchings.[54] A number of the *Figurine* also show a kind of half tone shading

[53] In addition to the fact that Rosa's *Genius* print [113] was modeled on Castiglione's (fig. 18), his *Democritus* [104] also follows Castiglione's *Melancholy* (fig. 14) very closely. See below Ch. V.

[54] Bartsch xx, p. 257; Ozzola, pp. 191-93; Pettorelli, p. 27. See also Rotili, especially pp. 39-42.

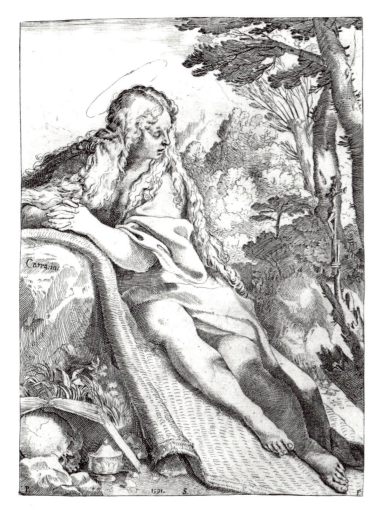

11. Annibale Carracci, *Magdalene*, etching. Rome, Gabinetto Nazionale delle Stampe (F.C. 30494)

made up of carefully placed parallel strokes, straight and curved, running frequently on a slant; and although this device is not uncommon in the graphic art of the period, it occurs with such frequency in Testa's etchings and in those of Rosa's larger prints that were most clearly influenced by Testa that Rosa may have been following Testa's lead in using this approach in the *Figurine* as well.[55]

The influence of Callot, Liagno, and della Bella on the basic conception of the *Figurine* series has already been discussed; and although Callot's etching style and technique seem to have influenced Rosa in his creation of the early Oriental group [77], this seems to be an isolated example. A more extensive influence on Rosa's etching style and technique can be found, in my opinion, in the etchings of Stefano della Bella. Very similar kinds of what I have called negative contour effects appear in a great many of this artist's etchings,[56] and it seems likely that Rosa, in addition to looking to such things as della Bella's *capricci* and *capriccio*-like prints as typological models for his *Figurine* series, was struck by this stylistic feature as well. Moreover della Bella's prints are particularly rich in varieties of graphic effects, including staged biting, a great variety of etched lines and strokes, and varied toning effects produced by applying acid directly to the plate, and it may also be that this richness of graphic invention inspired Rosa to attempt the wide range of graphic effects that are evident in the *Figurine*.

What is of much greater interest and significance than these few limited examples of influence and borrowing is that they are manifestations of, and are subsumed within, a much broader, more comprehensive attitude toward style and technique. In doing the *Figurine* Rosa embraced with a sweeping enthusiasm and an energetic gusto most of the significant kinds of printmaking styles and techniques that can be found in Italian baroque

[55] The half-tone shading lines are most evident in Rosa's [6], [27], [40], [41], [44], [46], [49], [50], [51], [54], [57], [64], and [74].

[56] This particular feature in della Bella's prints is noted by P. D. Massar, *Stefano della Bella, Catalogue Raisonné by Alexander de Vesme*, New York 1971, I, p. 14.

graphics. He was clearly seeking to make the *Figurine* as much *capricci*, as varied, and as imaginative in style and technique as they are in postures, gestures, costumes, groupings, and psychological interplay. Not only are the *Figurine* more capricious in this sense than any of the prints of the small figure and *capriccio* tradition that preceded them, but they are also in their graphic solutions among the most varied and inventive prints of the period. To be sure, other prints of the time used most of the techniques found in the *Figurine* to varying degrees and in varying mixtures and with varying emphases, and in that sense Rosa's approach is more derivative than inventive. But as far as I have been able to discover, no other series or group of prints of this period in Italy brings together such a broad range of so many diverse and varied kinds of technical, stylistic, and formal solutions within a single graphic program.

This quest for variety and inventiveness in all aspects of the *Figurine* is a typical reflection of a basic attitude on Rosa's part toward the concept of originality, as seen also in his constant search for new and unusual subject matter and symbolic programs that would attract attention by their novelty and originality. It is noteworthy in this context that in the later large subject prints originality and variety lie chiefly in subject matter and symbolism rather than in style and technique, which are usually clear, straightforward and not particularly inventive or imaginative. The only contemporary technique of importance that Rosa did not use in the *Figurine* was staged biting, which was not common in Italian Baroque graphics in any case. The closest he came to it was the use of drypoint and burnishing to alter early states. And staged biting would have been inappropriate to the *Figurine*. One of the great strengths of this series is that Rosa realized that he should not push his technical experiments with them into an unsuitable polish and overrefinement.

It must also be observed here that there are clearly elements of contradiction in the style and technique of the *Figurine*. Despite the considerable advance in graphic sophistication, the later *Figurine* have many of the awkward qualities of the earlier ones. Rosa meant the *Figurine* to demonstrate his mastery of the human figure in a great variety of poses, groupings, costumes, and positions in space, but they often do just the opposite and reveal the difficulties he had in drawing the human figure. The rendering of anatomy and relationship of body parts in many of the *Figurine* are clumsy and their movements often seem stiff. And despite the effort he made to achieve graphically subtle spatial penetrations and transitions, his difficulty in foreshortening the human figure often make it seem as if the figures are compressed into flattened layers parallel to the picture plane. But these contradictions can also be considered, it seems to me, a source of a curious kind of strength for the *Figurine*, lending them a sense of tension and nervous disequilibrium. They seem not to be at rest and complete in stylistic terms but in the process of undergoing some form of stylistic stress, to be off balance and changing. In this they remain as elusive, restless, and fugitive in formal terms as they do in their sense of implied narrative.

CHAPTER III

═══

THE TRITON GROUP

c. 1660–1661

═══

After the rather ambitious project of the *Figurine* there seems to have been a lull in Rosa's printmaking activities. The next reference to etching is found in a letter of November 20, 1660, in which the artist told Ricciardi that he had been "playing or joking around," ("vado spassando") with etching for many weeks.[1] Then on January 8, 1661, he wrote that he had given himself over completely to etching ("in tutto e per tutto") and had made many "coglionerie," a word he frequently used in his letters to suggest not only foolish things (the literal translation) but also lighthearted, inventive, or capricious things. In the same letter he went on to say that he hoped gradually to perfect these endeavors and that etching was a technique requiring a great deal of practice.[2] Three weeks later, on January 29, 1661, Rosa wrote Ricciardi that he would be able, at an appropriate time, to see some of the products of his labors in etching, with which he had made an impression out of the ordinary.[3] For a number of reasons I think that the prints he was referring to in these letters are the three etchings of *Battling Tritons* [91], [93], [94], the *Piping Satyr* etching [95], the two *River Gods* prints [96], [97], and the *Shepherd* print [98]. In my opinion they can be considered as a group, which for convenience' sake I would like to call the Triton Group, all done at approximately the same time. They show strong similarities in style and technique, and in their *capriccio*-like subjects, which reflect a knowledge of Mantegna's famous engraved fantasies of battling sea gods, Oduardo Fialetti's *capricci* of nereids and tritons, and della Bella's and Castiglione's satyr *capricci*.[4] Rosa's three *Battling Tritons* print are also a restatement, at least in subject, of one of his earliest commissions, a frieze of nereids and tritons done in fresco in the

[1] De Rinaldis, p. 113, no. 86: "Sono molte settimane che me la vado spassando in intagliare d'acquaforte...."

[2] *Ibid.*, p. 115, no. 87: "Mi sono in tutto e per tutto dato alle operazione dell'acquaforte, et ho a quest'hora fatte di molte coglionerie. Spero però di ridonarle a qualche perfezione col tempo, essendo questa una facenda ch'ha bisogno assaissimo dell'uso."

[3] *Ibid.*, p. 117, no. 88: "A suo tempo vederete qualche fatica del mio intaglio che non vi dispiacerà, havendo con esso fatto colpo non ordinario."

[4] See above Ch. II, n. 32.

Bishop's palace at Viterbo and now lost.[5] All of the prints are nearly the same size, and their horizontal format is unusual in Rosa's production; only the early *Male Nude* [1], the later large *Atilius Regulus* [110], and *Polycrates* [111] share it. As is often the case in Rosa's prints, they can be divided into pairs that are the same size and similar in subject matter and style. The *River Gods* [96] and [97] form one pair; the *Piping Satyr* [95] and the larger *Battling Tritons* [94] another pair of the same size as the *River Gods*; and the other more nearly square *Battling Tritons* [91] and [93] a third pair. The odd print, the *Shepherd* [98], is the same size as the pair last mentioned.

Placing these prints within an overall chronology of Rosa's etched oeuvre is one of the most difficult of the dating problems presented by the etchings. Tomory groups them together and assigns them to the years 1651-1656, before the *Figurine* series. Bozzolato dates them 1660, but separates the *Shepherd* from the group and considers it to be one of Rosa's earliest prints, done in 1652. Rotili also considers the *Shepherd* to be one of Rosa's first prints, dating it 1640; and like Tomory, he sees the *Battling Tritons* prints, *River Gods* prints, and *Satyr* as having been done before the *Figurine* series, in the years 1651-1656.[6]

To me the best date for them both on stylistic grounds and on documentary grounds appears to be 1660-1661. Rosa's own remarks in his letters about the prints done in late 1660 and early 1661 offer important evidence to support this contention. Nothing in his etched oeuvre, not even the *Figurine* series, fits the notion of "playing around" with "coglionerie" better than the prints of the Triton Group, especially the *Piping Satyr* and the *Battling Tritons* with their bizarre, fanciful, and even humorous qualities. In addition, if these prints were to be assigned to the years

[5] Salerno, 1963, p. 92; Passeri, p. 387.
[6] Tomory, nos. 3-9; Bozzolato, nos. 3, 69-74; Rotili, nos. 6, 11-17, and pp. 34-35, 71-73, 247-48. It should be noted that Rotili gives as an important reason for dating the Triton Group prints early the resemblance he feels they show to the *Battle of the Centaur and Tritons* print, often attributed to Ribera. However, Brown, p. 81, no. 19, calls this print a "crude work in no way related to Ribera's style, being much inferior to it." Brown's opinion, in which I heartily concur, has general scholarly acceptance although Rotili (pp. 247-48) disputes it.

1651-1656, as Tomory and Rotili propose, it is difficult to see which of the prints that remain in Rosa's oeuvre could be chosen to make up the "molte coglionerie" he mentions in 1661 or which could have been done in a playful manner. The rest of his prints are large, ambitious, serious in subject, and very carefully executed. At least four and probably more of them were done by using a process of scoring to make precise transfers to the prepared etching plates of cartoons which are among the most meticulously finished of all of Rosa's drawings. It can be argued that Rosa in using words like "vado spassando" and "coglionerie" was simply being playfully self-deprecatory, and that the interpretation presented here falls into the error of reading these remarks too literally. But all the evidence indicates that Rosa took his art quite seriously, especially those works involving learned or philosophical subject matter, or ideas taken from classical literature, and almost all of the remaining prints have such themes. I find it hard to believe that he would consider as "coglionerie" such works as the *Jason* [118], the *Genius of Rosa* [113], the *Dream of Aeneas* [117], the *Death of Atilius Regulus* [110], the *Crucifixion of Polycrates* [111], or even the *Glaucus and Scylla* [101], to cite some typical examples of the remaining prints in his oeuvre.

In my opinion the style and technique of the prints support these arguments from documentary evidence, although it is true that the prints show considerable variation in style and technique among themselves. The matched *Battling Tritons*, [91] and [93], are done, as befits their subject matter, with a rougher, more excited stroke than any of the other prints, and the two prints of the matched pair differ significantly from the long *Battling Tritons* print [94] in their much more summary and irregular use of crosshatching. The *Shepherd* [98] is lighter and more open than any of the others. Even the *River Gods*, [96] and [97], which must have been done at about the same time, are somewhat different from each other, although this can be largely explained by the unusual biting of [96], which produced a rather coarse and granular line and a consequent blurring of definition in contours, modeling lines, and shadowed areas.

But these differences are much less important than the striking similarities which the prints show among themselves. And

it is significant that the Triton Group prints in general show qualities that are most like the *Figurine* prints that I consider to be the later ones in the series, and are rather unlike the early ones. In many ways the etchings of the Triton Group show a continuation and development of the qualities that are most characteristic of the later *Figurine*. In general the Triton Group prints have complex, subtly realized spatial arrangements and widely varied effects of light and shade. There is much overlapping of forms in space, and faces and shapes are often seen through a foreground frame or grid of forms or lines. A wide variety of strokes, lines, and systems of hatching are used to model forms, to create vibrant light effects, to establish relative positions of forms in space, and to make the spatial transitions from one form to another fluent. There is extensive use of quick, sketchy strokes to produce blurred, space-creating effects, and a sense of distant forms veiled in atmosphere, obscured by shadow, or dissolved by light. In short, the Triton Group prints continue the development seen in the *Figurine* series, a development away from the flatter, more pattern-like contrasts of light and dark of the early prints in that series toward the greater refinement and complexity of the later examples in the handling of space, chiaroscuro, and atmospheric effects.

In addition, the Triton Group prints also show a continuation and development of refinement and control characteristic of the later *Figurine*. This is evident in the firm, confident deliberation in the placement of the lines that define and model major forms. The hatchings and crosshatchings used in the *Piping Satyr* [95], its companion the long *Battling Tritons* [94], and one of the *River Gods* prints [97], for example, are more regular and more precisely organized than in almost any of the later *Figurine*. The matched *Battling Tritons* [91] and [93], the *Piping Satyr* [95], and especially the *River Gods* [97] and the *Shepherd* [98] also show a use, more developed than is seen in the *Figurine*, of the orderly, Testa-like modeling and shading lines, both straight and curved, placed carefully parallel to each other.[7]

There is also, in the prints of the Triton Group, a continuation

[7] See above Ch. II, n. 55.

and development of the stylistic and technical decorum seen in the *Figurine*, of the deliberate attempt to render a given subject in a suitable etching style and technique. It occurs most frequently in the later *Figurine* prints and is even more pronounced a factor in the prints of the Triton Group. The *River Gods* [96] and [97] with their connotations of classical relief sculpture, are executed in a polished and classically controlled way that makes extensive use of a traditional kind of crosshatching—this somewhat compromised in [96] by the roughness of the biting. The *Battling Tritons*, especially the matched pair [91] and [93] are done in a more energetic and forceful way that makes use of savage slashing lines. The long *Battling Tritons* [94] has many of these qualities but is brought into consonance with its companion, the *Piping Satyr* [95], through the use on the body of the chief figure of extensive, regular crosshatching like that which models the satyr. The latter print, when seen in good impressions, which are very rare, has an unassertive orderliness of rendering and transparency of graphic tone which are highly appropriate to its sylvan subject and mood. The *Shepherd* [98] is done with light, deft strokes so widely spaced that they read clearly as individual lines, lines that seem to vibrate in the gently luminous atmosphere of the print. This consciously controlled and consistent selection of an etching style appropriate to a given subject is, it seems to me, another indication that in the prints of the Triton Group Rosa had moved beyond the more freely experimental exploration of a variety of styles seen in the *Figurine* in the direction of the sophisticated stylistic decorum that plays an important role in a number of his later, larger prints.

In addition to the evidence already adduced for dating the Triton Group prints after the *Figurine*, the drawings for the Triton Group prints support this contention. Only three drawings that can clearly be associated with these etchings are now known, two for the *River Gods* [96a] and [96b] and one for the *Piping Satyr* [95a], and all are done in a bold, confident manner that makes them very unlike the restrained, conservative drawings for the early *Figurine* and much closer to the preparatory studies for the later prints in that series. It is also worth noting that, much as with some of the later *Figurine*, Rosa had the

confidence to depart from his final drawing for the *River Gods* etching in designing significant changes directly on the plate.

If the dating here proposed for the prints of the Triton Group is accepted, they occupy a particularly interesting position in his etched oeuvre. In them can be seen, in my opinion, a culmination of the stylistic and technical solutions and experiments of his earlier prints. In this culmination the qualities of freedom, variety, and a bravura handling of the needle, combined with a confident, and self-assured control of the medium, reach a high point. The result is a group of prints in which the potential of the etching medium is realized with great sensitivity to produce prints of extraordinary variety and subtlety. They are, in my opinion, among the most successful and visually appealing of all of his prints, and they represent, in a sense, the end of the freer and more spontaneous side of Rosa's career as an etcher. After the Triton Group prints were done, he set out after different goals as a printmaker and began working on large subject prints. It is to be regretted that in the course of doing them he largely abandoned the graphically adventurous drive that informs the *Figurine* and the Triton Group prints.

CHAPTER IV

―――――

THE EARLIEST
LARGE PRINTS
c. 1661

―――――

Rosa left Rome for Tuscany in May 1661 and spent the months from July to November vacationing at Ricciardi's villa, Strozzavolpe, not far from Poggibonsi.[1] While there he must have worked on a number of etchings and drawings for etchings since in a letter of November 11, 1661, written to Ricciardi immediately after his return to Rome, he reported that the things that had been sent by post had been "shipwrecked," meaning, as the context makes clear, dropped and watersoaked, but that the plates, *i rami*, had arrived in better condition than anything else. These were certainly plates that had already been designed since later in the same letter he said that he would begin to bite them the next day.[2] Five days later, November 16, 1661, he wrote that he had begun applying acid to the plates, but that the illness of his son Rosalvo had forced him to put everything aside. He promised when they were finished to send Ricciardi "the drawings," no doubt the drawings used in designing the plates which he apparently wanted to keep with him until the plates had all been successfully bitten.[3]

The prints of these *rami* are not identified, but I think it most likely that they were one or both of the two matched pairs, *St. William* [99] and *Albert, Companion to St. William* [100], or *Glaucus and Scylla* [101] and *Apollo and the Cumaean Sibyl* [102]. All four prints are the same size, and all of them have features of format, style, content, and subject matter which are, in my opinion, consistent with a placement in Rosa's oeuvre immediately after the Triton Group prints and before the five larger prints specifically referred to in a letter of March 11, 1662.[4]

―――――

[1] Salerno, 1963, p. 97; De Rinaldis, p. 122, no. 92, dated May 7, 1661, p. 123, no. 94, dated November 11, 1661; Cesareo, ii, p. 114, no. 107, dated July 29, 1661.

[2] De Rinaldis, pp. 123-24, no. 94: "I rami son venuti meglio condizionate d'ogni altra cosa,... Domani incomincerò a dar l'acqua a i rami...."

[3] Limentani, 1953, p. 56, no. 5: "Havevo incominciato a dar l'acqua a i rami, ma la infermità del putto m'ha fatto lasciare ogni cosa; fenito ch'avrò questa funtione, vi manderò i disegni,..."

[4] The *Apollo and the Cumaean Sibyl* is slightly smaller than the others, but in my opinion this can be explained by a reduction in the size of the plate in the course of making the print. See the catalogue entry.

It may even be that the corrosion of the lower left corner of the *St. William* (see the catalogue entry) was the result of the plate's exposure to water in the soaking that Rosa mentioned in his letter, or a similar accident in the journey by post.

An important reason for thinking that these four prints were done after the Triton Group prints is that they are larger, more ambitious, and more formally finished compositions with clearly identifiable subjects, and as such are fundamentally closer as artistic statements to the large prints which can be securely dated to the years 1661-1663 than they are to the smaller, more capricious Triton Group etchings, which I have tried to show can probably be associated with the prints referred to in Rosa's letters of November 20, 1660, January 8, 1661, and January 29, 1661. However the "shipwrecked" *rami*, mentioned in the letters of November 11 and November 16, 1661, and presumably done at Strozzavolpe some time during the summer of that year, can be separated in date from the Triton Group etchings by only some six to nine or ten months; and in fact the prints that I would like to associate with these *rami*—the *St. William* [99], *Albert* [100], *Glaucus and Scylla* [101], and *Apollo and the Cumaean Sibyl* [102]— show important similarities to the prints of the Triton Group [91]-[98] in a number of ways. This is most evident in the *St. William*, *Albert*, and *Glaucus and Scylla*, which are informed with the savage romanticism of the three *Battling Triton* prints [91], [93], [94], of many of the *Figurine*, and, in a more sylvan sense, of the *Piping Satyr* [95], the *Shepherd* [98], and even the *River Gods* [96], [97]. The figures of Albert and Glaucus seem like direct descendents of the *Battling Tritons* and the Apollo has some of the incipient classicism seen in the *River Gods* print. And although Rosa uses the plural *i rami* in discussing the plates that had been watersoaked on their way from Tuscany, there need not have been more than two of them. It is possible that one or two plates of this group of *St. William, Albert, Glaucus and Scylla, Apollo and the Cumaean Sibyl* had been done immediately after the Triton Group etchings or possibly contemporary with some of its prints, even before Rosa left Rome for Tuscany.

St. William of Maleval [99];
Albert, Companion of St. William [100]

For a number of reasons I am inclined to think that the matched pair of *St. William* and *Albert* were done directly after the Triton group prints and before any other of Rosa's large prints, including the *Apollo and the Cumaean Sibyl* and *Glaucus and Scylla*. To begin with, the two etchings are unique among his larger prints in having nonclassical subject matter. In this they are closer to his early prints [1]-[3], the *Figurine*, and, if not in the strictest interpretation of the term classical, at least in basic feeling, to the Triton Group prints than they are to his other large echings, all of which are firmly rooted in clearly identifiable classical sources, literary, philosophical, and symbolic. The St. William represented is St. William of Maleval, a particularly austere Tuscan penitent of the 12th century whose companion and disciple was Albert. Although the details of St. William's early years are unclear, it was generally thought that he spent them as a licentious soldier. However, it is known that to do penance he spent the years from 1145 to 1153 on a pilgrimage to the Holy Land and then returned to take up monastic life, first on the Isle of Lupocavio in the territory of Pisa and then at Monte Prunio. Disillusioned by the laxity of both of these monasteries, he finally withdrew in 1155 to what was then called the Stable of Rhodes, an especially horrid valley in the territory of Siena which came to be known appropriately as Maleval. There he lived a life of the harshest self-denial and penitence, having at first only a cave for shelter until the lord of Burano had a cell built for him. Albert joined him in 1156, and in 1157 the saint died.[5]

The theme of the solitary penitent or contemplative figure isolated in the midst of a savage and hostile wilderness appears frequently in Rosa's art, as seen for example in the early *Praying Penitent in a Wilderness* etching [2], the early Riberesque *St.*

[5] S. Baring-Gould, *The Lives of the Saints*, Edinburgh, 1914, II, pp. 253-55.

Jerome at Fabriano, the late *St. Paul the Hermit* in the Brera, *Mr. Altham as a Hermit* in the Bankes Collection, the *Democritus in Meditation*, and in a number of drawings.[6] It can be taken, at least in part, as a reflection of Rosa's own rather gloomy, pessimistic, and often quite bitter attitude toward society and of his frequently expressed romantic yearnings for a life of solitude, simplicity, and withdrawal from the insincerity and vanity of ordinary life. These attitudes are evident in his satires with their savage attacks on the follies of his age, in such verses as "May God forgive you! You know that I have a wild unsociable soul and that by my nature I abhor dwelling in any but deserted haunts," or, "Happy the *Entimi* and the Stylites who, far from the crowd and from loathsome sights, alone with themselves and with God, live united";[7] in a number of his other pictures such as the *Cincinnatus* or the two versions of *Justice Appearing to the Peasants*;[8] and in certain letters in which he expressed sentiments of this kind to Ricciardi: "Consider yourself fortunate that you have hovel enough in which to comfort your genius, feeding it upon solitude to its heart's content; and I can assure you that a stove in a solitary setting is worth more than all the palaces in the world, and that one of those wild salads which you describe is more wholesome to me than all the delicacies that the ultimate refinement of priestly gluttony has yet devised." Or, "Not only have these setbacks kept me from writing to you, but, to tell you the truth, they have made me so disgusted with everything else that more than once I have been tempted to pack myself off to a monastery, never again to emerge from one of its cells. Oh God! and how impatient and sick I have become of seeing the human image any longer!"[9]

A particularly interesting and personal statement of these views is found in Rosa's *Self Portrait with a Skull* in the Metropolitan Museum of Art in New York (Fig. 12) in which he represents himself as a scholarly penitent, isolated "nell'Eremo," in the retreat or hermitage as an inscription in the picture declares, writing in Greek the words "Behold, whither, when" upon a skull. If this inscription has the ambiguity usually associated with such declarations, the *vanitas* and *memento mori* significance of the skull itself is perfectly clear and is reinforced by his crown of funerary cypress.[10] It would also seem that Rosa intended to refer to his own Stoicism, showing himself contemplating the death's-head with Stoic calm, equanimity, and resignation, since the book upon which the skull rests has "Seneca" written on its spine, lightly painted over apparently by the artist himself and now only faintly visible.[11]

[6] Salerno, 1963, p. 141; p. 126, no. 52; p. 123, no. 38; p. 110, no. XIII; and pp. 52-54, "La poesia della solitudine." See also Ch. V below and Wallace, "Democritus," pp. 21-31.

[7] Cesareo, I, p. 258, *La Guerra*, vv. 46-48: "Dio tel perdoni! Sai pur che selvaggia/ Hò l'almo, e che per genio aborro il tutto/ Fuor che lo stare in solitaria piaggia." P. 384, *Tirreno*, vv. 367-69: "Fortunati gli Entimi, e gli Stelliti/ Che lungi da tumulti e da ribrezzi/ Soli a se stessi, a Idio vissero uniti."

[8] Salerno, 1963, p. 118, no. 22; p. 107, no. II; p. 129, no. 63. See also Wallace, "Justice," pp. 431-34.

[9] De Rinaldis, pp. 133-34, no. 101 bis, dated Sabato Santo 1662: "beato voi ch'avete tanto di tugurio da poterci sollevare il genio, con cibarlo di solitudine a sua voglia, assicurandovi che val più un forno situato in solitudine, che quante Reggie si trovano, et a me più fa pro una di quelle insalate salvatiche ch'ella mi descrive, che quanti pasticci mai seppe inventare la più raffinata gola del pretismo." P. 237, no. 198, dated Dicembre 1671: "Questi accidenti, non solo m'hanno tenuto lontano dallo scrivervi, ma per dirvela, così nauseato d'ogn'altra cosa, che più d'una volta sono stato tentato di ficcarmi in una Certosa, per non uscir mai più d'una di quelle celle. O Dio, e quanto son divenuto impaziente e stufo di veder più imagine humana!"

[10] Salerno, 1963, p. 123, no. 40; Langdon, "Rosa: Paintings," no. 22. For a detailed discussion of the picture's iconography, see Wallace, "Democritus," pp. 21-22. For a discussion of the possibility of the picture's being a portrait of Ricciardi, see Langdon, "Rosa: Paintings," no. 22, and L. Salerno, "Salvator Rosa at the Hayward Gallery," *Burlington Magazine*, CXV, 1973, p. 827.

[11] Both the lettering and the painting over are done in a manner that is completely typical of Rosa's hand. Very similar kinds of inscriptions appear in a number of his other pictures. For Stoicism in the 17th century, see Wallace, "Genius," p. 474; and J. L. Saunders, *Justus Lipsius, The Philosophy of Renaissance Stoicism*, New York 1955.

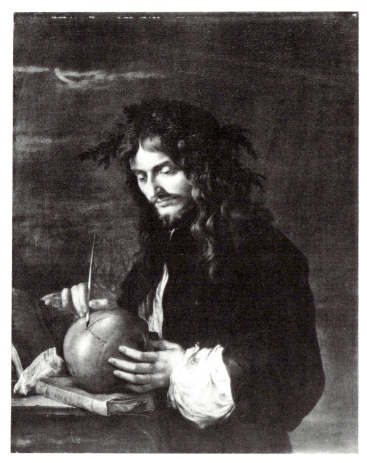

12. Rosa, *Self Portrait with a Skull*, painting.
New York, Metropolitan Museum of Art,
Bequest of Mary L. Harrison, 1921

Rosa's association of Seneca with solitary isolation in a hermitage or wilderness is a characteristic manifestation of his complex and mixed attitudes toward Stoic philosophy, in particular of his interest in the quietist tendencies implicit in much of Seneca's writings and in the later phases of Roman Stoicism.[12] It is also typical of Rosa that his understanding of the writings of Seneca, which form such an important part of the picture's iconography (or did at least when it was first painted), is less than profound. To be sure, Seneca does exhibit a degree of resignation and quietism not found in the earlier Stoics, and he discusses the value of withdrawal from society and its cares, pressures, and follies, as an aid to achieving tranquillity and peace of mind and as a way of protecting oneself from the barbs of Fortune. But he is far from a thoroughgoing quietist and he is always at pains, in discussing retirement, also to proclaim the traditional Stoic conviction that one of the individual's chief responsibilities is to his fellow man and to society. He specifically advises against total withdrawal and isolation from one's fellow man and he even states that solitude can be dangerous. Instead, retirement should be tempered by an interest in one's fellows and above all by duty, and should be concealed, not ostentatious. In an observation which could almost be taken as a criticism of the kind of ostentatious retirement proclaimed in Rosa's *Self Portrait with a Skull* Seneca says that one should not go about with a placard on one's back labeled "Philosopher and Quietist."[13]

Rosa may have realized that the writings of Seneca were not the best support for the quietist attitudes so evident in the *Self Portrait with a Skull* and for that reason he may have painted over the "Seneca" on the spine of the book. But he was of course

[12] Arnold, pp. 116, 349-50; Dudley, p. 188. I rely heavily on both of these classic studies for my remarks about Stoicism and Cynicism.

[13] Seneca, *Ad Lucilium Epistulae Morales*, 68.3 (Loeb, II, p. 47). For the other views referred to here, see also 73, "On Philosophers and Kings" (Loeb, II, pp. 105-13); 10, "On Living to Oneself" (Loeb, I, pp. 57-59); 19, "On Worldliness and Retirement" (Loeb, I, pp. 125-33); and Seneca, *Moral Essays*, 9, "On Tranquillity of Mind," 3.1-7.2 (Loeb, II, pp. 223-37). For the great importance the Stoics attached to the individual's responsibility to and membership in society, see also Arnold, pp. 281, 284, 311, 374; and Epictetus, *Discourses* (Loeb, I, introduction, p. xxiii).

perfectly right in recognizing the quietist tendencies in Seneca and in realizing that many Stoic views, if developed in certain directions, could lead quite naturally to quietism. This occurs, after all, in Marcus Aurelius[14] and also in Epictetus, of whose philosophy Rosa was clearly aware and to whom he referred specifically in one of his earliest and iconographically most ambitious pictures, *La Filosofia*, now in Caldaro, Bolzano.[15] In that painting La Filosofia is shown seated in gloomy isolation, one arm resting on a skull, the other pointing to the inscription "Sustine et Abstine" (Bear and Forbear), a maxim of Epictetus expressing a sentiment typical of a tendency in his writings and in the later phases of Roman Stoicism.

Rosa's philosophical inclinations toward quietism may also have been reinforced to some degree by quietist tendencies that were developing at this time in some philosophical and religious circles, especially those with Spanish or Neapolitan connections, but it seems unlikely that they could have had more than a limited influence on the artist's thinking since he seems to have been relatively indifferent to religious speculation and since the quietism of the period had its efflorescence in the years after Rosa's death.[16]

A much more important influence on Rosa's thinking along these lines can be found, it seems to me, in the pessimistic views of the Cynics toward society. As I will discuss in greater detail later, Diogenes the Cynic was a kind of personal hero, and the artist referred frequently to the Cynics in his satires, associating their rough criticism of society with his own vigorous satirical attacks on social folly and vice. In addition, many of the attitudes which he held with the greatest conviction and enthusiasm, such

as his insistence on complete individual liberty, had their roots in the Cynics; and whereas the Stoics in general stressed the value of society and the need for the individual to adapt himself to society and adopted a resigned attitude toward social follies and vices as being inevitable, the Cynics took a much harsher and more condemnatory and rebellious view, one which shows interesting similarities to Romantic attitudes toward society. The Cynics not only regarded civilization as the source of all social evils but saw salvation in a withdrawal from the corruption of society to a life of savage simplicity.[17] It is a theme that runs as a leitmotif through Rosa's art and thinking, and it is particularly interesting with reference to the *St. William* and *Albert* that Cynic attitudes of this kind had a definite influence on the ascetic orders of Christianity of the Middle Ages.[18]

Not only are the *St. William* and *Albert* closest to Rosa's earlier prints in their nonclassical subject matter, but more specifically the *concetto* of the remote, isolated figure is one central to the earlier prints as well. It can be seen especially in the early *Praying Penitent in a Wilderness* [2] and in the *Landscape with a Figure* [3], and even to a certain degree in the *Male Nude* [1]. And as I have tried to show, the theme of the romantically isolated figure or figures is fundamental to the *Figurine* series. It can even be said that the *Albert* and especially the *St. William* are larger and more ambitious versions of the *Figurine*. It is interesting in this context that Rosa was perhaps most famous among later Romantics for his landscapes with "solitary hermits," and "savage *banditti*." Since landscapes with hermits and *banditti* seem not, in fact, to have been so common in Rosa's production as the enthusiasms of his Romantic admirers would suggest, it appears very likely that these two etchings and the *Figurine* added considerable luster to his reputation as a painter of such scenes.

The *St. William* and *Albert* are also nonclassical in their formal solutions, despite the fact that the *Albert* is obviously modeled on the well-known Lysippan Marsyas type. Appropriate to

[14] Arnold, pp. 120, 125, 126, 343, 349, 350; Epictetus, *Discourses* (Loeb, I), introduction, pp. xvi-xvii, xxvii.

[15] Salerno, 1963, p. 139; Wallace, "Democritus," pp. 27-28; Wallace, "Genius," p. 478. See also Ch. V, nn. 134-36 below.

[16] Salerno, 1963, pp. 53-54; M. Petrocchi, *Il quietismo italiano del seicento*, Rome 1948; E. Herman, "Quietism," *Encyclopedia of Religion and Ethics*, ed. J. Hastings, New York 1919, x, pp. 533-38; E. A. Pace, "Quietism," *The Catholic Encyclopedia*, New York 1911, XII, pp. 608-10. See also Salerno, 1970, pp. 34-65 and Rotili, p. 9.

[17] Arnold, pp. 47-49, 371; Dudley, introduction, p. ix, pp. 29, 74, 143, 156, 190.

[18] Dudley, pp. 209-10.

their subject matter and mood, both prints have a harshness of form and rough vigor of composition and execution that are quite different from the more complex, accomplished, often quite classical and frequently less interesting compositional and formal solutions of the later large prints. Much of this is undoubtedly due to a conscious attempt at a decorous relation of style and technique to subject and content; but one also has the feeling that in these prints Rosa was at the beginning of a new phase of his etching career—the making of large prints—and, much as with the *Figurine* series, the early examples of this phase have a rough and even somewhat clumsy vigor, which is remarkably appealing and artistically effective.

The *Albert* is a particularly good illustration of these qualities. Forms tend to flatten out across the print surface and space is compressed, with the result that there is a pronounced tension between the two-dimensional and three-dimensional organization of the etching. It is noteworthy that these qualities are more pronounced in the *Albert, St. William, Glaucus and Scylla* [101], and *Apollo and the Cumaean Sibyl* [102] than in any of Rosa's other large prints, another reason for grouping the four together. And since, as will be shown in more detail later, his other large prints show a progressively more suave and more masterful handling of complex spatial problems on a large scale, these rather distinctive characteristics offer further reasons for placing the four prints at the beginning of his work with large etchings.

In similar fashion the composition of the *Albert* seems to be quite stiff and awkward; the artist has followed his model of the classical Marsyas sculpture so closely that the figure seems like a quotation taken abruptly out of context, and the composition seems to want another figure from the rudely sundered Marsyas group to compensate for its disturbing lean to the left. But this asymmetry and unbalance are not just the product of inexperience with large compositions in etching, although I think that this was a factor; the print was after all done at the height of Rosa's artistic maturity and he had done a great many complex figure compositions in his paintings by that time. Instead, the disturbing unbalance of the print serves very effectively to emphasize the strain and discomfort of Albert's penitential posture

and to set up a disquieting tension between the hermit and the cross he contemplates. Most important of all, it makes the harsh forms of the jagged rocks on the right important partners in the composition rather than just background elements. Rosa took pains to portray the wilderness of penitence as well as its lonely occupant.

This conscious adjustment of form to subject matter, content, and mood is seen in Rosa's choice of etching style and technique as well. He had the sophistication to revive the Riberesque qualities seen in his early *Praying Penitent in a Wilderness* [2] and *Landscape with a Figure* [3]. Like Ribera he placed the brightly lighted figure of the hermit against the foil of darker rocks and foliage; and he made extensive use of lively Riberesque zigzag strokes to model and shade the rocks, much as he did in the early *Praying Penitent* and *Landscape with a Figure*.[19] But it should be noted that the zigzag strokes used here are more carefully managed than in the two early prints. This is in part because the *Albert* is a much larger print, permitting greater clarity and definition of modeling, but it also seems to be a reflection of the conscious drive on Rosa's part for the greater control of stroke seen in the later *Figurine* and the Triton Group prints. The modeling of the figure echoes the energy and dash of the background lines, and it is in general done with sharp, staccato strokes and hatchings which are similar in feeling with those found in the two matching *Battling Tritons* prints, [91] and [93], and rather unlike the more regular systems of modeling used in most of the later large prints.

This lively treatment of modeling and shading does much to add energy to the print, which gives the impression of having been executed rapidly and with great freedom, especially in the rocks and trees. I am inclined to think that this impression is correct, and that the background areas were probably designed directly on the plate without benefit of detailed preparatory drawings. The only known drawing for the *Albert* is a sketch, now in the collection of Lord Leicester at Holkham Hall [100a],

[19] It is interesting in this context that Ribera did a drawing of Albert (Brown, p. 159, no. 9).

which shows a figure almost identical with that of the print but in a quite different setting. The *Albert* is also very like the slightly later *Oedipus* etching [116] in that it shows a figure foiled against a massive tree. And as Rosa himself said in a letter to Ricciardi, the huge tree of the *Oedipus* was designed directly on the plate without using any preparatory studies.[20]

The companion piece to the *Albert*, the *St. William*, shares many of its qualities. It exhibits a similar kind of spatial compression and tension, and there is a stiff awkwardness in the pose of the figure and its placement in the composition that, as in the *Albert*, underscores the harshness and discomfort of the saint's penitence. The jagged rhythms of the *Albert* are echoed in the *St. William* where the rigid diagonal of the saint's figure is set in bold opposition to the slashing diagonals of the tree trunks, creating a harsh, strained, angular surface design. The asymmetric unbalance of the *Albert* is even more pronounced in the *St. William*, so that the relationship between the penitent saint and the cross he prays to has become more powerfully tense, and the tree assumes a prominent and even dominant role in the composition. And although the actual modeling of the figure of the saint is more polished and restrained than in the case of the *Albert*, largely because he is encased in armor, the foliage is done with a vibrant energy of calligraphic stroke that gives the tree a powerful centrifugal force, causing it to boil upward and outward and, as it were, to spill some of its energy into the stormy clouds behind. In purely graphic terms the tree is a splendid match for the energetically modeled rocky background of the *Albert* and, like it, is done with a remarkable combination of freedom and control.

The settings have extremely important expressive roles not only in visual and formal terms but also as metaphors for the fierce devotion of the hermits they shelter. In addition the settings have an iconographic function. Albert, the humble servant and disciple, looks down toward earth in his devotion and is enclosed by earth arranged in downward sloping geological formations that reinforce the direction of his lowered gaze. St. William, a noble saintly figure, looks up and stretches his arms upward in his worship. The thrust of his devotion is picked up by the tree and carried to the heavens above.

A very interesting parallel to these two prints is seen on a much grander scale in two of Rosa's latest prints, the matched pair of the *Fall of the Giants* [115] and the *Oedipus* [116]. In the former, figures are set in a landscape of downward cascading boulders, in the latter, figures are foiled against a tree rearing majestically skyward.

It is tempting to speculate that the *St. William* and *Albert* etchings in which wilderness settings play such an important role may have been inspired by Rosa's experience of the Tuscan countryside around Ricciardi's Strozzavolpe. Ricciardi may have even proposed the subjects since he would certainly have known that Maleval was located in the same general territory as his villa. And Strozzavolpe was for Rosa, as many of his letters indicate, a romantic symbol of escape and retreat from the superficialities and stresses of everyday life and society.[21] This possibility, taken together with the documentary and stylistic evidence already discussed, suggests that the *St. William* and *Albert* may have been done shortly after Rosa's arrival at Strozzavolpe in the summer of 1661.

Glaucus and Scylla [101]; *Apollo and the Cumaean Sibyl* [102]

These two are, in my opinion, the earliest of Rosa's etchings to be based directly on classical literature; and appropriate to their subject matter, both show classicizing tendencies in their formal solutions. The stories are taken from Ovid's *Metamorphoses* where they are found in close sequential proximity, the story of Apollo and the Cumaean Sibyl coming immediately after the story of Glaucus and Scylla (13.898-14.153). In addition it seems

[20] De Rinaldis, p. 154, no. 121, dated August 25, 1663.

[21] Limentani, 1950, p. 124, no. 32, dated July 1662; De Rinaldis, pp. 113-14, no. 86, dated November 20, 1660; p. 140, no. 106, dated July 15, 1662; p. 145, no. 110 bis, dated September 16, 1662; p. 157, no. 124, dated October 21, 1663.

clear that Rosa relied on Antonio Tempesta's lavish series of etched illustrations of the *Metamorphoses* since his figure of the Cumaen Sibyl is modeled closely on Tempesta's and since his Glaucus is in effect a synthesis of the two figures of the sea god which appear in the two Tempesta prints illustrating that episode.[22]

Ovid tells how the maiden Scylla was bathing naked in the sea when Glaucus, himself recently transformed from a mortal to a sea god, saw her and loved her. He approached her and pleaded his love, but she fled, wondering at his monstrous appearance. To win her, Glaucus went to Circe to beg for a love charm, but he was received by the enchantress with declarations of her own love for him. He refused it and in her wrath she revenged herself on her rival by poisoning Scylla's bathing pool with evil roots so that when she entered the water her loins were transformed into barking dog-like monsters and she was fixed to the shoreline to become a cruel wrecker of ships.

The story of the Cumaean Sibyl is strikingly similar in its basic theme of a mortal woman spurning the love of a god and suffering for it. The story is told in the *Metamorphoses* by the Sibyl herself as she conducts Aeneas through the dim regions of hell and death's realm to see the ghost of his father Anchises. When she was still a mortal maiden Apollo had promised her anything she wanted if he could possess her. She pointed to a heap of sand and prayed that her years be as many as the grains of sand it contained. Apollo granted her the years and promised her eternal youth if he could have her, but she refused. Because of her refusal she was condemned to live out the thousand years granted her, growing older and uglier with every year.

It is no accident, I think, that Rosa thought these two episodes from Ovid appropriate companions to the *St. William* and *Albert*. By the time these prints were done he had established himself as a master of subtle and complex iconographical programs in his paintings, and he would certainly have been aware that by

grouping these four prints together he was drawing a nice contrast between spiritual passion and sensual passion and also, more subtly, between the piety of two men who accepted God and the impiety of two women who spurned gods. It should also be pointed out that although the *Glaucus and Scylla* and *Apollo and the Cumaean Sibyl* are taken from a classical source, they are both based on episodes in Ovid that are filled with qualities that seem always to have appealed to Rosa's romantic instincts— magic, enchantment, prophecy, violence and cruelty, dark passion and dark places. In this too they have much in common, at least in mood, with the *St. William* and *Albert*.

Something of this mixture of classical and romantic qualities is seen in the *Glaucus and Scylla* in formal terms as well. It can even be said that the print shows a pronounced tension between formal solutions that are fundamentally rough, energetic, and even violent, much as those seen in the *Battling Tritons* [91] and [93], or the *St. William* [99] and *Albert* [100], and a tendency to discipline these solutions into a more restrained, and controlled statement. This is most evident in the way Rosa, having decided on a basically diagonal and quite Baroque composition, much like that in the *Battling Triton* prints, does almost everything he can to deny it. The conceptually strong diagonal linking the two figures and thrusting out of pictorial depth into the right foreground of the etching is flattened out and compressed perceptually, making the already awkward and anatomically clumsy figures seem even more so. The figure of Glaucus is brought ambiguously close to the foreground, his legs and hands, especially his left, seem to exist in the same plane as large portions of Scylla's body, and his arms are disposed essentially parallel to the picture plane. In purely graphic terms Rosa uses forceful, regular systems of hatching, crosshatching, and Testa-like parallel lines to model and shade the forms and pointedly avoids the sketchy, blurred strokes and the space-creating effects seen in the Triton Group prints and many of the later *Figurine*. The body and tail of Glaucus are done with crisp, clear strokes whose graphic weight and legibility make them seem to be as close to the viewer as the lines which model and define Scylla. The same observation can be made about the etched strokes which define

[22] Bartsch XVII, 638-787. It is particularly interesting that although Ovid's text says that the Sibyl simply pointed to a heap of sand, Rosa follows Tempesta in showing the Sibyl holding out the sand to Apollo.

the sky, with the result that, much as in the early *Figurine*, it tends to read almost as a solid wall or plane which comes forward visually, compressing the figures even more. Despite this the sky is an extremely effective and expressive part of the etching, its stormy turmoil and strong contrasts of light and dark add great excitement to the scene. The dark cloud that boils upward above Scylla acts as a kind of exclamation point of her surprise, picking up and magnifying her movements of flight.

Some of the awkwardnesses and ambiguities of the print can be attributed, I think, as in the case of the *St. William* [99] and *Albert* [100], to a relative lack of experience in making prints on a large scale. Like the *St. William* and *Albert*, the *Glaucus and Scylla* has a rough, unsophisticated vigor which is highly appropriate to the subject matter. But in addition, these ambiguities and awkwardnesses are also, in my opinion, the result of a conscious attempt on the artist's part to reconcile the bold, Baroque features of the composition with a more disciplined, restrained approach which stresses a basically planar arrangement of forms in space. As will be shown later, a very similar and more successful attempt to do much the same thing is seen in the *Apollo and the Cumaean Sibyl*, and both prints stand at the beginning of a phase of developing classicism in Rosa's etched oeuvre.

The *Glaucus and Scylla* etching is virtually identical with a painting now in the Musée des Beaux-Arts, Brussels [101a] and is reversed from it, suggesting that the etching reproduces the painting, just as do the etchings of *Diogenes Casting Away His Bowl* [103], [103a], *Democritus* [104], [104a], and *Death of Atilius Regulus* [110], [110a]. But Rosa himself, in a letter of October 21, 1663, declared that of all of his etchings, only the *Democritus*, *Diogenes Casting Away His Bowl*, and *Atilius Regulus* existed in painted versions, making no mention at all of the *Glaucus and Scylla*.[23] It may simply have been an oversight on his part; but because the letter seems quite circumstantial and detailed, I am inclined to feel that he would have mentioned the

Glaucus and Scylla painting had it existed. A comparison of the painting with the etching throws into even sharper focus the curious spatial tensions and ambiguities of the print. As I shall show in discussing Rosa's latest etchings, the much more emphatically Baroque qualities of the painting, the full exploitation of the diagonal organization, the pronounced use of atmospheric effects—all these are quite typical of Rosa's production in painting and etching several years after the *Glaucus and Scylla* print was done.

The *Apollo and the Cumaean Sibyl* matches the *Glaucus and Scylla* just as the *Albert* [100] matches the *St. William* [99] in the number of its principal figures, their general compositional arrangement, and their scale in relation to the overall size of the prints. But the *Apollo and the Cumaean Sibyl* has a balanced composition, a frieze-like arrangement of figures in space, and a poised equilibrium that makes it rather unlike the other three prints in this group. The etching is based on the central figure group in the very large and beautiful landscape now in the Wallace Collection, London [102a]. It is noteworthy that in the etching Rosa has created a more classically restrained composition than exists in the painting by bringing the figures together in a more unified relationship, by modifying the posture and gesture of Apollo, and above all by eliminating the incidental figures behind the Sibyl. Despite this, something of the curious spatial ambiguity of the *Glaucus and Scylla* is seen in the *Apollo and the Cumaean Sibyl* as well. At first glance Apollo and the Sibyl seem to exist on the same plane in an easily apprehensible spatial relationship consonant with the other classical qualities of the print. It is therefore all the more unsettling to discover that a slight and ambiguous diagonal runs between them, that they do not exist on the same plane at all, and that the Sibyl's steady gaze must pass Apollo by. This evidently bothered Rosa since in the third state of the print he reworked the Sibyl's eye in what was apparently an attempt to establish an exchange of gaze between the two figures [102/III].

It is especially relevant to the etching's classical qualities that in the first state of the print, which is extremely rare and known to me only in a single impression [102/I], Rosa included a figure

[23] De Rinaldis, p. 157, no. 124. For a fuller discussion of the letter, see below Ch. VI, n. 1.

much like the one immediately behind the Sibyl in the painting [102a]. This of course gave the first state a much greater spatial complexity than the later states have, especially since, much as in the later *Figurine* and in the Triton Group prints, he used a variety of loose, sketchy lines, many of them blurred and broken, to give the figure a sense of atmospheric distance. He then evidently decided he disliked the effect this figure created and burnished it out, replacing it with a rather roughly done tree trunk in drypoint. It was then necessary to balance this large drypoint area of a predominantly gray tone with a similarly gray tonal fill of drypoint lines in the background area around Apollo and in parts of his body and drapery. In short this print, even more than the *Glaucus and Scylla* shows Rosa deliberately suppressing complex spatial, atmospheric, and technical effects in favor of a formal solution having a greater restraint and regularity in composition, spatial arrangement, and technique, and a conscious classicism much like that of the prints that follow it in date. The changes made in the print also show that it was done after the painting, the first state following the picture most closely and the second moving away from it.

Aside from the sketchy drypoint necessitated by the change of the plate, the graphic handling of the *Apollo and the Cumaean Sibyl* is, like that of the *Glaucus and Scylla*, quite regular and orderly. Crosshatchings, although often done with considerable energy of stroke and some choppiness in the drapery, are in general regular and carefully constructed. There is a consistent use of carefully placed parallel lines to create half tone effects on Apollo's shadowed face, his right leg, and in the shadow cast by his left arm, as well as in the background figures and the lower tree trunk, an approach reminiscent of Pietro Testa's etchings, as has been noted in some of the *Figurine*, the Triton Group prints, and the *Glaucus and Scylla*. Carefully ordered and delicately placed dots are used to create smooth, sculptural roundings of the arms, legs, and necks of both figures. A few small but sprightly zigzag strokes do occur in the Sibyl's drapery and in the background areas of this print as they do in the *Glaucus and Scylla* but their handling is much more restrained and their role much less important than in the *Albert* [100]. A similar note of graphic dash is seen in the negative contour at the top of the

Sibyl's head and in her right arm where the upper contour line is dotted and light-dissolved. It is interesting in this context that the very pronounced negative contour seen at the outer edge of Apollo's left arm in the first state [102/I] has in the second state [102/II] been closed by light drypoint lines and toning patches along most of its length. In the etchings done later than this print negative contours are found only rarely and play a limited role.

This use of a more controlled and regular approach in the *Apollo and the Cumaean Sibyl* and the *Glaucus and Scylla* than in the *St. William* [99] and *Albert* [100] is, I think, another manifestation of the stylistic decorum seen in the Triton Group prints and in some of the later *Figurine*. The two subjects of a classical nature are treated in a more classical way, relatively speaking. In the case of the *Apollo and the Cumaean Sibyl*, a restrained subject to begin with, there is an appropriate consonance between the subject and formal solution, but in the *Glaucus and Scylla* this approach creates a conflict between the print's formal solution and its dramatic, violent narrative. It is particularly interesting that in the prints that immediately follow the *Glaucus and Scylla* and the *Apollo and the Cumaean Sibyl* in date Rosa avoids stories involving dramatic action and movement, and it is not until his latest etchings, such as the *Fall of the Giants* [115] or the *Jason* [118], that such subjects reappear.

CHAPTER V

════════

THE MATURE PRINTS

1661 – 1662

════════

It is important at this point to investigate in detail the documentary evidence which a number of Rosa's letters provide for the dating of what I would like to call his mature prints, done between the summer of 1661 and mid 1662.

Rosa returned to Rome from his summer sojourn at Strozzavolpe in November of 1661; and in a letter of November 11, 1661, describing the trip back, he made the reference to the "shipwrecked" *rami* that have already been discussed at length and associated with the *St. William, Albert, Glaucus and Scylla* and *Apollo and the Cumaean Sibyl*.[1] Then in a letter dated the last day of 1661 Rosa reported that he had received "the box" from Ricciardi through customs, that it was in excellent condition, and that Ricciardi would be served in proportion to Rosa's humble abilities.[2] As De Rinaldis and Salerno point out, this letter can almost certainly be associated with the letter of March 11, 1662, in which Rosa wrote Ricciardi that he was sending along "the box" with the design for the *Polycrates* in two pieces as done at Strozzavolpe [111], [111b], and for the *Diogenes and Alexander* [108], *Ceres and Phytalus* [112], the *Democritus* [104] and its companion, the *Diogenes Casting Away His Bowl* [103]. He goes on to say that they are all in excellent condition, just as they were when Ricciardi sent them to him.[3] It cannot be proved that the

[1] De Rinaldis, p. 193, no. 24. For the most important discussions of the dating of Rosa's etchings, see Ozzola, pp. 189-91; Salerno, 1963, pp. 51-54; De Rinaldis, pp. xxvi-xxvii; A. Petrucci, 1953, pp. 66-70; Tomory; Wallace, "Rosa: Etchings"; Bozzolato; Rotili.

[2] De Rinaldis, p. 130, no. 99: "...ho potuto riscuotere la cassetta di Dogana, la quale ho ricevuto benissimo condizionato. Del tutto v.s. resterà servita a proporzione delle mie debolezze...."

[3] Salerno, 1963, p. 97. De Rinaldis, pp. 131-32, no. 100 bis: "Prima di scrivere ho consegnato la cassetta al procaccia di Fiorenza. Al Signor Simon Torrigiani nella posta di Fiorenza franca per il Signor Gio. Battista Ricciardi. A Pisa. Con il quadretto ci troverete anche il disegno del Policrate in due pezzi, conforme fu disegnato a Strozza Volpe. Quello dell'Alessandro con Diogene, Filalao, e due altri, cioè quello del Democrito, al quale manca già un dito di disegno, il quale non ho potuto ancora trovare, ed il suo compagno del Diogene, che butta la tazza il tutto benissimo condizionato nella medesima maniera, che ella me l'invio a questa volta." The *Ceres and Phytalus* [112] is also referred to as a finished print in a letter of October 21, 1663 (De Rinaldis, p. 157, no.

box Ricciardi sent to Rosa at the end of 1661 contained the drawings Rosa mentioned in his letter of March 11, 1662, but all of the evidence strongly suggests it. Rosa referred to "the box" in both letters in such a way as to imply that it was the same one and promised Ricciardi a return of some kind in the letter acknowledging its receipt. Most important, in the letter of March 11, 1662, Rosa clearly stated that he was returning the drawings in the same excellent condition in which he received them, using, incidentally, "benissimo condizionato" just as he did in referring to the box his friend sent him. It seems reasonable then to think that not just the *Polycrates* but all of these drawings were done at Strozzavolpe during the summer of 1661, and left with Ricciardi, possibly for safekeeping or perhaps to gratify Ricciardi's pronounced avidity as a collector, and were then sent in late 1661 to be used by Rosa in making the etchings. Since Rosa apparently kept the drawings for the fully designed plates that had been "shipwrecked" until they had been bitten (see the beginning of Chapter IV above), it seems very likely that he would not have returned these later drawings until all five plates were fully etched.

If this line of reasoning is accepted, it provides some very interesting insights into Rosa's production in etching. It suggests that he may have been able to work up from drawings and to complete at least four large plates, the *Democritus in Meditation* [104], the *Ceres and Phytalus* [112], and the two *Diogenes* prints, [103], [108], and one very large plate, the *Polycrates* [111] in slightly less than two and a half months, the time that elapsed between his letter acknowledging the arrival of the box and his return of it. If so, he must have been an extremely proficient printmaker. In the case of the *Polycrates* at least, he was helped by being able to work from the large cartoon in two pieces which he mentioned specifically in his letter and which is still preserved in the Uffizi [111b]. This very carefully prepared drawing, identical with the print and in reverse from it, was rubbed with red chalk on the verso and then scored to transfer the design to the prepared plate. Three other such drawings for the large etchings are preserved, and although none is for any of the other prints mentioned in this letter, it is quite possible that at least some of the drawings he sent Ricciardi were of this type and have simply not survived.

It should be pointed out, however, that this argument is susceptible to modification in several ways. The drawings that Rosa mentions in his letter of March 11, 1662, may not have been sent to him in the box he received from Ricciardi at the end of 1661, he may instead have brought them with him when he returned from Tuscany in November of 1661. It does, however, seem quite clear from the reference in the letter of March 11, 1662, that the *Polycrates* drawing was done at Strozzavolpe during the summer of 1661; and from similar references in later letters cited below, it seems clear that the other drawings were also done during the summer there. Or it may be that the *rami* that survived "shipwreck" mentioned in the letter of November 11, 1661, with which I have tried to associate some of the prints of the *St. William, Albert, Glaucus and Scylla,* and *Apollo and the Cumaean Sibyl* group, may have also included one or more of the subjects mentioned in the letter of March 11, 1662. It is perfectly possible that while at Strozzavolpe Rosa had actually done varying degrees of work on plates for the *Polycrates, Diogenes and Alexander, Ceres and Phylatus, Democritus* and *Diogenes Casting Away His Bowl.* And since he was apparently in the habit of keeping the drawings for the plates until they were completely etched, there is nothing inconsistent either in his bringing drawings back from Tuscany for plates already designed or in his having Ricciardi send him drawings for such plates. I do not feel that either of these modifications is as persuasive as the original argument proposed above, but neither should they be completely ruled out. In neither case is there any significant effect on the chronological outline for the etchings suggested here.

In addition it is clear from Rosa's later correspondence that during the summer of 1661 he also did preparatory work for the *Death of Atilius Regulus* etching [110], the companion to the *Polycrates* and of the same very large size. There are two other

124). In the same letter he said that of his prints only the *Democritus* [104], *Diogenes Casting Away His Bowl* [103], and *Atilius Regulus* [110], had been done as paintings.

prints of these dimensions in Rosa's oeuvre, the *Fall of the Giants* [115] and the *Rescue of the Infant Oedipus* [116]; and as is so often the case with Rosa's etchings, they were conceived of as matched pairs, in this case one pair in a horizontal format, the other in a vertical format. In a letter of July 15, 1662, he wrote Ricciardi that he had two other large plates made but that he had not the heart to begin them, remembering how different and peaceful it was when he worked on those of the year before.[4] The implication that two very large etchings had already been worked on, to some degree at least, at Strozzavolpe and that another two were being considered is borne out by subsequent letters. In a letter of the latter part of July 1662 he said that the two large plates turned out well, that his prints were being bought for high prices as far away as Flanders and Paris, and that the *Atilius* came out dedicated to Ricciardi.[5] That the two large plates referred to in this letter are the *Polycrates* and the *Atilius Regulus* is further substantiated by a letter of September 16, 1662, in which he wrote that his etchings were venerated, requested, and the object of pilgrimages by everyone, and that he had two other large plates in order but could not bring himself to begin them, remembering how those of the past year had been done.[6] He

used a phraseology almost identical to that of the letter of July 15, 1662, in making nostalgic recollection of the conditions under which the large plates were done, again suggesting that not only the *Polycrates* but also the *Regulus* was worked on, to some degree at least, during the summer of 1661 at Strozzavolpe. On November 4, 1662, he wrote Ricciardi that he was not able to send him a print of the *Atilius Regulus* because they were scarce, confirming his claim that his prints were much sought after and indicating that neither he nor Ricciardi seemed to regard the earliest impressions from the plate as the most desirable ones.[7] All of the suggestions and implications in these letters are finally confirmed by a letter of July 14, 1663, in which Rosa wrote that he had done two other large plates—that is, two of the size of those done at Strozzavolpe—one of the *Fall of the Giants*, the other of *Oedipus*.[8] Rosa's choice of vocabulary in this letter deserves some consideration. He refers to the large plates he made ("quelli che feci") at Strozzavolpe, thus raising the possibility that, like some or all of the *rami* of the *St. William*, *Albert*, *Glaucus and Scylla*, and *Apollo and the Cumaean Sibyl* group, the designs were transferred to the plates there and that they were then subsequently bitten after Rosa's return to Rome. However, it is possible, and in my opinion more likely, that Rosa was speaking loosely here in referring to having made drawings for the plates. He could very possibly have considered the production of a highly finished cartoon to be so important a part of the creation of the print as to be tantamount to the making of the etching itself. This argument is given weight by Rosa's remark in the aforementioned letter of July 1662 in which he said that the two large plates (*Polycrates* and *Regulus*) turned out well, the considerable time lag between his return from Tuscany in November 1661 and the execution of the plates suggesting that he did not have de-

[4] De Rinaldis, p. 140, no. 106: "Ho fatto fare due altri rami grandi, ne mi dice il core d'incominciarli, nel ricordarmi con quanta diversità di quiete furono lavorati quelli dell'anno passatto."

[5] Limentani, 1950, p. 125, no. 32: "I due rami grandi riuscirno assai bene, et a quest'hora sono in Fiandra e Pariggi assieme con tutto il resto, che vendono 6 giuli l'uno, e io li dò a li mercadanti per mezzo scudo l'uno, e si sbaiocca a qualche segno, con speranza ch'abiano ad esser col tempo in maggior prezzo, e venerazione al sicuro. L'Atilio è uscito fuori col vostro nome." In the same letter he goes on to give an amusing description of Pope Alexander VII spreading his prints out on a table, and *spienne*, saying what great fantasy, and *spienne*, what poetry and extraordinary bizarreness, and *spienne*. As Salerno, 1963, p. 97, points out, the Chigi archives show a disbursement on September 16, 1662, for the purchase of some prints by Rosa.

[6] De Rinaldis, p. 145, no. 110 bis: "Le stampe son venerate e richieste, ed a quest'ora pellegrinano per tutto. Ho due altri rami grandi in ordine, nè posso condurmi ad incominciarli, ricordandomi come furono lavorati quelli dell'anno passatto."

[7] *Ibid.*, p. 147, no. 113: "Non vi mando la carta dell'Attilio per haverle scarce; a meglior comodità ne resterete servito."

[8] *Ibid.*, p. 153, no. 120: "Ho fatti due altri rami grandi, cioè dell'istessa misura di quelli che feci a Strozza Volpe. In uno è la cascata dei Giganti fulminati da Giove, nel altro Edipo trovato dal contadino attaccato per i piedi furati nel bosco...."

signed plates with him when he returned. All of this indicates that it was during the summer of 1661 at Strozzavolpe that Rosa executed the large cartoon for the *Atilius Regulus* [110b] which is now in the Uffizi together with the drawing for the *Polycrates* [111b]. Both are very similar in style and technique, are in two pieces, and are rubbed with red chalk on the verso and scored for transfer. The fact that they are still preserved as a matched pair strongly suggests that Ricciardi once owned both of them and that they have been kept together ever since.

It is interesting, but not surprising, that such a large number of Rosa's important prints were conceived and, to varying degrees, carried out at Strozzavolpe. It was of course perfectly logical that while he was away from his Roman studio he chose to work in a medium that required little space and only a few easily portable materials. The result was a burst of printmaking activity during which, in about four months, he probably did the drawings for and designed at least two and possibly all of the plates of the group *St. William, Albert, Glaucus and Scylla* and *Apollo and the Cumaean Sibyl,* and prepared the drawings for at least six other large prints including the very large *Polycrates* and *Atilius Regulus.* In addition, it is possible that he may also have worked on some or even all of the plates for the six etchings.

Of the five prints mentioned specifically in Rosa's letter of March 11, 1662, the *Diogenes Casting Away His Bowl* [103], the *Democritus in Meditation* [104], and *Diogenes and Alexander* [108] are all considerably larger and graphically more ambitious than the *St. William* [99], *Albert* [100], *Glaucus and Scylla* [101], or *Apollo and the Cumaean Sibyl* [102], and the *Polycrates* is much larger [111]. These, and most of the prints that can be grouped with them as having been done soon after the *St. William* group (that is, the *Academy of Plato* [109], the *Genius of Rosa* [113], *Alexander in the Studio of Apelles* [114], and the *Death of Atilius Regulus* [110]), are also larger and more ambitious in subject matter and in content than the prints of the St. William group; and in them it is possible to find some of the most important and revealing statements Rosa ever made about his personal and artistic philosophies. All of them deal to varying degrees with such central issues in his thinking as Stoicism, quiet-

ism, Cynicism, Fortune, the vanity of worldly achievement, the artist as a philosopher, scholar, learned painter, satirist, and publicist, and the inspired nature of creative genius.

These prints also manifest quite emphatically a number of the tensions and conflicts that seem to have been an essential part of his artistic personality: an uneasy relationship between his almost instinctive drive for passionate, extravagant expression and his desire to appear as a sober, Stoic philosopher type; his adherence to a variety of philosophical principles and ideas which were often not fully reconciled; his employment of a complex iconography which was on the one hand learned, erudite, and often even dryly pedantic in its marshaling of traditionally correct symbols, but which was frequently the opposite in what might be called its style of usage, that is, emotionally charged, zealously overdone, and even romantically turgid.

It was no accident that such a large number of his important artistic and philosophical statements appear in the form of etchings. Given his taste for publicity, his satirist's drive to be heard by all, and his desire to be widely known as a learned painter of *cose morali*, it was only natural that he would turn to prints to achieve these ends, often repeating his most ambitious and complex paintings in etching to make sure that they received maximum exposure.[9] Nor is it an accident that all of these prints bear inscriptions which supplement the image, comment on it, or point out a moral to be found in it. The inscriptions are a very typical manifestation of his view that poetry and painting went together, that the best artists were also *literati* and that the best works of art should communicate ideas that could be given a verbal interpretation—that, to put it in the crudest terms, they should have a "message."

In style the etchings of the mature group show significant differences from those of the *St. William* group as well, differences that are consistent with their intellectual and philosophical scope. They have few of the awkward, tentative, and roughly vigorous qualities of style seen in the *St. William, Albert, Glaucus and*

[9] For a detailed discussion of Rosa's insistence on being known as a painter of learned, philosophical subjects and *cose morali*, see Ch. V below on the *Genius* etching, and especially Wallace, "Genius," p. 474.

Scylla or even the *Apollo and the Cumaean Sibyl*. Instead, although they do show some stylistic and technical differences among themselves, they are in general characterized by a confident handling of large and complex compositions, fluent relationships among figures, and an easy, unproblematic disposition of forms in space. Unlike Rosa's earlier prints, there is nothing capricious or experimental about them. One has the feeling that he knew exactly what he was about in creating all of these prints and that he was sure enough of his abilities as an etcher to be able to translate his often grandiose tastes for impressive subject matter into etchings which are among the most ambitious graphic endeavors of his time.

It is, in my opinion, unfortunate that in doing these larger prints he avoided the wide variety of graphic approaches and techniques he had mastered in his earlier prints in favor of a much more traditional handling. They do, to be sure, show the stylistic decorum and adjustment of technique to subject matter seen in the earlier prints, but in most cases this is achieved simply by slight differences of emphasis and stroke within a rather standard range of technical and stylistic procedures. As a result, all of the prints of this group are basically very much alike in purely graphic terms. There are few differences in basic graphic feeling among them and, most important of all, there is little variation in the range of chiaroscuro effects they display, despite the fact that their subject matter and content are frequently very dissimilar. For example, the *Democritus in Meditation* print [104], with its gloomy and somber subject matter and content is not very different in tonality from the classicizing and rationally didactic *Genius of Rosa* etching [113]. This is all the more remarkable for the fact that the *Democritus* etching is an almost exact reproduction of the Copenhagen painting, one of Rosa's most forcefully and dramatically lighted works, a picture filled with strong raking highlights and deep somber shadows [104a]. A comparison of the print with the painting makes it seem as if warmly colored romantic poetry has been translated into grisaille prose.

Of course part of this can be explained by the sheer limitations of single-stage biting and the great difficulties of producing a wide range of lights and darks within this technique. It seems to me,

however, that Rosa also deliberately chose, in these prints, to suppress graphic variety in favor of iconographical variety, and that he wanted to express the often complex ideas of these prints in the clearest, most didactic way possible with no intriguing graphic effect to distract the viewer's mind by beguiling his eye. It is as if the spirit of caprice and imaginative inventiveness which in the *Figurine* and Triton Group prints was expressed in graphic terms was transmuted in the later prints into an iconographic, symbolic, and philosophical inventiveness and originality. That these graphic limitations were deliberate on Rosa's part and linked in his mind with issues of subject matter and symbolic program receives further support from the evidence of his latest etchings, the *Dream of Aeneas* [117] and the *Jason* [118]. Like the earlier prints of the *St. William* group they are concerned with events of an essentially dramatic order, are free of philosophical or programmatic pronouncements, and even lack inscriptions. Most important for the argument being presented here, they are also, like the prints of the *St. William* group, done with greater dash and freedom than are the prints of the mature group which precede them.

Given the relatively limited range of stylistic variety displayed by the *Diogenes Casting Away His Bowl* [103], *Democritus* [104], *Diogenes and Alexander* [108], *Academy of Plato* [109], *Death of Atilius Regulus* [110], *Ceres and Phytalus* [112], *Genius of Rosa* [113], and *Alexander in the Studio of Apelles* [114], it is difficult to place them in any strict chronological order. It would also be a pointless overrefinement to attempt too rigid a scheme of development since only a few months separate them in any case. They do, however, show a stylistic evolution in the direction of the definite classicism seen in such prints as the *Polycrates*, *Genius of Rosa*, and *Alexander in the Studio of Apelles*, an evolution which, as I hope to show in the following sections of this chapter seems to coincide with a chronological succession.

Diogenes Casting Away His Bowl [103]; *Democritus in Meditation* [104]

Stylistically, these two are closest to the *St. William* group and therefore, it seems to me, the earliest of the mature prints. Both

have something of the rough vigor and tense unbalance of the *St. William* [99], *Albert* [100], and the *Glaucus and Scylla* [101], and like them they rely heavily on the expressive force of stormy skies and broken tree trunks. The *Democritus* especially is like both the *St. William* and *Albert* in showing a solitary figure sunk in meditation in the midst of a savage and hostile wilderness.

However this argument from general stylistic features has obvious limitations; the etchings were not free inventions but rather reproduced almost exactly paintings done as companion pieces some ten years earlier, [103a] and [104a]. There are, however, considerations of etching style and technique which suggest, but of course do not prove, that the *Diogenes* and the *Democritus* were done before the more classicizing prints of the mature group. In the *Diogenes* especially the movement of the needle is in many passages sharp, staccato, harsh, and charged with nervous energy. This can be seen most notably in the treatment of drapery which is in many areas modeled with short, choppy lines and irregular hatchings which cut across and interrupt the flow of drapery and underlying form. *Diogenes'* face is modeled with similarly rough, clawed strokes, and the trees, foliage, and sky are in many places done with analogously tense, stabbing lines. One particularly interesting note of graphic brio is found in the shading of the drinking youth's back where a cluster of roughly slashed shading lines overlaps the edge of the print. Although the treatment of the drapery in the *Democritus* is more regular and smoothly fluent, its trees and sky share many of the graphic qualities of the *Diogenes*.

These characteristics of etching style and technique place the *Diogenes* and *Democritus* closer to the prints of the *St. William* group—especially the *Albert*, the *St. William*, and even the *Apollo and the Cumaean Sybil* [102]—than are any of the other prints of the mature group.

Both the *Democritus* and *Diogenes* also reflect Rosa's quietist tendencies, already discussed in connection with the *St. William* and *Albert*; and both philosophers, as Rosa treats them, can almost be called the classical equivalents of hermit saints. Democritus shut himself away from society and mankind in order to

pursue undisturbed his studies and, in Rosa's interpretation, melancholy speculations. Diogenes the Cynic cut himself off from society not by retreating to wilderness isolation but by severing all bonds with social convention in order to live a life of complete liberty and honesty.

Diogenes seems to have been as much Rosa's personal hero as he was the hero of Stoics in general. The artist did more paintings, etchings, and drawings of Diogenes than of any other single subject, beginning in the early 1640s with the *Selva dei Filosofi* in the Pitti Palace, which has as its subject the famous episode of Diogenes casting away his last remaining possession, a simple bowl, upon seeing a boy drink from his hand [103b]. Some years later, probably in the late 1640s, he did the painting now at Althorp, showing the famous confrontation of Alexander and Diogenes, in which Diogenes tells Alexander that the only thing the emperor can do for him is to stand out of his sunlight [108a]. The story of Diogenes casting away his bowl was repeated in 1651-1652 in one of Rosa's largest and most impressive figure pictures, the Copenhagen painting [103a] from which the etching was made; and the story of Diogenes and Alexander was repeated in an etching considerably different from the painting [108].

It is not difficult to see why Diogenes would have been so attractive a figure to Rosa, who seems in character and personal philosophy to have somewhat resembled the Diogenes as known from classical literature. Diogenes' philosophy and that of the Cynics had a fundamental influence on the shaping of Stoic thought, and the philosopher was always greatly revered by the Stoics for his indifference to worldly concerns and for his self-sufficiency, independence, honesty, and moral and intellectual courage.[10] But it is clear from classical literature that Diogenes differed greatly from Seneca, who espoused a well-balanced life, who was cognizant of mankind's folly but was basically resigned

[10] Arnold, especially pp. 48-50; Dudley, especially pp. 97-99, 187-200; Epictetus, *Discourses*, 3.22, "On the Calling of a Cynic" (Loeb, II, pp. 131-69). For a discussion of Rosa's Stoic and quietist views, and for his views in general on philosophy, see Salerno, 1970, pp. 43-61.

to it, and who was optimistic in his view of the world.[11] Quite to the contrary, the picture of Diogenes that emerges from ancient writings, especially the delightfully gossipy account of Diogenes Laertius, is of an irascible and rough-spoken man, whose method of dealing with social folly was to pierce it with biting wit and to cover it with scorn.[12] He seems to have been an instinctive satirist, as was Rosa, and it is noteworthy that Cynic literary genres played an important role in the development of ancient Roman satire, which in turn influenced Rosa.[13]

Diogenes Laertius' account of Diogenes' life is the most comprehensive one that has survived and was almost certainly the one best known to Rosa. His *Diogenes Casting Away His Bowl* and *Diogenes and Alexander* paintings and prints follow very closely the two anecdotes as they occur in close succession in Diogenes Laertius, and he also made use of that author's writings on several other occasions.[14] But Diogenes Laertius, by dwelling on the many colorful anecdotes about the philosopher's behavior, gives a slanted view of a man who was not simply a misanthrope but, as the veneration of the Stoics in general and Epictetus in

particular testify, a man motivated by a genuine desire to help and reform mankind.[15] Nevertheless his methods, and those of the Cynics in general, were harsh and stringent; he is supposed to have said, "Other dogs bite their enemies, I bite my friends, for their salvation."[16] Rosa's understanding of Diogenes and his philosophy seems to have been shaped primarily by Diogenes Laertius, and it is typical of him that he chose to emphasize the savage and satiric in Diogenes and the Cynics in his references to them.

Despite the imprecision of much of his philosophical thinking, Rosa was perfectly correct in recognizing that the most fundamental of Diogenes' beliefs was his insistence on complete freedom, on being able to say and do whatever seemed to him right without regard for convention or for the opinions of other men.[17] The desire for complete liberty and sincerity was beyond any doubt the most deeply held of all of Rosa's personal and artistic convictions. He referred to it many times in his letters, quarreled with his closest friend Ricciardi because of it, and made a formal proclamation of it in the *Genius of Rosa* etching [113]. Most important of all, his entire career was shaped by the determination to paint what he pleased, a desire which produced in him the revolutionary attitude toward patronage and his own creative genius already discussed and more fully documented in the chapter on the *Genius of Rosa* print.[18] It is important to note here that the Stoic's attitude toward personal liberty was a much less straightforward, more ambivalent one. They saw it as a precious privilege but felt that at times it had to be sacrificed in the press of circumstances.[19]

Rosa laid claim to Stoic attitudes in his writings; his letters and satires as well as many of his important works of art, celebrate

[11] For Seneca's views along these lines and for the views of the Stoics, see Seneca, *Epistulae Morales*, 66, "On Various Aspects of Virtue" (Loeb, II, pp. 3-35); Arnold, pp. 204-9, 330, 406; see also below n. 31.

[12] Diogenes Laertius, *Lives of Eminent Philosophers*, "Diogenes" (Loeb, II, pp. 23-85). See also Dudley, pp. 17-39, for an extended discussion and evaluation of the source material about Diogenes.

[13] Dudley, introduction, pp. xi-xii, pp. 95, 115, 199; Limentani, 1961, pp. 124-25; Highet, pp. 217, 245, 330.

[14] Diogenes Laertius, *Lives*, "Empedocles," 8.69 for the drawing on a wooden panel in the Pitti Palace, *Empedocles Casting Himself into the Crater of Mount Aetna* (Salerno, 1963, p. 135, no. 85; Langdon, "Rosa: Paintings," 45) and the painting of the same subject now in the collection of the Hon. Mrs. Hervey-Bathurst (Langdon, *Ibid.*, 44); "Pythagoras," 8.41 for the painting entitled *Pythagoras Emerging from the Underworld*, now in the Kimball Art Museum, Fort Worth, Texas (Langdon, *ibid.*, 36); and "Menedemus," 6.102 for a reference to Menedemus in his satires (see n. 29 below). Similar versions of the stories of Diogenes casting away his bowl and Diogenes and Alexander are found in Seneca, *Epistulae Morales*, 90.14, Plutarch, *Lives*, "Alexander," 14.1-3; Cicero, *Disputations*, 5.32.92; and Valerius Maximus, 4.3.4.

[15] Epictetus, *Discourses*, 3.24.64 (Loeb, II, pp. 204-5); Arnold, pp. 48, 121, 296; Dudley, pp. 28, 31, 88, 193.

[16] Dudley, p. 43. For Diogenes' and the Cynics' harshness of criticism, see Diogenes Laertius, *Lives*, "Diogenes"; Arnold, pp. 50, 69, 99; Dudley, introduction, p. ix, pp. 2, 28, 127.

[17] Dudley, p. 28; Arnold, p. 49.

[18] See also Wallace, "Genius," especially pp. 472-73, 476.

[19] Arnold, p. 322.

Stoic virtues.[20] But he seems to have realized, and it can be taken as a tribute to his fundamental intellectual honesty, that the Stoic values of Seneca—order, balance, self-control, equilibrium, and tolerance—could not by themselves serve as a comprehensive personal philosophy for him since his instincts and spontaneous behavior often tended in quite other directions. He even wrote of this dilemma in the satire *La Babilonia*, "I conquer my emotions, I endeavor to keep my agitated sentiments subject to my reason, nor do I take a step that is beyond my powers." And, "A hidden worm of anguish gnaws at my heart; and there are two things that cannot go together—to have a flame burning within one's breast, and to conceal it."[21] He also, quite rightly, saw a close connection between the Stoics and Cynics and their values, as he states in the satire *La Poesia*, "For, in spite of the Cynics and the Stoics, with no fear of the tongues of satirists, rulers as evil as Tiberius are praised to the skies in heroic verse."[22]

One gets the impression that many of these Stoic ideas, especially those calling for restraint, balance, and constancy, were to him aspects of a philosophy which offered him a mode of self-control and which he sought, with considerable difficulty, to impose on himself. On one occasion he even referred to his Stoic bearing as "a masquerade."[23] And although he was not above striking a pose as a Stoic philosopher, as Baldinucci implies he

did,[24] it would be a mistake, it seems to me, to regard his Stoicism as hypocritical or dishonest. As the verses cited above suggest, he seems to have been aware of the worth of Stoic attitudes in helping to rein in his more spontaneous impulses, but at the same time he recognized the value of these impulses. He after all made emphatic proclamation of this in the *Genius of Rosa* etching, in which both Stoic equilibrium and spontaneous self-expression are presented as being equally important to the artist's genius.

Far from pretending to be a Stoic exclusively in Seneca's sense of the term, he frequently referred to the Cynics and to the Cynic attitudes in his poetry in a way that leaves no doubt as to his conviction about the value of these attitudes to his art, both pictorial and literary. In fact there are more references to Cynic attitudes in his satires than to Stoicism, and this is quite natural since the satires are denunciations of man's folly. In his satire *Tirreno* for example he says, "Like Jonah I remonstrated and I wept like Joel; I darkened my pages with biblical accusations; and with the courage of the Cynics I painted my canvases."[25] Rosa offers, as far as I know, no equivalent statement that he painted with Stoic principles in mind. At the beginning of the satire *La Guerra* he has his protagonist Autore say, "Arise from the dead, now that the holy fury of the Rannusian divinity kindles in my breast the courage of the Cynics to stimulate my wits."[26] It is typical of Rosa's tendency in the satires to stress bitter and misanthropic attitudes that Autore's words are directed to Timon, the legendary misanthrope of Athens.[27]

[20] De Rinaldis, p. 157, no. 124, dated October 21, 1663: "Oh quanto siamo tenuti alla scuola degli Stoici, i quali ci hanno insegnato un'efficace medicina per alcune humane difficoltà." See also Wallace, "Genius," p. 474. For the works of art: *Cincinnatus*, Salerno, 1963, p. 118, no. 22; *Death of Atilius Regulus*, Salerno, 1963, p. 121, no. 33, Langdon, "Rosa: Paintings," 24, Wallace, "*Atilius Regulus*," pp. 395-97; *Astraea*, Salerno, 1963, p. 107, no. II; Wallace, "Justice," pp. 431-34; *Self Portrait with a Skull*, Langdon, "Rosa: Paintings," 22; Wallace, "Democritus," pp. 21-22.

[21] Cesareo, I, p. 335, vv. 268-70: "Domo gli affetti miei, cerco tenere/ Sogetto à la ragion senso che freme,/ Nè fo passo magior del mio potere." P. 341, vv. 403-5: "Chiuso verme di doglia il core intarla,/ E son due cose che non ponno unirsi,/ Haver la fiamma in seno, et occultarla."

[22] *Ibid.*, I, p. 209, vv. 574-76: "Che dei Cinici ad onta e degli Stoici/ Senza temer le lingue de' satirici,/ S'inalzano i Tiberi in versi eroici."

[23] De Rinaldis, p. 66, no. 45, dated May 5, 1654: ". . . e con una mascherata stoichezza, mi son fatto il più delle volte veder ridere di si fatte imposture."

[24] Baldinucci, 1773, pp. 84-85 (Salerno, 1963, p. 70): "Da tale suo soverchio amore, e appetito di gloria era ancora nato in lui fin da gran tempo un fervente desio d'apparire in ogni suo fatto e detto quasi un vero filosofo: e pare, che il passeggiare per gli spaziosi portici d'Atene in compagnia degli antichi Stoici, fosse continova occupazione de' suoi pensieri,..."

[25] Cesareo, I, p. 370, vv. 121-23: "Sgridai da Giona, e piansi da Joele,/ Di Davidiche accuse ombrai le Carte/ E con Cinico ardir pinsi le Tele."

[26] *Ibid.*, I, p. 256, vv. 4-6. "Sorgi da i morti, or che nel sen m'avviva/ Cinico ardire à stimolar l'ingegno/ Santo furor de la Rannusia Diva." (La Rannusia Diva is Nemesis.)

[27] For Timon of Athens, see Plutarch, *Lives*, "Antony," 70; Lucian, *Timon, or the Misanthrope*.

He also refers to Diogenes specifically upon several occasions in the satires, associating him with pessimistic denunciatory attitudes,[28] and he also frequently brings in the eccentric Cynic philosopher Menedamus who, according to Diogenes Laertius, went about dressed as a fury, telling people that he had come from Hades to discover and report their sins to the powers below. In the satire *Tirreno* Rosa even associates himself and his creative activity directly with Menedamus, making use of the bacchic symbolism that was in his mind associated with satire, "And ready to face any threat, in the mask of a satyr or a Menedamus I sported with my thyrsus and threatened with my brow. And, enkindled with supreme fury, full of zeal, full of courage, knowing no fear, I prophesied—but I was taken for a fool."[29]

It is evident from these references that in Rosa's mind Cynic attitudes were closely linked with daring, passionate, and even furious social criticism and satire. And his satires have many such furious denunciations, which, even though the Stoics themselves made use of satire as a mode of social criticism, are fundamentally at odds with the Stoic principles of tranquillity, restraint, balance, and tolerance. A typical example is found in the satire *La Poesia*, "Oh! Take up the whip, close your eyes, and whoever gets hit gets hit. Let this uncouth rabble feel the scourge." Or, in *Tirreno*, "My Lord, today I offer you my exculpation. With the scourges of my satires I stung the Vices with

that sacred fury that you kindled within me."[30] A comparison of Rosa's bitter and even savage declarations with some of Seneca's remarks on the value of social criticism is illustrative of how widely the artist's attitudes diverged from Stoic thinking. Seneca says, for example:

. . . for one is sometimes seized by hatred of the whole human race. When you reflect how rare is simplicity, how unknown is innocence, and how good faith scarcely exists, except when it is profitable, . . . there comes overwhelming gloom. We ought therefore to bring ourselves to believe that all the vices of the crowd are, not hateful, but ridiculous, and to imitate Democritus rather than Heraclitus. For the latter, whenever he went forth into public, used to weep, the former to laugh; to the one all human doings seemed to be miseries, to the other follies. And so we ought to adopt a lighter view of things, and put up with them in an indulgent spirit; it is more human to laugh at life than to lament over it.[31]

It is especially relevant to this discussion that when Rosa did his painting and etching of Democritus, he upset the traditional interpretation of Democritus as the laughing philosopher and made him weep. This clearly un-Stoic revision will be discussed in greater detail below. Further, Seneca manifests traditional

[28] Cesareo, I, p. 177, *La Musica*, vv. 412-14: "Testimonio bastante, e non già solo,/ Il Cinico mi sia, che già nel foro/ Tutto accusò de' Musici lo stuolo." Or in *La Guerra*, vv. 124-26: "Spegnete i lumi, o Cinici d' Atene,/ Chè fra popolo omai ch'hà rotto il collo/ È vanità cercare un huom da bene." (p. 262)

[29] *Ibid.*, I, p. 369, vv. 106-11: "E disposto a soffrire ogni periglio/ In maschera di Fauno, e Menademo/ Scherzai col Tirso, e minaciai col Ciglio./ E riscaldato da furor supremo/ Tutto zel, tutto ardir, senza timore/ Vaticinai, ma fui stimato un Scemo." Or in *La Guerra*, vv. 16-18 he says: "Un Galantuom son'io d'una natura/ Ch'al par di Menademo, e d'Adimanto/ Di ricchezze, e favor non hò premura" (p. 257). And in *La Babilonia*, vv. 772-77: "E ad inritar gli sdegni à i Menademi/ Sfacciate andar per queste rive in giro/ E la gloria avelir de i più supremi./ Prenderci in men d'un lampo e d'un sospiro,/ La troppo hoggi adorata Hipocresia/ Le porpore che già smarrite hà Tiro" (p. 356).

[30] *Ibid.*, p. 212, *La Poesia*, vv. 679-81: "Deh! prendete, prendete in man la scotica,/ Serrate gli occhi, et à chi tocca, tocca/ Provi il flagel questa canaglia zotica." P. 367, *Tirreno*, vv. 82-84: "Signor, faccio hoggi teco i miei pretesti./ Con flagelli di Carmi i Vizij io punsi/ Con quel furor che in me sacro accendesti." See also p. 255, *La Pittura*, vv. 853-55: "Siasi pur il mio stil sublime, ò vile,/ À color che sferzi sò che non gusta:/ Sempre i palati amareggiò la bile." P. 258, *La Guerra*, vv. 40-42: "Maggior nemico l'huom di me non ebbe,/ Che pensando à lasciar la forma umana/ L'aspettato morir nulla m'increbbe." P. 227, *La Pittura*, vv. 91-96: "Sotto la destra tua provò la sferza/ Musica, e Poesia: vada del pari/ Con l'altre due sorelle anco la terza./ E se da' tuoi flagelli aspri, et amari/ Alcun percosso esclamerà, suo danno:/ Da le voci d'un solo, il resto impari."

[31] Seneca, *Moral Essays*, 9, "On Tranquillity of Mind," 15.1-3 (Loeb, II, p. 273). See also Seneca, *Epistulae Morales*, 97, "On the Degeneracy of the Age," 1-2 (Loeb, III, p. 109). For other manifestations of this attitude in Stoic thought, see Arnold, pp. 344-45, 353, and Epictetus, *Discourses* (Loeb, I, introduction, p. xxiii).

Stoic thinking in calling anger, the emotion that runs most strongly throughout Rosa's satires, "the most hideous and frenzied of emotions."[32]

In Rosa's view, passionate social criticism should not be limited to the written word but should extend to pictorial art as well. He says as much in a harsh restatement of the age-old doctrine of *Ut Pictura Poesis* in the satire *La Pittura*, "And these blunderers have the presumption to call themselves painters, and protest against the use of the lash of the satirical poets?" Or, as has already been discussed earlier in connection with the frontispiece to the *Figurine* [6], in *La Pittura* a personification of *Pittura* appears to the artist-hero and urges him to be a fiery, satirical, moralizing painter.[33] And just as a number of his pictures celebrate Stoic themes, so too were a number of them pictorial satires, sometimes of the most daring and outspoken kind. Foremost among them was the *Fortune*, perhaps the most famous, or infamous, of all his works, and one which embroiled him in a serious conflict with the Papal authorities. In addition he did the *Sasso*, already mentioned, and apparently planned to do, but never carried out, a painting to be entitled *Invidia*.[34]

It is particularly interesting in the light of this discussion that *Diogenes Casting Away His Bowl* follows the painting of 1651 exactly [103a] and follows in spirit the earlier *Selva dei Filosofi* [103b] in showing Diogenes as a rough-hewn but basically respectable philosopher. But in creating the etching *Diogenes and Alexander* [108], for which he had no exact model, Rosa took considerable pains to transform the calmly dignified, snowy bearded, and handsome philosopher of the Althorp picture [108a] into a savage, ape-faced misanthrope whose abrupt words to Alexander are reinforced by a rough gesture which carries with it a threat of physical violence. The Diogenes of the three paintings and the etching *Diogenes Casting Away His Bowl* could be almost any philosopher; in the etching *Diogenes and Alexander* he is unmistakably Diogenes the Cynic, the pictorial embodiment of many of Rosa's most important attitudes. Even the inscription is taken directly from Juvenal.[35]

The *Democritus in Meditation* etching [104] was clearly intended to form a matched pair with the *Diogenes Casting Away His Bowl* print [103], just as the two pictures of 1650-1652 which the etchings reproduce were done as companion pieces [104a] and [103a]. The paintings are not only among Rosa's largest and most ambitious pictures but the *Democritus* is iconographically one of the most complex works he ever did. He was obviously concerned that the pictures and the ideas they embodied be given the widest possible circulation as prints, particularly since the paintings had been sold in 1652 to the Venetian ambassador Nicolo Sagredo and either were, or could be at any time, removed to Venice, where they would in effect be lost to the art world Rosa most wanted to please, that of Rome.[36]

Democritus was not a particularly important figure for the Stoics, but many of his attitudes and practices were clearly sympathetic to them. Seneca, for example, speaks approvingly of Democritus for considering wealth a burden to the virtuous mind and for renouncing it.[37] He also quotes Democritus in support of the worth of the individual, a classic Stoic doctrine, "One man means as much to me as a multitude, and a multitude only as much as one man."[38] More significant for this discussion, Democritus is associated in Seneca's writings with ideas of a quietist nature. In discussing tranquillity and the tranquil life, Seneca cites Democritus a number of times, saying, "We shall do well to heed the sound doctrines of Democritus in which he says that

[32] Seneca, *Moral Essays* 3, "To Novatus on Anger," 1.1.1 (Loeb, I, p. 107). For anger as an anathema to the Stoics, see the entire essay, and Arnold, pp. 330, 356.

[33] Cesareo, I, p. 230, vv. 196-98: "E presumono poi quest'indiscreti/ D'esser Pittori, e non voler ch'adopra/ La sferza de' satirici Poeti?" See also above Ch. II, n. 29.

[34] For the *Fortune* and *Sasso* see above Ch. II, nn. 15-16. For the *Invidia* see Fabbri, p. 329.

[35] Juvenal, *Satires*, 14.311-314.

[36] It is clear that the pictures were sold to Sagredo in 1652 (De Rinaldis, p. 36, no. 22, dated July 6, 1652; Salerno, 1963, p. 110, no. XIII, p. 121, no. 31; Olsen, 1961, pp. 85-86), but it is not clear when they were taken to Venice. It is possible that they were still in Rome when the etchings were done some ten years later although Rosa must have used *ricordi* of some kind to do the designs for the prints at Strozzavolpe.

[37] Seneca, *Moral Essays*, I, "On Providence," 6.2 (Loeb, I, p. 43).

[38] Seneca, *Epistulae Morales*, VII, "On Crowds," 10-11 (Loeb, I, p. 35).

tranquillity is possible only if we avoid most of the activities of both private and public life, or at least those that are too great for our strength."[39]

But Seneca's keenest appreciation of Democritus is as the laughing philosopher. In his essay "On Anger," for example, he says, "Democritus, on the other hand, it is said, never appeared in public without laughing; so little did the serious pursuits of men seem serious to him. Where in all of this is there room for anger?" Or as Seneca states in the passage already cited in connection with the Diogenes discussion, "We ought, therefore, to bring ourselves to believe that all the vices of the crowd are not hateful but ridiculous, and to imitate Democritus rather than Heraclitus. For the latter, whenever he went forth into public used to weep, the former to laugh. . . ."[40]

It is clear from the iconography of the *Democritus* painting and etching, and from the print's inscription, that the decisive factor in Rosa's interpretation of Democritus was his familiarity with the well-developed tradition of the paired philosophers mentioned by Seneca, the weeping Heraclitus and the laughing Democritus. This dichotomy, already well established in ancient literature, was especially popular in the northern countries during the Renaissance and the Baroque period. Since it was, however, a relatively unusual subject in Italian art prior to Rosa, he may have known a northern model of some kind. He himself did several traditional interpretations of the paired philosophers earlier than the large *Democritus* painting and etching, one a painting now in the Kunsthistorisches Museum, Vienna, the other a drawing now in the Teyler Museum, Haarlem.[41] However, in the large *Democritus* painting and the etching after it Rosa did just the opposite of what Seneca advised, he upset the traditional interpretation of Democritus as the laughing philosopher and transformed him into a weeping Heraclitus who sits overwhelmed with grief and despair in the face of the futility and vanity of all things. As the etching's inscription proclaims, "Democritus, the mocker of all things is here stopped by the ending of all things." (Democritus omnium derisor / in omnium fine defigitur.) This inversion of a well-established theme was a bold stroke on Rosa's part and one which gave it a new poignancy. It is both a typical manifestation of his desire to be as original as possible, and also a characteristic expression of one of the most persistent themes in Rosa's art and writing, that of *vanitas*. It comes as no surprise that a professed Stoic would choose to point out the vanity of man's worldly achievements in the face of obliterating death, but the insistence with which Rosa does this, and the passion and even despair he evidences in doing so reveal a spirit far removed from a Stoically resigned acceptance of death. Moreover in Rosa's interpretation the Stoic aspects of the Democritus legend are tinged with Cynic overtones, and Democritus becomes the mocker mocked.

In addition to Rosa's primary reliance on the paired philosophers tradition, two other literary sources have been suggested for the Democritus, neither of which is an adequate explanation

[39] Seneca, *Moral Essays*, III, "To Novatus on Anger," 3.6.3 (Loeb, I, p. 269). See also IX, "On Tranquillity of Mind," 13.1 (Loeb, II, p. 265).

[40] *Ibid.*, III, "To Novatus on Anger," 2.10.5 (Loeb, I, p. 187); IX, "On Tranquillity of Mind," 15.1-3 (Loeb, II, p. 273).

[41] In addition to Seneca's references to Democritus as the laughing philosopher, he is mentioned as such by Cicero, *De oratore*, 2.235 and Horace, *Epistles*, 2.1.194f. The laughing Democritus and weeping Heraclitus are written about together by Juvenal in *Satires*, 10.28-53; and Lucian, *Philosophies for Sale*, 13f. For the painting and drawing see K. Garas, "Wiedergefundene Gemälde Salvator Rosas," *Pantheon*, XXVII, 1969, pp. 42-47; and

Wallace, "Democritus," pp. 24-25. The discussion of the iconography of the *Democritus* in the present chapter is a slightly modified version of that found in my "Democritus" article. For Democritus and Heraclitus, see also W. Weisbach, "Der sogenannte Geograph von Velasquez und die Darstellungen des Demokrit und Heraklit," *Jahrbuch der Preussischen Kunstsammlungen*, XLIX, 1928, pp. 141-58; L. Möller, "Demokrit und Heraklit," *Reallexicon zur deutschen Kunstgeschichte*, 1954, III, pp. 1244-51; D. F. Darby, "Ribera and the Wise Men," *Art Bulletin*, XLIV, 1962, pp. 284-95; W. Stechow, "Rembrandt-Democritus," *Art Quarterly*, VII, 1944, pp. 232-38; E. Wind, "The Christian Democritus," *Journal of the Warburg Institute*, I, 1937-1938, pp. 180-82; J. Bialostocki, "Rembrandt's Terminus," *Wallraf-Richartz Jahrbuch*, XXVIII, 1966, pp. 49-60; A. Blankert, "Heraclitus en Democritus," *Nederlands Kunsthistorisch Jaarboek*, XVIII, 1967, pp. 31-123. See also Rotili, pp. 91-95, who follows the iconographical interpretation of my "Democritus" article almost exactly.

by itself. Pigler proposes as a possible source a dialogue of Lucian's in which Democritus is described as having shut himself up in a tomb with his studies, only to be disturbed by boys who dress themselves in skeleton costumes and try, without success, to frighten him.[42] Since the pranksters are not present in Rosa's works, it is clear that Lucian's anecdote cannot be considered his immediate source.

The more commonly accepted interpretation of Rosa's picture and etching is that they relate to the story of Hippocrates' visit to Democritus as told in the apocryphal letters of Hippocrates, which were known in a number of Latin translations in the 16th and 17th centuries.[43] This text relates that Hippocrates was called in by Democritus' fellow citizens at Abdera because, seeing the philosopher off by himself and surrounded by his books and the bodies of dissected animals that he was studying, they mistook his scholarly absorption and odd behavior for insanity. The physician found Democritus strange in appearance and preoccupied with his research, but sane, hospitable, and wise. As in the case of Lucian's dialogue, the absence of any reference in the painting and etching to the essential elements of Hippocrates' visit, together with the complete lack of any *vanitas* significance in the apocryphal letters, rule them out as a specific literary source. However, it is possible that Rosa may have known and been influenced by a painting, print, or drawing of Hippocrates' visit

to Democritus, several Northern examples of which are known.[44]

These two accounts are, however, clear reflections of Democritus' reputation in classical literature. He was known chiefly as the great atomist,[45] and also as a philosopher of immense erudition, wide experience, and great productivity; the author of works on ethics, astronomy, physics, agriculture, mathematics, literature, music, and medicine, to give only the broadest categories.[46] He was also thought of as a magician and seer,[47] and one anecdote about him relates that he foresaw his own death

[42] Pigler, II, p. 296. Lucian, *The Lover of Lies, or the Doubter*, 32. In the Loeb Classical Library edition by A. M. Harmon, London, Cambridge, Mass., 1947, III, pp. 369-70.

[43] Olsen, p. 86, mentions the letters as a probable source for Rosa's interpretation; Salerno, 1963, p. 110, no. XIII, p. 44, accepts them as the definite source. W. Stechow, "Zwei Darstellungen aus Hippokrates in der holländischen Malerei," *Oudheidkundig Jaarboek*, IV, 1924, pp. 34-38, has shown that this text was used as the basis for paintings by the Dutch artists Moeyart and Berchem and has pointed out that Latin translations of the apocryphal letters appeared in editions as early as 1544 in Paris, 1579 in Basel, and 1588 in Venice. He reproduces (pp. 35-36) the most important parts of the description of Hippocrates' visit to Democritus from the Latin Geneva edition of 1657. The association of this account with Rosa's picture seems to have been made originally by O. Jørgensen, cited by E. Zahle, "Tilvaekst af Italiensk Barok," *Kunstmuseets Aarskrift*, XXIV, 1937, p. 150.

[44] Using similar arguments, R. Oertel, "Die Vergänglichkeit der Künste," *Münchner Jahrbuch der Bildenden Kunst*, 1963, p. 120, finds it very unlikely that Rosa referred directly to the text for his *Democritus*, but thinks he may have been influenced by a pictorial prototype. As he points out, paintings by Jan Lievens and Jakob Adriaensz Backer of Hippocrates' visit to Democritus are now known in addition to the examples discussed by Stechow, and they show Democritus absorbed in his studies and surrounded by books and animals, dead and alive, with Hippocrates standing near or approaching. Stechow, "Zwei Darstellungen," p. 37, also proposes a *Stammbaum* of this pictorial type, including a lost painting by Pieter Lastmann in addition to those by Moeyart and Berchem, which may go back to the circle of Elsheimer. As Oertel says, this would increase the likelihood of pictorial examples being known in Italy. However, it should be observed that not only is the Castiglione print a much more direct model for the *Democritus* but Rosa was, in any case, also fond of painting animals, skeletons, skulls, and bones. Nevertheless, the way he places the dead animals around his philosopher is reminiscent of these Northern examples, and is a persuasive, if not conclusive, argument in favor of Rosa's knowledge of such a model. See also R. Burton ("Democritus Junior"), *The Anatomy of Melancholy*, Oxford 1621, and later editions, for an interesting variation on the story of Hippocrates' visit to Democritus. Tomory, no. 15, points out that on the title page of the Burton book Democritus is shown seated in a serious pose of thought.

[45] In the satire *Invidia* Rosa says: "Altro camin non ho che la finestra,/ Dove al foco del sol mi fà Democrito/ Un pan grattato d'Atomi in minestra." A marginal note by Rosa himself says: "S'allude all'opinione di Democrito ch'il tutto diceva esser fatto d'atomi." (Cesareo, I, p. 293, vv. 241-43.)

[46] Diogenes Laertius, *Lives*, "Democritus," 46-49 (Loeb, II, pp. 455-63).

[47] Pliny, *Natural History*, 30.2.9-11, considers Democritus the most important of all students and teachers of magic. See also C. Dempsey, "Tiepolo Etchings at Washington," *Burlington Magazine*, CXIV, 1972, pp. 503-7.

but postponed it for three days by breathing the fumes of hot loaves in order not to die during a festival and inconvenience his sister.[48] In addition, he was known as a solitary scholar, as the sources discussed above mention, and even as a frequenter of tombs.[49] Thus Democritus, when encountered in the context of Rosa's painting and etching, is the lonely master of great knowledge that extends even into the realm of the supernatural, who nevertheless despairs of it all and sits brooding over the wreckage of mortality.

It can also be shown that the *Democritus* is specifically dependent on a pictorial and iconographic tradition that received its decisive formation with Albrecht Dürer's *Melencolia I*.[50] Dürer's subtle and complex print engendered in Italy two major responses that led in turn to Rosa's painting. The earlier and most important reaction was Domenico Fetti's *Melancholy* (Fig. 13) which, like the Dürer, shows a brooding female figure sunk in melancholic inaction and surrounded by implements symbolizing human activities, practical and theoretical. Fetti departs from his model in adding brushes, a palette, and a sculpture as specific references to artistic activities and, most important, he also gives his Magdalene-like Melancholy a skull as a *memento mori*, thus making his picture unmistakably an allegory of *vanitas*.[51] As Panofsky and Saxl have observed, that which had been

with Dürer only a dark, barely conscious doubt whether human works and thought were really significant in the face of eternity here condenses into a question that is answered with a resolute and unequivocal No.[52]

The second major Italian response to *Melencolia I* was Castiglione's etching of 1648, *Melancholy* (Fig. 14). In its fundamental conception it depends on the Dürer print but borrows many of its implements and symbols directly from the Fetti painting. Even more important, the etching has the *memento mori* and *vanitas* significance of the Fetti, and develops the moralizing character of the painting even further by the addition of an inscription, *Ubi Inletabilitas ibi Virtus* (Where there is melancholy, there also is virtue).[53]

Rosa in turn used Castiglione's etching as the basic model for the *Democritus*.[54] His philosopher and Castiglione's *Melancholy* are seated in very similar postures; she holds a scroll of music and a skull in her lap,[55] he holds only a book but looks down at the macabre still life on the ground, which also contains a human skull as a *memento mori*. In both, the compositional format is very similar, crumbling overgrown ruins and fragments surrounding a central solitary figure. The picturesque setting and

[48] Diogenes Laertius, *Lives*, "Democritus," 43 (Loeb, II, p. 453).

[49] *Ibid.*, 36.38-39 (Loeb, II, pp. 445-49); and Pliny, *Natural History*, 30.2.9.

[50] In my discussion of Domenico Fetti's and G. B. Castiglione's interpretations of *Melancholy* and their relation to the Dürer print, I have relied heavily on Panofsky-Saxl, especially pp. 151-54 (also found in R. Klibansky, E. Panofsky, and F. Saxl, *Saturn and Melancholy*, New York 1964, pp. 388-90). The authors state that the Fetti was no doubt the most important work of art to arise under the influence of the Dürer print, and the Castiglione etching is dependent on both the Dürer and the Fetti. They also discuss the *memento mori*, *vanitas*, and moralizing qualities of the two later works. Both Tomory, no. 15, and Brown, p. 59, see Ribera's *Poet* (Bartsch no. 10, Brown no. 3) as a source of inspiration and a model for the *Democritus*, an association that I find perfectly plausible in a general sense.

[51] Panofsky-Saxl, p. 154, mention the figure's strong connection to a penitent Magdalene type and point out that the Paris version was actually catalogued as such in the 17th century. See also Oertel, p. 116.

[52] Panofsky-Saxl, p. 154.

[53] Bartsch (no. 26) observes that the first impressions of the Castiglione etching were made before the inscription and the address of the publisher Rossi were added, and he calls the print simply "La femme assise dans des ruines." See also Percy, cat. nos. E14, 117.

[54] Oertel, p. 110, states that Rosa definitely modeled his painting on the print. Blunt, p. 13, makes a general association of the *Democritus* with the grim, picturesque phase of Castiglione's work which includes the *Melancholy*; and he says that in a number of compositions, among them the *Democritus*, Rosa borrowed freely from Castiglione. It is noteworthy in this context that Rosa's *Genius* is based on the Castiglione print of the same subject (see below p. 84, and Wallace, "Genius," p. 475), and that the seated woman in Rosa's *La Filosofia*, now in the Enzenberg Collection, Palazzo Enzenberg, Caldaro, Bolzano, repeats the pose of Dürer's *Melencolia I* figure almost exactly. See W. Arslan, "Sul seicento napoletano," *Le Arti*, August-December, 1943, pp. 257-60, fig. 1; Salerno, 1963, p. 139, who dates it a little before 1649; Wallace, "Genius," p. 478.

[55] See G. Bandmann, *Melancholie und Musik*, Cologne 1960, pp. 101-3, 123-26.

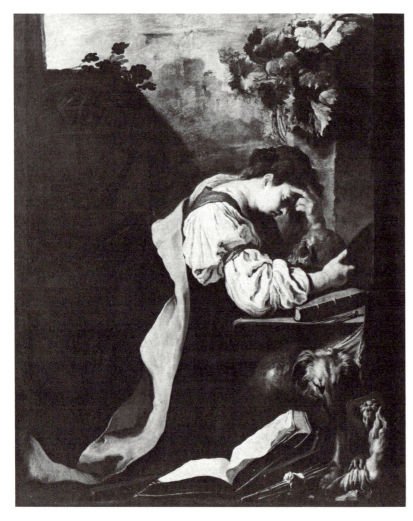

13. Domenico Fetti, *Melancholy*, painting.
Venice, Gallerie dell'Accademia

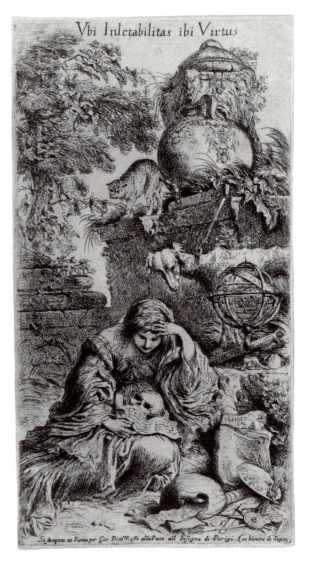

14. Giovanni Benedetto Castiglione,
Melancholy, etching. British Museum

variations on antique urns, altars, and reliefs of the *Democritus* also show the influence of other Castiglione etchings, especially the *Diogenes* with its herm, urn, altar, owl, and large animal skull.[56] Despite this the Rosa etching, done some ten years after the painting, shows no particular influence of the Castiglione print in purely graphic terms, aside from a general similarity in tone.

Important as these compositional similarities are, the essential link between Castiglione's *Melancholy* and Rosa's *Democritus* is their agreement in basic theme, the melancholic contemplation of the frailty of human life and the vanity of human achievement. Nevertheless, there is an important difference of emphasis between the two. Castiglione accentuates man's vain accomplishments by filling his composition with symbols of human activities, practical, theoretical, and artistic, but Rosa melodramatically emphasizes mortality itself. He includes only a few symbols of human activities in the form of books, papers, and a warrior's helmet in the painting, with the addition of a painter's brush and stick in the right foreground of the etching, and even these are all but buried in piles of bones and skulls. A similar statement of despair is found in Rosa's satire *Tirreno*: "And let Cleanthes' lantern tell them that all of our works are short-lived and feeble; there is nothing here below that lasts forever. The colosseums crumble, the *terme* crumble, the worlds are dust, their pomps a nothing, and human pride a smoke, a worm. In this comic fiction which attracts and beguiles us and which is called life, the cradle is for us the prologue to tragedy."[57]

[56] Bartsch 21. Blunt, p. 12, finds 1648 the most probable date for this etching on stylistic grounds. Percy, cat. no. E15, dates it to the second half of the 1640s probably before 1647. See also Bartsch 16, *Festival of Pan*; Bartsch 6, *Lazarus*; and Bartsch 24, *A Tomb Filled with Arms*.

[57] Cesareo, I, p. 380, vv. 316-24: "E sapin pur di Cleantea Lucerna/ Tutte l'opre di noi caduce e inferme;/ Cosa non v'è qua giù che duri Eterna./ Muoiono i Collossei, mouion le Terme,/ Son polve i Mondi, le sue pompe un Nulla/ E l'humana alteriggia un fumo, un Verme./ In questa che ci alletta, e ci trastulla/ Comica finzion che nome ha Vita/ Prologo di Tragedia è a noi la Culla." Cleanthes was successor to Zeno as head of the Stoic school, from 263 to 232 B.C. "Lucerna" probably refers to the fact that he worked at night in order to support his daytime studies.

The artist exploits his characteristically picturesque handling of formal means to achieve a mood of disturbing uneasiness appropriate to the subject matter. In the painting the colors are somber and the strong raking light produces gloomy and mysterious shadows, effects which are unfortunately much diminished in the print, as has already been discussed. The grim tombs and jagged trees behind the philosopher are dramatically silhouetted against the stormy sky. He is the center of a menacing composition; broken trees push through crumbling ruins and loom ominously over him and a jumble of grisly wreckage crowds in upon him.

In addition to their picturesque grimness, these implements and objects provide a wealth of iconographic detail which buttresses the basic symbolic program of the *Democritus*. And these iconographic details are used in a way that is typical of many of his most ambitious paintings and etchings; on the one hand these erudite, scholarly, and even pedantic details are the work of an artist who wanted to be known as a learned painter, but on the other hand they are presented in a curiously emotional and romantic style that exhibits a tendency toward a zealously ostentatious and even passionate display of knowledge, frequently of a rather arcane and mysterious kind. The result is a stuffed symbolic statement which has close parallels to his satires with their endless recitals of names, ideas, and stories from literature, poetry, and philosophy. It is also typical of his iconography that the symbolism of the *Democritus* is not particularly subtle or difficult to unravel once the keys are found. As a rule it consists of an accumulation of iconographic details, usually from Ripa or Valeriano, which tend to make the same basic and rather straightforward points in a number of different ways. In most of his iconography there is relatively little of the kind of subtle and sophisticated thinking seen in Dürer's *Melencolia I*, in the Galleria Farnese, or in the art of Poussin, to choose just a few examples.

Democritus stares down at a striking *vanitas* still life composed of a human skull, animal skulls and skeletons, bones, a helmet, crumpled books, and tattered papers. The painting has a volute-like architectural fragment, a dead rat in front of the human

skull, and a scroll next to the rat, which are not found in the etching, and the etching has a stone plaque next to the philosopher and a painter's brush and stick in the right foreground not present in the painting. As has been discussed earlier, these objects are symbolic of death, evanescence, and the vanity of man's literary, artistic, and military achievements, and this significance is heightened by their battered disorder and negligent clutter, a method of handling often used in *vanitas* still-life paintings.[58]

Although it hardly seems necessary to consult literary sources to discover the significance of the dead rat as used in this context, it is possible to connect it with several rather specific symbolic traditions. Most commonly the mouse or rat is used as a symbol of all-devouring time, disappearance, and destruction, a meaning that fits Rosa's usage quite well.[59] It is noteworthy, however, that Rosa goes a step beyond the usual symbolic treatment, which makes use of destructively alive rodents. It seems likely that the best explanation is found in Pierio Valeriano's *Hieroglyphica*, an iconographic handbook that was one of Rosa's favorites and which he specifically used in this picture for the leaning obelisk with its relief carvings at the extreme right (Fig. 15). According to Valeriano, a dead rat signifies weakness and helplessness, *Imbecillitas*, because the rat is an especially fragile creature that is easily killed and generally short-lived.[60]

The artist also introduced a personal note into the *vanitas* still life of the *Democritus* by signing the scroll next to the rat with his name. In my opinion, this can be interpreted as a general

15. *Humanae Vitae Conditio* (from Valeriano, *Hieroglyphica*, 1567, 219r)

[58] I. Bergström, *Dutch Still-Life Painting in the Seventeenth Century*, London, 1956, p. 172. Oertel, "Vergänglichkeit," pp. 105-20, presents a comprehensive analysis of the still-life tradition of the evanescence of the arts and sees the *Democritus* still life as related to it (pp. 109-10).

[59] Ripa, 1613, pt. 1, pp. 164-65, "Danno," and pp. 191-93, "Detrattione"; Valeriano, pp. 99v-100r, *Detrimentum*; Boas, Bk. I, p. 80, no. 50, "Disappearance"; Panofsky, 1957, pp. 307-8; idem, *Studies in Iconology*, New York, Evanston, London, 1962, pp. 80-81; idem, *Hercules am Scheidewege, und andere antike Bildstoffe in der neueren Kunst*, Leipzig 1930, p. 92.

[60] Valeriano, p. 100r, *Imbecillitas*. For other examples of Rosa's use of this text, see Wallace, "Genius," p. 475-76. The obelisk will be discussed below.

reference to his own literary activities and is reminiscent of the *vanitas* of the arts still life in his large painting *Fortune*, now in the J. Paul Getty Museum, Malibu, California. This shows beasts trampling on a palette and brushes, a laurel branch, papers, and a volume signed with Rosa's monogram.[61] The pig sniffs at pearls and steps on a rose blossom, the latter an additional reference to Rosa's name.[62] The same floral symbolism may also be present in the still life of the *Democritus* painting, since there seem to be rose leaves and faint traces of a pink rose bud and white blossom near the architectural fragment. However, this is difficult to establish definitely because of darkening and loss in that area. Finally, the scrap of paper beneath the scroll bears the Greek letter omega, which as the last letter of the alphabet is frequently used to symbolize the end and death, and is often seen on tombs.

On the other side of the composition the head of a pig, an animal that invariably stands for stupidity, gluttony, and intractability,[63] seems to jeer at the philosopher, while thistle flourishes and grape leaves wither, and the eagle, symbol of noble, lofty thought and imperial power, is toppled.[64] In the painting

only the skull and antler remain of a stag, an animal often used as a symbol of longevity because its large antlers display its great age.[65] Trees crowd in menacingly around the elaborately carved tomb, ruined wall, urn, and two obelisks, the latter symbolic of the glory of princes.[66] One is already overthrown, and both are scarred and cracked, just as the reliefs of the urn and the block Democritus leans on are battered and worn. The human skeleton in its moldering coffin has an obvious significance,[67] and it is closely related in meaning to the toppled obelisk immediately behind it. This obelisk not only symbolizes fallen glory in general

to have been so widely accepted in the Renaissance and Baroque periods that Rosa need not have consulted a particular source in this case either. The strength of this tradition of meaning is reflected in Ripa, for whom the eagle is always a symbol of nobility, loftiness, and high-mindedness, and is never associated with disagreeable qualities (Ripa, 1613, pt. 1, pp. 88, 362-63; pt. 2, pp. 6-7, 21, 30-31, 140, 186, 204, 223). Valeriano, pp. 137r-143v, who by the nature of his study was much more concerned with animals and their various meanings than Ripa, agrees with the latter in the main, citing the eagle as a symbol of *Imperatoria Maiestas* (pp. 138v-139r), *Benignitas* (p. 139v), *Ingenium Velox*, and *Alta Cogitatio* (p. 141v), but also mentions the eagle as a bird of prey and a symbol of rapacity and related characteristics. It is in the latter sense that Rosa uses the live eagle in the *Fortune*.

[61] Exhibited at the Pantheon in August 1659; Salerno 1963, p. 122, no. 36, and p. 45. Haskell, pp. 153-54, discusses the picture's satirical implications at some length.

[62] Although it would appear that the artist did not explicitly make a connection between his name and the rose in his writings, the appropriateness and probable currency of the conceit in Rosa's time was clearly expressed by one of his acquaintances, Francesco Melosi, who in a poem entitled *Capitolo a Salvator Rosa* wrote: "Ed in ciò 'l vostro nome co l'effetto/ S'accorda ben, poichè, dando qual rosa/ Aspre ponture, havete odor perfetto." (Limentani, 1954, p. 48.) Oertel, p. 108, also mentions the association of the artist's name with the flower in connection with what may be a portrait of Rosa in the Museum of Fine Arts, Dallas, Texas.

[63] Although it was not necessary for Rosa to consult a learned text for this symbolism, it is nevertheless of interest that according to Ripa, 1613, pt. 1, pp. 151, 159, 300, 369, 375, pt. 2, pp. 123-24, the pig is always a symbol of bad qualities and never of good ones. Valeriano, pp. 63r-70v, has equally unkind words for the pig, using him in most cases to stand for bad things, among them *Pernicies* and *Sensus Maxime Brutus* (p. 63v), *Profanus* (pp. 65r-65v), and *Indocilitas* (pp. 65v-66r), and finding him most agreeable when sacrificed. The pig in Rosa's *Fortune* has the same significance. See also Boas, Bk. II, p. 92, no. 37.

[64] Once again, the association of these qualities with the eagle seems

[65] Ripa, 1613, pt. 2, pp. 364-65, "Vita Longa," and p. 361; Valeriano, p. 55v; Boas, Bk. II, p. 89, no. 21, "A Long Space of Time."

[66] Ripa, 1613, pt. 1, pp. 296-99, "Gloria de' Prencipi." For the association of ruins with ideas of *vanitas* and evanescence see H. W. Janson, "The Putto with the Death's Head," *Art Bulletin*, XIX, 1937, p. 439; and E. Panofsky, "*Et in Arcadia Ego*, On the Conception of Transcience in Poussin and Watteau," in *Philosophy and History, Essays Presented to Ernst Cassirer*, Oxford 1936, pp. 245-47. A more general discussion of the landscape of ruins is found in A. R. Turner, *The Vision of Landscape in Renaissance Italy*, Princeton 1966, pp. 153-74.

[67] For the symbolic significance of skulls and skeletons and their association with ideas of *memento mori* and *vanitas*, see F. P. Weber, *Aspects of Death and Correlated Aspects of Life in Art, Epigram and Poetry*, 3rd ed., London 1918; É. Mâle, *L'Art Religieux après le Concile de Trente*, Paris 1932, pp. 203-27; Panofsky, 1957, pp. 308-9; Janson, "Putto," pp. 423-49; K. Bauch, *Der frühe Rembrandt und seine Zeit*, Berlin 1960, pp. 21-29; J. Seznec, "Youth, Innocence and Death," *Journal of the Warburg Institute*, I, 1937-1938, pp. 298-303.

terms but, because of its relief decorations, also has a very particular meaning. According to Valeriano's *Hieroglyphica* (Fig. 15)[68] the obelisk stands for *Humanae Vitae Conditio*; the reliefs refer to human frailty, the baby's head above the old man's showing the cycle of the decline from infancy to old age and return again to childhood, the falcon representing God and that which is divine in man, the fish symbolizing hatred and death, and the hippopotamus denoting shamelessness, violence, discord, and consequent death. In the tree above, an owl, the bird of night, bad augury, and death, broods over these grim remains.[69]

Next to Democritus and in front of another tomb and fallen obelisk appears Terminus, the god of boundaries, the end, and also of death.[70] He appropriately wears a crown of funerary cypress similar to the one seen in the *Self-Portrait with a Skull*

(Fig. 12). It is noteworthy that in the etching his bandoleer includes ivy, a symbol here of decay and ruin because it creeps over old walls, buildings, and trees and helps to destroy them.[71] The smoking tripod at the extreme left of the painting is well suited to the macabre setting and calls to mind the verses quoted earlier, "the worlds are dust, their pomps a nothing, and human pride a smoke, a worm."[72]

The etching contains an addition that is of considerable importance, a stone plaque next to Democritus which is incised with a large omega and several smaller M's. Once again, its basic explanation can be found in Valeriano, who describes and illustrates a pyramid of ten M's as a symbol of *Finis*.[73] Valeriano states that ten M's represent ten thousand, which is the perfect, finished number, the product of the multiplication of the dimensions of the pyramid of Egypt, which he says is one hundred feet on each side. The omega repeats the omega of the painting's scroll and has, as the last letter of the alphabet, the same significance. Although Rosa could certainly have made the association of the M's with an omega without referring to a particular source, it seems more likely that he knew and used the later editions of Cesare Ripa's *Iconologia*, which describe and illustrate "Fine" as a seated old man who holds a pyramid of ten M's in his right hand (Valeriano is properly cited and quoted almost verbatim in the Ripa explanation) and a rectangle with an omega

[68] Valeriano, pp. 218v-219r, who in turn bases his description on Plutarch, *Moralia: Isis and Osiris*, 363. See also Wallace, "Genius," p. 476.

[69] Ovid, *Metamorphoses*, 5.542-50, describes the owl as a prophet of woe and a bird of evil omen to man; Ripa, 1613, pt. 1, pp. 82, 94, 353-54, 356, pt. 2, pp. 216-17, uses the owl as a symbol of darkness and bad augury; and Valeriano, pp. 147v-148r, gives *Mors* as a major significance of the owl. Rosa himself, in the satire Babilonia, says: "Cangierassi il tuo Giove in fier Saturno/ E toccherai con man, che 'l mio presaggio/ Non fu di Gufo, o d'altro Augel Noturno." (Cesareo, I, p. 361, vv. 922-24.)

[70] Because of the context in which this figure is placed, its cypress crown, and its repetition as a symbol in the painting *L'Umana Fragilità*, it is clear that Rosa intended it as more than a decorative herm. A Terminus figure very similar to the one in the painting is illustrated in Alciati, p. 561, Emblema CLVII, and discussed at some length as a symbol of death (pp. 561-63). See E. Wind, "Aenigma Termini," *Journal of the Warburg Institute*, I, 1937-1938, pp. 66-69, for a study of Erasmus' use of Terminus as a personal emblem, and its association with death symbolism. See also W. Stechow, "Homo Bulla," *Art Bulletin*, xx, 1938, p. 228; and Bialostocki, "Rembrandt's Terminus," pp. 49-60. Many of the ideas found in the *Democritus* are repeated in the slightly later *L'Umana Fragilità* now in the Fitzwilliam Museum, Cambridge. Like the *Democritus* it depends heavily on Dürer's *Melencolia I* and the pictorial and iconographical tradition it engendered. It repeats many of the iconographical features of the *Democritus* exactly, and exhibits qualities of iconographic style very much like those already discussed in connection with the *Democritus*. See Salerno, 1963, pp. 110-11, no. xv; Wallace, "Democritus," pp. 27-31; and Langdon, "Rosa: Paintings," no. 27.

[71] This significance is mentioned by Ripa, 1613, pt. 1, p. 22, "Ambitione," p. 377, "Ingratitudine," and is discussed at length by Valeriano, pp. 377r-378r. Rosa himself made a specific reference to this symbolism in the satire *Tirreno*; "A che d'Ellere, e Allor cincersi il crine?/ Sì amaro è il Lauro? e l'Edere pudiche/ Han sì gran simpatia con le rovine?" (Cesareo, I, p. 374, vv. 220-22). As a plant sacred to Bacchus, ivy is most frequently used as a poetic crown, a tradition Rosa here refers to. In addition, it is often a symbol of tenacity and diligence because of its persistent creeping and climbing, a meaning with which the destructive quality of the plant is usually closely associated. See Alciati, pp. 704-7, Emblema CCIIII; Ripa, 1613, pt. 1, pp. 4f. 52, 257-58, pt. 2, pp. 77, 145, 299; Wallace, "Genius," p. 480. For the funerary significance of cypress, see Wallace, "Genius," p. 475.

[72] See above footnote 57; and Wallace, "Democritus," p. 30.

[73] Valeriano, pp. 291r-291v.

in his left hand, both as symbols of "fine."[74] He stands for the end and death, among other things, and corresponds nicely with the "fine" of the etching's inscription. It is noteworthy that Ripa has him wear a crown of ivy as a symbol of age and ruin.

Diogenes and Alexander [108];
The Academy of Plato [109]

The first of these exhibits qualities of style and technique which show Rosa moving away from the rugged picturesqueness of the *Diogenes Casting Away His Bowl* [103] and the *Democritus* [104] in the direction of the developing classicism mentioned earlier. It is based on one of Rosa's most ambitious early figure pictures, the large canvas done probably in Florence in the late 1640s and now in Althorp, Northampton [108a]. In the etching the landscape has been greatly reduced in favor of a primary concentration on the figures, and the background tree is a much less important part of the composition than are the trees of the *St. William* [99], *Albert* [100], *Diogenes Casting Away His Bowl*, or the *Democritus*. In those etchings the trees are an integral part of the composition, balancing and reconciling the asymmetrical tensions of the figures, and serving as partners with the figures in both compositional and expressive terms. The tree in the *Diogenes and Alexander* print, although it does act as a kind of exclamation point of sentiment typical of Rosa, picking up and magnifying the force of Diogenes' gesture, nevertheless it serves basically as a backdrop and is much less important to the figural composition, which is carefully organized and balanced in its own right.

The figures of the *Diogenes and Alexander* etching are arranged generally in planes parallel to the picture plane with the two principal figures occupying a clearly defined foreground plane. There is little of the spatial ambiguity and tension seen in the prints of the *St. William* group. The two figures in the center of the composition and the soldiers behind them are arranged in a pyramid-like grouping, the center of which is what might be called the dialogue between Diogenes' violent gesture of rejection and Alexander's assured grasp of the staff of authority. The cluster of figures and the horse and the shield on the left are balanced by the figures on the right and the barrel, with the round shapes of the shield and barrel echoing each other, and the thrust of the tree toward the upper left is matched by the thrust of the lance toward the upper right. Several of the figures are distinctly classical: The soldier in the center background who points to Diogenes calls antique sculpture to mind; the rearing horse derives, as the painting shows, from the famous Quirinale group; and Alexander himself seems to be based ultimately on Raphael's Alcibiades from the *School of Athens* fresco.[75]

The etching style and technique used in this print is particularly interesting in the light of earlier discussions of graphic decorum and, in this case, in the adjustment of style and technique to classicizing ends. The figures of the print, with the exception of Diogenes, are treated with a greater graphic regularity and polish than is seen in any of the earlier large prints. Very precisely regulated systems of crosshatching, parallel lines, and carefully placed dots are used to model and shade these figures, as seen especially in the two most classical types, the Alexander and the pointing soldier. The etched lines themselves seem deliberate in pace and moderate in velocity. These qualities are even found to a degree in the background tree, which is less energetically done than the trees of the *St. William* [99], *Albert* [100], *Democritus* [104], or *Diogenes Casting Away His Bowl* [103].

Diogenes himself is an altogether rougher type on all levels. The dignified graybeard of the Althorp painting has been transformed into an almost savage creature whose jagged, angular posture and violent gesture are in marked contrast to the smooth suppleness of Alexander and the members of his entourage. It

[74] I use the 1625 Padua edition, *La novissima Iconologia di Cesare Ripa Perugino*, pp. 249-52. The text and illustration are repeated exactly in the 1630 Padua edition, pp. 265-68. The illustrator has shown only eight of the ten M's specifically mentioned by Ripa, apparently because of space limitations.

[75] The Alexander is also very like one of the *Figurine* [14].

is clear from the preparatory drawings for the etching in the British Museum and in Leipzig [108b] and [108c] that Rosa's chief concern in revising the painting was with Diogenes' posture and gesture, and it is equally clear that these changes were intended to assert the philosopher's separation from the carefully controlled world of established authority that surrounds him. The result in the etching is a particularly successful visual realization of a symbolic idea, one which is effectively reinforced by the etching style and technique used to create the figure of Diogenes. In comparison with the other figures of the print he is delineated and modeled with rougher, more energetic strokes. His contours tend to be tense and angular and the strokes and hatchings that model his drapery, his arms, and his legs are in many places short, choppy, and done with a nervous, stabbing intensity. A particularly revealing contrast can be seen in the modeling of Diogenes' face in comparison with that of Alexander, of the pointing soldier, or of any of the other figures for that matter.

Rosa's etching *The Academy of Plato* [109] is nowhere mentioned in his letters, but it seems reasonable to think that it was intended to be a companion piece to the *Diogenes and Alexander* print. It is the same size and has figures of a similar scale arranged in a composition that is rather like that of the *Diogenes and Alexander* and has many of its classical qualities. In addition, the subject matter is basically similar, a philosopher engaged in a dialogue with another person in the midst of a group of secondary figures. Moreover, the pairing of the two prints permitted Rosa to achieve a philosophical comprehensiveness which embraces two of the most important strands of antique philosophy and also gave him the opportunity to contrast the coarse vigor of Diogenes and the philosophy he represented with the dignified propriety of Plato's Academy. As has already been discussed, the writings of Diogenes Laertius were probably a major literary source for Rosa's pictorial interpretations of Diogenes, and it may also be that his pairing of Diogenes with Plato was suggested by that writer as well since on a number of occasions Diogenes Laertius relates typically colorful anecdotes about the differences and antagonisms that existed between the two philosophers.[76] Moreover, these anecdotes stress precisely those differences that can be seen in Rosa's prints—Plato as the lofty, dignified idealist; Diogenes as the rough spoken, coarse, iconoclastic rebel.

To judge from the *Academy of Plato* print itself, which in my opinion is the least interesting of Rosa's etchings, it is clear that the subject was suited less well to Rosa's style than was the story of Diogenes. It is interesting as a manifestation of the difficulties the artist often had in reconciling his ambition to be a *peintre-philosophe* with his natural artistic strengths. These difficulties are shown in a number of ways in the etching. The figure grouping has many of the classical qualities seen in the *Diogenes and Alexander*, and the etching style and execution are appropriately regular and controlled and make use of precisely executed hatchings, parallel strokes, and dots. A preparatory study that is almost certainly the final drawing for the print exhibits a similarly high degree of regularity and careful finish [109a].

Although the formal solution of the etching is certainly appropriate to the subject and content of the print, it is also undeniably dull. In addition there is a disturbing disharmony between the classically arranged figures and the setting behind them, which is supposed to represent the philosophers' grove, the garden of Academus, but seems rather to be a savage wilderness. It is a conflict which can be taken as another manifestation of the tension between Rosa's desire to make serious philosophical statements with his art and his more spontaneous drive for vigorous and even violent expression. Although the trees are skillfully and consciously arranged to echo the figures' positions and angles of posture, they are not an integral part of the composition as they were in the *St. William* [99], *Albert* [100], *Diogenes Casting Away His Bowl* [103], and *Democritus* [104]. Nor are they reduced to subsidiary importance as is the case in the *Diogenes and Alexander* [108]. Moreover the trees in all of those prints clearly play expressive roles consonant with and often essential to the overall expression of the print. The opposite is true in the *Plato*. In fact it seems fair to say that the *Plato* represents a high point of tension between Rosa's developing classicism and

[76] Diogenes Laertius, *Lives*, "Diogenes" (Loeb, II, pp. 23-85).

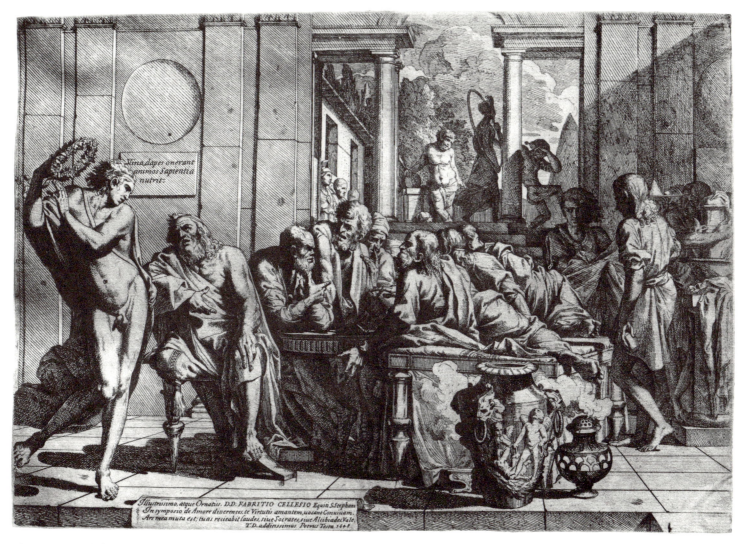

16. Pietro Testa, *The Seven Sages of Greece*, etching.
Rome, Gabinetto Nazionale delle Stampe

the more spontaneous, energetic qualities of his earlier style, and also a turning point within the group of mature prints under discussion here. After the *Plato* the prints of the mature group become increasingly classical in their figural groupings and display a concomitantly reduced, controlled, and classically harmonious setting.

It should be noted, finally, that the *Academy of Plato* shows interesting similarities to one of the most Poussin-like of Pietro Testa's etchings, *The Seven Sages of Greece*, Bartsch 18 (Fig. 16). Not only is Rosa's subject an unusual one, rather like the *Seven Sages*, but the figure of Plato shows striking similarities in pose and facial type to the principal figure in the Testa print, the sage at the extreme left. In addition a comparison of the two etchings tends to confirm the view that Rosa's use of heavy, richly folded drapery owes something to Testa as well.[77] The *Plato* also shows pronounced similarities to Testa's prints in general and in the use of carefully stroked parallel modeling and shading lines running frequently on a diagonal. This approach has already been noted briefly in connection with some of the *Figurine*, a number of the Triton Group prints [91], [93], [95], [97], [98], and the *Glaucus and Scylla* [101] and *Apollo and the Cumaean Sibyl* [102], in which prints it plays a quite limited and not very consistent role.[78] But as Rosa's prints become more classicizing this approach appears more often and is used more consistently, as seen in the *Plato*, the *Diogenes and Alexander*, and most notably in the *Crucifixion of Polycrates* [111] and the *Death of Atilius Regulus* [110], the most classical and also the most Testa-like of all of Rosa's etchings.

[77] See above Ch. II, n. 54. Tomory, no. 18, thinks that the print may have been modeled on the Francesco Furini fresco of the same subject in the Palazzo Pitti, Florence. I find the association too general to be convincing and share Rotili's reservations (p. 90) about it.

[78] See above Ch. II, n. 55, and Ch. III, n. 7.

The Death of Atilius Regulus [110];
The Crucifixion of Polycrates [111]

These two were also intended to be a matched pair, as Rosa's letters, their subject matter, and a number of stylistic considerations indicate. As in the case of his other paired prints, the two etchings are the same size and have figures of a similar scale arranged in similar compositions. Both prints also continue to develop the classicizing tendencies already evident in varying degrees in a number of his earlier etchings, and both are modeled on Italian Renaissance paintings which Rosa must have seen during a visit to Venice about 1650. The *Regulus*, as will be discussed in greater detail below, is based on the Giulio Romano fresco of the same subject in the Palazzo del Te, Mantua (Fig. 17), and the *Polycrates* is modeled, in a more general way, on the great Tintoretto *Crucifixion* in the Scuola di San Rocco. Both prints are easily and harmoniously balanced and have their figures disposed in space in a clear and carefully controlled way. In the *Regulus* the figures are arranged in what is essentially a regular, shallow curve into depth, and in the *Polycrates* they form groups placed basically in planes parallel to the picture plane. Background elements form a harmonious part of these regular spatial constructions, with the ruined wall of the *Regulus* and the rocky cliff in the background of the *Polycrates* placed precisely parallel to the picture plane and the figure groupings.

The *Regulus* and *Polycrates* are also unique among his larger prints in having a horizontal format, an arrangement which occurs elsewhere in his oeuvre only in the early *Male Nude* [1] and the Triton Group prints [91]-[98]. This format is well suited to the frieze-like groupings of figures in both prints; and although it obviously reflects the models Rosa relied on, especially the Tintoretto, it also seems likely that he may have been influenced in this by the etchings of Pietro Testa just as he was, in my opinion, in his extensive use in both prints of the parallel modeling and shading lines discussed on several earlier occasions, especially in connection with the *Plato* [109] and *Diogenes and Alexander* [108] prints. This kind of compositional organization

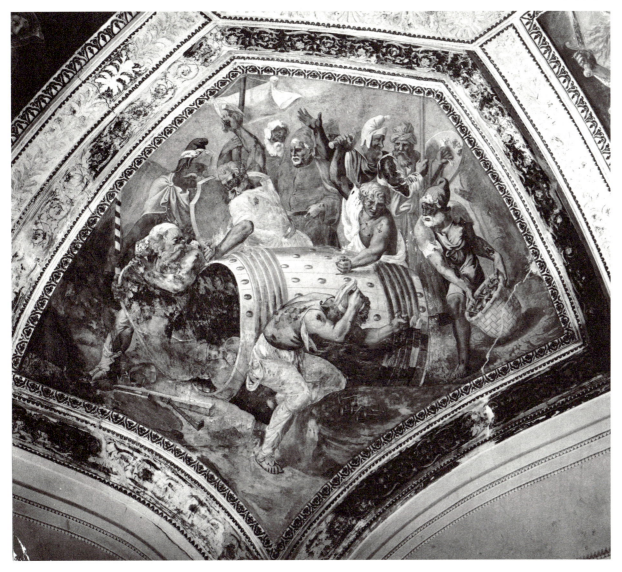

17. Giulio Romano, *Death of Atilius Regulus*, fresco. Mantua, Palazzo del Te
 (photograph courtesy Frick Art Reference Library)

occurs frequently in Testa's prints,[79] producing a classical ordering of forms in space that is much like that seen in both of Rosa's etchings. The *Regulus* etching is, to be sure, based on one of Rosa's largest and most impressive pictures, which was done some ten years earlier and is now in the Virginia Museum of Fine Arts [110a], but it is not at all improbable that Rosa was influenced by Testa's Poussinesque prints in developing the composition of the painting as well. This seems all the more likely in light of the fact that both the painting and the etching have a specific quotation from Poussin's *Martyrdom of St. Erasmus* now in the Vatican Museum in the pointing soldier on horseback in the left background.

The *Regulus* painting, which the etching reproduces almost exactly, is one of Rosa's finest and most ambitious pictures, and his choice of the subject is a resounding statement of his insistence on being known as a painter of large figure pictures involving learned and philosophical subject matter and *cose morali*. In addition the story of Atilius Regulus was especially well suited to the interesting combination in Rosa's temperament of his almost instinctive love of drama with his rather self-concious Stoicism.

The picture and etching show the moment when the heroic Roman consul, Marcus Atilius Regulus, was enclosed in a nail-studded barrel by the Carthaginians. During a forced embassy to the Roman Senate after his capture by Carthage he had refused to plead for negotiations favorable to the enemy, and then had insisted on returning to certain cruel death because he had given the Carthaginians his word to do so. The death of Regulus was thus both a grisly spectacle, whose savage horror had a strong appeal to romantic tastes,[80] and a striking example of courage, honesty, and calm acceptance of misfortune—Stoic qualities to which Rosa referred in the inscription: "*Io. Bapte. Ricciardo Amico Unico / Attilium Regulum in praecipitis Fortunae vertigine tot inter clavos firmioris constantiae centrum.*" (To Giovanni Battista Ricciardi, special friend / Atilius Regulus in the

change of headlong fortune remains a firm center in the midst of so many nails.)

The inscription's reference to changing fortune not only relates to Stoic thinking in general but is also one of many expressions of Rosa's personal preoccupation with this theme. He made a number of pessimistic statements about fickle fortune in his poetry,[81] and devoted two complex allegorical paintings to this subject.[82] In addition, many of his large and ambitious figure pictures and etchings deal with this theme, albeit less directly, in so far as they show men crushed by fortune or somehow coming to terms with fortune, usually through the exercise of virtues admired by the Stoics.[83]

As is often the case with Rosa, the subject was quite an unusual one in the art of the period and may have been suggested to him by one of his learned friends, possibly Giovanni Battista Ricciardi, to whom the etching is dedicated.[84] Regulus' capture and death are described at considerable length in a number of classical sources, ranging from the relatively straightforward historical account of Polybius (*Histories*, 1.25-35) to the eulogistic ode of Horace (3.5), in which the Roman consul is exalted as the embodiment of virtue, loyalty, and self-sacrifice. Sempronius Tuditanus (whose remarks are preserved as a fragment in Aulus Gellius, *Attic Night*, 7.4) describes Regulus' forced embassy in some detail and states that he was killed by being deprived of sleep by his captors. This author introduces a chest full of spikes as an instrument of torture, although in his version Regulus'

[79] Bartsch xx, 20-23, 26, 29, 32-39; Harris, "Testa," figs. 43 (B. 20), 47 (B. 29), and pp. 33-60. See also Rotili, pp. 39-42.

[80] Morgan, I, pp. 248-50.

[81] Cesareo, I, p. 326, *La Babilonia*, vv. 64-66; p. 336, *La Babilonia*, vv. 298-300; p. 268, *La Guerra*, v. 276; p. 205, *La Poesia*, v. 466; and Limentani., 1950, pp. 163-65.

[82] The first version is known today only through an anonymous engraving, an impression of which, in the Gabinetto Nazionale delle Stampe, Rome (Colloc. 40-H-33, Inv. 51728) is published by L. Ozzola, "Pitture di Salvator Rosa sconosciute o inedite," *Bollettino d'Arte*, V, 1925-1926, p. 32, fig. 3. See also Salerno, 1963, p. 151; W. Roworth, "Salvator Rosa's Lost Painting of *Fortuna*," *Burlington Magazine*, cxvii, 1965, pp. 663-64; and Ch. II above, nn. 15, 16.

[83] The most important examples are Rosa's *Cincinnatus* (Salerno, 1963, p. 118, no. 22); and his paintings and etchings of Diogenes (see above p. 55), and Polycrates (see below, p. 76).

[84] The subject is not listed in Pigler.

sons avenged their father's death by confining Carthaginian prisoners in the device. Cicero refers to Regulus as an example of fearlessness, tranquillity, dignity, and honor, and as a man who, because of these qualities, was able to rise above misfortune.[85] It is also Cicero (*In Pisonem*, 43) who first states that Regulus himself was bound to a machine (with his eyelids cut off) and so done to death by lack of sleep. Other sources consistently accept the main outlines of the Regulus story as a well-established legend, and most of them comment on the consul's heroic virtue and brave acceptance of misfortune.[86] Although a variety of ingenious machines of torture are described in these texts, none mentions specifically a barrel lined with spikes as seen in Rosa's painting and etching.

Rosa supplemented this well-established literary tradition by referring to earlier pictorial sources. Most important, the central part of Rosa's composition is clearly based on the Giulio Romano fresco of the same subject in the Palazzo del Te, Mantua (Fig. 17).[87] In addition to their use of spike-lined barrels, the two works show a striking resemblance in composition and specific parallels in the poses of the hammerers, the position of the barrel lid and the figure who holds it, Regulus' position in the barrel, the rocky trough in the foreground, and the waving banner in the background.

It is not inconceivable that Rosa saw the fresco at first hand since he did make a trip to Venice sometime before 1650.[88] However, it seems clear for several reasons that Rosa used the engraving by Diana Scultori (1535-1587) which reproduces the Mantua fresco with a few additions.[89] These additions include civilian spectators who react emotionally to the martyrdom, and architectural ruins flanking the scene, motives which Rosa also used in a general way. More specifically, the figures of the old man leaning on a staff and the young woman behind him at the right side of the Scultori print are repeated, with slight variations in pose and position, on the left side of Rosa's painting and etching. It is also noteworthy that the earlier print bears a moralizing inscription, much as Rosa's etching does: "Et patriae, et fidei dum Regule consulis unus / Non dubitas diris ipse perire modis." (While you alone take thought for your fatherland and your honesty, Regulus, you do not hesitate to die in a horrible manner.)

In addition to his fundamental reliance on a pictorial prototype from the Raphael tradition, Rosa also referred to the art of two other great Roman masters, Michelangelo and Poussin. As mentioned earlier, the pointing horseman in the left background of the painting and etching is modeled on the horseman in the background of Poussin's *Martyrdom of St. Erasmus* now in the Vatican Museum. The man seated on the column fragment in the left foreground gestures in a way that is strongly reminiscent of the Libyan Sibyl on the Sistine Ceiling. The resemblance is even more apparent in a sheet of drawings related to this figure in the Cabinet des Dessins, Musée du Louvre, especially in the position of his legs and choice of seat [110d]. In a particularly ingenious and succinct bit of iconographic invention, Rosa used this figure to refer to the theme of fortune which was so central to his interpretation of the story of Atilius Regulus. This figure,

[85] *De Officiis*, 3.99-111 and 1.39; *De Senectude*, 20.75; *De Finibus*, 2.65; *Tusculan Disputations*, 5.14; *Paradoxa Stoicorum*, 2.16.

[86] Diodorus Siculus, 23.12-16, and 24.12-13; Livy, Summary of Book 18; 28.42.1-2, and 30.30.23; Silius Italicus, *Punica*, 6.240-551; Appian, *Roman History*, 5.2.1, and 8.1.4; Seneca, *Moral Essays*, I, "On Providence," 3.4, and 3.9 (Loeb, I, pp. 17, 21), "On Tranquillity of Mind," 16.4 (Loeb, II, p. 277); Seneca, *Epistulae Morales*, 67.7, 71.17-18, and 98.12; Valerius Maximus, 1.1.14, and 9.2 ext. 1; and Dio Cassius, *Roman History*, 11.20-32, Zonaras 8.12-15.

[87] F. Hartt, *Giulio Romano*, New Haven 1958, II, fig. 286, assigns the execution of this fresco to an assistant, probably Rinaldo Mantovano, from the designs of Giulio. He observes that the frescoes of the Sala d'Attilio Regolo were much restored in the 18th century, but that the paintings are certainly of Giulio's own time (I, pp. 142-43).

[88] There are very brief references to a visit to Venice in Rosa's letters but there is no mention of a stop in Mantua. See Limentani, 1950, p. 61, no. 1, probably January 1650; p. 140, no. 39, dated October 9, 1666; p. 143, no. 40, dated October 23, 1666; and p. 21. See also Salerno, 1963, pp. 42, 94.

[89] Bartsch, XV, 36. Listed under the incorrect name, Diane Ghisi. An impression is in the Gabinetto Nazionale delle Stampe, Rome (Vol. 40-H-17, F.C. 50742) illustrated in Wallace, "Regulus," fig. 16. The present discussion of the *Regulus* painting and etching is based directly on my "Atilius Regulus" article, with some changes and a number of additions.

unstably seated on a precariously balanced column drum, is clearly intended to call to mind the classic formula of Fortune perched on a wheel or sphere, and even resembles in a general way the figure of Fortune in the two paintings by Rosa of this subject. Although these borrowings are revealing in themselves, it is even more significant that they do not remain isolated quotations but are fully integrated into a composition that has much of the gravity and restraint of the Roman classical tradition. Like Poussin, the *peintre philosophe par excellence*, Rosa here chose a subject which lent itself to the expression of stern moral and philosophical ideas, and like Poussin, probably via the etchings of Pietro Testa, he treated it with an appropriately disciplined control of formal means.

But Rosa characteristically chose to exploit the sensational qualities of his subject as well, most markedly in the painting [110a]. In the painting the brutal executioners, whose *bamboccianti*-like coarseness is well suited to the grim task they perform, the strong raking light, striking highlights, and brooding shadows all evoke the savage cruelty of Regulus' martyrdom with great dramatic force and imbue the picture with the somber moodiness characteristic of the best aspects of Rosa's art. The *Death of Atilius Regulus* is thus firmly rooted in the Roman tradition of grand history painting which Rosa admired and at the same time has those "splendid horrors" that were to be so appealing to the Romantics of the succeeding two centuries. However, much of the somber moodiness of the painting was deliberately sacrificed in the etching.

The *Crucifixion of Polycrates* [111] is closely related to the *Death of Regulus* in theme as well as in form, and it bears an inscription of a similar nature, "Polycrates Sami Tyrannus, opibus, et felicitate inclytus, ab Orete Persarum Satrapa captus, ac cruci / affixus docuit, neminem ante obitum merito dici posse felicem. / Salvator Rosa Inv.pinx.scul." (Polycrates, the tyrant of Samos, famous for his wealth and good fortune, when he was captured by Oretes, Satrap of the Persians, and fastened on a cross showed that no one can truly be said to be happy until he is dead.)

Like the *Regulus*, the *Polycrates* is an unusual subject in the art of the time and may also have been suggested to Rosa by Ricciardi or another of his learned friends. It does appear in a number of classical sources however, where the story is told in considerable detail. The most comprehensive account of the life and death of Polycrates is found in Herodotus, who related that Polycrates came to be tyrant of all Samos by killing one of his brothers and banishing another, that ". . . he harried all men alike, making no difference; for, he said, he would get more thanks if he gave a friend back what he had taken than if he had never taken it at all," and that when faced with a revolt he shut the wives and children of his subjects in the arsenal and threatened to burn them if the subjects deserted to the rebels. According to Herodotus' account, the tyrant enjoyed such good fortune that his friend and ally Amasis, King of Egypt, wrote a letter warning him of the jealousy of the gods, saying that a life checkered by prosperity and mishap was better than the unbroken good fortune that Polycrates had enjoyed. As Amasis wrote, "For, from all I have heard I know of no man whom continued good fortune did not bring in the end to evil, and utter destruction." He advised Polycrates to take whatever he regarded as most precious and cast it away so that it would never be seen among men. Seeing that Amasis' advice was good, Polycrates sailed far from Samos and cast his most beloved possession, a precious ring, into the sea. But a few days later a fisherman caught a great fish, Herodotus continues, and brought it as a gift to Polycrates. When the fish was opened Polycrates' ring was found in its belly. The tyrant saw the hand of heaven in this and wrote of it to Amasis, who immediately perceived ". . . that no man could save another from his destiny, and that Polycrates, being so continually fortunate that he even found what he cast away must come to an evil end." Amasis then renounced his friendship with Polycrates so that he would not have to grieve for the loss of a friend.

Polycrates' evil end came when, greedy for gold, he was lured to Magnesia by Oroetes, the Persian Viceroy of Sardis who had conceived a great hatred for him. Oroetes promised him great wealth if he would save him from King Cambyses, who, he claimed, desired his death. Despite the pleas of his diviners and

his daughter, who had foreseen evil for him in a vision, Polycrates sailed to Oroetes in Magnesia where he was betrayed and, Herodotus writes, ". . . foully murdered, making an end which ill beseemed himself and his pride." Oroetes killed him in a way not fit to be told, Herodotus says, and then impaled him.[90]

Very similar, if more condensed accounts are found in both Strabo and Pliny who also stress the theme of fortune at length.[91] Cicero, who exalted Regulus as an example of Stoic virtues, discusses the tragedy of Polycrates in terms of Stoic attitudes toward fortune and misfortune, saying in effect that if he was foolish (that is, without virtue) he was never happy, despite his good fortune, but if he was wise (i.e., virtuous) he was not unhappy even when crucified by Oroetes.[92]

As in the case of the paired *Diogenes and Alexander* [108] and the *Academy of Plato* [109] discussed above, a contrast is here drawn between the two subjects as different manifestations of the same basic idea. Regulus triumphs over death by his steadfast exercise of Stoic virtue. Polycrates, the cruel, greedy, and unscrupulous tyrant of Samos, was so blessed with power, wealth, and success in his lifetime that he was thought of as the most fortunate man in the world until in the end fortune had its revenge and brought him to a barbarously cruel end, an end unsuccoured and unrelieved by virtue. There is even an ironic contrast, in Rosa's prints, between Regulus' being brought down by headlong fortune only to rise above it, and Polycrates' being raised aloft by fortune, but in death. As with the story of Regulus, the Polycrates subject offered Rosa the double attraction of savage drama and philosophical exegesis. In addition the artist added a further note of gloomy pessimism to the already macabre story of Polycrates by interweaving another of his favorite themes, that of *vanitas*, with the theme of fortune, saying in the inscription

that the crucifixion shows that "no one can truly be called happy until he is dead." It is a statement that calls to mind the "Postmortem summa voluptas" of Rosa's *Portrait of Mr. Altham as a Hermit*.[93]

As Rosa's letters indicate (see the catalogue entry) the *Polycrates* etching was done before the two paintings now in the Art Institute, Chicago, which show the return of the ring and the crucifixion [111a]. The *Regulus* painting precedes the etching by some ten years and was in the Colonna collection in Rome and presumably accessible to Rosa at the time he was working on the etching, although, as has already been discussed above, the drawing for the print and possibly even portions of the etching were done when he was away from Rome, visiting Ricciardi at Strozzavolpe during the summer of 1661. It seems very probable, therefore, that he had some kind of *ricordo* of the *Regulus* painting to work from.

Although no such *ricordo* has survived, the drawing for the *Regulus* print, and the drawing for the *Polycrates* etching mentioned specifically in his letter of March 11, 1662, are still preserved in the Uffizi [110b], [111b]. It is an indication of the extreme care with which he approached the creation of the two prints that these cartoons, together with those for the *Genius of Rosa* [113], [113a], and the *Alexander in the Studio of Apelles* [114], [114a], are the most complete, detailed, and meticulously finished of all the known preparatory drawings for the etchings. In this they develop much further the qualities already seen to some degree in the preparatory drawing for the *Plato* [109], [109a]. Both drawings were originally done in black chalk heightened with white, but the *Regulus* drawing has been gone over with pen and brown ink by what I think must be a later, less skillful hand. Both drawings have careful corrections made by covering over unwanted passages with white chalk, and in some places making changes over the cancellations. They are both rubbed on the verso with red chalk and are scored for transfer. In almost every detail they are identical with their etchings; even the background settings of the etchings are quite fully developed

[90] Herodotus, 3.39-45, 120-126. In the Loeb Classical Library edition by A. D. Godley, London, Cambridge, Mass., 1938, II, pp. 53-59, 149-55. Rotili, p. 101, fig. 25, notes the interesting association between Rosa's print and a drawing by Ribera showing Polycrates fastened to a tree.

[91] Strabo, *Geography*, 14.1.16; Pliny, *Natural History*, 37.2. See also Valerius Maximus, 6.9.5.

[92] Cicero, *De Finibus*, 5.30.

[93] Salerno, 1963, p. 123, no. 38; Wallace, "Democritus," p. 22, fig. 3.

in the drawings, with the details of landscape, foliage, clouds, and architecture much more precisely rendered than in any of the other preparatory drawings for the etchings including the stylistically very similar studies for the *Genius of Rosa*, [113], [113a], and *Alexander in the Studio of Apelles*, [114], [114a]. It is noteworthy that they were both originally done in black chalk heightened with white, a very unusual medium for Rosa, who almost always worked with pen and wash, even in doing the preparatory drawings for the *Figurine* and the Triton Group prints. He obviously was determined to work out every aspect of the etchings in the drawings, using a medium that permitted great detail, careful finish, very precise adjustments of modeling and shading, and easy corrections. Moreover the medium is by its very nature better suited than pen and wash to the kind of restrained, carefully controlled qualities that Rosa was clearly after in the prints.

This control is evident to the same degree in the execution of both prints. The etching needle was moved with great deliberation, there are almost none of the energetic strokes or irregular crosshatchings seen especially in the *Albert* [100] and *Diogenes Casting Away His Bowl* [103], and to a lesser degree in the *St. William* [99], *Apollo and the Cumaean Sibyl* [102], *Democritus* [104], and *Diogenes and Alexander* [108]. Instead, he relied extensively on the Testa-like method already discussed of using very deliberately stroked lines placed parallel to each other. These can be seen throughout the *Regulus* and *Polycrates* prints, both in the figures and the settings. Nowhere else in Rosa's etched oeuvre, including the prints that follow the *Regulus* and *Polycrates* in date, is this approach so consistently and systematically applied, and nowhere else is the regulation of modeling strokes so strict. As a result the figure groupings of the two prints are remarkably even and uniform in what might be called their graphic weave. Not only do most of the modeling and shading lines run parallel but the distance between these etched lines is basically quite constant, so that white-black relationships within modeled and shaded areas are usually very similar. In addition the graphic weave of the figure groups has a definite horizontal bias—most of the modeling and shading lines tend to run generally across the print, reenforcing the frieze-like character of the composition. The systems of parallel lines are used in a careful and controlled way to organize groups of figures within each print; they are also carefully integrated with the figural composition of the print as a whole.

It is worth noting that despite the careful control and regularity of execution of the *Polycrates* and *Regulus*, they are not very different in basic tonal range from the rougher and more dramatic of Rosa's larger prints, such as the *Diogenes Casting Away His Bowl* [103] or the *Democritus* [104]. In fact the *Regulus* print reflects the same kinds of problems that Rosa had in translating the *Democritus* painting [104a] into etching. Like the *Democritus* print the *Regulus* etching is an almost exact repetition of an earlier painting with the lighting changed. But it is the lighting—the strong raking light, forceful highlights, and somber shadows, which give the picture much of its expressive force, its sense of romantic disquiet, urgency, and horror. In my opinion it is a serious loss, just as it was in the case of the *Democritus*. But unlike the *Democritus*, where the sheer limitations of Rosa's etching style and technique afford an explanation of the differences between the painting and the etching, the changes in the *Regulus* seem to have been deliberate on Rosa's part. Even though he could not, given his etching style and technique, have captured the very rich tonal range of the painting, he could certainly have handled the needle in a rougher, more energetic, and more varied way to capture some of the savage power of the *Regulus* painting just as he did in the *Diogenes Casting Away His Bowl* or the *Democritus* etchings. Furthermore, he consciously refined and idealized the figures of the painting in transforming them into etching. Anatomy and drapery are more polished and abstract, and above all the coarse *bamboccianti*-like faces of many of the figures of the painting have been replaced with more regular, idealized facial types. It seems very probable that these changes were made to achieve what Rosa must have considered a loftier, nobler statement both pictorially and philosophically. He may even have decided deliberately to reduce that aspect of the story that attracted him so strongly when he first did the picture, that is, the horror of the grisly torture and martyrdom

of Regulus, in order to stress more clearly the philosophical implications of the Stoic hero's death.

Since the *Polycrates* etching was done as a companion piece to the *Regulus* it would of necessity have to be done using a similar style and technique. But it also seems reasonable to think that Rosa also intended the etching to stress the philosophical implications rather than the sheer horror of Polycrates' death, and for that reason disciplined his style and technique into an appropriately decorous etched solution. It is interesting that in the painting of the *Crucifixion of Polycrates* [111a], done after the etching, he reverted to a less classicizing, more dramatic style like that of the *Regulus* painting. It is a stylistic shift which has interesting parallels in his late etchings, the *Fall of the Giants* [115], the *Rescue of the Infant Oedipus* [116], and especially the *Dream of Aeneas* [117] and the *Jason* [118].

Ceres and Phytalus [112]

This etching is unusual among the five prints mentioned in Rosa's letter of March 11, 1662, in being considerably smaller than the other four (it is the same size as the earlier *St. William, Albert, Glaucus and Scylla,* and *Apollo and Sibyl*) and in not having a companion piece. It also differs from them in not being a serious or philosophical statement, but instead is a lighthearted, personal tribute to the fig, a fruit of which Rosa was particularly fond.[94] The subject is an extremely rare one. I have found no other example of it in art, and as far as I know it appears in classical literature only in Pausanias. In his description of Athens, he mentions briefly the legend that Phytalus welcomed Ceres into his home and in gratitude the goddess gave him the fig tree.[95] There is no doubt that this was the literary source for Rosa's etching since the print's inscription is a direct translation of the inscription on the grave of Phytalus as quoted by the Greek writer.

Despite its more informal nature, the print does share many

[94] Even Baldinucci commented on it. See Salerno, 1963, p. 128, no. 60.
[95] Pausanias, *Description of Greece,* 1.37.2. Tomory, no. 20, also makes this observation.

of the basic classicizing qualities seen in the *Diogenes and Alexander* [108], *Plato* [109], *Polycrates* [111], and *Regulus* [110], in its balanced composition and frieze-like arrangement of figures in space. The figures themselves also have a polished amplitude of form, ease of movement, and fluency of compositional relationship that make them very like the figures in those prints and quite unlike the stiffer and generally more slender figures of the earlier *St. William* [99], *Albert* [100], *Glaucus and Scylla* [101], and *Apollo and the Cumaean Sibyl* [102]. A good illustration of these differences can be seen in a comparison of the *Ceres* with the compositionally similar *Apollo and the Cumaean Sibyl,* especially in the female figures. The *Ceres* is done with an analogously controlled and polished technique, etched strokes and hatchings are regular and orderly, and subtle dotting is used to model Ceres' legs, arms, and especially face and neck. Somewhat freer but still quite regular drypoint strokes and hatchings are used to shade the background, which is typical of much of Rosa's art in its use of picturesquely broken and jagged trees. It is interesting, however, that these trees are in effect compressed and flattened out across the background into an essentially planar foil for the planar figure grouping. This effect is reinforced by the extensive use of parallel etched shading lines in the areas of the background supplemented by drypoint. Together they give the background an even gray tonality against which the more brightly lighted figures are foiled much as in a high relief sculpture. The approach is fundamentally closer to that already discussed in the *Regulus* and *Polycrates* prints than it is to the treatment of backgrounds in the *St. William, Albert,* or even *Plato,* with their superficially more similar reliance on picturesquely broken, jagged trees.

The Genius of Salvator Rosa [113]; Alexander in the Studio of Apelles [114]

These two etchings are not mentioned in any of Rosa's letters, but because they have so much in common with the *Diogenes and Alexander* [108], *Plato* [109], *Polycrates* [111], *Regulus* [110], and *Ceres and Phylatus* [112], and differ so markedly from the

somewhat later *Rescue of the Infant Oedipus* [116] and *Fall of the Giants* [115], it seems very likely that they were done at about the same time as the earlier five.[96] Like them the *Genius* and *Alexander in the Studio of Apelles* prints exhibit definite classicizing tendencies; their compositions are easily and harmoniously balanced, albeit less strictly than in the *Plato* or *Ceres and Phylatus*, and their figures tend to be grouped in planes parallel to the picture plane, modified however by a freer play of diagonals than is seen in the *Plato, Ceres, Polycrates,* or *Regulus.* Moreover, Rosa made a number of references in both prints to the art of the classical tradition, references which are so overt that he clearly meant them to be recognized as such and thereby to contribute to the etchings' classicism both of form, and as will be shown later, of content. The most obvious is the quotation in the *Genius* etching of the kneeling figure from the foreground of the Raphael-Giulio Romano *Transfiguration* as the kneeling figure of *Pittura* in the left foreground of the print. The genius figure is a paraphrase of an antique river god, and the standing Stoic philosopher in the left background is modeled on the Roman *togatus* sculpture type. In the *Apelles* etching Alexander's pose is reminiscent of that seen in a number of ancient reliefs and coins,[97] and Apelles is strikingly like the pointing woman with her finger to her lips in the background of Poussin's *Exposure of Moses* now in the Ashmolean Museum, Oxford, a figure which seems to derive in general terms from the classical Harpocrates type.[98] In addition to these specific classical references all of the figures have a solid, sculptural amplitude of form, an easy equilibrum, and a fluency of interrelationship which makes them very similar in basic feeling to the figures of his other classicizing prints, the *Plato, Diogenes and Alexander,* and especially the *Ceres, Regulus,* and *Polycrates.* In both the *Genius* and *Apelles* the settings are carefully controlled and brought into harmony, both visually and expressively, with the figure groupings, and in the case of the *Genius* with the print's iconographical program.

Both etchings were also done from cartoons [113a], [114a], which are almost identical in style with those for the *Polycrates* and *Regulus* [111b], [110b]. Like them the *Genius* and *Apelles* cartoons are done in carefully managed black chalk heightened with white, have similar cancellations and corrections, and are rubbed on the *verso* with red chalk and scored for transfer to the plate. The only differences between the cartoons and the prints are found in a few details of the setting in the *Apelles,* and in the landscape, sky, and tomb of the *Genius.* The changes in the latter Rosa made directly on the plate, relying to some extent on an earlier preparatory drawing now in the Louvre [113b].

The prints themselves are, however, somewhat freer and more varied in execution than the *Regulus* or *Polycrates,* just as they are more *detente* in composition, placement of forms in space, and use of diagonals in depth. They are nevertheless among the most polished of his performances in etching and are done with lines that are in general distinctly finer than those of any of his other large prints. The *Genius* etching especially shows a particularly refined handling of fine lines, delicate crosshatchings, carefully adjusted parallel strokes, and subtly modulated dottings to produce fluently modeled forms. It is especially evident in the crosshatchings and dots which model the upper torso of the female satyr and in the extensive, carefully adjusted dottings which give the genius figure its smooth sculptural roundness. Since Rosa modeled this print directly on Castiglione's *Genius* etching

[96] It should be noted, however, that in a letter of October 21, 1663 (De Rinaldis, p. 157, no. 124), written after the *Giants* and *Oedipus* were completed, Rosa apparently asked Ricciardi for several dedicatory inscriptions, "...le dedicatorie, o latine o volgari ci devono importar poco, con tutto ciò procurero di sodisfarvi." There is no way of ascertaining the purpose of the dedications, but it is possible that they were meant to be used with the *Genius* and *Apelles* prints. If so, it would obviously mean that the latter two were done after the *Giants* and *Oedipus.* I think that the evidence is too meager to support a solid argument either way.

[97] D. E. Strong, *Roman Imperial Sculpture,* London 1961, pl. 78, 80, 94, 111; H. Mattingly, *Roman Coins,* London 1960, 2nd. ed., pl. xliii, 13; xlv, 7, 10.

[98] Done in 1654, see A. Blunt, *The Paintings of Nicolas Poussin,* London

1966, p. 12, no. 11. For Harpocrates, see S. Donadoni, G. A. Monsuelli, "Arpocrate," *Enciclopedia dell'Arte Antica,* Rome, 1958, i, pp. 671-72.

(Fig. 18),[99] it may be that Castiglione's suave and polished use of dottings to model his genius figure encouraged Rosa in this approach as well, although, to be sure, it was a technique familiar to him and one that he used extensively in the *Figurine*.

Rather similar qualities of style and technique can be seen in the *Apelles* print, producing an effect that is comparably polished and harmonious, although in a few limited areas, such as the sleeve of the boy at the extreme left, the trailing drapery beneath Alexander, and passages of Apelles' drapery, the needle was moved more freely and abruptly. A particularly interesting departure from the etching style and technique used in the large prints done before this etching is seen in Apelles' painting, which is executed with light, sketchy broken lines to suggest distance and atmospheric blurring and dissolution of forms. It is an approach strongly reminiscent of that seen in the Triton Group and, as in those etchings, achieves its varied effects within the limitations of single stage biting. Although this technique plays a special role in the *Apelles*, which has no equivalent in any of the earlier large etchings, it clearly shows that Rosa could have achieved a much greater variety of graphic and tonal effects in these prints if he had chosen to do so. Instead he deliberately ignored these possibilities with the result, already discussed, that the etchings are often disappointingly uniform in graphic handling and in their effects of light and shade despite their great variety of subject matter, content, and expression. It is particularly incongruous that the *Genius* etching when seen in good, fresh impressions, actually shows greater contrasts of light and dark than does the *Democritus*.

18. Giovanni Benedetto Castiglione, *Genius of Castiglione*, etching. Rome, Gabinetto Nazionale delle Stampe

[99] Bartsch 23. The print is dated 1648 at the bottom center. Blunt, p. 12, notes that the date is an addition but supports 1648 as the most likely date on stylistic grounds. He also points out that Rosa's *Genius* etching is "close in idea" to Castiglione's and shows strong reminiscences of that artist (p. 13). See also Percy, cat. no. E 16; and Wallace, "Genius," p. 475. Many of the present observations about the *Genius of Rosa* etching are based directly on my article. Rotili, pp. 96-98, repeats the iconographical analysis of my article almost exactly. Tomory, no. 29, apparently accepts most of my conclusions but sees the satyr as being a *genius loci*, using an argument that I find very difficult to follow.

In addition to their formal similarities, the *Apelles* and *Genius* prints match in iconographical significance as well. Together they can be taken as programmatic statements of Rosa's personal and highly original views about art, the artistic personality, creative genius, and patronage. The *Genius of Rosa* is by far the more symbolically and philosophically complex of the two, and iconographically it is in fact one of his most ambitious and sophisticated works. In it he anticipates attitudes toward creative genius that are usually thought to have first arisen in the Romantic period of the 18th and 19th centuries.

As has already been mentioned in connection with Rosa's "banditti" *Figurine*, the artist had a wide and enthusiastic following among the Romantics, who associated his fieriness and extravagance with ideas of sublime and inspired genius. This is found in a number of the most important writers of the Romantic period as, for example, Uvedale Price, who in his *A Dialogue on the Distinct Characters of the Picturesque and Beautiful* has his dilettante protagonist, Mr. Howard, say, "Let me show you . . . this landscape, with banditti, by Salvator Rosa, a painter of a wild original genius, and of whom I am a most enthusiastic admirer." Elsewhere Price speaks of "the savage grandeur of that sublime though eccentric genius," and in his classic *Essays on the Picturesque as Compared with the Sublime and Beautiful* says, "Mola . . . is as remarkable for many of those . . . qualities which distinguish S. Rosa, though he has not the boldness and animation of that original genius. . . . Salvator has a savage grandeur often in the highest degree sublime."[100]

This conception of Rosa's genius was echoed by Horace Walpole, who observed, "The greatest Genius Naples ever produc'd resided generally at Rome; a Genius equal to any that City itself ever bore. This was the great Salvator Rosa. His Thoughts, his Expression, his Landscapes, his Knowledge of the Force of Shade,

and his masterly Management of Horror and Distress, have plac'd him in the first Class of Painters."[101]

But the most emphatic statement of the Romantic attitude toward the genius of Salvator Rosa is found in Lady Morgan's study of 1824, *The Life and Times of Salvator Rosa*, a mixture of Romantic hero worship and sound information, naiveté and shrewd insight.[102] In the preface she states, "I have been the first (my only merit) to light a taper at the long-neglected shrine, and to raise the veil of calumny from the splendid image of slandered genius. . . ." She associates Rosa's gift with Byron's and states that Rosa's giant genius, "beyond all sordid control," looked down on his detractors as pygmies. For her he was ". . . one who, in his flashing eye, mobile brow and rapid movement—all fire, feeling and perception—was the very personification of genius itself."[103]

In general, Rosa's Romantic admirers chose one aspect of the traditional meaning of genius, that of the person especially gifted or inspired, and in applying it to Rosa made him the subject of a genius cult. They saw in his paintings the work of a wild, free spirit of extravagant inventiveness and unique originality. Correspondingly, they were beguiled by the myth of Rosa's adventurous personal life, and found in his dashing career a precociously romantic contempt for convention and sense of superiority to the world of ordinary men. One receives the impression that many of these admirers were enthusiastic about Rosa not so much because he was a painter of genius (they were capable of keen appreciation for copies, forgeries, and lackluster prints after his works) but rather because he was for them the genius of savage sublimity and Romantic inspiration.[104]

[100] See Price, III, pp. 308-9 of *A Dialogue* . . . , which was first published in 1801; II, p. 202, from *An Essay on Architecture and Buildings as Connected with Scenery*; I, pp. 66-67 of *Essays* . . . , which was first published in 1794, respectively.

[101] H. Walpole, *Aedes Walpolianae: Or, a Description of the Collection of Pictures at Houghton Hall in Norfolk*, London 1747, p. xxvii of the introduction. The passage is also cited by Salerno, 1963, p. 78, who gives *Anecdotes of Painting in England* as the source.

[102] For a brief discussion and critical evaluation of this work see Cesareo, I, pp. 3-4; and Salerno, 1963, pp. 15-16, 81.

[103] Morgan, I, p. xiv; II, p. 117; I, pp. 248-49; and II, p. 84, respectively.

[104] Rosa's extraordinary popularity with the Romantics of later ages is discussed in Ch. VII below.

Despite the exaggeration and lack of balance of this view of Rosa, it does recognize that one of the most important aspects of his artistic personality was his conviction that as an artist he was different from and superior to other men and could consequently insist on complete freedom to create as his own exceptional spirit moved him, a remarkable point of view for the period.

The most revealing manifestation of this attitude is seen in his revolutionary attitude toward patronage, already discussed at length, and in such of his *pronunciamenti* on the subject as his letter to Don Antonio Ruffo, already cited, which Haskell calls, "an astonishingly early claim of the painter's complete dependence on inspiration," and in which Rosa proudly told Ruffo that although he had promised to serve his excellency, it was necessary for him to bear with Rosa since, as he said, "I do not paint to enrich myself but purely for my own satisfaction. I must allow myself to be carried away by the transports of enthusiasm and use my brushes only when I feel myself rapt."[105] Or in another letter to Ricciardi, his learned advisor on literary, philosophical, and historical questions, Rosa reproved his friend for straying out of his proper literary sphere and meddling in aspects of the artist's work which Rosa felt should have been left to him—the creator.

To painters of my condition and extravagant genius, it is necessary to leave everything after the measurements free (so I would have done in a similar incident with you), and to content oneself with not wanting to tell fathers how to make sons, and, as I have said above, to back up the genius of whoever has to work, and to believe that every little thing by a classic painter should be prized and praised by whoever really understands it. And I remind you that a single verse by Homer is worth more than an entire poem by a Cherilo.[106]

In addition, as Salerno has observed,[107] there seems to have been an association in Rosa's mind between the intuitive and irrational qualities of creative genius and the mysteries of magic and divination, a reflection of which occurs in Rosa's satire *Invidia*: "If you look at the books of Vasari you will see that of the painters, the best ones are famous for their poetry. And not only were these painters poets, but also great philosophers, and were demons in seeking out the great secrets of nature."[108]

Another echo of this interest in the secret, mysterious, and irrational is perhaps to be found in Rosa's taste for extravagant subject matter as well as for subjects previously ignored by painters.[109] His desire for finding such subjects is made quite explicit in a letter to Ricciardi: "I immediately read Philostratus' life of Apollonius . . . but I did not find there the singular and extravagant material for painting that you indicated I would, these being facts that almost anyone would give in a similar case. Therefore I beg you to suggest something else so that I could find things more out of the ordinary. . . ."[110] In still another

[105] Haskell, p. 22 (whose English translation I use); and Ruffo, p. 180. See also above Ch. II, nn. 9-11; and Salerno, 1963, pp. 24-26, "Il rifiuto del mecenate."

[106] De Rinaldis, p. 165, no. 131, dated June 21, 1664, quoted in part by Salerno, 1963, pp. 24-25. "Ai pittori della mia condizione e genio stravagante, è forza dalla misura in poi lasciare il resto in libertà (così haverei fatto io in un accidente simile con voi), e contentarsi di non volere insegnare a i babbi a far figlioli, e, come ho detto di sopra, asecondare il genio di chi ha d'operare, e credere ch'ogni poca cosa di pittore classico, è per ricevere e pregio e lode da chi veramente intende. E vi ricordo che val più un solo verso d'Homero, che un intero Poema d'un Cherilo." Cherilo of Samos was a 5th-century epic poet and the author of a once famous poem about the triumph of Athens over the Persians.

[107] See Salerno, 1963, pp. 39-42, and 1970, pp. 43-53, for discussions of Rosa's treatment of magic and witchcraft in his paintings and poetry.

[108] Cesareo, I, p. 309, vv. 652-57: "S'i libri del Vasari osservi, e note,/ Vedrai che de' Pittori i più discreti/ Son per la Poesia celebri, e noti./ E non solo i Pittori eran Poeti/ Ma filosofi grandi, e fur demonij/ Nel cercar di Natura i gran segreti."

[109] Limentani (1953, p. 48, and 1961, pp. 173-74) notes Rosa's concern to seek out and use obscure subject matter.

[110] Cesareo, II, p. 119, no. 113, dated September 16, 1662: "Lessi subito la vita d'Apollonio composta da Filostrato . . . ma non ci ho trovato quello, ch'ella mi significò, che ci averia trovato di singolare, e stravagante per la pittura, essendo fatti, che quasi tutti darebbono in una cosa medesima, onde vi prego a propormi qualch'altra cosa, acciò vi potessi trovar cose più fuori dell'ordinario. . . ."

letter to Ricciardi he wrote, "I have finished the two pictures I was working on, the subjects of which are completely new, never touched by anyone."[111]

Although these reflections of Rosa's creative spirit lend strong support to the Romantic view that Rosa thought of himself as an inspired, extravagant genius, his concept of his own genius, as expressed in the *Genius* etching is the result of a far more complex personal philosophy. The *Genius* etching does, to be sure, make the clearest statement found anywhere in his art or writings of his belief in the inspired, impulsive, and irrational qualities of his own genius. And although at first glance it seems odd that he would couch such a proclamation in a work of art that is one of the least impulsive and spontaneous he ever did, the print's iconography makes it clear that he saw his genius as having other facets as well, facets which he chose to express in a pedantically didactic, symbolic way, using a formal solution that is equally didactic in its straightforward and easily read grouping of personifications and symbols.

Above all the *Genius* etching is an expression of what Rosa considered to be the principal aspect of his art, the learned, philosophical treatment of "cose morali."[112] This can be seen in the complex philosophical *pronunciamento* of the etching's inscription: *Ingenuus, Liber, Pictor Succensor, et Aequus, / Spretor Opum, Mortisque. hic meus est Genius. / Salvator Rosa.* (Sincere, free, fiery painter, and equable, / despiser of wealth and death, this is my genius. / Salvator Rosa.)[113] It is a formal, all-embracing statement of Rosa's personal and artistic philosophies and a typically ostentatious proclamation of his belief in the principles of liberty, honesty, and equability, and indifference to wealth and death, all of which have their roots in Stoic and Cynic thinking.

The figures in the etching and their attributes illustrate the inscription almost word for word. Genius is represented by Rosa as a handsome youth crowned with ivy, his left hand resting on a cornucopia out of which spill coins and jewels, his right hand offering his heart to a woman holding a dove. This personification of genius conforms in most details to the traditional representations of such a figure as it had been defined by Ripa, Gyraldo, Cartari, and Conti from the evidence of antique coins and reliefs.[114] But in showing the figure half reclining in a posture reminiscent of a river god rather than standing in the traditional pose, Rosa relied on Castiglione's *Genius* of 1648 (Fig. 18) already mentioned, which includes a very similar figure and which, bearing as it does the inscription: *Genium Io: Benediciti Castilionis Ianven—Inv. Fe.* (Genius of Giovanni Benedetto Castiglione Genovese—Inv. Fe.), must be considered the direct model for the

[111] *Ibid.*, II, p. 118, no. 112, and also De Rinaldis, p. 141, no. 107, dated July 29, 1662: "Ho concluso i due quadri che stavo lavorando, i soggetti de' quali sono del tutto e per tutto, nuovi, nè tocchi mai da nessuno." It is noteworthy that one of the pictures was the *Pythagoras Emerging from the Underworld*, now in the Kimbell Art Museum, Fort Worth, Texas (Langdon, "Rosa: Paintings," no. 36).

[112] Rosa's ambition to be considered a learned painter of histories and allegories is one of the most conspicuous aspects of his artistic personality. As Baldinucci (1773, p. 85) put it: "...non si vegga fra l'infinite opere sue, o siano in verso, o siano in pittura, stetti per dire, cosa, che non abbia in se invenzione o componimento, che qualche bella moralità non esprima, o che alcuni di quei tanto rinomati uomini in loro più memorabili azioni al vivo non rappresenti." See also the same source, pp. 60-62, 70 and 73; Passeri, pp. 391-92, 396; De Dominici, III, p. 484; Ozzola, p. 81; Limentani, 1961, pp. 171-74; Salerno, 1963, pp. 27-30, 42-46; De Rinaldis, pp. 191-92, no. 156; and Haskell, p. 142. In his satire *La Pittura* Rosa wrote: "Bisogna che i Pittor siano eruditi,/ Ne le scienze introdotte, e sappian bene/ Le Favole, l'Istorie, i Tempi, i Riti." (Cesareo, I, p. 230, vv. 175-77.)

[113] Although Rosa's use of *Pictor Succensor* is somewhat puzzling grammatically, it will be shown that "fiery painter" is a reasonable translation.

[114] Ripa, 1613, pt. 1, pp. 287-90; Lilio Gregorio Gyraldo, *De deis gentium libri sive syntagmata XVII*, Lyons 1565, pp. 369-72; Vicenzo Cartari, *Imagini degli dei delli antichi*, Padua, 1626, pp. 367-71, and pp. 516-20 of the "Annotationi di Lorenzo Pignoria"; Natalis Comitis *Mythologiae*, Padua, 1616, pp. 153-55. One of the commonest ways of portraying genius in these texts is as a youth, often wearing a crown of poppies, plane tree leaves, or other flowers, and usually holding a cornucopia and often a patera, as seen in the illustration found in both Conti and Cartari. Ripa, 1613, pt. 1, pp. 289-90, states that the genius may hold other attributes when suitable, such as books for literary genius, and also mentions the use of a wide range of accessories, crowns, and costumes as required by the particular genius involved.

Genius of Rosa. In addition, it seems very likely that Rosa intended both the frontispiece figure for the *Figurine* and the genius figure to be in the nature of idealized allegorical self-portraits.

The setting of the figure group is unusual and is in fact meant to refer to the inscription's *Spretor . . . Mortisque*. In true Stoic-Cynic fashion the genius ignores the disturbing symbols of mortality that fill the background: the tomb set in a grove of cypress trees and wreathed with smoke issuing from a large *stamnos* decorated with a goat's skull and a garland. The funerary significance of cypress was clear to Rosa, who used it in this sense to wreath his own head in the *Self-portrait with a Skull*, as well as in other works.[115] He also used this symbolism in the satire *La Guerra*: "It was you, ambition, who designed the towers, the moats, the walls, and the arsenals, and impiously grafted the olives to the cypresses."[116] The significance of the tomb is clear enough, and is also found in the *Democritus* [104], [104a]. The smoking *stamnos* with its garland and goat's skull, although not archaeologically correct, is an effective pictorial prop and seems to have been associated in Rosa's mind with ideas of death and mortality.[117] Both tomb and urn are reminiscent of the strange

and vaguely sepulchral implements and shapes found in the etchings of Castiglione.[118]

In addition to despising death, the genius expresses an analogous Stoic-Cynic contempt for wealth. He rests his left hand negligently on an overturned cornucopia, spurning, in accordance with the incription, the symbol of "la soprabbondante ricchezza del Mondo."[119] Unlike the usual genius figure who holds the cornucopia mouth side up, carefully preserving its contents, the horn of Rosa's genius is overturned and its treasures are heedlessly spilled out and neglected much as the cornucopia in Rosa's pictorial satire, *Fortune*, is overturned and spills its riches before brute beasts with a like prodigality.[120]

The fish, placed rather incongruously next to the genius, also is intended to refer to the artist's contempt for wealth and death.

[115] Cypress crowns appear on the heads of the herms in both the *Democritus* painting and etching and also in the *L'Umana Fragilità* in the Fitzwilliam Museum, Cambridge. See Salerno, 1963, p. 110, no. XIII, and pp. 110-11, no. XV; Wallace, "Democritus"; and Langdon, "Rosa: Paintings," no. 27. The pomegranate tree behind the *stamnos* was also probably intended by Rosa to refer to ideas of death and mortality through its association with the Persephone legend (see G. E. Mylonas, *Eleusis and the Eleusinian Mysteries*, Princeton 1961, pp. 3-6). Oddly enough, the pomegranate is not given this significance by either Ripa or Valeriano although they both discuss it as a symbol of other things, especially *Concordia*, at considerable length.

[116] Cesareo, I, p. 266, vv. 229-231: "Ambizion fusti tu, che disegnasti/ Le Torri, i Fossi, i Muri, e gl'Arsenali,/ E gl'Ulivi à i Cipressi empia innestasti." The trees are identified as cypresses without comment on their meaning by Morgan, II, p. 99, and Ozzola, p. 196. Tomory, no. 29, incorrectly calls them poplars. The funerary significance of cypress is discussed in Gyraldo, *De deis gentium*, p. 168, Valeriano, pp. 379v-380v, who gives it first place in Book LII, *De funestis arboribus, et coronis aliquot...* and Alciati, pp. 694-95, Emblema CXCVIII.

[117] Oertel, p. 106, points out that the motif of a skull and garland on

an urn in a still life attributed to Rosa in the Ältere Pinakothek, Munich, although taken over from the antique, was not used by the artist as a symbol of sacrifice but rather of mortality. See also W. Altmann, *Die römischen Grabaltare der Kaiserzeit*, Berlin 1905, especially pp. 59-87, for a discussion of ancient Roman usage of the skull and garland motive.

[118] This can be seen especially in Bartsch XXI, 16, 6, 26, and 24.

[119] Ripa, 1613, pt. 1, p. 289. The overturned cornucopia and the genius' negligent gesture are interpreted as a rejection of wealth by Morgan, II, p. 99, and Petrucci, 1934-1935, p. 29.

[120] Salerno, 1963, pp. 122-23, no. 36; and Haskell, pp. 153-54. A similar use of this conceit can be found in the satire *Babilonia*: "Come soffrite di veder . . . à vista del ben languir digiune/ L'Anime grandi: e in man de' Parasiti/ La Copia rovesciar de le fortune?" (Cesareo, I, p. 326, vv. 61, 64-66.) Rosa's most bitter attack on wealth occurs in the ode *Delle ricchezze* which says in part: "L'oro, origin primiera/ D'ogni discordia e rissa,/ L'oro, che rubba a i Dei/ L'onor, la riverenza,/ Gli attributi, le preci,/ L'or, che con strania forza/ Premer può i giusti et esaltare i rei." (Ozzola, pp. 227-28.) See also Limentani, 1961, p. 217. Rather like his Stoic model Seneca, Rosa voiced this pugnacious contempt for wealth from a comfortable material position. Despite the fieriness of his poetic attack, his actual behavior seems to have been unselfconsciously consistent with the Cynics' and Stoics' view that wealth is a matter of indifference. He seems, in fact, to have been rather uninterested in wealth as such, was by no means grasping or ambitious as regards money, and was apparently generous to a fault. See Baldinucci, pp. 85-86, 89-90; De Rinaldis, pp. 161-62, no. 128, dated January 2, 1664; and Limentani, 1950, p. 133, no. 37, dated June 16, 1666.

Rosa's immediate source was undoubtedly Pierio Valeriano's *Hieroglyphica*, which follows Plutarch's *Isis and Osiris* almost exactly in discussing the fish as a symbol of *Odium* because of its association with the sea, the hated, salty enemy of the agricultural Egyptians. That Rosa knew and used this source is proved by his exact copying, in his *Democritus* and *L'Umana Fragilità*, of an obelisk described and illustrated by Valeriano in the section *Humanae vitae conditio* that immediately precedes and serves as a prelude to the section *Odium* (Fig. 15). The obelisk is also based on Plutarch's text, and its fish is used to symbolize death and hatred.[121] A very similar interpretation is found in the *Hieroglyphics of Horapollo*, where the fish is cited as a symbol of "the lawless or abominable."[122]

Rosa thus frees his genius from the confinement of two of man's most fundamental weaknesses, according to the Stoics and Cynics, greed and the fear of death. This accomplished, the genius offers his heart to a woman who holds a dove, and has a cap placed upon his head by another woman who carries a staff. The first personification can be unmistakably identified with the first word of the etching's inscription, *Ingenuus*, and is described and illustrated by Ripa as *Sincerità*, a woman with a dove in her right hand and a heart in her left (Fig. 19).[123] An echo of this pictorial conceit can be found in his satire *Babilonia*: "The chief love and aim of my genius is to follow the footsteps of few, and I strive with all my might that the heart which I have in my breast can be read in my face."[124]

The woman behind the genius who moves to place a cap on his head, and also, in the etching and the finished drawing for it, a scepter in his hand, is, of course, Liberty, the personification of

[121] See n. 68 above; and Valeriano, pp. 218v-219r, *Humanae vitae conditio*; p. 219r, *Odium*. Plutarch, *Moralia: Isis and Osiris*, 363.

[122] Boas, *Horapollo*, Bk. I, p. 78, no. 44.

[123] Ripa, 1613, pt. 2, p. 237. Petrucci, 1934-35, p. 29, says that the dove is a "simbolo del candor," but does not make a definite identification of the figure. In the Louvre drawing the genius indecisively withholds his heart from a persuasive *Sincerità*, who holds only a dove.

[124] Cesareo, I, p. 334, vv. 259-61: "Del mio genio il magior studio, e diletto/ Seguir l'orme di pochi, e à tutto studio/ Che mi se legga al volto il Cor c'ho in petto."

19. *Sincerità* (from Ripa, *Iconologia*, 1613, pt. 2, p. 237)

20. *Libertà* (from Ripa, *Iconologia*, 1613, pt. 2, p. 8)

the second word of the inscription, *Liber*. Once again Ripa provides a precise description of her as *Libertà*, a woman who holds a scepter in her right hand and a cap in her left, and who has a cat, lover of liberty, at her feet (Fig. 20).[125] As Ripa points out, the cap is a symbol of liberty because of the ancient Roman tradition of ceremoniously freeing a slave by placing a cap on his head. Valeriano describes *Libertas* much as Ripa does, cites a number of ancient coins on which the cap and scepter are used to symbolize liberty, and illustrates the ceremonial freeing of a slave.[126] The simultaneity of the two actions, the giving of the heart and the bestowing of the cap can be taken as a statement of Rosa's conviction that liberty and sincerity are mutually dependent, freedom is the reward of sincerity, and sincerity in turn requires freedom. Rosa's passionate insistence on liberty would seem to be one of the most genuine and spontaneous of his philosophical predilections, and it is fundamentally closer to the Cynic's uncompromising demand for complete individual freedom than it is to the Stoic's rather more flexible and accommodating stance.[127]

The genius of the artist is confronted by a trio of figures in hortatory poses. The kneeling woman in the foreground is unmistakably *Pittura* and fits Ripa's description of her as a beautiful woman who holds a brush in one hand and a panel in the other and who has at her feet various implements associated with painting.[128] In modeling her on the kneeling woman in the Raphael-

Giulio Romano *Transfiguration*, Rosa clearly intended her to refer to his own firm belief in the classical tradition of painting, just as the general classicism of the print as a whole does.[129] In addition the panel held by *Pittura* depicts a classically posed male nude, a pictorial statement of Rosa's often expressed desire to be considered a painter of grand figure pieces. Also since the nude covers his *vergogna*, to use Rosa's own terminology, the panel proclaims another of the artist's principles, insistence on a strict propriety and decency.[130] As has already been mentioned in connection with the frontispiece etchings for the *Figurine* series, a personification of *Pittura* also appears in Rosa's satire *La Pittura* where she urges the artist hero to uphold virtue and attack vice in terms that call to mind the fieriness suggested by the *Succensor* of the inscription: "Up, up, awaken men's spirits and kindle their ire, and with a heart filled with noble daring rebuke and reprehend these wicked artificers." Most interesting of all, she then touches him on the head with a staff twined with vine leaves, clearly a thyrsus, with the result that, as the artist hero states: "From that moment on it was as if my internal fibers were afire, and as if the Furies all united were encamped within my heaving breast."[131]

[125] Ripa, 1613, pt. 2, p. 8. The figure and her attributes are associated with liberty without reference to an iconographic source by Morgan, II, p. 99; Bartsch, xx, 24; and Petrucci, 1934-1935, p. 29. In the Louvre drawing, *Libertà* indecisively holds the cap above the head of the genius, much as he withholds his heart from *Sincerità*.

[126] Valeriano, p. 293v. For examples of *Libertas* with the attributes of cap and staff on ancient Roman coins, see H. Mattingly, *Coins of the Roman Empire in the British Museum*, IV, Antoninus Pius to Commodus, London, 1940, figs. 3.9, 47.8, 95.13, 96.20, 98.1, and 99.3.

[127] See nn. 17-19 above.

[128] Ripa, 1613, pt. 2, pp. 154-55. The Ripa description is actually more complex than the summary given here, and in some ways too subtle to illustrate in the etching. Rosa therefore limited himself to the essential attributes of *Pittura* and omitted others, just as he logically left out the cap of *Libertà*. In the Louvre drawing both the brushes and panel are held in *Pittura*'s right hand, but in the etching and finished drawing for

it a palette and brushes are shown on the ground next to her. The figure is identified as *Pittura* by Morgan, II, p. 99 (albeit in a very confused way) and by Petrucci, 1934-1935, p. 29.

[129] The association is most emphatic in the Louvre drawing because of the position of *Pittura*'s left arm, which was subsequently lowered in the Rome drawing and the etching.

[130] Rosa's satire *La Pittura* repeats a familiar reference to Michelangelo's *Last Judgment*: "E voi senza temer Christo, e la Madre,/ Fate che mostrin le vergogne aperte/ In fin dei Santi qui l'intere squadre." (Cesareo, I, p. 237, vv. 388-90.) The strictness of the artist's propriety, which was almost legendary in his time (see Passeri, pp. 399-400; Salerno, 1963, p. 68; and Limentani, 1961, pp. 174-78) is reflected in the zeal with which he attacked nudity in painting in the satire *La Pittura*: "Queste pitture ignude, e senza spoglia/ Son libri di lascivia. Hanno i pennelli/ Semi da cui dishonestà germoglia," or, "Gl'impudichi Carracci, e i Tizziani/ Con figure di chiassi han profanati/ I Palazzi de' Prencipi Christiani." (Cesareo, I, p. 250, vv. 727-29, and p. 249, vv. 703-5 respectively.)

[131] Cesareo, I, p. 227, vv. 109-11: "Sù, Sù, desta gli spirti, e l'ire accendi;/ E pieno il cor d'un nobile ardimento/ Questi artefici rei sgrida e riprendi."

Behind the figure of *Pittura* appears a *togatus* who gestures toward a book and a balance he is holding. Although this figure clearly is intended to represent the *Aequus* of the inscription, he presents an iconographical problem more difficult to solve than those treated so far since here the artist has been more freely inventive. Like the other figures discussed, the primary attribute of the *togatus* can be found in established iconographical sources, where the balance is listed as the chief attribute of *Equità*,[132] but in this case Rosa departed from the source in making this balance-holding figure masculine and in placing an open book in his hand. Both of these changes suggest that Rosa had in mind a conception more subtle than equity or fairness, a suggestion which is strengthened by the evidence of the Paris drawing [113b] where the presence of numerous *pentimenti* indicates that this figure was the most difficult for Rosa to develop and reveals that the artist experimented with attributes other than those finally decided upon.

These *pentimenti* show that Rosa had given the *togatus*, in addition to the book and balance of the final etching, the attribute of a large mirror.[133] What Rosa intended for the meaning of his figure by introducing a mirror here can be surmised from his use of the same symbol in his painting *La Filosofia*.[134] Here, Rosa represents *La Filosofia* as a woman seated in the pose of Dürer's *Melencolia I*, resting her right elbow on a skull and indicating with her left hand the inscription *Sustine et Abstine*. The Stoic nature of the declaration is unmistakable, and, as has already been observed, derives from a popular phrase of the Stoic

philosopher Epictetus which has been preserved as a fragment, ἀνέχου et ἀπέχου, in *The Attic Nights of Aulus Gellius*.[135] Putti rummage through books at the feet of *La Filosofia* and, pertinent for this study, a white-bearded man stands before her holding and pointing to a large mirror which rests on the ground next to a balance, much as in the Louvre drawing.

Baldinucci discusses this painting at some length, and although he erroneously describes the old man as seated, the explanation is nevertheless a good one. He says: ". . . a seated philosopher in the act of showing to a woman, intended as Moral Philosophy, a large mirror: meant to signify that the discipline has as its goal the perfect knowledge of oneself. He also made there some putti with various symbols alluding to the *concetto* of the work, and many books of philosophy. . . ."[136] Baldinucci's interpretation of the mirror's meaning is the traditional one found, for example, in Ripa who says in the section "Prudenza" that the mirror is an attribute signifying self-knowledge and cites the well-known injunction of Socrates to his students to study themselves in a mirror every morning in order to know themselves better.[137] That Rosa was fully aware of this meaning is confirmed by his specific reference to it in the satire *La Guerra*: "Thus,

Vv. 115-17: "Da quel momento in quà par che m'avvampino/ Le fibre interne, e che le furie unite/ Ne l'agitato sen tutte s'accampino." See also above Ch. II, n. 29.

[132] Ripa, 1613, pt. 1, pp. 210-11. The *togatus* is identified as a philosopher by Morgan, II, p. 99, as "l'Equité" by Bartsch (XX, 24), and as "la Giustizia" by Petrucci, 1934-1935, p. 29.

[133] There is also a suggestion of a staff held in the figure's right hand but it seems to be of no particular significance.

[134] In the Palazzo Enzenberg, Caldaro, Bolzano. See Salerno, 1963, pp. 45, 139; W. Arslan, "Sul seicento napoletano," *Le Arti*, August-December 1943, pp. 257-60, fig. 1; and Ch. IV above, n. 15.

[135] 17.19.6. See J. C. Rolfe, *The Attic Nights of Aulus Gellius*, London, New York, Loeb Classical Library, 1927-1928, III, p. 266, and Epictetus (Loeb, II, p. 454). It is quite probable that Rosa's immediate source was Alciati's *Emblemata*. Emblema XXXIV (pp. 169-71) has as its title the Greek phrase quoted here, and in it the author cites the Aulus Gellius fragment, discusses it and Epictetus at some length, and translates the Greek precisely as Rosa does, *sustine & abstine*.

[136] Baldinucci, 1773, p. 26: "...un Filosofo sedente, in atto di mostrare ad una femmina, fatta per la Morale Filosofia, un grande specchio: dicesi per significare, che tale scienza, ha per fine la perfetta cognizione di se stesso. Fecevi anche alcuni putti con vari simboli, alludenti al concetto dell'opera, e più libri di Filosofia...." For an almost identical account, see De Dominici, III, pp. 468-69. According to these two writers, the picture moved Jacopo Salviati to dedicate an ode to Rosa, calling him "famoso pittore di cose morali." From what is known of Rosa's artistic aspirations (see above n. 112), few tributes could have pleased him more.

[137] Ripa, 1613, pt. 2, p. 167. For an example of Poussin's use of this conceit, see Wallace, "The Later Version of Nicolas Poussin's *Achilles in Scyros*," *Studies in the Renaissance*, IX, 1962, pp. 322-29.

among new worlds and old, Rhodopis with her shoes and her chains defeats the heads of the Socratics and their mirrors.[138]

In the light of the other examples in which Rosa used the symbol of the mirror, particularly in conjunction with the balance, it seems reasonable to believe that Rosa intended the balance held by the *togatus* to suggest more than the idea of fair or equitable, as might be arrived at by a simple translation of the *Aequus* of the inscription. The association of the balance[139] with the mirror of self-knowledge would seem to reflect the Stoic belief that in order to maintain his essential inner balance, man must know himself. He must be aware of his own weaknesses and be constantly on his guard to correct such flaws and impulses as might destroy this basic equilibrium. From self-knowledge and self-control the Stoic believed man would achieve balance, evenness, and the Stoic ideal of temperance.[140]

The open book gestured to by the *togatus* must represent a book of philosophy and, in this case must function as the source of the Stoicism alluded to both by the balance and by the mirror of the earlier drawing.[141] The gesture of the *togatus* is an in-

junction to Rosa's genius to heed the principles contained therein. Although the mirror is omitted in the final states, the book and the balance together serve to identify the *togatus* as the personification of Stoic thought, the Stoic philosopher in general, stoically fair and equable, to be sure, but also, and more important, stoically even, composed, and tranquil.

The third member of the triad facing Rosa's genius is a satyr, apparently female, crowned with ivy, who holds a piece of paper in her left hand and gestures with her right.[142] Her coarse appearance is in marked contrast to the dignity of the other figures of the etching, and the assumption that she stands for satire, the rough side of Rosa's creative activity is borne out by the fact that in the Louvre drawing she is shown writing with a pen [113b]. Moreover, Rosa explicitly refers to this conceit in the satire *Tirreno*, where he discusses his career as a satirist and complains of

[138] Cesareo, I, p. 261, vv. 121-23: "Così tra Mondi nuovi, e Mondi vecchi/ Rodope con le scarpe e le catene/ Vince i capi de' Socrati, e gli specchi." The reference is to Rhodopis, a famous courtesan of antiquity whose charms were brought to the attention of an Egyptian king through the agency of an eagle who stole one of her shoes and dropped it in the king's lap. He was so impressed by the beautiful shape of the slipper that he had the country searched until the owner was found and brought to him. See also Strabo, *Geography*, 17.1.33 (808); Aelian, *Varia Historia*, 13.33, and Herodotus, 2.134-35. Both Baldinucci, 1773, p. 73, and Pascoli, p. 86, say that Rosa kept a large mirror in his studio and used it extensively to study his own movements, postures, and facial expressions for use in drawings and paintings.

[139] As befits Stoicism's preference for simplicity, the balance is not the elegant *libra*, most usually seen as an attribute of Justice, but rather the homely steelyard of the shop and market.

[140] An especially relevant statement of the importance of self-examination to Stoicism is found in Seneca, *Moral Essays*, 3, "To Novatus on Anger," 3.36 (Loeb, I, pp. 339-41).

[141] Books are basic attributes of philosophy in Ripa, 1613, pt. 1, pp. 245, 267, 271, and are used as such by Rosa in the painting *La Filosofia* discussed above.

[142] The sex of the satyr is puzzling since although the figure has a strong masculine face, hands, and arms, it also has female breasts. I have not been able to find an explanation, precedent, or a source for an androgynous satyr, and it is possible that by this representation Rosa simply intended to emphasize the roughness of *La Satira* and to set her even more emphatically apart from the other idealized women. However, the artist may also have wanted to give the figure some of the qualities of Silenus, whose association with Bacchus, satyrs, and ivy is of course a very close one. Although by Rosa's time Silenus was usually shown as being basically a fat man with limited, if any, bestial characteristics, a representation of him as a fat satyr with goat legs is found in Valeriano (pp. 48v-49r), who uses Silenus as an example of "Divina in Occulta," the divine in the hidden, because his coarse exterior hides a noble inner character and intelligence. Valeriano's discussion is based directly on Alcibiades' praise of Socrates from Plato's *Symposium* (215f.) in which Alcibiades stresses Socrates' resemblance to Silenus in his great wisdom concealed within a coarse exterior. And although Silenus is usually thought of and referred to simply as a drunken reveler, there are in fact a good many references in ancient literature to his intelligence, wisdom, and knowledge of hidden things. (See Virgil, *Ecologue* 6; Plutarch, *Moralia*, "A Letter to Apollonius," 115.27; H. J. Rose, *A Handbook of Greek Mythology*, London 1953, pp. 156-57; W. H. Roscher, *Ausführliches Lexicon der Griechischen und Römischen Mythologie*, IV, Leipzig 1914, 503-16; *Oxford Classical Dictionary*, "Satyrs and Sileni." These qualities of Silenus are of course nicely in keeping with the symbolism of the etching, especially the ivy crown worn by the Genius figure.

the difficulties of that calling in a passage already cited: "And, ready to face any threat, in the mask of a satyr or a Menedemus, I sported with my thyrsus and threatened with my brow."[143]

The juxtaposition of Satire with *Pittura* and the Stoic philosopher reflects, once again, Rosa's concern to be considered not only a painter, but a poet and philosopher as well. In addition, the connection between Rosa's Stoicism and Cynicism and his taste for satire is a strong one, and his attacks on the behavior and morals of others are launched from a self-assumed position of Stoic-Cynic superiority and disdain for the vanities of the world.[144]

Even more pertinent to this discussion, however, is the close connection in Rosa's mind between satire and painting. In the satire *La Pittura* his personification of *Pittura* actually uses the thyrsus, an implement traditionally associated with Bacchic and satyric (hence for Rosa satiric) activities, to enflame the artist with fiery zeal, and later in the same satire Rosa has his artist-hero say: "And these blunderers have the presumption to call themselves painters, and protest against the use of the lash of the satirical poets?"[145] This close association of the whip of satire with painting provides an important, although not a complete, explanation for the inscription's *Pictor Succensor,* "fiery painter." The fieriness of Rosa's satires, reminiscent chiefly of Juvenal[146] is evident in the

violence of the artist's attacks on the follies of his age, particularly in such phrases as: "Oh! take up the whip, close your eyes, and whoever gets hit gets hit: Let this uncouth rabble feel the scourge." Or, "With the scourges of my satires I stung the vices, with that sacred fury that you kindled within me."[147]

But although Rosa clearly associated his form of fiery satire with Bacchic ardor, the Bacchic symbolism of the *Genius* etching has, in my opinion, an additional and more important significance. It is particularly noteworthy that the attribute that is most directly and intimately associated with the genius figure is the full wreath of Bacchic ivy which crowns him. This is all the more significant for the fact that it forms a deliberate contrast with the wreath of laurel of the inscription. Rosa's use of laurel, the sacred plant of Apollo, is of course perfectly in keeping with his desire to be known as a painter-philosopher, and as a learned artist who dealt with profound allegories and histories. He seems to have had this kind of philosophical association specifically in mind when he did a preparatory study for the personification of Stoic thought, now in the Uffizi [113c], in which the philosopher is crowned with laurel.[148]

It therefore seems especially curious that Rosa chose to crown the classically idealized genius figure with Bacchic ivy, thus linking him to the unidealized figure of Satire who is similarly, if less abundantly, wreathed with ivy. On the one hand Rosa certainly knew that as a lively satirist, the poetic crown most appropriate to his genius was one of ivy, the symbol of fame and immortality appropriate to *poeti allegri* and *poeti ditirambici.*[149]

[143] Cesareo, I, p. 369, vv. 106-8: "E disposto a soffrire ogni periglio/ In maschera di Fauno, e Menademo/ Scherzai col Tirso, e minaciai col Ciglio." Also cited above in n. 29. The satyr is identified as "le Vice" by Bartsch (xx, 24) and as Satire by Petrucci, 1934-1935, p. 29. The association of satire with satyrs, if unsound from the classicist's point of view, nevertheless seems to have been perfectly acceptable in the Renaissance and Baroque periods. See especially the great Julius Caesar Scaliger's authoritative *Poetices libri septem,* In Bibliopolio Commeliniano (Heidelberg), 1607, pp. 43-44.

[144] For a discussion of the importance of Cynic literary genres in the development of Roman satire, which in turn influenced Rosa, see above n. 13. For the importance of Stoic doctrine to satire in classical literature, see C. W. Mendell, "Satire as Popular Philosophy," *Classical Philology,* xv, 1920, pp. 138-57.

[145] Cesareo, I, p. 230, vv. 196-98: "E presumono poi quest'indiscreti/ D'esser Pittori, e non voler ch'adopra/ La sferza de' satirici Poeti?" See above n. 33, and Ch. II, n. 29.

[146] Highet, pp. 217, 330, mentions the influence of Juvenal on Rosa,

and points out (p. 245) that Rosa imitated the opening of Juvenal's *Satire One* in his satire *La Poesia.* Limentani, 1961, pp. 125, 148, makes similar observations.

[147] Cesareo, I, p. 212, *La Poesia,* vv. 679-81: "Deh! prendete, prendete in man la scotica,/ Serrate gli occhi, et à chi tocca, tocca:/ Provi il flagel questa canaglia zotica." P. 367, *Tirreno,* vv. 83-84: "Con flagelli di Carmi i Vizij io punsi/ Con quel furor che in me sacro accendesti." See also n. 30 above.

[148] I am indebted to Rotili, no. 103c, for making the connection between the drawing and the *Genius* etching.

[149] The wreath worn by the genius figure is also identified as ivy by Petrucci, 1934-1935, p. 29. Rosa crowned Satire with the light strands of

But in addition Rosa must have intended the ivy crown to reflect his own unusual ideas about genius. In my opinion, the ivy crown is Rosa's most precise statement about those views. By crowning his genius with the sacred ivy of Bacchus, the god of inspired fervor, Rosa proclaimed himself "Pictor Succensor" and stated his belief in the intuitive, irrational, inspired, and mysterious qualities of his own genius. Inspiration's freedom and release are also referred to by the close association between the crown of ivy of Bacchus, *Liber*, and the cap of liberty held by the personification of the inscription's "Liber."

It is a remarkable conception of genius for the time, one which did not receive its full development until over a century later during the Romantic period when it was commonplace to speak of "a genius" in the sense that we generally understand it today. But the evidence of Ricciardi's proposal for the dedicatory inscription of the *Figurine* series in which he said ". . . the tablets which a playful hand carves may earnestly testify to those laws which a genius (unus Genius) has written with a sincere heart," indicates that he, Ricciardi, had just such an interpretation of genius in mind.[150] And the close connections between the dedicatory print [6] and its variant [7] and the *Genius* etching in the use of idealized, allegorical self-portraiture and Bacchic sym-

bolism, together with the statement in the *Genius* etching of the concetto of the sincere heart of genius makes it seem very likely that the notion of genius as "a genius" put forward by Ricciardi was accepted and used by Rosa in the *Genius* etching.

However Rosa also emphasized in the *Genius* etching that these Dionysiac qualities existed side by side with Apollonian ones, and that the inspired freedom and fieriness of his genius were kept in check and balanced by Stoic equilibrium, *Pictor Succensor et Aequus*. Rosa thus anticipated the later Romantic attitudes toward genius and also proclaimed, in a typically contradictory way, that his genius was best expressed in the erudite, and by implication rational, treatment of philosophical themes.

It is characteristic of Rosa's art and thought that these two basic themes of the *Genius* etching coexist as curious and not fully compatible bedfellows. Their association calls to mind the similarly uneasy relationship between Rosa's Stoicism and his un-Stoic passion as manifested especially in his satires and in his enthusiasm for Diogenes and Cynic ardor. In a larger sense almost all of Rosa's art is informed with the conflict between, on the one hand, his passionate emotionalism and dashing extravagance as best seen in his landscapes, and, on the other hand, his drive to be known as a sober, philosophical painter of grand history pictures dealing with "cose morali." Critics and writers have often expressed regret that Rosa sacrificed so much of the former to struggle, in their opinion unsuccessfully, with the latter. Although these views have considerable critical merit, it is precisely this kind of tension, stress, and uneasiness that is the most salient characteristic of Rosa's art. It is at the root of the sense of disquiet and urgency in his art that appealed so strongly to the Romantics and still does to most modern viewers. Rosa would not be Rosa without these tensions, without the kind of strivings in diverse directions embodied in the *Genius* etching.

The *Alexander in the Studio of Apelles* [114] is iconographically more modest than the *Genius of Rosa*, but it has the same general significance and treats more specifically of the relationship between artist and patron. It is based on an anecdote found in Pliny about Alexander, who in his frequent visits to Apelles' studio talked about many things, by implication artistic matters,

ivy commonly seen on satyrs' heads but chose larger leaves for the wreath of the genius figure in order to produce a fuller, more important crown that would compare favorably in size with the inscription's laurel wreath. For a study of the sacred plants of Bacchus and Apollo, see E. Panofsky, *A Mythological Painting by Poussin in the Nationalmuseum Stockholm*, Stockholm 1960, especially pp. 36-44. According to Ripa (1613, pt. 1, pp. 4-5), whose discussion of poetic crowns is especially clear and helpful, ivy is best used for *poeti allegri* (he cites as examples Ovid, Propertius, and Catullus), and for *poeti dithiramboci* who sing in honor of Bacchus to whom ivy is consecrated. In the absence of a tradition for a specific type of wreath for satiric poetry, the ivy crown of the "poeti dithiramboci" was certainly the most appropriate one for Rosa's explosive satires. By the same logic, the sprigs of ivy worn by Satire are not simply the usual decoration of a satyr, but were intended to be a kind of poetic crown as well. See Panofsky, *Mythological Painting*, pp. 40-42, and J. B. Trapp, "The Owl's Ivy and the Poet's Bays," *Journal of the Warburg and Courtauld Institutes*, XXI, 1958, pp. 227-55.

[150] See above Ch. II, n. 24.

without any real knowledge of them. Apelles silenced him by saying that the boys who ground his colors were laughing at him "so much power did his authority exercise over a king who was otherwise of an irascible temper." The inscription at the bottom of the etching is an almost exact quotation from Pliny, and the scene depicted on the panel is one described by Pliny as being among the most famous of Apelles' works, "*Artemis in the Midst of a Band of Maidens Offering a Sacrifice*, a work by which he may be thought to have surpassed Homer's verses describing the same subject."[151]

Although it would be unreasonable to see in Apelles the same kind of allegorical self-portrait as in the genius figure, there can be little doubt that Rosa meant to associate himself in general terms with Apelles who, as Pliny states, "surpassed all the painters that preceded him and all who were to come after him."[152] Given Rosa's strong interest in *Ut Pictura Poesis*, he must have also found Pliny's comparison of Apelles' *Artemis* with the verses of Homer particularly agreeable and probably chose to represent this subject rather than one of the others described by Pliny, even though it calls for elements of landscape. Alexander of course stands for the patron in general, who because of his limitations and despite his power must submit to the superiority of the creative artist.

It is noteworthy that these two prints, which are the most direct and personal statements Rosa ever made about his artistic beliefs, should also be among the most classical works he ever did. He clearly intended the formal solutions of the prints to have a symbolic significance in themselves, stating his conviction that the art he regarded most highly, in his own works and others, was the noble art of history painting in the classical grand manner.

[151] Pliny, *Nautral History*, 35. 36, 85-86, 96. In the Loeb Classical Library edition by H. Rackham, London, Cambridge, Mass., 1952, ix, pp. 325, 333. Tomory, no. 11, also notes Pliny as the source for the story, the inscription, and the painting of Artemis.

[152] Fabbri, p. 329, notes Rosa's association of himself with Apelles' famous *Calumny* in the satire *Invidia*.

CHAPTER VI

THE LATE PRINTS

c. 1663–1664

The Fall of the Giants [115];
The Rescue of the Infant Oedipus [116]

These other two very large prints form a matched pair of the same size as the *Polycrates* [111] and the *Regulus* [110] and were done, as Rosa's letters indicate, about a year later.[1] Both show such striking similarities to the *Polycrates* and *Regulus* in their themes of downfall and ruin that it seems very likely that Rosa thought of one pair as complementing the other, and of all four prints as being representatives of the same basic ideas.

Despite these thematic similarities the later pair show a dramatic move away from the controlled classicism of the *Regulus* and *Polycrates* and from the classicizing tendencies of the etchings that can be grouped with them. This is seen most strikingly in the composition and format of the *Giants* and *Oedipus*—to create them the plates of the *Regulus* and *Polycrates* were, in effect, stood on end and filled with bursting compositions which

[1] See above Ch. V, n. 8, especially De Rinaldis, p. 153, no. 120, dated July 14, 1663: "Ho fatti due altri rami grandi, cioè dell'istessa misura di quelli che feci a Strozza Volpe. In uno è la cascata dei Giganti fulminati da Giove, nel altro Edipo trovato dal contadino attaccato per i piedi furati nel bosco...," and also De Rinaldis, p. 154, no. 121, dated August 25, 1663: "Voi mi chiedete il disegno dell'ultimo rame intagliate de' Giganti, quand'io già l'havevo messo da parte per voi, e ben vero che ne caverete poco di bello, per essere un semplice pensiero. La stampa pero è riuscita bene, e di non ordinaria sodisfazione presso quelli della professione. Circa all'altro disegno dell'Edipo, non posso prometervelo per non havervi fatto disegno, che per esser materia di paesi, è ho disegnato sopra il medaglione di rame." See also De Rinaldis, p. 156, no. 123, dated September 15, 1663; Limentani, 1950, p. 130, no. 35, dated October 6, 1663. In a letter of October 21, 1663 (De Rinaldis, p. 157, no. 124; Salerno, 1963, p. 98), Rosa told Ricciardi that although he signed the *Giants* and *Oedipus* "Inv. pinx. Scul.," he had in fact not done paintings of them, but that he hoped by this ruse to encourage a potential patron to ask for paintings of the subjects: "Per sodisfarvi circa a quell'pinx. delle mie carte, ce l'ho messo per mia cortesia e per far credere ch'io intanto l'ho intagliate, in quanto l'haverle dipinte. Ma la verità e che dall'Attilio in poi, tra le grandi, e dell Democrito e Diogene della scodella, fra le mezzane, nessuna altra è stata da me collorita. Nè è stata bastanta una fantasia come quella de' Giganti a movere la voglia a nessuno di vedersela collorita." In a letter of December 15, 1666 (De Rinaldis, p. 193, no. 157) Rosa wrote: "I giganti e l'Edipo non sono stati da me ancora dipinti...."

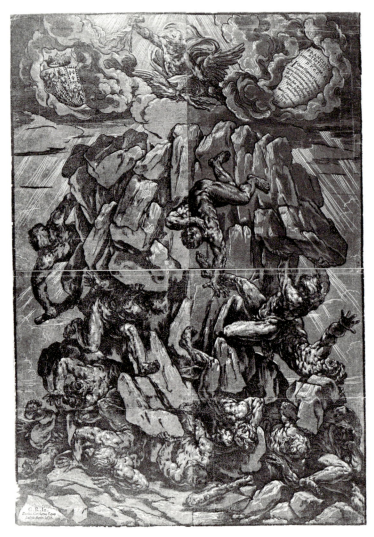

21. Bartolomeo Coriolano, *Fall of the Giants*
(after Guido Reni), chiaroscuro woodcut.
Boston, Museum of Fine Arts

can best be described as monumentally Baroque. In addition both prints return in many ways to the more spontaneous and exuberant qualities of his earlier career as an artist and etcher. This is most evident in the extensive incorporation of dramatically expressive landscape elements into the compositions in ways that have their closest parallels in his earliest large prints, the *St. William* [99] and *Albert* [100]. They pick up and restate in an even more forceful way the *concetto* of the human figure compositionally and expressively linked with rugged rocks, as in the *Albert* and *Giants*, or with jagged trees as in the *St. William* and *Oedipus*. There are even distinct parallels in the downward directed movements of the *Albert* and *Giants*, and the upward soaring qualities of the *St. William* and *Oedipus*.

The *Giants* is also a variation on one of the earliest and most popular kinds of subject matter in Rosa's art, the battle picture. Many of the figures and wild postures in the *Giants* etching are strikingly similar to those seen in the battle pictures, and one of the earliest of Rosa's drawings that can be associated with the fall of the giants theme, a red chalk study of the 1640s now in the Uffizi [115f], could equally well serve as a study for a battle painting. But the *Giants* print has an even greater and more concentrated violence than any of the battle pictures since the figures that were spread out horizontally across the front planes of the battles' vast panoramas are instead piled on top of each other in a narrow compressed format.

The *Giants* etching does not simply look backward for its formal solution however. It is the most progressively and daringly Baroque of all of Rosa's prints, drawings, or etchings, especially in its use of spatial illusionism. He undoubtedly knew, either directly or indirectly, Giulio Romano's frescoes of this subject in the Palazzo del Te; after all he did base his *Regulus* on a fresco there.[2] However, a much more important source is found in the chiaroscuro woodcut by Bartolomeo Coriolano after Guido Reni's fresco of the *Fall of the Giants*, a print which is known in at least two versions, one dated 1638, the other 1641 (Fig. 21).[3] Rosa

[2] See above Ch. V, n. 87, and Hartt, *Giulio Romano*, I, pp. 152-58; II, figs. 337-47.

[3] Bartsch XII, p. 113, no. 11; p. 114, no. 12 I and II dated 1647. See also C. Karpinski, ed., *Le Peintre Graveur Illustré, Illustrations to Adam*

clearly borrowed the overall composition of the woodcut, a piled up, cone-like mass of intermingled boulders and bodies capped with clouds surrounding the flying figure of Zeus. In addition the figure supporting a boulder at the lower right corner of Rosa's etching and the very similar running figure at the center of the lower left quarter of the print are both very like the rock-bearing figure near the left center of the woodcut, a figure which was also done as a separate chiaroscuro woodcut by Coriolano.[4]

But there is another, and, if less direct, even more interesting pictorial model for Rosa's etching—the scene of *Minerva Expelling the Giants* from Pietro da Cortona's Barberini ceiling, one of the most important of all High Baroque ceiling decorations (Fig. 22).[5] Several of the figures in Rosa's print are quite like Pietro's, especially the upside down Prometheus type which appears in the upper center of the etching and at the lower right of the fresco. The rock-bearing figures in the lower right corner of both the etching and the fresco are generally similar, and Pietro may also have based this figure on the rock-bearing giant in the Coriolano woodcut. In addition there are even more specific links with the Barberini ceiling in Rosa's preparatory drawings for the etching. The fallen giant seen feet first with his legs kicking up over the back of the rock-bearing figure at the lower right of the fresco appears, in reverse, in a very similar pose in the lower left corner of a large preparatory drawing for the etching now in the British Museum [115b]. The fallen giant in the left foreground of Pietro's painting is repeated almost exactly, if reversed, in the lower right corner of another large drawing for the print now in the Metropolitan Museum of Art in New York [115c]. More important than any of these details, Rosa followed Pietro in his High Baroque illusionism. The finite boundaries of the upper pictorial surface of the print are dissolved into a light and cloud-filled space dominated by a flying figure, with rocks and giants tumbling down, growing progres-

sively closer to the viewer until they threaten to burst through the picture plane. Rosa is rather more conservative than Pietro da Cortona in avoiding a pronounced foreshortening of the figures, but he was after all working in a *quadro*-like format, not on a ceiling. In addition the *Giants* could not be too extravagant in its spatial illusionism since it was intended to form a matched pair with the *Oedipus*, a pairing which in my opinion produces one of the most successful of all of the sets of etched companion pieces.

Like the *Giants*, the *Oedipus* has a vertical composition filled to bursting with angular, energetic forms. The downward cascade of boulders and giants is answered by the forceful upward thrusting of the magnificent tree; and the sweep of space from the great height and distance of Zeus' Olympus down to the titanic forms of the foreground of the *Giants* etching is matched in the *Oedipus* by the strong diagonal that runs from the vividly lighted tree in the left foreground through the shadows of the grove to the remote, atmospherically blurred mountains of the far distance at the right. Even the swaying pose of the shepherd echoes the shape of the tree just as the angular postures and gestures of the giants seem almost to have been carved out of the harsh rocks that surround and envelop them.

An analogous boldness and freedom can be seen in the drawings for both prints and in the way Rosa used them in developing the final etchings. It is especially noteworthy that despite the large scale and great complexity of the etchings they exhibit considerably more independence from their preparatory drawings than do the *Polycrates* [111], [111b], *Regulus* [110], [110b], *Genius of Rosa* [113], [113a], or *Alexander in the Studio of Apelles* [114], [114a] with their close dependence on carefully worked out and highly finished cartoons. The *Oedipus* is particularly interesting in this respect since, as Rosa wrote Ricciardi, the trees and landscape were done directly on the plate without benefit of preparatory studies.[6] He undoubtedly did rely on drawings for the figures, as was his habit, and as indicated by a splendid red chalk study of the shepherd now in the Brera, the only drawing I know that can be associated with the *Oedipus*

Bartsch's Le Peintre Graveur, University Park, Pa., and London 1971, I, 113.11, 1; 114.12.II. See also C. Gnudi, and G. C. Cavalli, *Guido Reni*, Florence 1955, pp. 97-98.

[4] Bartsch XII, p. 116, no. 13; Karpinski, *Bartsch*, 116.13.
[5] G. Briganti, *Pietro da Cortona*, Florence 1962, pp. 196-203, pl. 131.

[6] See above n. 1.

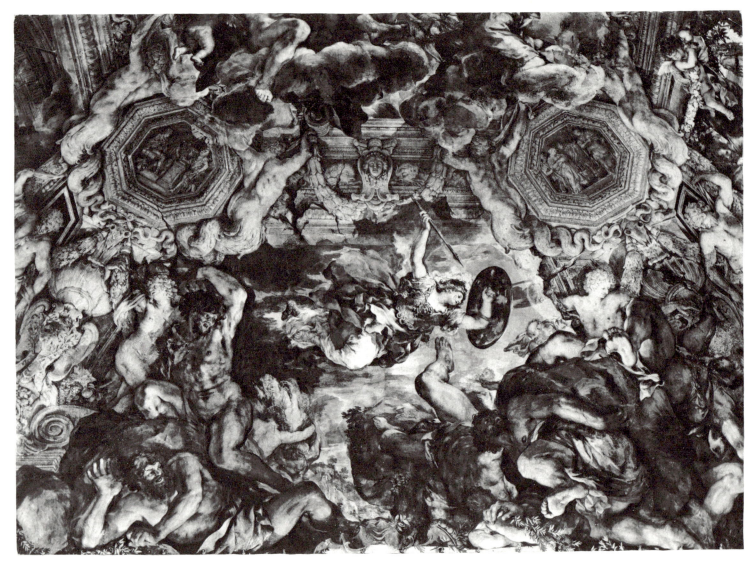

22. Pietro da Cortona, *Minerva Expelling the Vices*, fresco.
Rome, Palazzo Barberini (Alinari/Scala)

[116a]. It is clearly not a direct preparatory study for the print since the figure is seen from behind, but the pose is nevertheless virtually identical with that of the figure as finally etched. It is especially relevant to this discussion that whereas most of Rosa's chalk drawings tend to be quite conservative, this one is handled with a kind of brio that characterizes his finest pen and brush drawings. For the trees and other landscape elements Rosa seems to have thought of the early states of the etching itself as being in the nature of preparatory studies for the final state. At some point, almost certainly immediately after the initial biting, he lightened several passages by burnishing, most notably in the forks of the trees. I have never seen an impression in which these particular areas were not burnished; burnishing already occurs in the unique first state in the Bibliothèque Nationale, Paris [116/I]. In this impression the artist went over a number of passages in the tree branches with black chalk and then translated this toning into drypoint shading lines on the plate in producing the final state. Further changes were made from the Paris state in the final state by additional burnishing in several small passages in the tree and most notably in the sky at the right center.

A great many more drawings are preserved for the *Giants* than for any other of his etchings. I know of four large drawings and at least six smaller ones that can be associated with the print, two of them dating from quite early in his career (see [115a]-[115m]). One of this group is a magnificent red chalk study of giants and boulders now in the Gabinetto Nazionale delle Stampe e dei Disegni, Rome [115d], that is similar in style to the drawing for the *Oedipus* although it is somewhat less freely done. With the exception of this drawing and the aforementioned small red chalk study of the 1640s in the Uffizi [115f], the others make use of considerable amounts of pen or pen and wash, some with considerable chalk, and all done with great dash and energy. The most important of these is the cartoon for the print now in Dijon, Musée des Beaux-Arts [115a]. I have not seen it in the original and do not know whether it is scored for transfer, but it is noteworthy that it is very bold and free in execution and that in a number of details Rosa chose to depart from it in de-

signing the plate, revising, altering, and clarifying figures directly on the copper in a way that has clear parallels, albeit on a more modest scale, with his approach in the *Oedipus*. The drawing is moreover a finished version of the remarkable preparatory study in the British Museum [115b] which is almost the same size as the print, and which Rosa may have worked up as a cartoon but changed his mind about, in effect reworking it in the Dijon drawing. The British Museum drawing was clearly evolved in an extraordinarily free and unorthodox manner. Not only is it done with extremely spirited, slashing lines but it is also a patchwork of pieces—some cut out, some added—and of various alterations. It is clear that the drawing was not finished and then cut up, because in a number of areas a figure or passage has a portion cut off and then continued in a slightly different kind of line on a separate piece of paper. This drawing thus offers unique insights into an aspect of Rosa's working method in dealing with this large and complex composition, and serves to document with great vividness the verve with which the artist approached the problem.

In etching style and technique the *Giants* and *Oedipus* are the richest and most varied of all of Rosa's large prints. There are no particularly daring innovations in his approach in either print; he made extensive use of the familiar devices of quite regular hatchings, parallel lines, short strokes, and dottings. But these are handled with greater energy, vivacity, and variety of stroke than is seen in almost any of his prints discussed so far except the *Albert* [100], the *Battling Tritons* [91], [93], [94], and some of the *Figurine*. In the *Giants* especially the etched lines have much of the slashing power of the preparatory drawings and are brilliantly used to echo and reinforce the jagged, angular qualities of individual forms and of the composition as a whole. Similar effects are seen in the *Oedipus* in the way vigorous coiling lines are used to enhance the surging, centrifugally bursting quality of the tree. Most important of all, both prints show a richer, more complex, and more varied range of tone than any of Rosa's earlier large prints. In the *Giants* the deep shadows of the lower zone are created by complex overlays of lines and hatchings to produce intense and boldly extended areas of black.

At the top of the plate many of the forms and figures are done with sketchy lines that seem to be dissolved by light and distance. In the *Oedipus* a very similar effect is seen in the way the distant landscape, also done with broken, light-dissolved lines, forms a striking tonal contrast to the deep shadows of the grove of trees.

Moreover, Rosa in both prints paid particular attention to drypoint in developing a complex tonal scheme. In the *Giants* the drypoint is very distinctive and produces wonderfully velvety intermediate tones, most notably in the shadows at the center right of the print. It might even be said that in the *Giants* he worked in two stages, stages not achieved by staged biting but by leaving important areas unetched or under-etched with the intention of filling them out with drypoint after the biting. In Rosa's earlier large prints drypoint clearly played a secondary role as something that was added to make a few minor corrections or adjustments in tone. Even the extensive drypoint of the background of the *Ceres* [112] is rather arbitrarily applied to tone down areas which unexpectedly seem to have turned out to be too light after the biting. In the *Giants*, however, the drypoint plays such an important role and is so carefully and deliberately integrated with the tonal scheme as a whole that it is hard to believe that it could be in the nature of an afterthought or correction. Instead the print without the drypoint would simply not be successful graphically or pictorially. Without these webs of drypoint lines of varying degrees of density, important areas such as the large group of rocks at the center right, the mountain crest, and the clouds below Zeus would have been much too light, disturbing the complex compositional, spatial, and tonal organization of the entire print. As an experienced etcher Rosa would surely have been aware of this and would have done something about it before the plate was bitten unless he deliberately planned, as I think he did, to create a second stage by the addition of drypoint.

Drypoint also plays an important tonal role in the *Oedipus*, especially in darkening the area around the figure of the shepherd, but it would be difficult to argue that Rosa deliberately left this area light in etching the plate with the idea of creating a second

state with drypoint. The way drypoint is used in the print is not significantly different in principle from the way it is used in the *Ceres* [112] or *Apollo and the Cumaean Sibyl* [102/II], [102/III], although it is more carefully controlled and integrated with the etched lines. But as in the *Giants*, this drypoint creates soft and velvety intermediate tones and shadows that together with the strongly bitten darks and light dissolved distances produce one of the richest and most varied ranges of tonality to be found anywhere in Rosa's etched oeuvre.

These two prints raise interesting questions as to how Rosa intended his prints to be displayed. The *Giants* and the *Oedipus* are much more effective when hung together on a wall than laid flat on a table; they are so large that they have to be seen from some distance for their scale and sweep to be fully realized. This is particularly true of the *Giants* because of its rather special illusionistic qualities. I think Rosa would have preferred to see these two etchings displayed by being hung next to each other on a wall like paintings and that this is true for his other large prints as well. It helps to explain their grouping into matched pairs and the obvious concern Rosa showed in making them pictorially as well as programmatically harmonious with each other.

The two prints are also closely matched in their themes, which like the *Regulus* and the *Polycrates* deal with varieties of downfall and ruin. But both prints also show an interesting new freedom and imaginative flexibility in iconographic usage which has distinct parallels to the freedom with which their formal solutions are handled. For example, in all of Rosa's other prints that bear inscriptions there is a direct textual, literary, or symbolic connection between the inscription and the image, but in the *Fall of the Giants* this association is less direct and more complex. On the one hand the artist, in shaping his image, followed very closely the description of the fall of the giants found in Ovid's *Metamorphoses*, where it occurs at the end of the poet's classic account of the decline from the Golden Age to the Age of Iron:

And, that high heaven might be no safer than the earth, they say that the Giants essayed the very throne of heaven, piling

huge mountains, one on another, clear up to the stars. Then the Almighty Father hurled his thunderbolts, shattered Olympus, and dashed Pelion down from underlying Ossa. When those dread bodies lay o'erwhelmed by their own bulk, they say that Mother Earth, drenched with their streaming blood, informed that warm gore anew with life, and, that some trace of her former offspring might remain, she gave it human form. But this new stock, too, proved contemptuous of the gods, very greedy for slaughter, and passionate. You might know that they were sons of blood.[7]

It is especially relevant here that this passage follows immediately after Ovid's reference to the maiden Astraea who abandoned the blood-soaked earth during the Age of Iron, since Rosa did two important pictures of Astraea as Justice fleeing the earth to take up her place in heaven as the constellation Virgo.[8]

On the other hand, the etching's inscription is taken from a source that has no direct connection with the fall of the giants. *Tolluntur in altum, / Ut lapsu graviore ruant.* (They are raised up high / that they may be hurled down in more terrible ruin.) This is an exact quotation from *The First Book Against Rufinus* by Claudian Claudianus, who has been called the last poet of classical Rome.[9] The phrase seems to have been well known in Rosa's time and later. It appears for example in Schoonhoven's emblem book of 1618, and more recently in such standard reference works as Riley's *Dictionary of Latin Quotations* (1856), and Harbottle's *Dictionary of Quotations (Classical)* (1902).[10] But it would be uncharacteristic of Rosa, who prided himself on

his erudition, simply to have relied on a popular quotation without seeking its context. There are in fact striking similarities between the story of Rufinus as told by Claudian and the fall of the giants as told by Ovid. *In Rufinum*, which celebrates the triumph of Claudian's hero, Stilicho the Vandal, over the Praetorian Prefect Rufinus, begins with a conceit based on the Golden Age theme. Dire Allecto rallies "the hideous counsel of her nether world sisters," Discord, Hunger, Age, Disease, Envy, Sorrow, Fear, Rashness, Luxury, and Avarice, and urges them to rebel against the Golden Age that is beginning under the Emperor Theodosius in which Peace and Godliness, Love and Honor triumph and, in what seems to be a reflection of Ovid's account, even Justice returns to earth from heaven. The savage words of Allecto in turn rouse her evil sisters to rage for war against the heavens. But cruel Megaera proposes instead, and it is accepted by all, that Rufinus be turned loose in the world as a far more effective way of destroying the Golden Age. There follows a bitter denunciation of the evils of Rufinus' greed and tyranny and of the follies of ambition—a denunciation that Rosa, with his satirist's instincts and Stoic-Cynic predilections, must have found particularly sympathetic. Moreover, this account includes a passage which is strikingly similar to and probably based on the very passage from Vergil's *Georgics* that Rosa in a letter declared to be the basic source for his paintings of *Astraea*, paintings which proclaim Rosa's Stoic-Cynic beliefs in the natural virtue of the simple peasants among whom Astraea or Justice spent her last moments before fleeing the earth for heaven.[11]

Rufinus' end is also remarkably like that of the giants. He is overwhelmed by his enemies, torn to pieces, and trampled into the earth, his blood staining the feet of his attackers just as the giants' gore flowed upon the earth. Finally, at the end of the poem Claudian says: ". . . thrust him down into the empty pit beneath the lightless prison of the Titans."[12]

[7] Ovid, *Metamorphoses*, 1.150-62. In the Loeb Classical Library edition by F. J. Miller, London, Cambridge, Mass., 1936, I, p. 13. See also Ovid, *Fasti*, 5.35-44.

[8] See Wallace, "Justice," pp. 431-34.

[9] Claudian, *In Rufinum*, 1.22-23. In the Loeb Classical Library edition by M. Platnauer, London, New York 1932, I, pp. 28-29. *In Rufinum* 1 and 2 are on pp. 27-97 of the Loeb edition.

[10] *Emblemata Florentii Schoonhovii*, Gouda 1618, p. 154; T. B. Harbottle, *Dictionary of Quotations (Classical)*, London, New York 1902, p. 286; H. T. Riley, *Dictionary of Latin Quotations*, London 1856, p. 462.

[11] Vergil, *Georgics*, 2.458-75. In the Loeb Classical Library edition by H. R. Fairclough, London, New York 1930, I, p. 149. Claudian, *In Rufinum*, 1.198-219 (Loeb, I, p. 41). Wallace, "Justice," p. 433.

[12] Claudian, *In Rufinum*, 2.523-27 (Loeb, I, p. 97).

The *Giants* also represents an interesting variation on the theme of downfall as Rosa usually treated it since the element of blind, capricious fortune, so prominent in the stories of Regulus, Polycrates, and Oedipus is not present in the stories of the giants or Rufinus, who quite clearly and directly earned their terrible fates by their proud, ambitious behavior. This is made emphatically clear in the introductory passages of *In Rufinum* in which Claudian specifically states by way of a prologue: "My mind has often wavered between two opinions: have the gods a care for the world or is there no ruler therein and do mortal things drift as dubious chance dictates?" He then goes on to say that while the laws of nature seemed to him ordained by a God, the success of wicked men and the discomfort of good men drove him to embrace Epicureanism which holds that atoms drift in purposeless motion. But Rufinus' fate dispelled this uncertainty and, as he says in the sentence that immediately precedes the one quoted by Rosa as the print's inscription, "No longer can I complain that the unrighteous man reaches the highest pinnacle of success. They are raised up high that they may be hurled down in more headlong ruin."[13]

The fate of Oedipus is of a different sort than that of the giants and Rufinus. Unlike them Oedipus is a tragic and even heroic figure, the victim of a fate which he did everything in his power to avoid. The two prints thus contrast differing aspects of the same basic theme much as does the set of the *Regulus* and *Polycrates*. All four prints bear witness to the awful power of fate which sweeps everything in its path, noble and ignoble, virtuous and wicked, deserving and undeserving, and each print explores a different facet of this theme.

Rosa's presentation of the story of Oedipus is characterized by the kind of imaginative flexibility in iconographic interpretation that is seen in the *Giants*. The classic source of the story is of course Sophocles' *Oedipus Rex*, one of the most magnificent of ancient tragedies.[14] The basic argument of the story as told in Sophocles is that the infant Oedipus was exposed, with his feet pierced, on the order of his father King Laius of Thebes, because an oracle foretold that any son born to him and his queen Jocasta would slay his father and marry his mother. Rosa shows the moment in the narrative when the child was rescued by the shepherd who would then take him to Polybus, the childless King of Corinth, for adoption. The rescue set in motion the chain of events which led to the fulfillment of the oracle's prophecy. When he was grown, Oedipus also consulted the Delphic Oracle and received the same prophecy as King Laius, that he would slay his father and marry his mother. He therefore fled the house of his presumed father, Polybus, and in the course of his wanderings met, and in a roadside argument, slew his real father. Unaware of his monstrous crime he went to Thebes, solved the riddle of the sphinx, and was made king by the grateful Thebans. He married his mother, Queen Jocasta, and begat children by her. For a time Thebes prospered under his rule, but then a plague afflicted the city. The Oracle was consulted again and the Thebans were told to purge themselves of the blood guilt of King Laius' death by discovering and punishing his murderer. Led by Oedipus a search for the criminal followed and the truth was gradually revealed. With that Jocasta committed suicide and Oedipus blinded himself.

The story appears in a number of other ancient writings, most notably the *Phoenician Maidens* of Euripides, and the *Oedipus* of Seneca.[15] Most of these authors explain Oedipus' name, which means swollen-footed, by saying that his feet were maimed, usually by being pierced with a rod or piece of metal, before he was exposed. None of them, however, says that he was hung from a tree as Rosa shows him. If it were not for an unusual feature of the print's inscription it would be possible to argue that Rosa, in departing so radically from his classical sources, was simply striving for an imaginative and inventive compositional solution and one that would form an appropriate compositional complement to the *Fall of the Giants*. It is of course true that the composition of the *Oedipus* is marvelously successful and gains great expressive force by the interweaving of the figures with the

[13] *Ibid.*, 1.20-23 (Loeb, I, pp. 28-29).
[14] I use the Loeb Classical Library edition by F. Storr, London, New York 1928, I, pp. 6-139.

[15] See also Statius, *Thebaid*, 1.46-88; Apollodorus, *The Library*, 3.5.6-9; Didorus Siculus, 4.64.

splendid tree. But the inscription makes it clear that by showing the child in so unorthodox a pose, Rosa intentionally created a poignant variation on the Oedipus story as it is usually known. It says: *Oedipus hic fixis, verfisque ad sidera plantis / Edocet ad sortem quemlibet ire suam.* (Oedipus here, with his pierced feet upturned to the stars, shows that each man goes to his own fate.) Rosa clearly attached special significance to the conceit of placing the child with his feet to the stars since the phrase *sidera plantis* is a clearly recognizable quotation from an elegy of Propertius: *Nunc mihi summa licet contingere sidera plantis.* (Now it is mine to set my feet upon the highest stars of heaven.)[16] As the phrase occurs in Propertius, it is an expression of joy at a happy love, but in Rosa's *Oedipus* it takes on a bitter irony. The crippled feet of the child Oedipus are turned to the stars but will never touch them. Instead his headlong posture prefigures his tragic fall.

Given this conscious attempt at subtlety of meaning and the imaginative freedom used to achieve it, it seems possible to think that Rosa had a further refinement of interpretation in mind in giving the grove of trees in the print such prominence. None of the classical sources dwell at length on the appearance of the place in which the child Oedipus was exposed, they usually simply say he was left to die on Mt. Cithaeron. But Rosa's grove with the spring of water that flows from it is strikingly reminiscent of the grove described by Creon in Seneca's *Oedipus* in which he saw the ancient priest Tiresias summon up the shade of King Laius who reveals for the first time in the drama that it is Oedipus who was guilty. It cannot be proved that Rosa had Seneca's description specifically in mind when he conceived the *Oedipus* print, but he certainly would have known the version of the Oedipus story as presented by his favorite philosophical writer. And although the grove itself does not agree in every detail with the description or the text, it is strikingly similar in its savage picturesqueness and decay:

Far from the city is a grove dusky with ilex-trees near the well-watered vale of Dirce's fount. A cypress, lifting its head above the lofty wood, with mighty stem holds the whole grove in its evergreen embrace; and an ancient oak spreads its gnarled branches crumbling in decay. The side of one devouring time has torn away; the other, falling, its roots rent in twain, hangs propped against a neighbouring trunk. Here are the laurel with bitter berries, slender linden-trees, Paphian myrtle, and the alder, destined to sweep its oarage over the boundless sea; and here, mounting to meet the sun, a pine-tree lifts its knotless bole to front the winds. Midmost stands a tree of mighty girth, and with its heavy shade overwhelms the lesser trees and, spreading its branches with a mighty reach, it stands, the solitary guardian of the wood. Beneath this tree a gloomy spring o'erflows, that knows nor light nor sun, numb with perpetual chill; an oozy swamp surrounds the sluggish pool.[17]

Most important of all, Rosa's reliance on Seneca in this matter is notably consistent with his free play with levels of meaning seen in both this print and the *Giants*. By including the grove of trees in which the ghost of Laius was summoned up, the artist linked the beginning of the tragedy, the rescue of the child, with its high point—the revelation that Oedipus himself was the monstrous criminal who slew his father and married his mother. Just as his headlong posture serves to prefigure the fall of Oedipus, so does the landscape.

The Dream of Aeneas [117];
Jason and the Dragon [118]

In contrast to the *Giants* [115], the *Oedipus* [116], and most of Rosa's other large prints, neither of these two etchings seems to have any particular symbolic or philosophical program or intent. They even lack the inscriptions which proclaim such programs in most of his other large etchings. Instead they can be considered simply as pictorial realizations of specific dramatic episodes from classical literature, episodes which involve heroes who succeed

[16] Propertius, *Elegies*, 1.8.43. In the Loeb Classical Library edition by H. E. Butler, London, New York 1912, p. 25.

[17] Seneca, *Oedipus*, 530-48. In the Loeb Classical Library edition by F. J. Miller, London, New York 1917, pp. 473-75.

in their endeavors in a straightforward way, uncomplicated by philosophical commentaries or moralizing reservations.

The Dream of Aeneas is based on a particular passage in the *Aeneid* which Rosa follows quite closely, especially in his description of the river god Tiber: "It was night, and over all lands deep sleep held wearied creatures, birds and beasts alike, when father Aeneas, his heart troubled by woeful war, stretched him on the bank under the sky's chill cope, and let late sleep steal over his limbs. Before him the very god of the place, Tiberinus of the pleasant stream, seemed to raise his aged head amid the poplar leaves; thin lawn draped him in mantle of grey, and shady reeds crowned his hair."[18] The river god then speaks to Aeneas advising him how to proceed in his quest and prophesying the victory and success that the hero was to achieve.

The *Jason and the Dragon* is, of course, based on the famous account in Ovid's *Metamorphoses* in which Medea, who had fallen in love with Jason, makes it possible for him to win the golden fleece by giving him a magic potion to pour over the dragon guarding it.[19] This episode ends in victory for Jason, who triumphantly bears away both the golden fleece as his prize and Medea as his wife. Although subsequent events in the story of Jason and Medea lead to tragedy, there is no hint of this in Rosa's etching.

In this directness of presentation and lack of inscriptions, both the *Aeneas* and *Jason* have a great deal in common with Rosa's earliest large prints, the *St. William* [99], *Albert* [100], *Glaucus and Scylla* [101], and *Apollo and the Cumaean Sibyl* [102]. The *Jason* is also, like the *Glaucus and Scylla* and *Apollo and the Cumaean Sibyl* based on Ovid's *Metamorphoses*. Moreover, all of these prints are the same size, that is, distinctly smaller than any of his other subject prints except the *Ceres* [112], an etching which indicates, incidentally, that the use of inscriptions is not simply a function of print size. For all of these reasons it could be argued that the *Aeneas* and *Jason*, which are nowhere mentioned in Rosa's letters, were done at the same time as the *St. William*, *Albert*, *Glaucus and Scylla* and *Apollo and the Cumaean Sibyl*, as part of the same campaign. However, several considerations lead me to believe that the *Aeneas* and the *Jason* must be the latest of Rosa's prints, done after the *Giants* and *Oedipus* and probably before the letter of October 4, 1664, in which he told Ricciardi that it was no longer possible for him, because of failing eyesight, to work with "cose piccole."[20] Most importantly, both prints continue to develop the Baroque qualities of the *Giants* and the *Oedipus*. This is seen in the energetic, bursting quality of both and in the arrangement of their forms and gestures along forceful diagonals which push vigorously out of picture depth toward the viewer.

In the case of the *Aeneas* there is also documentary evidence from Rosa's letters that supports a late dating, since in the letter of October 21, 1663, in which he explained that the "pinx." of the *Oedipus* and *Giants* etchings was intended to encourage requests for paintings of the subject, he also stated that aside from the *Regulus* [110], the *Democritus* [104], and the *Diogenes Casting Away His Bowl* [103] he had not done paintings of any of his other etchings.[21] Since there is in fact a painting of *The Dream of Aeneas* now in the Metropolitan Museum of Art, New York, which is almost identical with the etching [117a], and since it can be shown that the etching almost certainly follows the painting, it must then be concluded that the *Aeneas* etching had not been done at the time the letter of October 21, 1663, had been written.

Although there is nothing to prove that the painting preceded the etching, strong reasons for thinking that it did are found in the reversal of the two from each other and, more circumstan-

[18] Vergil, *Aeneid*, 8.26-34. In the Loeb Classical Library edition by H. R. Fairclough, London, Cambridge, Mass., 1937, II, p. 63.

[19] Ovid, *Metamorphoses*, 7. The charming of the dragon occurs in 149-59.

[20] De Rinaldis, pp. 166-67, no. 132: "E per condimento di tutta questa mia disgrazia, m'ha indebolita la vista in maniera che non posso nè leggere nè dipingere senz'occhiali.... Dipinger cose piccole, son disperate per me...." For other references to his difficulties with health and vision, see De Rinaldis, p. 165, no. 131, dated June 21, 1664; p. 167, no. 133, dated November 9, 1664; and "Note Liminari," 9. See also Salerno, 1963, p. 98.

[21] See above n. 1. However, in the letter of December 15, 1666, also cited there (De Rinaldis, p. 193, no. 157), he said: "I giganti e l'Edipo non sono stati da me ancora dipinti, il resto, si è ben vero che ho pensiero

tially, in the preparatory drawings for the composition.[22] The earliest of the known studies for the *Aeneas*, a very free, sketchy pen and ink drawing now in Leipzig [117b], shows Rosa experimenting with a pronounced diagonal placement of forms in space. Aeneas, identifiable by his helmet, is seated asleep in an awkward posture, legs akimbo, in the immediate right foreground. The river god Tiber, known by his summarily sketched reed crown and urn, looks in from the left foreground. A small drawing in Berlin [117c] shows a figure very much like the Leipzig Aeneas seated in a similar, if reversed, pose, and another small drawing in Leipzig [117d] shows him seated in a more graceful position with his arms and legs arranged in a more planar fashion.

The next important study in the sequence is the splendid pen and wash drawing now in the Louvre which contains all the essentials of the final composition, and is closer to the painting than to the etching [117e]. It is especially interesting that in this drawing vivid *pentimenti* show Rosa experimenting with a variety of positions for the river god's outstretched arm, ranging from something close to the rather conservative solution of the painting to the boldly extended gesture of the etching. He was also dissatisfied with the pose of the Aeneas in the Louvre drawing and restudied the figure in two small sketches, one in the British Museum which shows the figure in essentially the same basic pose as in the Louvre drawing [117f] and the other, now in Leipzig [117g] in which an important change is made in the position of the figure's legs so that they push out of picture depth more forcefully to create the more vigorous diagonal in space seen in both the painting and the etching. This drawing, which is clearly for the painting, strongly suggests that the painting preceded the etching, and that this alteration of pose was established first in the drawing, then in the painting, and finally reproduced in the etching. It is much less likely that Rosa would have made so basic a change in the position of Aeneas directly on the plate in doing the etching from the Louvre drawing, only to do a preparatory drawing for the final painting which simply repeats, with a few very slight changes, the solution of the etching. Moreover, the fact that the drawing is reversed from the etching makes it unlikely that it follows the etching and precedes the painting.

The etching then seems to use both the painting and the Louvre drawing as models and to incorporate features from both. Most notably, Rosa returned in the etching to a pose for the river god which is closest to that seen in the drawing; he lengthened the right leg of the drawing as the left leg in the print in a way that is suggested by the *pentimento* of the drawing, and most significantly of all, he rejected the restrained gesture of the Tiber in favor of the much more aggressive gesture seen in the drawing's *pentimenti*. In sum, in creating the *Aeneas* etching, Rosa chose the most Baroque of the alternatives open to him, rejecting the pose of the Aeneas in the Louvre drawing in favor of the one seen in the painting, and rejecting the posture and gesture of the Tiber figure in the painting in favor of those seen in the drawing.

There are other reasons for thinking that the etching is late. The figures have the massiveness typical of those in the late etchings and are rather different in this respect from the more slender figures of the *St. William* [99], *Albert* [100], *Glaucus and Scylla* [101], and *Apollo and the Cumaean Sibyl* [102]. In addition, Aeneas and the river god relate to each other, both compositionally and spatially in a fluent and smoothly harmonious way, with no trace of the awkwardness, stiffness, tension, or ambiguity seen to varying degrees in his early large etchings. This is particularly evident, for example, in a comparison of the *Aeneas* with the compositionally very similar *Glaucus and Scylla*.

In analogous fashion the etching technique used in the *Aeneas* is characterized by a polished, assured handling of the needle, creating gliding effects of light and shadow and a kind of shifting, insubstantial, crepuscular tonality that is wonderfully evocative

d'una volta dipingerli (se mi verrà fatta)." Given the extreme vagueness of the phrase "il resto" I am very reluctant to give this later letter much weight in dating the prints, especially in the light of the strong evidence presented here for dating the print after the painting.

[22] It should be noted, however, that the reversal argument is not a conclusive one since all the evidence indicates that the *Glaucus and Scylla* painting was done after the etching even though the two are reversed from each other. See above Ch. IV, n. 23.

of the world of dreams. In this it has something of the tonal subtlety of the *Giants*.

The general type of composition seen in the *Aeneas* is also found in a number of Rosa's other late works. One of these is the painting *Pan and Pindar*, formerly in the Chigi Collection, Rome, which is known to have been exhibited at the Pantheon in 1666 and was probably done slightly earlier.[23] There are, moreover, a large oil sketch and several drawings for this composition, all of which are done in a free, assured late style which in the case of the drawings is like that of the *Aeneas* drawings.[24] Two other drawings, typically late in style, of a woman emerging from a clump of trees and gesturing to a man seated on the ground before her are very similar in composition to both the *Aeneas* and the *Pan and Pindar*.[25] And of course the *Jason* etching itself [118], the painting related to it [118a], and a number of drawings that can be associated with it [118c]-[118k] are all very similar to the *Aeneas* in their general compositional solutions and are all clearly late in style.

The prevalence of this kind of two figure composition in Rosa's late art can probably be explained not only by his growing interest in vigorously Baroque compositional solutions, but also by the difficulties he had, because of his health, in doing large, ambitious compositions with many figures. In the letter to Ricciardi of June 21, 1664, he explained that because of the great fatigue he felt in painting, it was necessary for him to choose easy subjects with a limited number of figures.[26]

It is not clear whether the *Jason* and *Aeneas* etchings were intended to be companion pieces. The *Jason* is slightly smaller, although this may be the result of a reduction in the size of the plate in the course of making the print (see the catalogue entry), and the scale relationship of the figures to the print as a whole is slightly different in each. The compositions do, however, have much in common, and even the use of a billowing flap of light drapery set off against a darker background is very similar in both. In addition, one of the finest of Rosa's late drawings, a marvelously free pen and wash sketch now in the Pierpont Morgan Library, New York City [117h] indicates that there are strong connections between the two prints since it shows a sleeping warrior very much like the Aeneas and an attacking figure in a pose which is almost identical with that of Jason's and which is based ultimately on the Borghese Warrior.

The precise evolution of the *Jason* composition in drawings is somewhat difficult to establish because of certain features several of them exhibit. The Morgan Library drawing seems to be an early idea, as is perhaps another similar pen and wash drawing in the École des Beaux-Arts, Paris, *St. George and the Dragon*, which is like the etching both in composition and in the dragon [118e].[27] This drawing is particularly interesting in its strong resemblance to Dürer's Apocalypse woodcut of *St. Michael and the Dragon* in the poses of the principal figures in relation to the monsters they spear. In addition the head of the dragon at the extreme right of the woodcut is remarkably like that of the dragon in the *Jason*.

The print was apparently done from the cartoon now in the Nationalmuseum, Stockholm [118c]. Unfortunately, I have not been able to see this interesting, somewhat puzzling drawing in the original; and in the Arts Council Exhibition catalogue I considered it a copy, chiefly because it seemed to me to be too perfectly finished to be a genuine Rosa preparatory drawing.[28] After having discussed the drawing with Dr. Michael Mahoney, who has no doubts about its authenticity, I have studied the issue more closely and have come to accept it although with the reservations discussed in greater detail in the catalogue entry.

Two other Leipzig drawings can be associated with the *Jason*. One is a very summary pen and wash study of Jason and the dragon which is almost identical with the etching, superimposed

[23] Salerno, 1963, p. 136, no. 87.

[24] The oil sketch is in the collection of Professor and Mrs. Milton Lewine, New York City; the drawings are in the Museum der Bildenden Künste, Leipzig (Bd. 25, no. 44; and no. 7434.2137).

[25] Museum der Bildenden Künste, Leipzig (Bd. 25, no. 2; and no. 7434.2137).

[26] De Rinaldis, p. 165, no. 131. Also cited above in Ch. V, n. 106.

[27] For the problems arising from associating this drawing with the *Jason* etching, see the catalogue entry.

[28] Wallace, "Rosa: Etchings," no. 106.

over a sketch of an armed man being led by a pointing woman, probably Jason and Medea [118f]. This group of two figures is repeated, seen from behind, in another drawing in Leipzig, suggesting that Rosa may have considered some such solution for the etching or perhaps for a related etching or painting [118g]. Two additional drawings in Leipzig are particularly puzzling and intriguing. Both are free sketches which have as their principal figures a Jason and the dragon group like that seen in the etching. Both are also reminiscent of Rosa's painting of *Cadmus* now in the Statens Museum for Kunst, Copenhagen,[29] and have subsidiary figures that are similar to those in the *Cadmus*. In one, what seems to be a female figure is surrounded by putti hovering in the air above Jason and holding up what is apparently a crown of some kind [118h]; in the other, a similar floating figure is very roughly sketched in, with Jason seen a second time in another pose, rather like that of the *St. George and the Dragon* figure, accompanied by secondary figures [118i]. It is especially curious that in each, the Jason and the dragon groups are made to fit compositionally into a pendentive-like shape, the boundaries of which are roughly sketched in. The only explanation that occurs to me is that in doing these drawings Rosa had in mind some kind of decoration in an architectural setting. Although he never executed such a program, similar architectural enframements are lightly sketched in on either side of a drawing in the Scholz collection: on one side the *Death of Aeschylus*, and on the other a group of men with a telescope. It is known from two of Rosa's letters of 1666 that he had refused a chance to do some kind of decorative scheme in the Palazzo Farnese,[30] and it is tempting to think that even though he turned down the offer he may have tried a few experimental studies for his own amusement. This would mean of course that these drawings follow

the etching rather than precede it, but there is no way of making certain that this was in fact the case.

It is true, however, that the *Jason* etching preceded and served as a model, with important variations, for paintings done some time later. The picture *Jason and the Dragon* now in the Museum of Fine Arts, Montreal [118a], and what seems to be a replica by Rosa's own hand in the collection of Lord Harrowby [118b] are clearly variations on the etching and very late in style. They were probably done, as Langdon suggests, in the late 1660s.[31] A drawing almost identical to the paintings is also definitely late in style [118k].

The *Jason* etching can also be considered the culmination of the Baroque qualities seen developing in the *Giants* [115], the *Oedipus* [116], and the *Aeneas* [117] prints. The composition is one of extraordinary violence in which, in a fashion typically Baroque, a dramatic instant is captured at the point of its highest intensity. The forms of the warrior and the dragon create a complex series of powerfully opposed diagonals locked into a precarious equilibrium which threatens to burst apart in centrifugal explosion at any moment. So strong was Rosa's interest in creating violent movement that, for the first and only time in his career as an etcher, he abandoned the accurate description of forms and indicated Jason's left leg simply by an impressionist blur of high velocity strokes and flapping drapery. The effect has a parallel in the right leg of the river god in the *Aeneas* painting—another reason for thinking that there is a close connection between the two compositions.

The graphic handling of the *Jason* is well suited to the essential violence of the etching. Looking at this print it is possible to understand how Theophile Gauthier could have maintained that Rosa etched with his dagger—the etched strokes have a stabbing, slashing intensity.[32] The background is done with rough lines of high velocity—straight, curved, hooked, and zigzag—overlaid

[29] Salerno, 1963, p. 126, no. 51. The stories of Cadmus and Jason have of course much in common, and a major source for the Cadmus legend is also Ovid's *Metamorphoses* (3).

[30] De Rinaldis, p. 187, no. 152, dated October 16, 1666, and p. 188, no. 153, dated November 13, 1666. For a group of small decorative frescoes in the Palazzo Pitti, Florence, quite plausibly attributed by the authors to Rosa, see M. Chiarini, and K. Noehles, "Pietro da Cortona a Palazzo Pitti, un episodio ritrovato," *Bollettino d'Arte*, LII, 1967, pp. 233-39.

[31] Langdon, "Rosa: Paintings," no. 43. She also observes that the composition of the painting is very closely dependent on that of the same scene in the illustrated edition of the *Metamorphoses* of 1641 by Johann Wilhelm Baur.

[32] Petrucci, 1934-1935, p. 28.

in many areas with sharp drypoint strokes to produce a dark foil for the vividly and harshly lighted figures. The lines that model Jason, and to a lesser extent the dragon, have an analogous energy; in their direction and velocity they add great force to the movements of both figures. Hatchings are in general rough, irregular, and composed of staccato, jabbing strokes, frequently supplemented by quick, sharp drypoint lines. Summarily executed burnishing is used to lighten the background next to Jason's upper right side and probably also in the sky at the top of the print.

In many ways the *Jason* seems like a reversion to the qualities seen in one of the earliest of Rosa's large subject etchings, the *Albert* [100]. Both have a similar kind of savage romanticism, and both use harsh, angular forms and compositions, and powerfully rough and irregular etching techniques. In a sense the *Jason* brings to a close a full circle of development in his subject etchings, which began with the *Albert* and *St. William* [99], and then gradually evolved into the more controlled regularity and balance of his classicizing prints from which he then turned away in the magnificently Baroque *Giants* and in the *Oedipus*. He restated this withdrawal in the *Aeneas* and brought this phase of his etching career to a close with the splendid *Jason*. The *Jason* more than any of his other large prints exploits the possibilities inherent in the etching technique for free, spontaneous, and dashing execution and surpasses all of them in realizing Rosa's romantic instincts in graphic form. This latest and most promising phase of his etching career was brought to an end by his failing eyesight.

CHAPTER VII

THE INFLUENCE OF SALVATOR ROSA'S ETCHINGS

Rosa's influence on later generations was extensive, and, in England particularly, so complex, rich, and many-faceted as to constitute a topic much too vast to go into in detail in a study of this scope. Fortunately, excellent work has been done in this area recently by John Sunderland in two important articles, already cited in connection with the *Figurine*, and his study of the 18th and 19th century followers of Rosa in the Arts Council Salvator Rosa exhibition catalogue.[1] Moreover, Elizabeth Manwaring, in her classic *Italian Landscape in 18th Century England* has demonstrated in great detail the profound impact Rosa's art and reputation had in England, not only on its art but also on its modes of vision, taste, art criticism and theory, philosophy, literature, and gardening. Although she concluded that Rosa's etchings played a very limited role in the dissemination of Rosa's influence because she thought they were not widely known,[2] the opposite seems to be the case. As has already been mentioned in the Introduction and the chapter on the *Figurine*, and documented in the catalogue entries on copies, imitations and derivations [131]-[144], Rosa's prints were well known in his lifetime, extensively printed after his death, and copied, imitated, and forged with extraordinary frequency. Sunderland has convincingly demonstrated that the *Figurine* and copies after them were evidently well known and extensively collected in the later 18th century in England.[3] It also seems very unlikely that those Rosa enthusiasts who collected his pictures avidly, traveled widely to see them, and discussed them eagerly would have overlooked the cheapest and easiest way to acquire his art.

Various dictionaries and encyclopedias of artists and the arts of the period also suggest that the etchings were well known. As early as 1695 Richard Graham in his *Short Account of the Most Eminent Painters*, which was added to the Dryden English translation of C. A. DuFresnoy's *De Arte Graphica*, refers to an

[1] Sunderland, "Mortimer and Rosa," pp. 520-31; "Legend and Influence," pp. 785-89; "Works by Other Artists," pp. 73-87, nos. 124-50. See above Ch. II, n. 3. See also Rotili, pp. 121-34, for further observations about Rosa's influence.

[2] Manwaring, p. 78.

[3] Sunderland, "Mortimer and Rosa," pp. 520-23.

"abundance of valuable prints" by Rosa's hand.[4] Joseph Strutt in his *A Biographical Dictionary . . . of all the Engravers . . . ,* London, 1785-86, mentions 60 *banditti*, soldiers, and other figures and 15 larger plates, 8 of which are identified specifically by title.[5] William Gilpin, in his *An Essay on Prints*, London, 1768, gave very favorable notice to Rosa's etchings,[6] and Lady Morgan gives quite a complete catalogue of his prints at the end of her book of 1824.[7]

In addition to their great popularity as prints, the etchings, especially the *Figurine*, seem to have significantly complimented and reinforced the influence of Rosa's paintings, and to have added thereby to his fame as a romantic painter. It seems not improbable that the frequent and even monotonous references to Rosa's "landscapes with *banditti*" in English writings on art of the period were much colored by a knowledge, direct or indirect, of the *Figurine* or *banditti* etchings, since the actual number of landscapes with *banditti* by Rosa himself is quite small even by Lady Morgan's accounting. In her catalogue of Rosa's pictures in which she lists approximately 180 works in British and Continental collections only 6 are specifically identified as scenes with *banditti*. Another 4 are identified as scenes with soldiers which could presumably be taken as *banditti*.[8] Today genuine Rosa landscapes with *banditti* are quite rare. Since *banditti* were particularly potent symbols of all that Rosa stood for to the Earl of Shaftesbury, Uvedale Price, Richard Payne Knight, William Gilpin, Mrs. Radcliffe, and Lady Morgan, to cite only the best known and most articulate spokesmen of the age, it seems reasonable to conclude that the *banditti* etchings must have had a significant influence in shaping the period's view of Rosa and

his art and thus in helping to determine the nature of his influence on the period in turn.

In most cases, in fact, it is difficult to separate the influence of Rosa's etchings from that of his paintings since later artists often relied to varying degrees on both. For example, Giovanni Ghisolfi, the closest and one of the most interesting and influential of Rosa's followers, specialized in ruin *vedute* which owe much to Rosa's paintings with ruins. Moreover, his *staffage* figures in general look a great deal like Rosa's, so much so that Baldinucci even claimed that some of them were actually painted by the master to help out his pupil. Such a gesture would have been unlike the proud Rosa, and a better explanation for the resemblance is found in Baldinucci's observation that Ghisolfi also studied models by Rosa zealously and eventually learned to do his own figures.[9] It is clear that the models Ghisolfi studied were above all the *Figurine* since in two of Ghisolfi's best and most ambitious pictures, the *Ruin Scene* in the Palazzo Rospigliosi, Rome (Fig. 23), and the *Ruins of Carthage* in Dresden, a considerable number of the principal figures are based directly on the *Figurine*.[10] It is especially interesting that many of Ghisolfi's compositions were much influenced by contemporary stage design,[11] and that he realized how effective Rosa's strikingly posed, energetically gesticulating *Figurine* could be when placed in such a context. It is as if he recognized the peculiarly theatrical qualities implicit in the strangely isolated *Figurine* and provided the kind of setting that they seemed to evoke.

Ghisolfi appears to have been an important and even seminal figure in the development of the ruin view in Baroque painting, and his introduction of Rosa-like figures into his compositions had interesting reverberations in that genre. Most importantly,

[4] *De Arte Graphica. The Art of Painting by C. A. DuFresnoy with Remarks. Translated into English . . . by Mr. Dryden . . . also a Short Account of the Most Eminent Painters . . . by Another Hand* [Richard Graham], London 1695, pp. 341-42.

[5] Vol. I, p. 275.

[6] Pp. 56-59, 131-33 of the 1792 ed., first published anonymously in 1768.

[7] Morgan, II, pp. 283-84. See also the introduction to the catalogue and Rotili, pp. 14-15.

[8] Morgan, II, pp. 269-82.

[9] Baldinucci, 1773, pp. 91-92. De Dominici, Tomo terzo, p. 251 says the same. See also A. Busiri Vici, "Giovanni Ghisolfi pittore di rovine romane," *Palatino*, VIII, 1964, pp. 212-19.

[10] In the former, [83] is repeated exactly, [58] is quite closely followed, and [73] is used with some variation. In the latter, [16] and [47] are repeated exactly, and [10], [41], [39], and [58] almost exactly.

[11] H. Burda, *Die Ruine in den Bildern Hubert Roberts*, Munich, 1967, pp. 29-31.

23. Giovanni Ghisolfi, *Ruin Scene,* painting. Rome, Palazzo Rospigliosi (Alinari/Scala)

the greatest practitioner of the architectural and ruin view in painting, Giovanni Paolo Pannini, was obviously influenced by him.[12] There are a number of figures in Pannini's ruin paintings that were based on specific Rosa *Figurine*, perhaps as known only indirectly through Ghisolfi,[13] but the actual number of such figures is much less important than the general Rosa-like qualities that so many of the figures in Pannini's ruin paintings have. They enliven and add a mood of romantic unease and disquiet to the compositions with their posturings, gesturings, and broodings, and they play roles that are often strikingly similar in basic feeling to those seen in many of Rosa's paintings, in his *Figurine* etchings, and especially in the Rosa-influenced ruin pictures of Ghisolfi.

Pannini in turn had a marked influence on Hubert Robert, who worked so closely with Pannini in Rome that paintings by the two artists have frequently been confused.[14] It is not possible to point to any figures in Robert's paintings which depend on specific examples from Rosa's paintings or *Figurine* etchings, but once again the flavor of the figures and figure groupings in many of Robert's ruin pictures is often Rosa-like, although the influence is usually considerably watered down by its transmission through the works of Ghisolfi and Pannini.

It is also possible to see the influence of Rosa, and of the *Figurine* in particular, on the etchings of Piranesi. The figures in the *Prisons* especially are generally reminiscent of Rosa's, perhaps as Mayor observer, as modified by the influence of Magnas-

co.[15] It is particularly interesting, and quite typical of the pattern that Rosa's influence often took, that one of Piranesi's earliest etchings, the *Dark Prison* (Fig. 24) copies two of the *Figurine* [69], [60], in a way that is so direct and literal that there can be no doubt about the connection.[16] In the later *Prisons* etchings, the figures are less directly modeled on Rosa's but in many ways they come closer to capturing the essential spirit of the *Figurine*, their tension, malaise, and, as Mayor puts it, their romantic unrestraint. The figures so derived are particularly appropriate to the somber and disturbing theatricality of the *Prisons* etchings, and it does not seem unreasonable to think that Rosa's art in general was a factor in directing Piranesi's art in the romantic directions exemplified not only by the *Prisons* series but also by his *Capriccio* etchings, which show interesting resemblances to Rosa's *Democritus in Meditation*, probably as known from the etched version [104].

Certainly the most important and most consistent follower in the Rosa tradition was Magnasco. His wild and turbulent landscapes, views of rocky coasts, shipwrecks, and scenes of penitent monks in the wilderness were obviously much influenced by Rosa's landscape paintings and represent a typical Late Baroque amplification of many of the romantic qualities found in Rosa. The similarities are striking not only in content, subject matter, and theme, but also in the actual treatment of forms and paint surfaces in rocks, trees, clouds, and water. The exaggerated descriptions of Rosa's paintings by later Romantic commentators apply so closely to the extraordinary violence and hallucinatory quality of Magnasco's pictures that it is hard to believe that these commentators were not looking at Rosa through the filter of

[12] *Ibid.*, p. 31; F. Arisi, *Gian Paolo Pannini*, Piacenza 1961, p. 30; Busiri Vici, "Giovanni Ghisolfi," pp. 212-19.

[13] Compare the following: Arisi's fig. 87 with [50]

109	[29]	174	[29]	222	[46] and [87]
125	[83]	192	[50]	241	[83]
148	[50]	212	[83]	358	[50]
167	[83]	215	[55]		

Arisi also publishes a drawing, fig. 12, after [83], which he incorrectly attributes to Rosa himself but which may have been a model used by Pannini, thus accounting for the frequent repetition of [83] in the paintings.

[14] Burda, *Die Ruine*, pp. 7, 31.

[15] A. H. Mayor, *Giovanni Battista Piranesi*, New York 1952, p. 16, "When he was in his later twenties he would seem to have studied the sixty-two little models for figure drawings that Salvator Rosa had etched about a century before. . . . Piranesi did not copy these figures literally in his etchings but certainly took their mood of romantic unrestraint. As he pushed this mood into the hectic, it seems impossible that he did not do so through studying the paintings of Alessandro Magnasco."

[16] See *G. B. Piranesi, Acqueforti e Disegni*, Turin, Galleria Civica d'Arte Moderna, 1 December 1961-21 January 1962, pl. i. See also Mayor, *Piranesi*, p. 6.

24. Giovanni Battista Piranesi, *Dark Prison*, etching.
New York, Metropolitan Museum of Art,
Harris Brisbane Dick Fund, 1937

Magnasco's (and other later artists') pictures as through a Claude glass. It is difficult and somewhat artificial to try to determine to what extent Magnasco was influenced by the etchings as opposed to the paintings since many of his figures show strong resemblances both to those seen in Rosa's landscape paintings and to the *Figurine*. As with Piranesi the figures are so modified by the artist's very particular and insistent style that singling out specific Rosa figures as particular models is virtually impossible, although at least one of the *Figurine* does appear repeatedly in Magnasco's pictures, most emphatically in his early period, much as in the case of Piranesi.[17]

Marco Ricci's paintings, drawings, and prints seem to reflect the influence of Rosa as known directly from Rosa's own works and also as transmitted through the art of Ghisolfi and Magnasco. His ruin pictures are in general very Ghisolfi-like, often with figures of the Rosa-Ghisolfi type, and his landscapes frequently show something of the wild extravagance of Magnasco.[18] However, many of his landscapes are relatively conservative and in many ways closer to Rosa than to Magnasco; they indicate a more direct knowledge of Rosa's art or possibly a contact through the art of the more restrained Peruzzini. Quite typically the influence of Rosa's landscape art and prints is most evident in Ricci's earlier pictures, but in a number of instances—including late pictures, prints, and drawings—specific borrowings from Rosa's *Figurine* series indicate at least some degree of continuing influence throughout his career.[19]

Ricci in turn, as an important initiator of a Venetian landscape tradition continued by Zais, Zuccarelli, and Marieschi,[20] passed on traces of Rosa's influence to these artists, many of whose pic-

[17] [41]. See B. Geiger, *Magnasco*, Bergamo, 1949, pls. 15, 47, 51, 65, 142, 469, 476.

[18] See *Marco Ricci*, Catalogo della mostra a cura di G. M. Pilo, con un saggio di R. Pallucchini, Bassano del Grappa, Palazzo Sturm, 1 September-10 November 1963, pp. XXXII, XXXVIII, LV, LVI.

[19] *Ibid*., fig. 6, *Allegorical Composition with a Monument to Newton*, [41] and [76]; pl. 9 [29]; pls. 10, 11 [51]; pl. 16 [46]; pl. 62 [87]; pl. 192 [55]; pl. 231 [50].

[20] *Ibid*., p. XXV.

tures are populated by *staffage* figures which are to varying degrees reminiscent of Rosa's *Figurine*.

Ricci may also have played a role in arousing Giovanni Battista Tiepolo's interest in Rosa's art since as a young man Tiepolo conferred on and corrected some of Ricci's etchings.[21] In any case, Tiepolo was certainly the most important printmaker to show the impact of Rosa's etchings.[22] This is easily demonstrated in two of the *Scherzi* (Fig. 25), which were strongly influenced by Rosa's *Democritus*, either as known in the painting or more probably in the etching after it [104].[23] Furthermore, several of the *Capricci*, especially the earlier ones, contain figures that are quite like certain of Rosa's *Figurine*.[24] More important than any of these details, Tiepolo's general approach to the *Capricci* and *Scherzi* is much like that seen in Rosa's etchings, particularly the *Figurine*; mysterious, conspiratorial groups of figures garbed in peculiar and exotic costumes are shown engaged in unidentifiable and often sinister activities.[25] However, the appearance of these effects in Tiepolo's prints can also in large measure be attributed to Tiepolo's pronounced interest in the etchings of Castiglione from which he borrowed a number of figures and many of the macabre implements and trappings. It is no accident either that the most direct examples of Tiepolo's use of Rosa's etchings, the two *Scherzi* are based on the *Democritus*, which in turn derives directly from Castiglione's *Melancholy* (Fig. 14). But in the *Capricci* especially, and also in the *Scherzi*, the arrangements of the figure groupings, the frequent appearance of *Figurine*-like types in armor and exotic costumes, and the kinds of postures and

[21] A. Rizzi, *The Etchings of the Tiepolos*, London, 1971, p. 10.

[22] Rosa's influence on Tiepolo's prints is very briefly noted in Rizzi, *Etchings*, p. 11, and in T. Pignatti, *Le acqueforti dei Tiepolo*, Florence 1965, pp. 11-12. See also C. Dempsey, "Tiepolo Etchings at Washington," *Burlington Magazine*, 114, 1972, pp. 503-7.

[23] The print illustrated here is De Vesme 17, Pignatti, *Le acqueforti*, XVII. The other is De Vesme 34, Pignatti XXXIV. See also Wallace, "Democritus," p. 31.

[24] De Vesme 4, Pignatti IV [49]; De Vesme 5, Pignatti V [50]; De Vesme 6, Pignatti VI [49].

[25] See Dempsey, "Tiepolo Etchings," pp. 504-7 for a fascinating investigation of the themes of magic, witchcraft, and gnosticism in Tiepolo's prints.

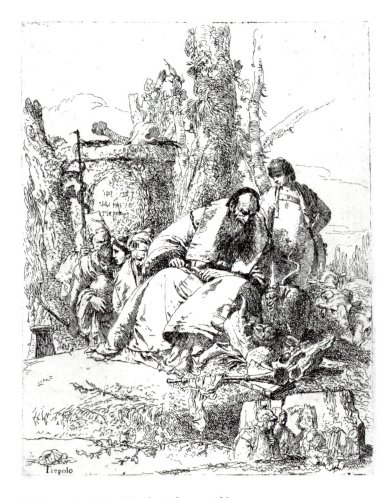

25. Giovanni Battista Tiepolo, *Scherzo*, etching. Boston, Museum of Fine Arts

gestures are in general much more like those seen in Rosa's etchings than in Castiglione's. Moreover, in both Rosa's and Tiepolo's etchings there is a conscious manipulation of form, composition, costume, posture, and gesture to achieve, in the true spirit of the *capriccio*, the widest possible variation on a theme, something that is less apparent in Castiglione's prints.

In addition to the important examples already cited, other interesting reflections of Rosa's etchings, the *Figurine* especially, can be seen in the *staffage* figures of Andrea Locatelli's landscapes, which were also much influenced by Rosa's landscape style; in the work of William Christian Ernst Dietrich, who did a number of etchings based on Rosa prints; and in the paintings of Joseph Vernet, whose scenes of rocky coastlines, storms, and shipwrecks, clearly owe a great deal to the landscape tradition initiated by Rosa, and are often populated with figures strongly reminiscent of Rosa's *Figurine*.

Other examples of Rosa's influence in general and of the *Figurine* in particular could be cited, but suffice it to say that the *Figurine* facilitated the vast production of Rosa-like romantic landscapes, derivations, imitations, copies, and forgeries that flourished in the 18th and 19th centuries by providing convenient models for the *staffage* figures of such landscapes. This was such a common practice that the *Figurine* can be used as a convenient guide in assessing the genuineness of Rosa landscape attributions; if any of the figures in the painting are identical with the *Figurine*, the picture is almost certainly not by Rosa. I know of only one exception to this rule, the *Landscape with Bathers* in the Yale University Art Museum.[26]

Rosa's influence in England in the later 18th century and 19th century deserves special attention since it permeated so many different levels of English art and thinking. His etchings were demonstrably very familiar to English critics, collectors, and connoisseurs of the period and his paintings were avidly collected

and evidently widely known, probably as much through derivations, imitations, and copies as through originals, and perhaps even more through the large number of engravings done after them.[27] Sunderland has outlined, with great acumen and sensitivity, the varying kinds of influence Rosa's art had on a number of the leading artists of the 18th and 19th centuries in England, Joseph Goupy, Richard Wilson, Philippe Jacques de Loutherbourg, John Hamilton Mortimer, Joseph Wright of Derby, Alexander Runciman, James Barry, Joshua Reynolds, John Henry Fuseli, J.M.W. Turner and Sir George Hayter.[28] He quite rightly observes that these influences were of a much more complex and subtle order than any simple borrowing of motifs, figures, or the like, and were closely bound up with the Rosa legend and the notions of savage sublimity and romantic extravagance that Rosa's name triggered.

It is particularly relevant here that the clearest and most extensive direct influence of Rosa's art in England is found in the work of John Hamilton Mortimer, and that it was Rosa's etchings in which Mortimer was most interested.[29] A major part of his production was in fact the large number of paintings, drawings, and etchings of *banditti* and soldiers, which clearly derive from Rosa's *Figurine* (Fig. 26); drawings and etchings of women and monsters (Fig. 27), which are very close to Rosa's *Battling Tritons* prints [91], [93], [94], and his *Glaucus and Scylla*, probably, in my opinion, as known through the etched version [101]; drawings and etchings of fighting monsters, which are directly derived from the Rosa *Battling Tritons*; a drawing of a man attacking a monster, which is very like the Rosa *Jason* etching [118]; and of course the painting, drawing, and etching

[26] Salerno, 1963, p. 125, no. 48a. See [50]. As noted in [29] the soldier group at Dulwich is not, in my opinion, by Rosa. A landscape painting with soldiers now in the Gemäldegalerie, Karlsruhe (see Rotili, no. 63a) repeats figures from [59] and [46] exactly, and is a typical example, albeit of high quality, of the many later imitations of Rosa's landscapes of this type.

[27] Manwaring, pp. 79-86. Tomory, "Prints after Rosa," nos. 31-63; "Checklist of Prints after Rosa not Exhibited," nos. 1-67.
[28] Sunderland, "Works by Other Artists," pp. 75-87; "Legend and Influence," pp. 787-88.
[29] Sunderland, "Works by Other Artists," pp. 78-80, nos. 133-39; Sunderland, "Mortimer and Rosa," pp. 520-31; *Mortimer A.R.A.*, especially pp. 26-27, nos. 29-30; pp. 34-39, nos. 51-75; pp. 46-47, nos. 87-94. Although Sunderland, "Mortimer and Rosa," p. 524, sees the *Man Attacking the Monster* as being closest to the painted version of Rosa's *Jason*, I feel it must certainly derive from the *Jason* etching [118].

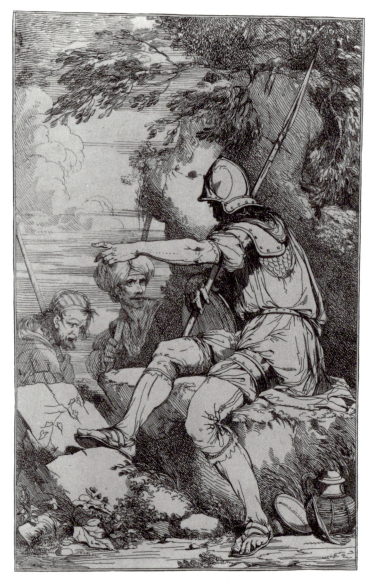

26. John Hamilton Mortimer, *Banditti Taking His Post*,
etching. British Museum

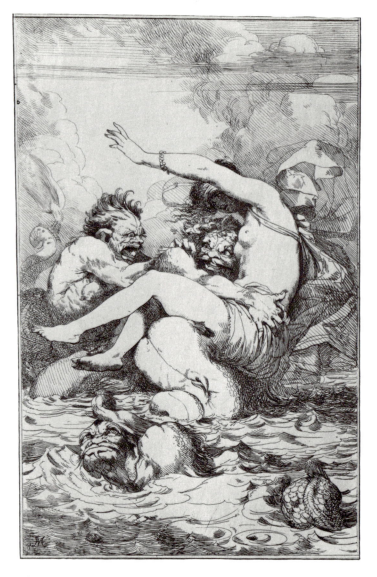

27. John Hamilton Mortimer, *Jealous Monster*, etching.
British Museum

of Salvator Rosa as a bandit seated in a landscape studying a book, the pages of which in the etching are covered with designs of *banditti* in landscapes (Fig. 4). And as Sunderland has pointed out, Mortimer not only followed Rosa clearly in such things as figure types, costumes, postures, gestures, groupings, compositions, and spatial organization, but also in etching style and technique, the latter extending even to the style of some of his drawings.

In addition to Mortimer's own etchings of *banditti*, soldiers, and monsters, his paintings and drawings of these Rosa inspired subjects were extensively reproduced in etchings and other graphic media by Robert Blyth, Joseph Haynes, and others. All of these prints obviously played an important role in publicizing Mortimer and his art much as the *Figurine* did in Rosa's case, except that, of course, the Mortimer prints played a double role, advertising Rosa as well as Mortimer since the public immediately recognized, as they were meant to, the connection between the two. This connection was not, apparently, limited to purely artistic considerations. Sunderland goes so far as to state that Mortimer "molded his own artistic personality, at least in part, on that of Salvator," and that this helps to explain the reckless, bohemian, and even riotous behavior that gained him so much notoriety in his lifetime and contributed to his reputation as "England's Salvator" and "the Salvator of Sussex."[30] It seems to me a plausible argument, but whether or not Mortimer consciously followed Rosa in adopting such behavior, his contemporaries thought he did, and this association must have gone far in reenforcing their image of Rosa as a similarly eccentric, extravagant, turbulent artist marked with all the qualities of Romantic genius.

There can be little doubt that Mortimer's art, his prints especially, contributed significantly to Rosa's reputation as a printmaker, in particular as one who dealt with similar kinds of exotic and savage subjects. Moreover, Mortimer's *banditti*, including the etching of Rosa as a bandit, taken together with his own bohemian ways, were major factors in fostering the growth of the Rosa legend. And since the Rosa legend seems to have been as impor-

tant to the art and thinking of the later 18th century and 19th century as was his actual production, the impact of Rosa's etchings on the period, simply through Mortimer, was surely considerable and wide-ranging.

After Mortimer, the English artist who shows Rosa-like qualities most directly and significantly is Joseph Wright of Derby. Mortimer probably had a hand in this since he and Wright were good friends, had studied together at Hudson's Academy, and worked together on a joint decorative scheme at Radburne Hall, Kirk Langley.[31] The most striking example of Wright's reliance on Rosa is seen in his *Hermit Studying Anatomy by Lamplight* of 1771-1773 (Fig. 28), a picture clearly based on Rosa's *Democritus*. This he could have known either in the original, which was in Foots Cray Place in Kent [104a], or through the etching after it [104].[32] He relied on Rosa's basic theme and compositional arrangement, and he seems also to have found sympathetic the somber light effects, the turbulent sky, and the macabre qualities of the *Democritus*. Furthermore, his earliest pure landscape, c. 1772, is, as Nicolson points out, a daringly wild and unconventional painting of a rugged cliff topped with shrubbery and broken trees and gushing a cascade of water—all in the style of Rosa.[33] In this picture Wright shows himself to be very much a child of his time and undoubtedly indebted to Mortimer as well as Rosa since he felt obliged to people the landscape with a group of *banditti*.

Wright's interest in *banditti*, especially Rosa's, seems to have been pronounced. In his journal he wrote admiringly of a Rosa landscape with *banditti*, which he had seen in Naples, as having great force and spirit.[34] And when he returned to England, he did one of his most Rosa-like pictures *A Grotto in the Kingdom*

[30] Sunderland, "Mortimer and Rosa," pp. 527-28.

[31] B. Nicolson, *Joseph Wright of Derby*, London 1968, New Haven, Connecticut, 1971, I, pp. 2, 4, 5.

[32] *Ibid.*, I, pp. 52-53, II, pl. 105. The author observes that the Rosa picture was readily accessible and well known, and that William Gilpin saw it and praised it in his *Southern Tour*. See also Wallace, "Democritus," p. 31, and Sunderland, "Works by Other Artists," pp. 82-83, no. 142.

[33] Nicolson, *Wright of Derby*, II, pl. 112; I, pp. 55, 75.

[34] *Ibid.*, I, p. 11.

of Naples with Banditti (Fig. 29).[35] Although the sources of his landscape style are many and complex, it seems likely that his interest in grottoes reflected not only his firsthand experience of those geological phenomena in the Salerno area but also his awareness of Rosa's landscapes.[36] The figures themselves are certainly clear reflections of Rosa's *Figurine* in general, and several of them are based on specific *Figurine*. The standing figure with his back turned is essentially a copy in reverse of [60] with slight variations in the position of his hands and feet but with striking similarities in costume. The figure seated on the ground in the painting repeats almost exactly (in reverse) the top half of the principal figure in [55], and the central seated figure is quite similar in the lower portions of his body to the bottom half of the same etched figure. This latter figure in the painting is also generally reminiscent of the principal figure in [57], and of the Aeneas in the *Dream of Aeneas* [117].[37] A very similar example of Rosa's influence on Wright is seen in the *River in a Rocky Gorge*,[38] which has much in common with Rosa's landscapes in general terms and which repeats exactly one of the same *Figurine* [60] that appears, slightly modified, in the *Grotto in the Kingdom of Naples with Banditti.*

[35] *Ibid.,* II, pl. 211; I, pp. 81-83, and Sunderland, "Works by Other Artists," pp. 81-82, no. 141.

[36] Although the basic design of the grotto was first established in drawings done on the spot in 1774 (Nicolson, *Wright of Derby,* II, pl. 171, 172; I, p. 81), he may also have later seen one of Rosa's most romantic landscapes, *A Grotto with Cascades,* which was in the Pitti Palace when Wright visited Florence in 1775; it has many fundamental qualities in common with Wright's grottoes and is peopled with *banditti*-like figures (Salerno, pl. VII). If Wright saw it, the Rosa landscape could conceivably have acted as a further stimulus for pursuing the subject in the *Grotto in the Kingdom of Naples with Banditti.*

[37] Nicolson, *Wright of Derby,* II, pl. 211; I, pp. 81-83, notes the connection of the *banditti* to Mortimer, but is strangely puzzled by the source of what he calls "this astonishing group." Sunderland, "Works by Other Artists," p. 82, no. 141, sees them as deriving in costume, armor, and weapons from the *Figurine,* but as having more in common with the figures of Mortimer, although he feels that. "the common source in Rosa is undeniable."

[38] Nicolson, *Wright of Derby,* II, pl. 263.

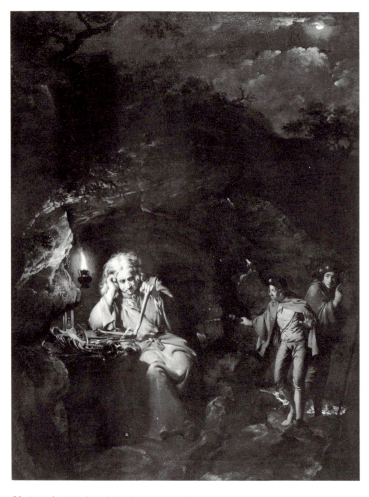

28. Joseph Wright of Derby, *Hermit Studying Anatomy by Lamplight,* painting. Derby Museum and Art Gallery

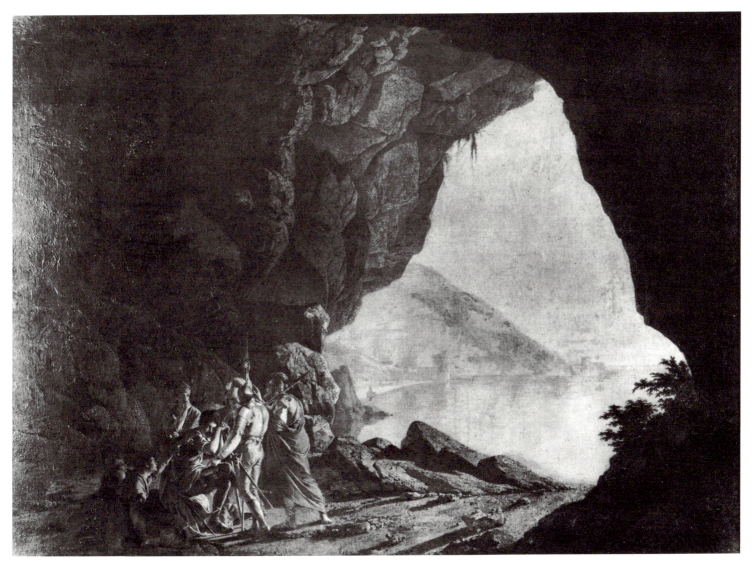

29. Joseph Wright of Derby, *A Grotto in the Kingdom of Naples with Banditti*, painting.
Derbyshire, Meynell Langley, Collection of Godfrey Meynell

Wright's interest in the *Figurine* seems not to have been limited to landscape paintings. The mother holding a child in *An Iron Forge Viewed from Without* is almost identical with Rosa's [87] down to the details of her costume.[39] Given this clear association, it seems reasonable to think that some of the other features of the picture—such as the turbulent sky with branches silhouetted against it, much as in the *Hermit Studying Anatomy*, or the broken tree stubs in the left foreground—may also show traces of Rosa's influence.

Aside from the works of Mortimer, Wright of Derby, and Philippe Jacques de Loutherbourg, whose *banditti* prints are clearly based on Rosa's and perhaps encouraged Mortimer's production in this vein,[40] the direct influence of Rosa's art on English pictorial art of the period seems to have been surprisingly circumscribed, when one considers that so much was written about him, that he was so much admired, and that his art was so widely known. To be sure there were a great many Rosa imitations, derivations, copies, and forgeries done by anonymous, minor, or amateur artists, although many of them were as much cliché reactions to a stereotyped view of Rosa as a painter of wild and savage landscapes as they were clear visual responses to his art itself. Apart from the works of Mortimer and Wright of Derby and a relatively few others, such as those by Richard Wilson, Thomas Jones, Alexander Runciman, James Barry, Joshua Reynolds, John Henry Fuseli, J.M.W. Turner, Sir George Hayter cited by Sunderland, and several works by Benjamin West,[41] it is not easy to find examples of a clear, direct influence of Rosa's

pictures, prints or drawings on the leading English painters of the period.

Instead, an extraordinary amount of Rosa's fame and influence in England seems to have rested on verbal and literary transmission, and to have had an impact that extended far beyond the boundaries of purely pictorial concerns, as both Manwaring and Sunderland demonstrate in considerable detail. The very nature of his pictures and etchings with their mysterious, elusive qualities evoked a wide range of fanciful commentary and romantic literary invention, so that, for example, landscapes with ordinary *staffage* figures were evidently transformed, in the eyes of Rosa enthusiasts, into landscapes with *banditti*, and a great many of his rocks and streams were metamorphosed into precipices and raging torrents in the same manner as his *Figurine* prints were transformed into savage *banditti*. His name came to be a code word for the qualities most appreciated by the Romantics of the later 18th century and early 19th century: savage sublimity, terror, grandeur, astonishment, and pleasing horror. Hartley Coleridge put it nicely, "Salvator Rosa—never was man so blest in a name!"[42] Horace Walpole in crossing the Alps in 1739 could invoke his name much as an earlier traveler might a patron saint, "Precipices, mountains, torrents, wolves, rumblings, Salvator Rosa."[43]

It is clear that Rosa's etchings, especially the *Figurine* played a significant role in the formation of this literary or verbal tradition and, through the writings of such important authors and critics of the period as the Earl of Shaftesbury, Uvedale Price, Richard Payne Knight, William Gilpin, and Mrs. Radcliffe, contributed in a very important way to the shaping of the Rosa legend, in much the same way as did Mortimer's art and life. And much as with Mortimer, the myth of Rosa's life with the *banditti* of the Abruzzi seems to have added a great deal to the attractiveness of Rosa's *banditti* etchings for many of these writers. It is particularly noteworthy that they seem to have been especially fascinated with his landscapes with *banditti*, and invariably referred to them when the occasion arose in their writings

[39] *Ibid.*, II, pl. 104.

[40] Sunderland, "Works by Other Artists," pp. 77-78, no. 132 [143], [144].

[41] *Ibid.*, idem, "Legend and Influence," pp. 787-88. In the case of Benjamin West this is seen most notably in the *Saul and the Witch of Endor* now in the Wadsworth Atheneum, Hartford, Connecticut, which is based directly on Rosa's picture of the same subject, and in a *Cadmus* drawing which is based on the *Jason* etching [118]. For the drawing, see F. Cummings, A. Staley, R. Rosenblum, *Romantic Art in Britain, Paintings and Drawings 1760-1860*, Detroit Institute of Arts, 9 January-18 February, 1968; Philadelphia Museum of Art, 14 March-21 April, 1968, p. 101, no. 52.

[42] Manwaring, p. 229.

[43] *Ibid.*, p. 170.

to drive home a particularly emphatic point about Rosa's romantic savagery.[44] Since, as I have already indicated, the actual number of Rosa landscapes with *banditti* seems in fact to have been relatively small, even by Lady Morgan's reckoning, it appears very likely that these writers' understanding of Rosa was strongly colored, directly or indirectly, by a knowledge of his *Figurine*.

This is seen most vividly in the writings of William Gilpin, who because of the great popularity of his travel books was probably the most generally influential critical voice of his time. He had a particularly keen taste for scenes of savage sublimity, and it is not surprising that Salvator Rosa was his favorite artist and the ultimate arbiter of the sublime.[45] Gilpin was especially enthusiastic about *banditti*, referring to them on a number of occasions and seeing them as especially well suited to landscape scenes in which wildness and horror figure: "The whole view is entirely of the horrid kind. Not a tree appeared to add the least cheerfulness to it.

"With regard to the adorning of such a landscape with figures, nothing would suit it better than a group of banditti. Of all the scenes I ever saw, this was the most adapted to the perpetration of some dreadful deed. The imagination can hardly avoid conceiving a band of robbers lurking under the shelter of some projecting rock; and expecting the traveler, as he approaches along the valley below."[46] Or:

. . . the picturesque eye, in quest of scenes of grandeur, and beauty, . . . ranges after nature, untamed by art, and bursting

wildly into all its irregular forms. . . . It is thus also in the introduction of figures. . . . The characters, which are most suited to these scenes of grandeur, are such as impress us with some idea of greatness, wildness, or ferocity; all of which touch on the sublime. Figures in long, folding draperies; gypsies; banditti; and soldiers,—not in modern regimentals; but as Virgil paints them,—*longis adnixi hastis, et scuta tenentes*; are all marked with one or other of these characters; and mixing with the magnificence, wildness, or horror of the place, they properly coalesce; and reflecting these same images, add a deeper tinge to the character of the scene.

For the truth of all these remarks I might appeal to the decisive judgment of Salvator Rosa; who seems to have thoroughly studied propriety in figures, especially in scenes of grandeur. His works are a model on this head. We have a book of figures, particularly composed for scenery of this kind, and etched by himself. In this collection there is great variety, both in the characters, groups, and dresses: but I do not remember, either there, or in any other of his works, a low, mechanic character. All his figures are either of (what I have called) the negative kind; or marked with some trait of greatness, wildness, or ferocity. Of this last species his figures generally partook; his grand scenes being inhabited chiefly by banditti.[47]

The book of figures he referred to was certainly a bound volume of the *Figurine* or copies after them, probably the former since he was something of an authority on graphics and the author of one of the earliest and most important studies in English on the subject, *An Essay on Prints* (1768). Like his other writings it seems to have been very popular and influential, and it must have contributed significantly to Rosa's reputation as a printmaker, since Gilpin is, by his standards, quite warm in his praise of Rosa's etchings, finding them superior to Rembrandt's and singling out the *Polycrates* [111] as one of the select group of prints he chooses to discuss and analyze at length.[48] As might be

[44] Anthony, Earl of Shaftesbury, *Second Characters, or the Language of Forms*, edited by B. Rand, Cambridge 1914, pp. 155-57. For Shaftesbury, see also Manwaring, *Italian Landscape*, pp. 17-19, 44-48. Uvedale Price, *A Dialogue on the Distinct Characters of the Picturesque and Beautiful*. See the London, 1810 edition, III, pp. 308-9, and above Ch. V, n. 100. R. P. Knight, *The Landscape, A Didactic Poem*, London 1794, I, vv. 79-92, pp. 6-7.

[45] W. Gilpin, *Observations on the Western Parts of England, Relative Chiefly to Picturesque Beauty*, London 1798, p. 75.

[46] W. Gilpin, *Observations, Relative Chiefly to Picturesque Beauty, Made in the Year 1772, on Several Parts of England; Particularly the Mountains, and Lakes of Cumberland and Westmoreland*, 3d ed., London 1792, I, pp. 174-75.

[47] *Ibid.*, II, pp. 44-47.

[48] Gilpin, *An Essay on Prints* (1972 ed.), pp. 56-58, 131-33. See also n. 6 above.

expected he is particularly enthusiastic about the *Figurine*, even conceding them a separate entry in his index, "Robbers, Salvator Rosa's."

He also, in this study, fostered and added considerable luster to Rosa's reputation as a wild, savage type, and he seems to have been one of the earliest writers to refer to the legend, of unexplained origin, that Salvator spent the years of his youth with *banditti* in his native Calabria: "A roving disposition, to which he is said to have given a full scope, seems to have added a wildness to all his thoughts. We are told, he spent the early part of his life in a troop of banditti: and that the rocky and desolate scenes, in which he was accustomed to take refuge, furnished him with those romantic ideas in landscape, of which he is so exceedingly fond; and in the description of which he so much excels. His *Robbers*, as his detached figures are commonly called, are supposed to have been taken from the life."[49] Such an association, clearly inspired in large measure by Gilpin's knowledge of the *Figurine*, obviously added much to the aura of savage sublimity that surrounded Rosa and his art during the period. As Professor Manwaring puts it: "To how many law-abiding and amiable gentlemen and ladies . . . must not the consideration that these wild scenes and personages that they beheld with pleasure, were taken from the life, have imparted an extra thrill?"[50]

The counterpart to Shaftesbury, Price, Knight, and Gilpin in the realm of pure fiction was Mrs. Radcliffe. She was one of the most popular and extravagant of a group of lady novelists active in the later 18th century who were much given over to enthusiasm for the picturesque and who invoked the name of Claude and Salvator with great frequency. Her books, especially the later *The Mysteries of Udolpho* (1794) and *The Italian* (1797) are filled with descriptions of landscapes which, since her travels in the territories she describes so vividly were very limited—she had never been to Italy for instance—are, as Professor Manwaring observes, based chiefly on paintings, especially those of Claude and Rosa.[51]

She, like Gilpin, Price, and Knight, was much influenced by notions of the sublime as embodied in Rosa's art, and her frequent use of Salvatorial conceits certainly did much to popularize him and his art. Like Gilpin she loves wild, savage landscapes peopled with *banditti*, and in *The Mysteries of Udolpho* a major part of the plot is taken up with the comings and goings of a robber band whose headquarters is a gloomy castle in the mountains. It is particularly interesting that her frequent descriptions of *banditti*, singly and in groups, show such striking parallels to Rosa's *Figurine* that one cannot help but feeling that they could almost have been written with the etchings before her.

To sum up, Rosa's art and reputation had an enormous impact on the 18th and 19th centuries, especially in England. His important and even formative influence on concepts of the sublime and the aesthetic of terror, and his extravagance helped to pave the way for the fantasy, violence, and passion of Romantic art. The gloomy melancholy and bizarre mystery of many of his large figure pictures and etchings anticipated an important aspect of later 18th century history painting and printmaking, just as his powerful landscapes with frail men threatened by a hostile nature adumbrate the most important qualities of Romantic landscape art. He contributed significantly to the notion of the creative genius as a superior spirit, a concept that was of central importance to Romantic art, literature, and thinking.

Throughout this tangled, dense web of Rosa's influence on later generations, his etchings, especially the *Figurine*, are interwoven, adding romantic luster to his art and reputation and contributing significantly to the legend that grew up around him. They were extraordinarily successful, undoubtedly beyond even Rosa's most extravagant dreams, in realizing the intention he had in doing them of publicizing his art, his ideas, and himself.

[51] *Ibid.*, Ch. 8, especially pp. 212-17.

[49] *Ibid.*, pp. 57-58. See also Sunderland, "Mortimer and Rosa," p. 527.
[50] Manwaring, p. 48.

CATALOGUE RAISONNE

CONTENTS

INTRODUCTION

Rosa's prints were listed, with varying degrees of comprehensiveness, by a number of writers and encyclopedists prior to Bartsch. As early as 1767, F. Basan, in his *Dictionnaire des graveurs anciens et modernes*, Paris, mentioned sixty prints of soldiers and other figures and sixteen larger prints, nine of which he identified by subject. G. Gori Gandinelli, *Notizie istoriche degl'intagliatore*, Siena, 1771, says that Rosa did seventy-four or eighty-four prints; he cites a *libretto* of small figures and five of the large prints by title. J. Strutt, in his *Biographical Dictionary . . . of All the Engravers*, London, 1785, mentions sixty small figure prints and fifteen large ones, eight of which he cites by title. In 1800 M. Huber, in his *Manuel des curieux et des amateurs de l'art*, Zurich, cites sixty soldier prints, six prints of tritons and river gods, and he lists eighteen of the large prints by subject. M. Bryan, *A Biographical and Critical Dictionary of Painters and Engravers*, London, 1816, mentions sixty-two small figure prints, six plates of tritons, sea nymphs, etc., and lists thirteen of the large prints specifically by subject. A less complete listing is found in H. R. Füssli's *Kritisches Verzeichnis der besten, nach den berühmtesten Malern aller Schulen vorhandenen Kupferstiche*, Zurich, 1802.

The basic catalogue of Rosa's etchings was produced in 1820 by Adam Bartsch in volume xx of *Le Peintre Graveur*. With the comprehensiveness typical of his work, Bartsch assigned to Rosa the eighty-six prints that remain to this day the basic corpus of his etched oeuvre. Bartsch did, however, miss the unusual, rare, and variant prints, and for that reason made one attribution that I consider incorrect [65a]. Also he was apparently unaware that various states exist for many of Rosa's large etchings.

In 1870, C. Meyer, in "Nachtrag zum Verzeichniss der Radirungen Salvator Rosa's," *Jahrbücher für Kunstwissenschaft* (Zahn), attributed another twenty-four prints to Rosa. A few of them are derivations or imitations by other artists, but most of them are rare and unusual etchings by Rosa himself, such as the early *Praying Penitent in a Wilderness* [2], the *Landscape with a Figure* [3], the skull studies related to the *Democritus* [105], [106], [107], and most of the variants of the *Figurine*. Meyer's list was then reproduced exactly, with appropriate acknowledg-

ment, by G. K. Nagler, *Die Monogrammisten*, v, Munich, Leipzig, 1879.

Recently there has been a considerable revival of interest in Rosa's art, and in 1971 P. Tomory organized a show at the Ringling Museum of Art, Sarasota, Florida, entitled *Salvator Rosa, His Etchings and Engravings after His Works*. The catalogue is a rather brief survey of the basic etched oeuvre of Rosa as it has been generally known, and an excellent survey of the engraved works after Rosa.

In the fall of 1973 I organized and catalogued the etchings part of the Salvator Rosa exhibition sponsored by The Arts Council of Great Britain at the Hayward Gallery, London (October 16-December 23, 1973). A limited number of etchings, only twenty-six, could be shown, but for the first time in Rosa studies a comprehensive citation of states, variants, trial proofs, and drawings related to the etchings was made for each print catalogued. It was an approach that is followed in considerably more detail in the present study.

Coincident with the Arts Council exhibition, P. & D. Colnaghi & Co. organized a sale exhibition of Rosa's prints in London (October 11 - November 2, 1973), a number of them outstanding in quality, with a brief catalogue of his basic etched oeuvre. Various states were mentioned in a number of cases, and Mrs. Katharina Mayer Haunton of Colnaghi's was the first to recognize that Rosa's larger prints do exist in different states. She has been extremely generous in sharing this information with me and with others.

Also in the fall of 1973 the Libreria Marsilio da Padova organized an exhibition in Padua entitled *Terzo centenario di Salvator Rosa* and published G. Bozzolato's *Le incisioni di Salvator Rosa*. Bozzolato's study is an ambitious undertaking, and many of the variants and all but five of the different states of the large prints are cited. The text and catalogue entries are summary, and the catalogue is flawed by the poor quality of the reproductions and by a number of errors—the variants are usually incorrectly identified as different states of the same print, and a number of prints are confused with each other in numbering and illustrations. Related drawings are rarely mentioned.

M. Rotili's *Salvator Rosa incisore*, Naples, 1974, is the most important of the recent publications on Rosa's prints. The text is very thorough, but the catalogue has certain limitations. It does not include some fifteen of the *Figurine* variants, including a number listed by Nagler. The discussion of the different states of the large prints is summary—and references to them in most cases simply cite either the Arts Council catalogue or Bozzolato's catalogue. Five states of the large prints are omitted, the same ones overlooked by Bozzolato. The treatment of drawings related to the etchings is less than thorough, particularly in connection with the *Figurine* where, in most cases, he fails to cite the important final drawings that exist for many of them.

The present study attempts, for the first time in the literature on Rosa, to catalogue comprehensively all of the etchings, variants, trial proofs, and states—in short, all etchings of any kind that can be attributed to the artist himself—and to cite all of the paintings and drawings related to them. Prints formerly attributed to Rosa but not in my opinion by him are also catalogued and discussed as rejected attributions. The most important of the seemingly countless copies after his prints have been cited and included at the end of the catalogue with descriptions that I hope will be useful in identifying different copies.

Technical Issues and Quality of Impressions

Since this book is intended to be not only an art historical study but also a useful reference work for collectors, curators, dealers, and print specialists, I have tried to be as precise and detailed in describing the individual prints as is reasonably possible. This is quite important since state changes were often made by slight burnishings or additions of drypoint, or by both. Most important, since the quality of the drypoint in a given print is usually the most reliable guide to the freshness, earliness, and quality of the impression, drypoint deserves special attention. Rosa used it basically as a convenient way of modifying, correcting, accenting, adjusting, and toning his plates, which were done with single-stage biting, and he seems not to have been especially concerned with the particular qualities of burr, richness of inking, and subtle tonal effects that drypoint can produce, nor with earliness of

impression. He did not handle the needle in a way that would produce pronounced burr and, as has already been mentioned in connection with the *Regulus* [110] in Chapter V, he told Ricciardi that he would have to wait for a copy since they were so much in demand, indicating that he attached little importance to the earliness of the impression. Despite this attitude, the best impressions of his prints are of course the earliest ones, such as a number of first states and early proofs of the *Figurine* in the Gabinetto Nazionale delle Stampe, Rome, the *Figurine* in the Chambers Hall volume in the British Museum, a set of the *Figurine* in the Rijksmuseum, and many of the first states of his larger prints. All of these, when they are well printed and in good condition, have not only a freshness, distinctiveness, and often richness of drypoint effects but also an analogous freshness, clarity, and brilliance in all of their graphic qualities. In general, the less distinctive the drypoint characteristics in a given impression are, the more worn the plate was at the time of printing and the less good the print is, as can readily be seen by comparing a number of different impressions of the same etching. Since drypoint wears quickly and much of the drypoint Rosa used was quite light with little or very fragile burr, it is the most reliable index to the best impressions. In some cases, however, late impressions can be distinguished because the light drypoint lines do not register at all, having been worn out in the course of repeated printings.

Therefore, since knowing where to look for drypoint in Rosa's prints is especially important, I have tried to give a reasonably precise identification of where it occurs most significantly in each print. In many cases I have simply used the phrase "extensive drypoint," "considerable drypoint," or even "some drypoint" when it would be tedious to describe large amounts of drypoint in exact detail. I have also used the terms "light," "medium," and "deep," to describe the drypoint as seen under a hand lens. These are obviously gradations that are difficult to quantify and are relative to Rosa, whose deep drypoint is not the boldly slashing and deep drypoint of Rembrandt. But I think that in a careful examination of a print these gradations will be evident when they occur.

Many of Rosa's etchings, especially the early prints and the *Figurine*, show varying degrees of overbiting and plate break-

down and wear in the most deeply etched parts. In the early prints and the *Figurine*, which are often quite deeply etched, these defects are frequently seen in even the earliest impressions and trial proofs, so that they are not a very reliable guide to earliness or lateness of impression, especially since a print can be much affected by the amount of care taken in inking and printing the plate. These defects occur less often in his larger etchings, which are generally less densely etched, although they appear to varying degrees in many of them. If they are pronounced in the larger prints, this is usually a clear indication that the impression was pulled from a badly worn plate.

In Rosa's smaller prints it is also often possible, as was first pointed out to me by Mrs. Haunton of Colnaghi's, to use the plate corners as one index of the earliness of the impression. In the *Figurine* the earliest impressions usually have square corners which grow progressively more rounded with repeated printings or through deliberate filing down by the printer to avoid cutting the paper. Since this equation holds for most of the *Figurine*, I have noted in the catalogue entries only the exception, that is, an obviously early impression or trial proof that has a rounded or beveled corner or corners. In the case of plates that were infrequently printed—the early *Male Nude* [1], the *Praying Penitent in a Wilderness* [2], the *Landscape with a Figure* [3], or the *Shepherd* [98], and a number (but not all) of the variant *Figurine* prints—the impressions I have seen all have square corners. In my experience this is not, however, a guide that is completely reliable by itself; depending on the nature of the paper and the printing, aberrations do occur, as for example a slightly rounded corner or corners in an obviously early, fresh impression of a print which in the trial proof has very square corners, or the opposite, a slightly rounded corner in the trial proof of a print which in later impressions shows distinctly square corners. It can, however, be helpful when used in connection with considerations of drypoint quality. Since there is no way of measuring or quantifying precisely the progressive rounding of plate corners, this is an approach which is most reliable in distinguishing the earliest impressions. It does not work for the Triton Group prints [91]-[97] or for the larger etchings, in which no significant differences in plate corners occur.

Paper and watermarks do not, I have found, afford any clear-cut evidence for establishing whether a given impression is early or late. The small prints usually do not have watermarks because of their size, and many of the larger prints are laid down or done on paper for which it is extremely difficult to make an indisputable reading of the watermark without special technical examination. I have not been able therefore to discover large enough groups of watermarks to be able to draw conclusions from them. I have noted no consistent pattern in the watermarks I have been able to read: in several cases, almost exactly the same watermark appears on early, fresh, first-state impressions as on impressions of the same print which are clearly later and definitely more worn. I have, however, noted watermarks in the catalogue entries whenever they can be read, and perhaps additional research along these lines will produce some useful guidelines. In general the most common watermarks are variations on a fleur-de-lis in an oval, circle, or double circle.

In a number of cases I have found that the earliest and best impressions of Rosa's etchings have been printed on a paper of somewhat light weight. This is true in general of the excellent impressions of the *Figurine* in the Chambers Hall volume in the British Museum, of several *Figurine* in my possession, and of the very rare first-state impressions of the *Giants* [115/I], the *Polycrates* [111/I], and the *Oedipus* [116/I] in the Bibliothèque Nationale, Paris. In the *Giants* and *Polycrates* the watermark is a shield with a schematized warrior or figure in armor holding a small fleur-de-lis. It is typical of the printing history of Rosa's etchings that almost exactly the same watermark is found in later, more worn, second-state impressions of these prints as well. The *libretto* of first states and early proofs of the *Figurine* in the Gabinetto Nazionale delle Stampe, Rome, would seem to offer the most reliable information about the paper used in the earliest impressions of Rosa's etchings, but the evidence is not clear cut. Many of these trial proofs are done on rather light paper, but a number of them are done on paper of medium weight, typical of the more ordinary impressions of the *Figurine*, and several are done on somewhat heavier than average paper. Watermarks occur in only a few of them and are noted in the individual catalogue entries.

Collections

High quality impressions of Rosa's etchings are rare. The best *Figurine* I have seen are those of the Chambers Hall volume in the British Museum. The Rijksmuseum has a set of excellent impressions of the *Figurine*. Several years ago Colnaghi's had a small group of superb impressions of the *Figurine*, three of which are now in my possession. Unusually fine impressions of the three *Battling Tritons* [91], [93], [94], the *Piping Satyr* [95], and the two *River Gods* prints [96], [97] were exhibited in the Colnaghi sale exhibition, October 11-November 2, 1973.

The rare Nagler prints are well represented in the group in the Kunsthalle, Hamburg, which was the basis for the Meyer-Nagler list. An even richer collection of rare Nagler and variant *Figurine* prints is found in a volume once owned by the English art historian Thomas Bodkin and purchased by the Museum of Fine Arts, Boston, from Colnaghi's in 1969. It contains almost all of the Nagler prints that are actually by Rosa, plus a number of others not listed in Nagler, Bartsch, or the other literature on Rosa. The same volume contains a full set of Rosa's other prints, including rare first states of five of the larger prints. The Albertina, Vienna, has a very good collection of the rare Nagler and variant prints, and an excellent collection of first states of seven of the larger prints. The British Museum has a very full collection of the Nagler and variant *Figurine* etchings, and a considerable number of them are at the Fogg Art Museum, Harvard University, and the Grunwald Center for the Graphic Arts, University of California, Los Angeles. The British Museum and the Grunwald Center also have the very rare, unrecorded *Adoration of the Shepherds* [121]. The Bibliothèque Nationale, Paris, has a remarkable collection of all but two of the first states of the larger prints, which provide particularly strong evidence of the high quality of the earliest impressions of Rosa's etchings.

In the catalogue entries for the prints that have variants or first states, I list the collections in which examples are found. This obviously is not meant to be a comprehensive listing since it has not been possible to visit all of the print rooms or collections in which such impressions might be found. It is very likely that the variants and first states that I mention will be found in other

collections as well, and it is hoped that other variants, states, or trial proofs of the prints will be discovered.

As has already been mentioned, first states and early proofs for forty-eight of the *Figurine*, originally placed together in a bound volume of indeterminate date, are now in the Gabinetto Nazionale delle Stampe, Rome. Most of them differ from the finished states in some way, either in lacking the monogram signature, or by differences in drypoint or burnishing or both. Many of them tend to be rather carelessly and unevenly printed, as might be expected of trial proofs. Despite this, the freshness of the plate is very evident in most of them.

The plates for all of Rosa's prints in the Bartsch listing and for a number of variants are preserved in the Calcografia Nazionale, Rome. In several cases prints of the Bartsch listing were done on both sides of a plate, but more frequently variant, canceled impressions are found on the *rovesci*, the reverse sides of plates for the Bartsch listing prints. All the plates for the Bartsch prints, used until some ten years ago, are now badly worn; and several of the Triton Group plates were at some time steel faced.

Drawings and Copies

At the time I prepared this catalogue there was no published catalogue of Rosa's drawings, so I included as full a consideration of the drawings related to the etchings as possible. Shortly before the present study went to press I was able to study Michael Mahoney's manuscript of his Garland Press catalogue and to incorporate his numbers into my manuscript. There are occasional discrepancies between our two studies since we pursued our research independently, but in the main we are in agreement to a remarkable degree. I am extremely grateful to Dr. Mahoney for his kindness and openness in this matter.

The collection of Principe Ladislao Odescalchi in Rome was particularly rich in preparatory drawings for the etchings, especially the *Figurine*, and I am very grateful to Principe Odescalchi for letting me study and photograph them in 1969. Since then a great many of these drawings have been dispersed and are on the art market, so that establishing a final location for most of them is impossible at this time. I have however tried to give the most recent location of each drawing, following the system used by Mahoney.

As Mahoney points out in his section 46, there is also a considerable body of Rosa drawings of a generally *Figurine* type which were never actually used for prints, but which may have been considered by the artist for possible translation into etchings.

Rosa's etchings were so often copied, imitated, and forged that I have included at the end of the catalogue a section [131]-[144] dealing with the most important examples. The listing of the locations of these copies in the catalogue entries for them is not exhaustive, and the copies cited here are not meant to comprise a comprehensive survey of all the seemingly countless copies of Rosa's prints, many of which have undoubtedly escaped my attention.

ABBREVIATIONS

Albertina	Graphische Sammlung Albertina, Vienna
Boston	Museum of Fine Arts, Boston
Colnaghi	P. & D. Colnaghi & Co., London
Fogg	Fogg Art Museum, Harvard University
Grunwald	Grunwald Center for the Graphic Arts, University of California, Los Angeles
Hamburg	Hamburger Kunsthalle, Hamburg
Leipzig	Museum der Bildenden Künste, Leipzig
London, B.M.	British Museum, London
Metropolitan	Metropolitan Museum of Art, New York
Odescalchi	Collection of Principe Ladislao Odescalchi, Rome (Many of these drawings have been dispersed in recent years and are now on the art market or in other collections. In the catalogue the original Odescalchi identification is followed, when relevant, by the most recent location.)
Paris, B.N.	Bibliothèque Nationale, Paris
Paris, Louvre	Musée du Louvre, Paris
Rijksmuseum	Rijksprentenkabinet, Rijksmuseum, Amsterdam
Rome, C.N.	Calcografia Nazionale, Rome
Rome, G.N.S.	Gabinetto Nazionale delle Stampe, Rome
Uffizi	Uffizi, Florence
M.	M. Mahoney, *The Drawings of Salvator Rosa*, Doctoral Thesis (unpublished), University of London, 1965. Published in a revised form by Garland Press, New York, 1977

GLOSSARY

Laid down: The etching impression is glued down or affixed to a piece of backing paper or other material with the result that the reverse side of the original paper cannot be examined.

Rounded corners: Since the square corners of a new plate tend to become progressively rounded with repeated printing or through the deliberate filing down by the printer to avoid cutting the paper, rounded corners may indicate whether the print is early or late in relation to other prints of the same impression. (See Introduction, p. 125.)

Rovescio (rovesci): When a plate contains an impression on both sides, the reverse side containing a variant or canceled impression is referred to as the *rovescio*. (See Introduction, p. 127.)

NOTE ON PROCEDURE

When an etching is known in more than one state, the catalogue number is followed by a roman numeral referring to the state, as 101/I. A lower case letter following the catalogue number refers to a painting or drawing related to the etching or to a dependent illustration, as 110a. References to catalogue numbers appear in brackets, as [100], to distinguish them from text illustration numbers, which appear in parentheses, as (Fig. 1).

Bibliographical references are in chronological order, and abbreviated citations appear in full in the General Bibliography. The date appears in abbreviated citations if needed to distinguish the publication from other works by the same author as cited in the General Bibliography.

An asterisk follows every item that is reproduced in this catalogue. When details are reproduced, the information is given as shown in the following:

104/I* Etching with drypoint (* and detail)
104/II Etching with drypoint (*detail only)

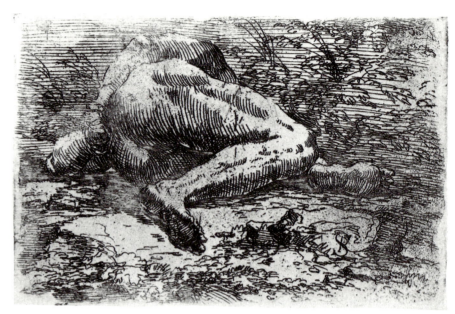

1. Rosa, *Male Nude*, etching.
 New York, Metropolitan Museum of Art,
 Whittelsey Fund, 1953

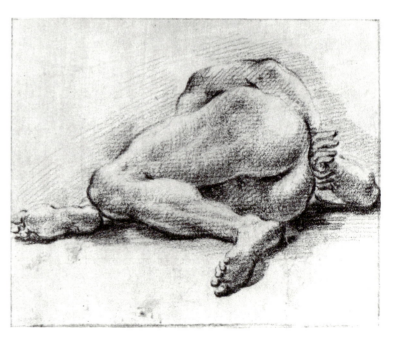

1a. Rosa, final drawing for the *Male Nude*
 etching [1]. Haarlem, Teyler Museum

THE EARLY PRINTS [1-5], c. 1635-1645
(See Ch. I above)

1*. *MALE NUDE*

Not listed in Bartsch or Nagler. Rotili, 2
Etching. 80 x 120 mm.
Signed with the monogram *SR*, in etching, at the lower right.
c. 1635-1640

No drypoint. Incompletely bitten around all four sides. Considerable speckled plate tone caused by false biting, especially at the right. An accidental scratch across the figure's thigh. Overbiting in most of the deeply bitten parts of the plate. Known in only one impression.

Metropolitan (Acc. no. 53.509.10)

Related drawing

1a*. Haarlem, Teyler Museum (C 10)
The final drawing for the print, in reverse from it.
Red chalk. 81 x 100 mm. (M. 2.2)

2*. *PRAYING PENITENT IN A WILDERNESS*

Nagler 93
Etching with drypoint. 142 x 92 mm.
Not signed
c. 1640

Known in only one state.

Light drypoint in curved strokes added as foliage to the tips of the branches at the upper left. Light drypoint shading lines in the foliage at the upper right, and in the shaded portion of the rock at the lower right edge of the print. Incompletely bitten at the lower right edge, and along the left edge.

Collections

Albertina (AL 16); Boston (2 impressions); Hamburg (no. 2229); London, B.M. (W. 7-125); Metropolitan (Acc. No. 53.509.3)

Related drawings

2a. London, B.M. (Cracherode F.f. 2.175)
A kneeling penitent in a wilderness, quite similar to the figure in the print. Typical of a number of drawings by Rosa in this vein, with nothing to show that it is specifically related to this print although it may be.
Pen and brown ink, brown wash. 185 x 120 mm. (M. 30.15)

For other drawings of a generally similar kind, see M. 30.1-30.14.

Literature

Meyer, 93; Ozzola, p. 205; Wallace, 1968, p. 21; Tomory, 2; Wallace, 1973, pp. 50-51, no. 80; Bozzolato, 2; Rotili, 4, and pp. 33-34

3*. *LANDSCAPE WITH A FIGURE*

Nagler 92
Etching. 144 x 92 mm.
Not signed
c. 1640

Known in only one state.

No drypoint. Incompletely bitten along the top.

Collections

Boston; Fogg; Hamburg (no. 2228); London, B.M. (W. 7-124); Metropolitan (Acc. No. 53.509.8)

Literature

Meyer, 92; Ozzola, p. 205; Tomory, 1; Wallace, 1973, p. 51; Bozzolato, 1; Rotili, 7, and pp. 33-35

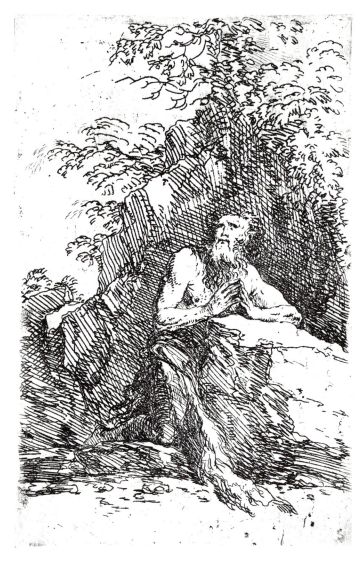

2. Rosa, *Praying Penitent in a Wilderness*, etching.
Boston, Museum of Fine Arts

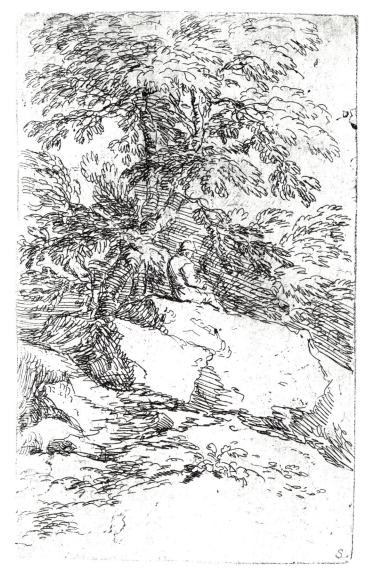

3. Rosa, *Landscape with a Figure*, etching.
Boston, Museum of Fine Arts

4*. *LANDSCAPE WITH HERDSMEN*

Not listed in Bartsch or Nagler. Wallace, 1973, 93; Bozzolato, 78 (illustration confused with his 79); Rotili, 9.
Etching with drypoint. 88 x 87 mm.
Not signed
c. 1640-1645

Known in only one state.

A few very light strokes of drypoint added behind the figures. Lightly and delicately etched and printed.

Collections

Lodon, B.M. (W. 7-123). Printed together with [5], below, on the same piece of paper; Metropolitan (Acc. No. 53.509.9)

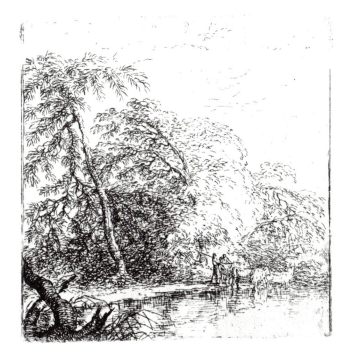

4. Rosa, *Landscape with Herdsmen*, etching.
British Museum

5*. *LANDSCAPE WITH FIGURES AND A HILL*

Not listed in Bartsch or Nagler. Wallace, 1973, 94; Bozzolato, 79 (illustration confused with his 78); Rotili, 8.
Etching with drypoint. 80 x 121 mm.
Not signed
c. 1640-1645

Light drypoint added to fill out underbitten areas in the mountains and water along the left edge of the print. Traces of false biting at the upper and lower left corners. Lightly and delicately etched and printed. Known in only one impression.

London, B.M. (W. 7-126). Printed together with [4], above, on the same piece of paper.

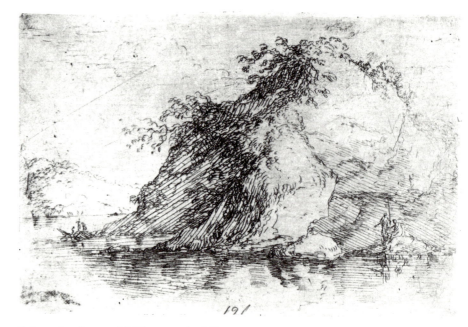

5. Rosa, *Landscape with Figures and a Hill*, etching. British Museum

THE FIGURINE SERIES [6-90], c. 1656-57
(See Ch. II above)

Literature for the series

Basan, II, p. 419
Gilpin, *Essay*, p. 58
Gori Gandinelli, III, p. 166
Strutt, I, p. 275
Huber, IV, p. 27
Bryan, X, p. 320
Bartsch, XX, 25-86
Joubert, III, p. 57
Morgan, II, p. 283
Meyer, 95-107
Nagler, V, 95-107
Le Blanc, III, p. 360
Ozzola, pp. 193, 197-206
Pettorelli, p. 28
Petrucci, 1934-1935, pp. 33-36
Limentani, 1953, p. 53, no. 3, p. 38

Petrucci, 1953, pp. 73-74
C. A. Petrucci, p. 107, no. 747y
Salerno, p. 137, no. 94, p. 149
Barricelli, p. 13
Fabbri, pp. 328-30
Sunderland, 1970, pp. 520-23
Tomory, 10
Mahoney, "Rosa: Drawings," 1973, 65
Wallace, 1973, pp. 50-56, nos. 81-91
Colnaghi, 7-39
Bozzolato, 4-66
Sunderland, 1973, pp. 785-89
Rotili, 18-89, and pp. 16-18, 74-84

For copies, imitations, and derivations from the *Figurine*, see [131]-[141], [143], [144].

6. THE FRONTISPIECE TO THE *FIGURINE* SERIES

A youthful male figure in a plumed hat defying a personification of Envy behind him and pointing to a block which bears the inscription: *SALVATOR ROSA / Has Ludentis otij / CAROLO RUBEO / Singularis Amicitiae pignus / D.D.D.* (Salvator Rosa dedicates these prints of playful leisure to Carlo de' Rossi as a pledge of outstanding friendship.) De' Rossi was Rosa's close friend and chief patron.
Bartsch 25
143 x 93 mm.

6/I*. Etching
The inscription written in pen and ink in Rosa's hand, with De' Rossi's first name spelled "Carlo." The bellows behind the principal figure's leg not yet burnished out. No drypoint. In poor condition, badly stained and abraded, and torn along the left edge. Laid down. Unique impression.
Rome, G.N.S. (F.C. 31505)

6/II*. Etching with drypoint
Small amounts of light to medium drypoint in the principal figure's hair, plumes, and in the adjacent portions of the sky. Drypoint to define the contour of the secondary figure's right knee where part of a bellows has been burnished out, with additional light drypoint shading lines in that area.
Copperplate: Rome, C.N. (737y, 25B)

Related drawings

6a*. Odescalchi
The final drawing for the print, in reverse from it, and almost identical with it except for variations in the shape of the inscription block. Done apparently after variant [7].
Pen and brown ink with traces of black chalk. 147 x 77 mm. (M. 45.1)

6b. Leipzig (Bd. 25, no. 52B)
A warrior leaning against a block and turning to a figure behind the block. Possibly an early idea for [6] and somewhat like [7].
Pen and brown ink. 152 x 89 mm. (M. 46.3)

Addendum

The frontispiece was reproduced as a 25 lire postage stamp in 1973 to commemorate the tercentenary of Rosa's death.

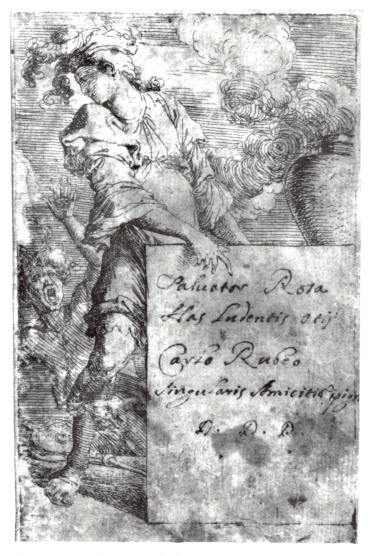

6/I. Rosa, unique first state of the frontispiece,
etching with inscription in pen and brown ink.
Rome, Gabinetto Nazionale delle Stampe

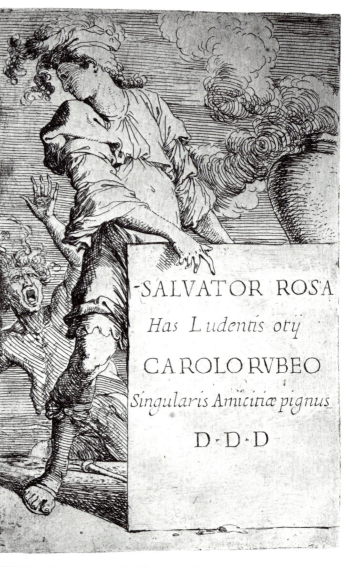

6/II. Rosa, frontispiece to the *Figurine* series,
etching. British Museum

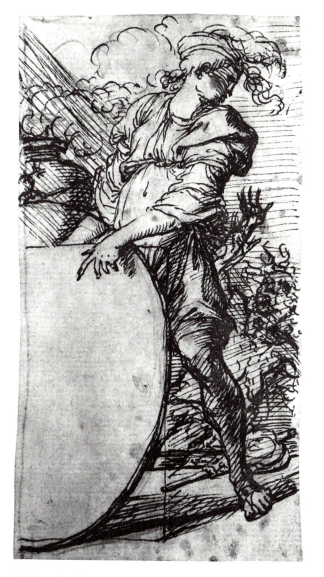

6a. Rosa, final drawing for the frontispiece
 etching [6]. Odescalchi

7*. VARIANT OF [6]

A youth similar to the one in [6], standing behind a block without an inscription and pointing out to a personification of Envy a panel with a personification of *Pittura* designed on it.

Not listed in Bartsch or Nagler. Wallace, 1973, 81; Bozzolato, 4b; Rotili, 19 (with illustration reversed)

Etching (with drypoint?) 143 x 93 mm.

Not signed

The strokes running horizontally across the panel with *Pittura* may be drypoint, although it is difficult to be certain because of the condition of the plate. It is ruined by false biting and by later finger mark corrosion at the edges. Discovered by the author in 1968 as the *rovescio* of the plate for [6]. A small number of modern impressions were pulled in 1968 and 1973 and are now found in Bologna, Pinacoteca Nazionale: Naples, Museo di Capodimonte; Rome, C.N.; Rome, G.N.S.; Uffizi, and in the author's collection

Copperplate: Rome, C.N. (747y, 25B *rovescio*)

Related drawings

See [6]

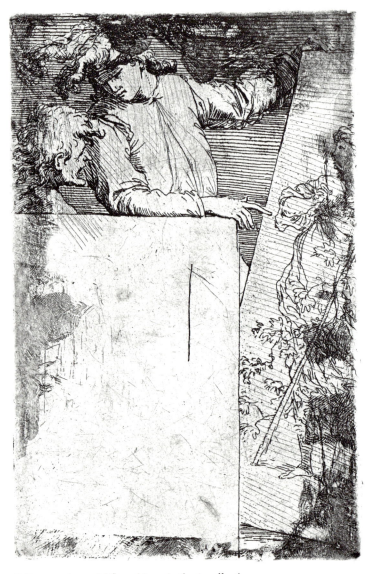

7. Rosa, variant of [6], etching. Author's collection

8*. VARIANT OF [6]

A print almost identical with [6], same direction, with no urn and no inscription.

Not listed in Bartsch or Nagler. Wallace, 1973, 81; Bozzolato, 4c; Rotili, 20 (with illustration reversed)

Etching. 146 x 96 mm.

Not signed

No evident drypoint, although it is difficult to be certain because of the very poor condition of the plate. Badly underbitten, false bitten, and corroded by later finger marks. Discovered by the author in 1968 as the *rovescio* of the plate for [48]. Impressions as in [7].

Copperplate: Rome, C.N. (747y, 51B *rovescio*)

Related drawings

See [6]

8. Rosa, variant of [6], etching. Author's collection

9. FIGURINA

A walking warrior carrying a long staff over his shoulder. Bartsch 26. Sometimes confused with Bartsch 33, this catalogue [21].
139 x 91 mm.

9/I. Etching

Not signed. Otherwise graphically the same as 9/II. Rather lightly and carelessly printed on paper with the watermark a six-pointed star in a circle. Known in only one impression.
Rome, G.N.S. (F.N. 31552)

9/II*. Etching

Signed with the monogram *SR*, in drypoint, at the lower right.
Copperplate: Rome, C.N. (747y, 26B)

10. FIGURINA

A standing warrior holding a long staff over his shoulder and pointing.
Bartsch 27
140 x 90 mm.

10/I. Etching with drypoint

Not signed. Less extensive drypoint than in the second state. Well printed on paper with the watermark a series of concentric circles with a crown above. Known in only one impression.
Rome, G.N.S. (F.N. 31532)

10/II*. Etching with drypoint

Signed with the monogram *SR*, in reverse, in drypoint at the lower right. Some light to medium drypoint in the shaded portions of the figure's legs and feet and in the background between his legs.
Copperplate: Rome, C.N. (747y, 27B)

Related drawings

10a. Odescalchi

The final drawing for the print. Very unusual in not being in reverse from the print.
Pen and brown ink, brown wash. 145 x 98 mm.

10b. Odescalchi

A very similar drawing, in reverse from the print.
Black chalk, red chalk, traces of pen and brown ink, brown wash. 145 x 98 mm.

Copies

Rotili, 26a, cites and illustrates a drawing in the Museum of Art and Archaeology, University of Missouri, Columbia, Missouri, as being a study by Rosa for this etching and [41]. It is in fact a rather crude copy of the two prints by another hand.

11*. FIGURINA

The standing figure of an old warrior leaning on a long sword. Bartsch 28
Etching. 141 x 93 mm.
Signed with the monogram *SR*, in reverse, in drypoint at the lower right.

Known in only one state.

Copperplate: Rome, C.N. (747y, 28B)

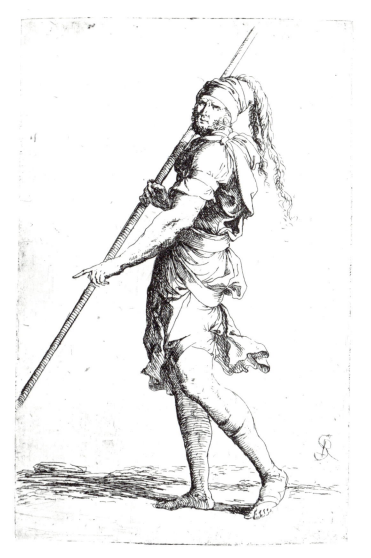

9/II. Rosa, *Figurina*, etching. British Museum

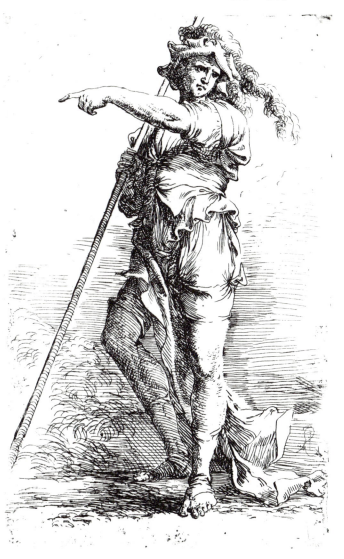

10/II. Rosa, *Figurina*, etching. British Museum

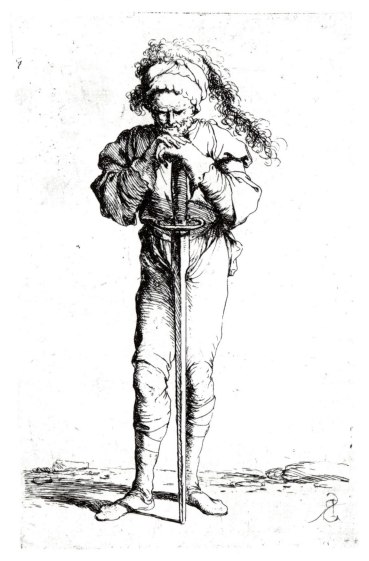

11. Rosa, *Figurina*, etching. British Museum

12. *FIGURINA*

A warrior seated on a low wall.
Bartsch 29
142 x 91 mm.
Signed with the monogram *SR*, in etching, at the lower right in both states.

12/I. Etching with drypoint
Some light to deep drypoint in the shaded portions of the lower part of the figure and in the shadows on the wall around the sword. It appears that portions of the sky to the left of the figure have been lightened by burnishing. Well, but rather lightly printed. Known in only one impression.
Rome, G.N.S. (F.N. 31522)

12/II*. Etching with drypoint
The figure's left heel, which is simply omitted in the first state, is added in light, sketchy drypoint in the second state. Otherwise graphically the same as the first state.
Copperplate: Rome, C.N. (747y, 29B)

13*. *FIGURINA*

A standing warrior holding an elongated octagonal shield.
Bartsch 30
Etching. 145 x 96 mm.
Signed with the monogram *SR*, in etching, at the bottom of the shield. Bartsch incorrectly describes the signature as "S. Rosa."

Although the print is known in only one state, an impression appears in the bound volume in Rome, G.N.S., which contains all the known first states of the *Figurine*. This impression (F.N. 31529) is rather lightly and carelessly printed, as are many of the first states, suggesting that Rosa may have pulled an impression as a trial proof and then decided that no changes were needed. The upper left corner of the plate is slightly rounded even in early impressions.

Copperplate: Rome, C.N. (747y, 30B)

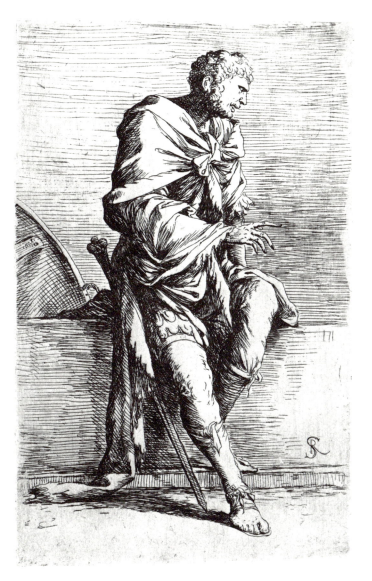

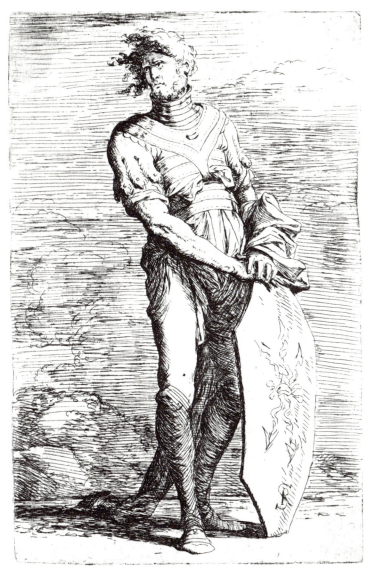

12/II. Rosa, *Figurina*, etching. British Museum

13. Rosa, *Figurina*, etching. British Museum

14*. *FIGURINA*

A standing warrior in vaguely antique armor, holding a staff.
Bartsch 31
Etching with drypoint. 140 x 91 mm.
Signed with the monogram *SR* in reverse, in drypoint, at the lower left.

Known in only one state.

Light drypoint at the top of his plume, touches of light dry-point at his left shoulder, the upper edge of his breast plate, and the top of his left boot. Faint traces of very light drypoint at his eye and chin.

Copperplate: Rome, C.N. (747y, 31B)

Related painting and etching

The figure is very much like the Alexander in Rosa's etching *Diogenes and Alexander* [108], and in his painting of the same subject at Northampton, Althorp [108a]. The figure derives ultimately from the Alcibiades in the Raphael *School of Athens* fresco.

Copy

A variation by Leendert van der Cooghen dated 1665 on the plate.

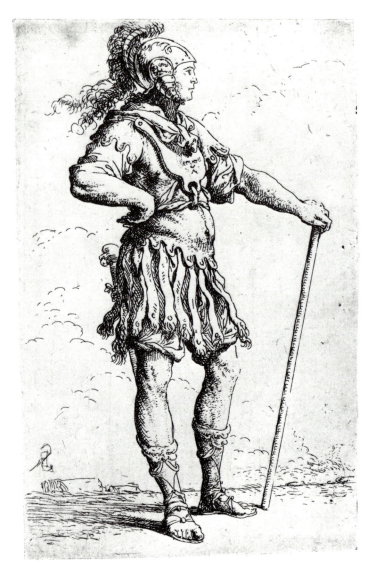

14. Rosa, *Figurina*, etching. British Museum

15*. VARIANT OF [14]

A figure almost identical with that of [14], in the same direction.

Nagler 100

Etching with drypoint. 142 x 91 mm.

Not signed

Clearly an earlier version of [14] which turned out badly and was abandoned (done on a separate plate and not a first state, as Bozzolato, 10, calls it). Although the plate was unevenly and, in the upper portions, much too heavily bitten, an attempt was made, almost certainly after Rosa, to save it by burnishing down the heavy background lines and by adding light to deep drypoint to the lower portions of the figure and the adjacent background. This reworking, especially the handling of the drypoint, is not typical of Rosa's hand. The attempt at salvaging the plate must have been abandoned and the plate canceled.

Collections

Albertina (AL 16); Boston; Hamburg (no. 2236); London, B.M. (W. 7-54)

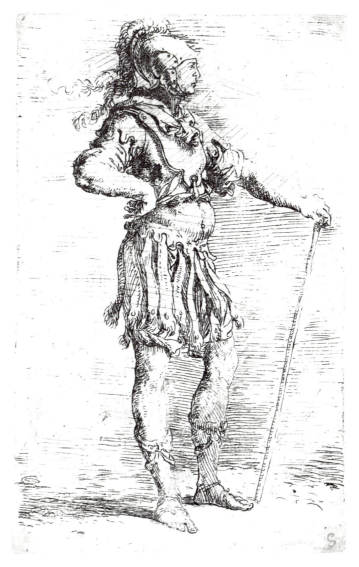

15. Rosa, variant of [14], etching. Boston, Museum of Fine Arts

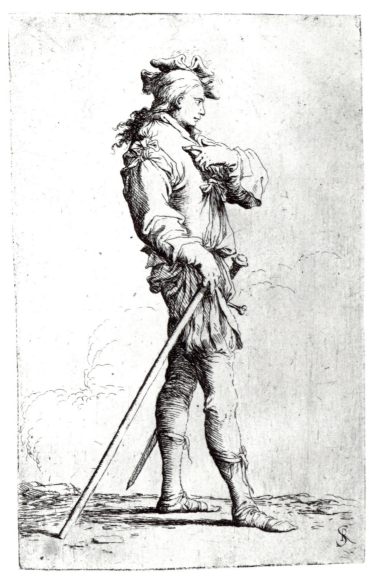

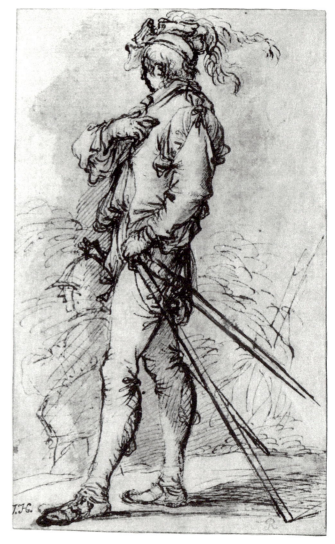

16a. Rosa, final drawing for [16]. British Museum

16/II. Rosa, *Figurina*, etching. British Museum

16. *FIGURINA*

A standing warrior holding a staff and pointing to his chest.
Bartsch 32
146 x 95 mm.
Signed with the monogram *SR*, in etching, at the lower right in both states.

16/I. Etching
No drypoint. Rather lightly and unevenly printed. Known in only one impression.
Rome, G.N.S. (F.N. 31541)

16/II*. Etching with drypoint
Light drypoint added to the figure's headdress to complete the contour of the lowest projecting fold and to create the plume, which is entirely in drypoint.
Copperplate: Rome, C.N. (747y, 32B)

Related drawing

16a*. London, B.M. (Cracherode F.f. 2-168)
The final drawing for [16] and for variants [17], [18], [19], and [20]. In reverse from [16]. It shows Rosa experimenting with a number of the variations that appear in [16] and the variants. It seems likely that the drawing preceded all of them, and that the prints were in turn based on each other, probably in the order in which they are catalogued here. Variant [17] was probably the first print done after the drawing since it is in reverse from it and has the same plumes and lost profile. Variant [18] was probably based on [17], having the same plumes and lost profile, and being in reverse from it. Variant [19] moves in the direction of the final version, [16], by turning the principal figure's head into full profile. The final version, [16], was probably then based on [19], in reverse from it with the full plumes much modified.
Not enough of the variant in two-thirds length, [20], remains to be able to place it in this scheme with any certainty.
Pen and brown ink, brown wash. 137 x 84 mm. (M. 46.5)

17*. VARIANT OF [16]

A figure very similar to that of [16], with full double plumes on his headdress, his head turned in lost profile. Same direction as [16].
Nagler 102
Etching. 146 x 92 mm.
Not signed

Done on a different plate than [16] and not a first state, as Bozzolato, 11, calls it. Quite unevenly and in several places very lightly bitten so that many lines barely register. It would obviously not stand up to repeated printing. The entire plate surface covered with fine diagonal scratches.

Hamburg (no. 2238)

Related drawing

See [16]

18*. VARIANT OF [16]

Very similar to [17], in reverse from it, with some changes in the background.
Nagler 103
Etching. 142 x 89 mm.
Signed with the monogram *SR*, in etching, at the lower left.

Unevenly bitten, in many areas so heavily that the deepest shading is blurred and muddy. Considerable light false biting over much of the plate surface.

Collections

Albertina (AL 16); Boston; Grunwald; Hamburg (no. 2239); London, B.M. (W. 7-51); Metropolitan (Acc. No. 53.509.4)

Related drawing

See [16]

Copy

18a*. A print virtually identical with [18], in the same direction, with slight changes in the background.

Not listed in Bartsch, Nagler, or the other literature.

Etching with drypoint. 146 x 95 mm.

Signed with the monogram *SR*, in etching, at the lower right.

This print is a very clean, crisp version of [18], with none of the uneven, irregular biting of that print. In my opinion it is a copy of [18] by another hand. The etched lines seem too tight and dry to be by Rosa, and the handling of the drypoint (considerable amounts in most of the shaded portions of the print) does not resemble his. Finally, the print as a whole has a flat, dull quality that makes it quite unlike Rosa's own etchings.

Collections

Albertina (AL 16); Boston; Fogg (Randall 1240); London, B.M. (W. 7-49)

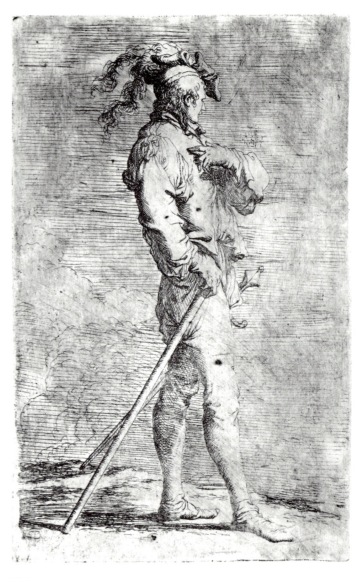

17. Rosa, variant of [16], etching. Hamburg, Kunsthalle

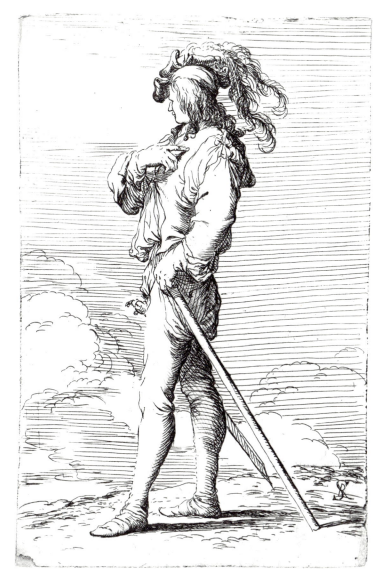

18. Rosa, variant of [16], etching.
 Boston, Museum of Fine Arts

18a. Copy of [18] by another hand, etching.
 Boston, Museum of Fine Arts

19*. VARIANT OF [16]

A figure more like [16] than are either [17] or [18] in that the principal figure's face is shown in profile. In reverse from [16] with a secondary figure behind.
Nagler 104
Etching with drypoint. 147 x 96 mm.
Signed with the monogram *SR*, in etching, at the lower left.

Faint traces of light drypoint added to the shadow next to the principal figure's left hand, and in the face and hair of the secondary figure. The plate was quite unevenly bitten so that some lines fail to register and other areas are too deeply etched.

Collections

Albertina (AL 16); Boston; Grunwald; Hamburg (no. 2240); London, B.M. (W. 7-53)

Related drawing

See [16]

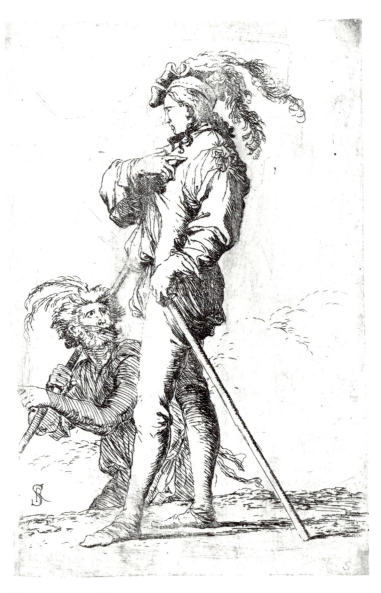

19. Rosa, variant of [16], etching.
Boston, Museum of Fine Arts

20*. VARIANT OF [16]

The lower two-thirds of a figure much like that of [16], in
the same direction, holding a sword with his right hand
instead of a staff, with foliage behind. The plate cut across
the figure's chest.
Not listed in Bartsch, Nagler, or the other literature.
Etching. 89 x 87 mm.
Not signed

Although the technique is somewhat crude in comparison with
Rosa's other etchings, I am inclined to think that it is in fact
by him. The delineation and modeling of the figure is quite
similar to that seen in [76], [77], and [90], all definitely by
Rosa, and the treatment of the background foliage is very
typical of him. In addition, this print is unique among all the
variations of [16] in showing the figure with slashed leggings
and projecting stockings at both calves. Rosa experimented
with precisely this motive in the drawing [16a], which is un-
questionably by his own hand. It seems unlikely that a copyist
would have picked up this motive, which does not exist in
any of the variants and is found only in the drawing.

London, B.M. (W. 7-57)

Related drawing

See [16]

20. Rosa, variant of [16], etching. British Museum

21. *FIGURINA*

A standing warrior holding a staff over his shoulder and gesturing with an outstretched arm.

Bartsch 33. Sometimes confused with Bartsch 26, this catalogue [9].

148 x 95 mm.

Signed with the monogram *SR*, in etching, at the lower right in both states.

21/I. Etching

No drypoint. Quite well, if somewhat lightly printed. Known in only one impression.

Rome, G.N.S. (F.N. 31517)

21/II*. Etching with drypoint

Considerable light to deep drypoint in most of the shaded areas of the figure.

Copperplate: Rome, C.N. (747y, 33B)

Related drawing

21a. Haarlem, Teyler Museum (E 16)

The final drawing used for [21] and for the variants [22] and [23], in reverse from them with a secondary figure behind.

Pen and brown ink, brown wash, traces of black chalk. 141 x 96 mm. (M. 45.2)

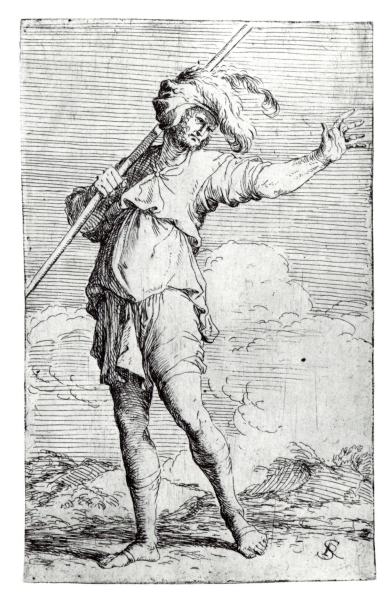

21/II. Rosa, *Figurina*, etching. British Museum

22*. VARIANT OF [21]

A principal figure almost identical with that of [21], in the same direction, with two half length figures behind and below him.

Nagler 101

Etching. 143 x 90 mm.

Signed with the monogram *SR*, in etching, at the lower right, barely legible because of false biting in that area.

No evident drypoint, although it is difficult to be certain because of the poor condition of the plate. Unevenly bitten with the background figures not fully registered. Badly corroded by false biting over much of the plate surface. Rotili, 34, calls this print a copy, incorrectly, in my opinion.

Collections

Albertina (AL 16); Boston; Fogg (Gray 3391); Hamburg (no. 2237); London, B.M. (W. 7-17)

Related drawing

See [21]

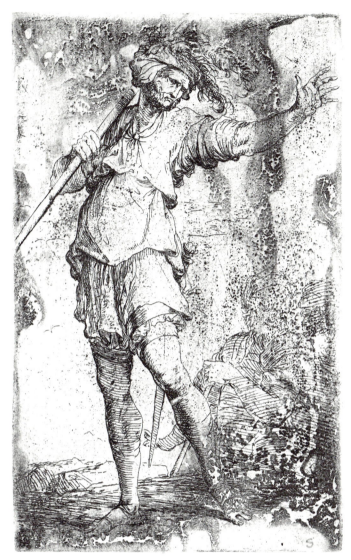

22. Rosa, variant of [21], etching.
Boston, Museum of Fine Arts

23*. VARIANT OF [21]

A figure almost identical with that of [21], in the same direction, holding a sword instead of a staff over his right shoulder. Foliage and a tree stub behind him.

Not listed in Bartsch or Nagler. Ozzola, p. 206; Wallace, 1973, 88; Rotili, 34.

Etching. 143 x 92 mm.

Not signed

Discovered by the author in 1968 as the *rovescio* of the plate for [52] in Rome, C.N. Probably discarded because of a relative lack of graphic subtlety and variety and because of quite heavy biting which produced a muddy blurring together of lines in many places. Rosa may also have disliked the placement of the figure, somewhat unusual for the *Figurine* series, on a high rise of ground with consequent squeezing of the figure toward the top of the print. It was canceled at some point, perhaps by Rosa himself, but later "salvaged," by a rough burnishing out of the cancellation strokes in the areas where this could be done without affecting the original etching, and reused.

Impressions are found in bound volumes of late impressions of Rosa's prints in the Biblioteca Marucellana, Florence, and in the Fogg Art Library, Harvard University (FA 3750.17PF). These volumes contain similarly salvaged canceled variants of two *Figurine*, [34] and [45], and the *Putti with a Garland* [120], all of which are preserved as *rovesci* in Rome, C.N. Several impressions were pulled from this plate for study purposes in 1968. One of them is now in the author's collection.

Copperplate: Rome, C.N. (747y, 55B *rovescio*)

Related drawing

See [21]

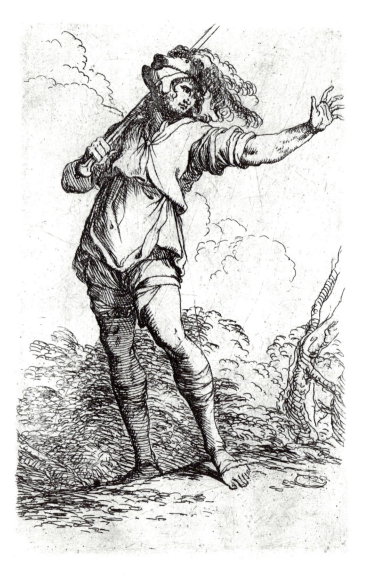

23. Rosa, variant of [21], etching.
Author's collection.

24*. *FIGURINA*

A warrior in full armor in a grotto.
Bartsch 34
Etching with drypoint. 145 x 94 mm.
Signed with the monogram *SR*, in reverse, in etching at the lower left.

Although the print is known in only one state, an impression appears in the bound volume in Rome, G.N.S., which contains all the known first states of the *Figurine*. This impression (F.N. 31527) is rather lightly and unevenly printed and has what seem to be traces of gray wash added to the left sleeve and background next to it, especially in the burnished areas. It is possible that Rosa thought of this impression as a trial proof, experimented with wash toning, and then decided against making any graphic changes.

Considerable light to deep drypoint in many of the shaded portions of the figure and in the background near him. Burnishing of his right shin, upper left leg, left sleeve, and portions of the background near his upper left arm.

Copperplate: Rome, C.N. (747y, 34B)

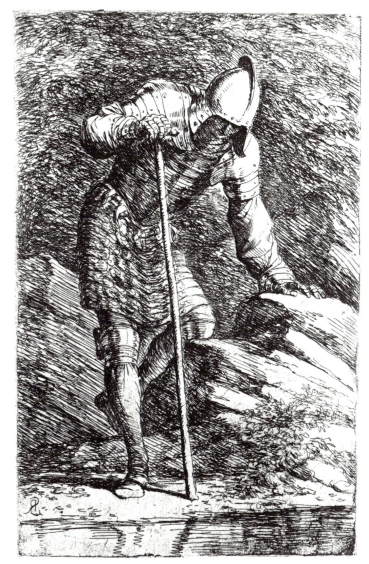

24. Rosa, *Figurina*, etching. British Museum

25. *FIGURINA*

A standing warrior holding a spear, his face turned to the background.
Bartsch 35
140 x 92 mm.

25/I. Etching with drypoint
 Not signed. Light drypoint added as fill in the ground at the lower left. Quite well, if somewhat fuzzily printed. Known in only one impression.
 Rome, G.N.S. (F.N. 31520)

25/II*. Etching with drypoint
 Signed with the monogram *SR*, in reverse, in drypoint at the lower right. Otherwise graphically the same as the first state.
 Copperplate: Rome, C.N. (747y, 35B)

Related drawing

25a*. Odescalchi (sold: London, Christie's, July 6, 1976, no. 56)
 The final drawing for the print, in reverse from it.
 Pen and brown ink, brown wash, with red chalk used to draw a sketchy secondary figure. 142 x 74 mm. (M.45.3)

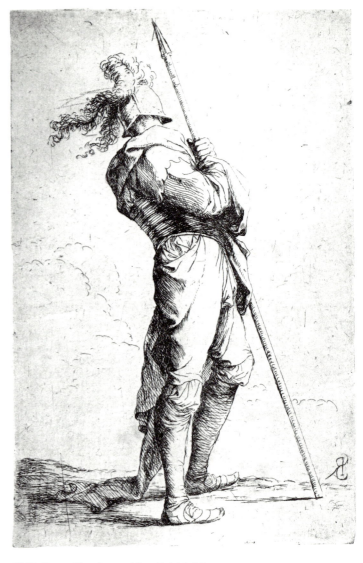

25/II. Rosa, *Figurina*, etching. British Museum

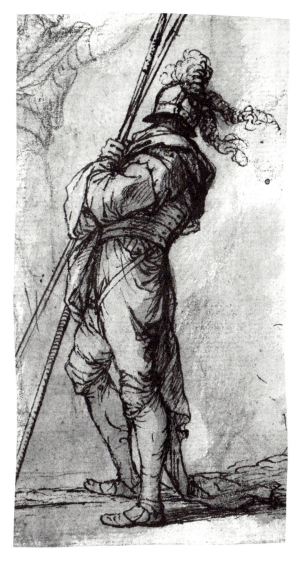

25a. Rosa, final drawing for [25]. Odescalchi

26*. *FIGURINA*

A standing warrior holding a long staff and a shield inscribed *SR* in reverse.
Bartsch 36
Etching with drypoint. 140 x 92 mm.
Signed with the monogram *SR*, in reverse, in etching on the shield.

Known in only one state.

The only drypoint is a curving stroke delineating a drapery fold in front of the figure's left shoulder.

Copperplate: Rome, C.N. (747y, 36B)

Related drawing

26a. Odescalchi
The final drawing for the etching, in reverse from it.
Pen and brown ink, brown wash, traces of black chalk. 148 x 92 mm.

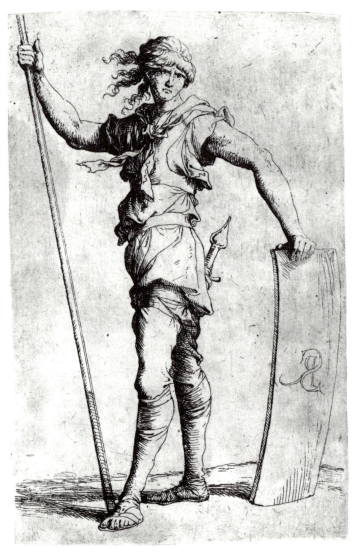

26. Rosa, *Figurina*, etching. British Museum

27. *FIGURINA*

A warrior seated asleep.
Bartsch 37
140 x 91 mm.

27/I. Etching with drypoint
Not signed. Light drypoint at the figure's lower back contour, upper left leg, and along the contour of the trailing drapery. Quite well, if lightly printed. Known in only one impression.
Rome, G.N.S. (F.N. 31525)

27/II*. Etching with drypoint
Signed with the monogram *SR*, in drypoint, at the lower right. Additional medium to deep drypoint used to define the upper contour of the figure's helmet, and medium drypoint added to create several clusters of leaves adjacent to the helmet.
Copperplate: Rome, C.N. (747y, 37B)

Related etching

This print is in many ways a graphically more sophisticated version of [57].

28*. VARIANT OF [27]

A figure almost identical with that of [27], but with his left leg drawn back rather than outstretched. A cliff instead of tree trunks at the left edge of the print.
Not listed in Bartsch or Nagler. Bozzolato, 17a; Rotili, 39.
Etching. 143 x 94 mm.
Not signed

So unevenly bitten as to be impossible to use. Canceled, perhaps by Rosa himself. Discovered by the author in 1968 as the *rovescio* of the plate for [78] in Rome, C.N. A small number of modern impressions were pulled in 1968 and 1973 and are now found in Bologna, Pinacoteca Nazionale; Naples, Museo di Capodimonte; Rome, C.N.; Rome, G.N.S.; Uffizi; and in the author's collection.

Copperplate: Rome, C.N. (747y, 78B *rovescio*)

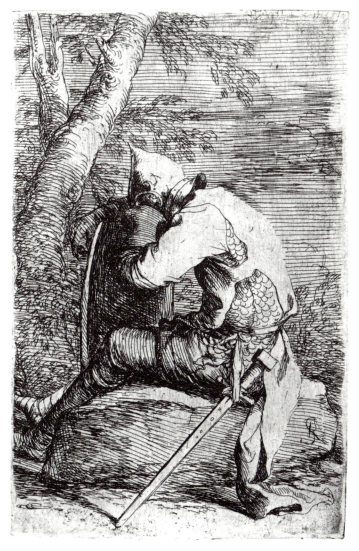

27/II. Rosa, *Figurina*, etching. British Museum

28. Rosa, variant of [27], etching. Author's collection

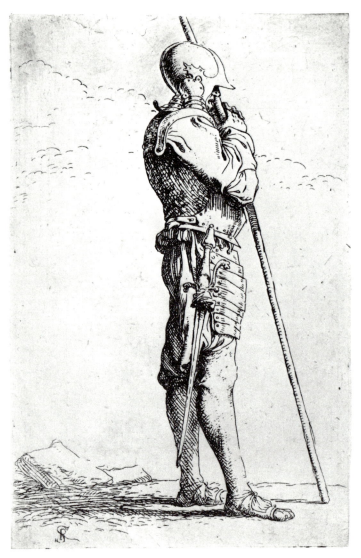

29. Rosa, *Figurina*, etching. British Museum

29*. *FIGURINA*

A standing warrior wearing an elaborate helmet, and holding a long staff.
Bartsch 38
Etching. 140 x 92 mm.
Signed with the monogram *SR*, in etching, at the lower left.

Known in only one state, although an impression appears in the bound volume in Rome, G.N.S., which contains all the known first states of the *Figurine*. This impression (F.N. 31519) is better printed than most of the first states, but its inclusion in the volume suggests that Rosa may have pulled an impression as a trial proof and then decided that no changes were needed.

Copperplate: Rome, C.N. (747y, 38B)

Related drawings

29a. Odescalchi (sold: London, Christie's, March 30, 1976, no. 56)
The final drawing for the etching, in reverse from it.
Pen and brown ink, brown wash, traces of black. Framed, hung, impossible to measure, but of the same general dimensions as the etching. (M.45.4)

29b. Odescalchi
A generally similar figure, possibly related to the etching.
Pen and brown ink, brown wash. 168 x 59 mm.

29c. London, Witt Collection (no. 2115)
A free sketch of a very similar figure. Possibly an early idea for the print, and closer to it in basic feeling than is the second Odescalchi drawing above.
Pen and brown ink. 81 x 43 mm. (M. 66.35)

29d. New York, Metropolitan Museum of Art (Rogers Fund, 1970.101.14)
A drawing of several figures, one of them very much like that of the etching, in reverse from it.
Pen and brown ink. 110 x 191 mm. (M. 66.39)

Copy

The same figure appears in a painting, *Gambling Soldiers*, now in the Dulwich College Picture Gallery. The painting is not, in my opinion, a genuine Rosa, although it could be a very good copy after a lost original. But since Rosa almost never did paintings with figures identical with the *Figurine*, it seems more likely that an imitator was inspired by the print.

30. *FIGURINA*

A standing exotic warrior wearing a lion-head cap, and holding a mace and shield.
Bartsch 39
142 x 92 mm.

30/I. Etching
Not signed. A good, if somewhat light impression. Known in only one impression.
Rome, G.N.S. (F.N. 31533)

30/II*. Etching
Signed with the monogram *SR*, in drypoint, at the lower right.
Copperplate: Rome, C.N. (747y, 39B)

Related drawings

30a. Odescalchi
The final drawing for the etching, in reverse from it, with a *pentimento* showing the sword being changed into a mace.
Pen and brown ink, brown wash. Framed, hung, impossible to measure, but of the same general dimensions as the etching. (M. 45.5)

30b. Odescalchi
A seated figure wearing a lion-head cap, generally like the figure in the print. Possibly an early idea for this etching or another similar *Figurina*.
Pen and brown ink over red chalk. 143 x 80 mm. (M. 46.10)

31*. VARIANT OF [30]

A figure almost identical with that of [30], except that he holds a sword rather than a mace over his left shoulder. In the same direction as [30].
Not listed in Bartsch, Nagler, or the other literature.
Etching with drypoint. 142 x 90 mm.
Not signed

Clearly a first version of the print from a plate that was too lightly bitten to be usable. An attempt was made to save it by adding light drypoint to complete the contours of his left hand and upper left arm, and by adding light drypoint to the background at his left and to the modeling of his upper right chest. The plate was then evidently abandoned and replaced with [30].

Collections

Albertina (AL 16); Boston; Fogg (Gray 3398); London, B.M. (W. 7-16)

Related drawings

See [30]

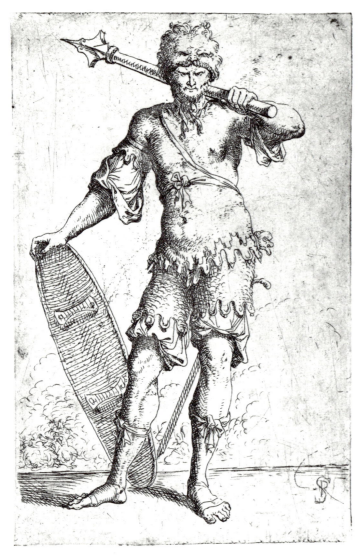

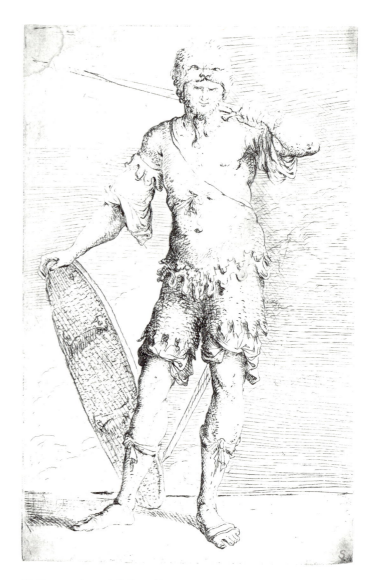

30/II. Rosa, *Figurina*, etching. British Museum

31. Rosa, variant of [30], etching.
Boston, Museum of Fine Arts

32. *FIGURINA*

A warrior in elaborate armor, holding a staff and seated on a rock in a grotto.
Bartsch 40
143 x 93 mm.
Signed with the monogram *SR*, in etching, at the lower right in both states.

32/I. Etching with drypoint

Light drypoint to form the curving tip of his plume. Light drypoint added to the shading of his left leg near the knee. Medium to deep drypoint crosshatching in the background area bounded by his right hand, staff, and left leg. The background to the right of the figure burnished extensively with possibly some drypoint lines added to the hatching there. The area behind the figure's buttocks unclearly printed or possibly burnished. An uneven and in many places quite blurred impression, often hard to read. Known in only one impression.
Rome, G.N.S. (F.N. 31513)

32/II*. Etching with drypoint

A very light drypoint line added across the helmet above the etched line that defines the top of the visor. Light, short drypoint lines, basically parallel, added down the side of the helmet near where the above-mentioned lines converge. Several arcs in light drypoint added to his right shoulder armor make a generally circular shape. Light to deep drypoint added to the shading of the rock, with some light drypoint shading lines added to the background above the rock. The drapery at his buttocks worked over with medium to deep drypoint to clarify the contours and modeling.
Copperplate: Rome, C.N. (747y, 40B)

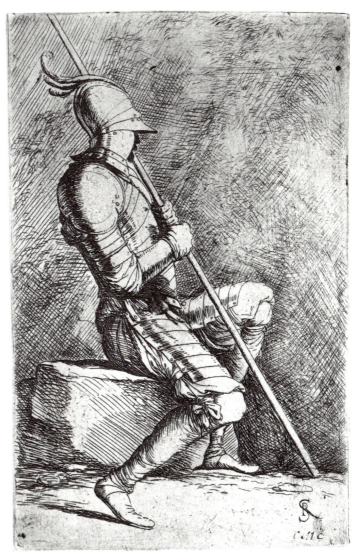

32/II. Rosa, *Figurina*, etching. British Museum

33. *FIGURINA*

A standing warrior holding a war hammer, his back turned
to the viewer.
Bartsch 41
142 x 93 mm.

33/I. Etching with drypoint

Not signed. Some light drypoint in the shading of the left
side of the figure's helmet. Light drypoint in the shading of his
left leg and foot and in the shadow he casts on the ground. An
excellent impression, much better printed than most of the first
states of the *Figurine*. Known in only one impression.
Rome, G.N.S. (F.N. 31534)

33/II*. Etching with drypoint

Signed with the monogram *SR*, in drypoint, at the lower right.
Medium to deep drypoint added to the shading of his helmet.
Touches of light drypoint added to his hair. Light to medium
drypoint at the fold at his waist and on his left arm, with the
upper contour of his left hand raised with drypoint. Light to
deep drypoint shading and modeling lines added to the war
hammer. Light drypoint shading lines on his left skirt. Light
drypoint, beyond that seen in the first state, added to the shadow
he casts on the ground. Horizontal and diagonal lines of light
to medium drypoint added to the sky.
Copperplate: Rome, C.N. (747y, 41B)

Related drawing

33a. Odescalchi (Berlin, Galerie Gerda Bassenge in 1974)
The final drawing for the print, in reverse from it.
Pen and brown ink, traces of black chalk. 145 x 88 mm.
(M. 45.6)

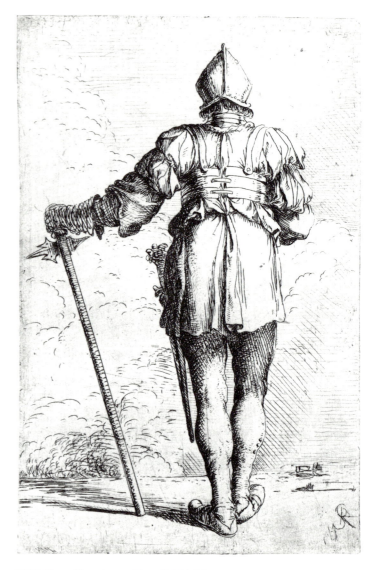

33/II. Rosa, *Figurina*, etching. British Museum

34*. VARIANT OF [33]

A figure very similar to that of [33], in the same direction, with a slightly different costume and holding a battle-ax head down rather than a war hammer head up.
Not listed in Bartsch or Nagler. Rotili, 43.
Etching. 142 x 90 mm.
Not signed

Discovered by the author in 1968 as the *rovescio* of the plate for [40] in Rome, C.N. Probably discarded because of anatomical awkwardness at the shoulders and neck of the figure, lack of graphic variety and subtlety, and rather coarse biting. Canceled, perhaps by Rosa himself. Later "salvaged," by roughly burnishing out the cancellation strokes in the areas where this could be done without affecting the original etching, and reused.

Impressions as in [23]

Copperplate: Rome, C.N. (747y, 46B *rovescio*)

Related drawing

See [33]

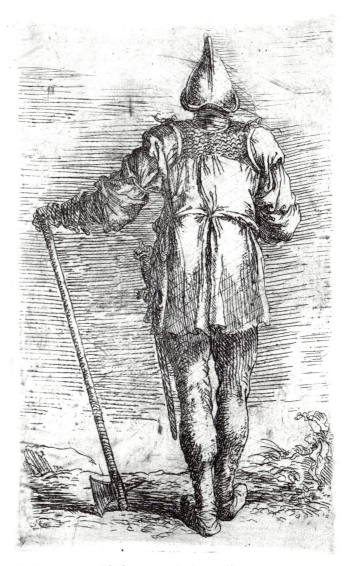

34. Rosa, variant of [33], etching. Author's collection

35. *FIGURINA*

A standing warrior, exotic and semi-nude, wearing a turban and holding a war hammer.
Bartsch 42
142 x 92 mm.

35/I. Etching

Not signed. No drypoint. A very good impression. The watermark is a lion or dragon rampant in an oval. Known in only one impression.
Rome, G.N.S. (F.N. 31515)

35/II*. Etching with drypoint

Signed with the monogram *SR*, in reverse, in drypoint at the lower right. Small amounts of light drypoint in the clouds, the landscape, and the drapery at the figure's right hip. Limited burnishing of the figure's right knee with light drypoint added to give the knee greater anatomical articulation.
Copperplate: Rome, C.N. (747y, 42B)

Related drawing

35a. Metropolitan (Rogers Fund, 1970.101.12)
The final drawing for the print, in reverse from it.
Pen and brown ink, brown wash, traces of black chalk. 132 x 82 mm. (M. 45.7)

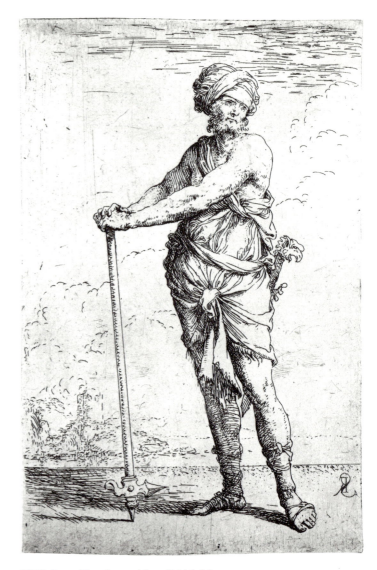

35/II. Rosa, *Figurina*, etching. British Museum

36*. *FIGURINA*

A warrior standing in front of a large rock, holding a staff, and looking into the background.

Bartsch 43

Etching. 142 x 92 mm.

Signed with the monogram *SR*, in etching, at the lower right.

Known in only one state, although an impression appears in the bound volume in Rome, G.N.S., which contains all the known first states of the *Figurine*. This impression (F.N. 31536) is rather lightly and unevenly printed, as are many of the first states, and it is possible that Rosa pulled an impression as a trial proof and then decided that no changes were needed.

Copperplate: Rome, C.N. (747y, 43B)

Related drawing

36a. Present location unknown. Exhibited Thos. Agnew and Sons, *Master Drawings and Prints*, March-April 1974, no. 4.

A drawing of a figure quite similar to that of the print, in the same direction.

Pen and brown ink, brown wash, black chalk. 139 x 77 mm. (M. 46.4)

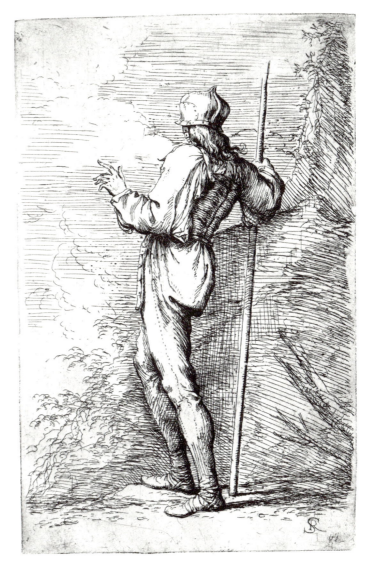

36. Rosa, *Figurina*, etching. British Museum

37*. *FIGURINA*

A standing warrior in elaborate armor, holding a shield and halberd.

Bartsch 44

Etching with drypoint. 143 x 92 mm.

Signed with the monogram *SR*, in reverse, in drypoint at the lower right.

Known in only one state.

Touches of light drypoint added to the ground at the figure's right.

Copperplate: Rome, C.N. (747y, 44B)

Related drawing

37a. Location unknown (Sold: London, Sotheby's, Nov. 26, 1970, No. 42)

I have not seen this drawing, and know it only through a photograph in Mahoney's thesis (revised). It does seem to be a genuine Rosa and the final drawing for the print, which is in reverse from it.

Pen, brown ink, brown wash over black chalk. 146 x 89 mm. (M. 45.8)

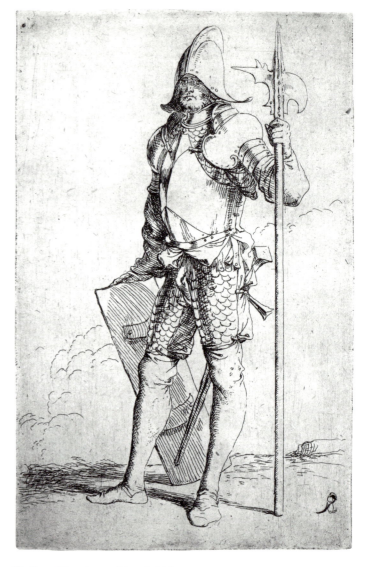

37. Rosa, *Figurina*, etching. British Museum

38*. VARIANT OF [37]

A figure virtually identical with that of [37], in the same direction.
Nagler 105
Etching. 145 x 92 mm.
Not signed

Done on a different plate than [37] and not a first state, as Bozzolato, 24, calls it. Much too deeply bitten, producing muddy, blurred lines in many places. Abandoned and repeated exactly in [37].

Collections

Albertina (AL 16); Boston; Hamburg (no. 2241); London, B.M. (W. 7-18)

Related drawing

See [37]

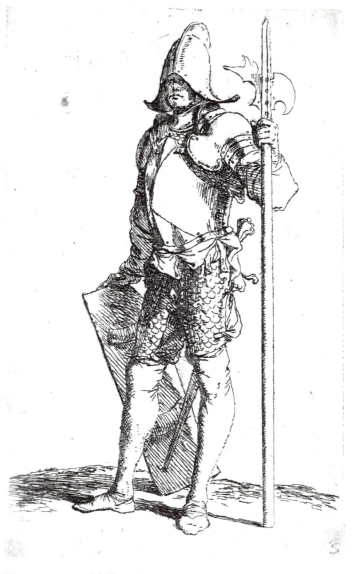

38. Rosa, variant of [37], etching.
Boston, Museum of Fine Arts

39*. *FIGURINA*

A warrior holding a staff over his shoulder and stepping off a low ledge.
Bartsch 45
Etching with drypoint. 142 x 92 mm.
Signed with the monogram *SR*, in reverse, in drypoint at the lower left.

Known in only one state.

Traces of light drypoint in his plume. Medium to deep drypoint shading strokes on his right shoulder armor. Medium drypoint at his right armpit, and in the shadow of his left arm. Some light drypoint on his left hand. The sword done in light to medium drypoint. The background lightened by extensive burnishing, possibly with some drypoint added.

Copperplate: Rome, C.N. (747y, 45B)

Copy

Madrid, Museo Goldiano
A drawing, an exact copy. Known to me only through Witt Library photograph no. 39796D.
Chalk. Measurements wanting.

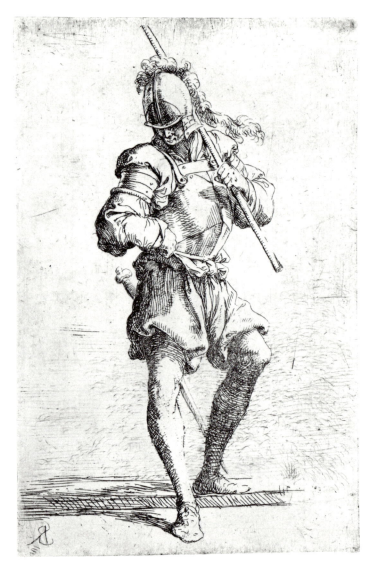

39. Rosa, *Figurina*, etching. British Museum

40. *FIGURINE*

Two warriors, one seated on a foreground rock; the other standing behind him and pointing.
Bartsch 46
142 x 89 mm.

40/I. Etching with drypoint
Not signed. No definite drypoint except for light touches on the principal figure's right leg just below the knee. Dotted false biting in the sky near the tip of the second figure's pointing finger. What appears to be incomplete biting at the second figure's lower right leg and the background and rock adjacent to it. A good impression if a trifle fuzzy in the darks. Known in only one impression.
Rome, G.N.S. (F.N. 31511)

40/II*. Etching with drypoint
Signed with the monogram *SR*, in reverse, in drypoint at the lower right. A few light drypoint shading lines added to the right shoulder drapery of the second figure. Medium drypoint contour and modeling lines added to the underbitten lower right leg of the second figure and the adjacent rock. Burnishing to remove the dots of false biting near the tip of the second figure's pointing finger.
Copperplate: Rome, C.N. (747y, 46B)

Related drawings

40a*. Odescalchi (Berlin, Galerie Gerda Bassenge in 1974)
The final drawing for the print, in reverse from it, with major *pentimenti* in the principal figure and significant differences from the print in the background figures.
Pen and brown ink, brown wash, traces of black chalk. 134 x 92 mm. (M. 45.9)

40b. Leipzig (Bd. 25, no. 8)
A free sketch, very similar in composition to the Odescalchi drawing above.
Pen and brown ink. 198 x 106 mm. (M. 82.9)

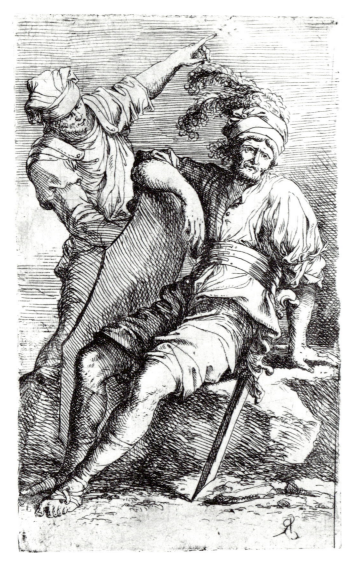

40/II. Rosa, *Figurine*, etching. British Museum

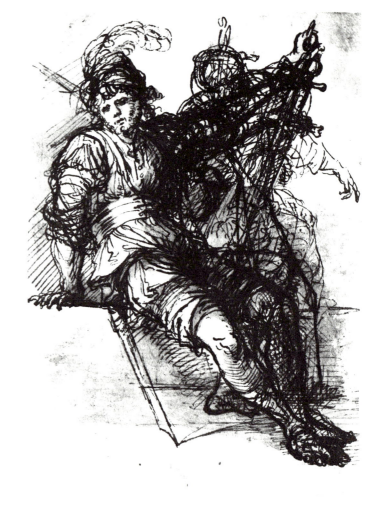

40a. Rosa, final drawing for [40]. Odescalchi

41. *FIGURINE*

Two warriors seated on low rocks.
Bartsch 47
140 x 91 mm.
Signed with the monogram *SR*, in reverse, in drypoint at the lower left in both states.

41/I. Etching with drypoint

The drypoint monogram *SR* has very rich burr that blurs the letters. Light touches of drypoint on the principal figure at the edge of his armor back plate near his right arm and the adjacent shoulder armor, at his left elbow, in the folds of drapery inside his left knee, and in the lower part of the knot of his sword hanger. Light drypoint shading on the block to the right of the sword. Light drypoint added to the second figure at his lower back, right hip, right arm, and below his right arm. A well-printed, clear impression on paper with an illegible watermark. Known in only one impression.
Rome, G.N.S. (F.N. 31518)

41/II*. Etching with drypoint

Several short strokes of deep drypoint added to the bump of drapery on the principal figure's upper left leg where foiled against the staff behind. One of these overlaps the staff slightly. Several strokes of light drypoint on his upper left leg to the left of the staff, running generally parallel to the contour line.
Copperplate: Rome, C.N. (747y, 47B)

Related drawings

41a. Holkham Hall, Collection of Lord Leicester (Portfolio IV, 6)
 The final drawing for [41] and [42], in reverse from them.
 Pen and brown ink, brown wash. 122 x 95 mm. (M. 45.11)

41b. Odescalchi
 A figure very similar in pose to the principal figure of [41], in the same direction, but unarmed and with his left arm lowered. Possibly an early idea for the print. On the verso can be read: "Salvator R . . . has . . . Carolo Ru. . . ." This, combined with the presence of a similar inscription on the drawing for [43] below, suggests that Rosa may have considered using [41] or a similar print for the frontispiece to the *Figurine* series.
 Pen and brown ink, black chalk. 108 x 75 mm. (M. 46.2)

See also [43].

Copies

Paris, Louvre, Cabinet des Dessins (n. 27278)
A drawing, a close copy.
Red chalk. Measurements wanting.

See also [10].

42*. VARIANT OF [41]

A print virtually identical with [41], in the same direction.
Nagler 95
Etching. 142 x 92 mm.
Not signed

Done on a different plate than [41], and not a first state, as Bozzolato, 27, calls it. Overbitten and badly false bitten. A very tentative experiment was made in cleaning up the plate by burnishing a small area behind the principal figure's left foot, but there is no way of telling if this was done by Rosa or at a later date. The plate was abandoned, and repeated exactly in [41].

Collections

Albertina (AL 16); Boston; Hamburg (no. 2231); London, B.M. (W. 7-39)

Related drawings

See [41]

43*. VARIANT OF [41]

A print quite similar to [41] with the principal figure leaning forward much more energetically and the background figure an old man in a turban looking up at him.

Nagler 106

Etching with drypoint. 141 x 92 mm.

Signed with the monogram *SR*, in drypoint, at the lower right.

Considerable light to deep drypoint as shading and also occasionally as contour line in many places throughout the print. Since the plate is free of serious flaws and was extensively worked over with drypoint and then signed in drypoint, Rosa at one time must have considered using it as part of the regular *Figurine* series. He may have decided against it because of the rather light, sketchy character of the print.

The background figure in this print is quite similar in its position and compositional effect to a background figure in the Holkham drawing for [41] and [42] above, but omitted in the etchings themselves.

Collections

Albertina (AL 16); Boston; Fogg (Gray 3407); Grunwald; Hamburg (no. 2242).

Related drawings

43a. Odescalchi (Berlin, Galerie Gerda Bassenge in 1974)

The final drawing for the print, in reverse from it. An inscription on the block supporting the principal figure is scrawled, drawn over, and barely legible, but can be seen to have the words "Salv. Rosa Napoletan" and a phrase that cannot be read.

Pen and brown ink, brown wash, traces of black chalk. 115 x 93 mm. (M. 45.10)

See also [41].

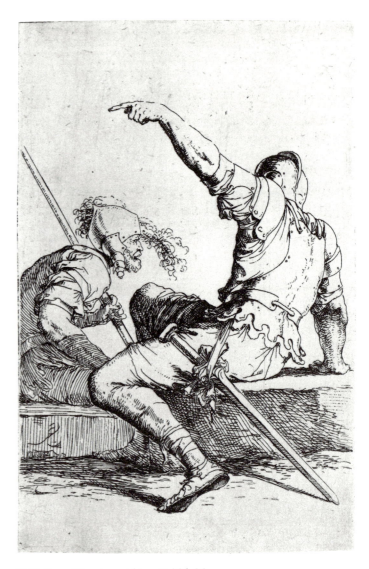

41/II. Rosa, *Figurine*, etching. British Museum

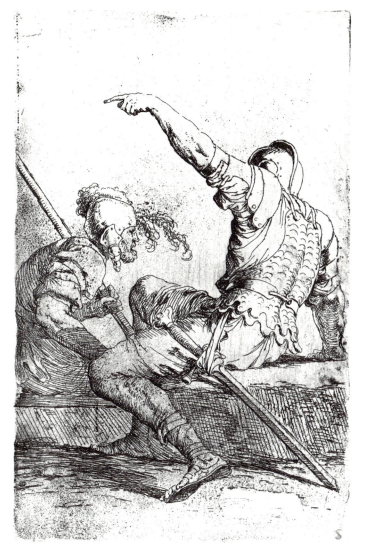

42. Rosa, variant of [41], etching.
Boston, Museum of Fine Arts

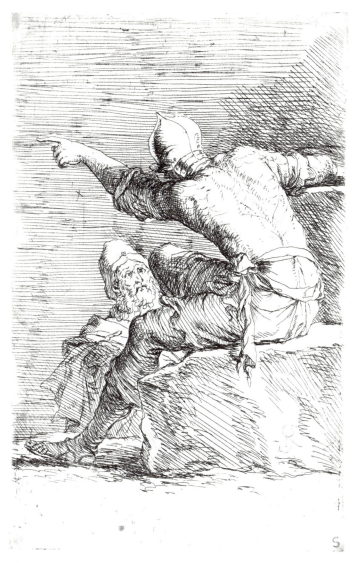

43. Rosa, variant of [41], etching.
Boston, Museum of Fine Arts

44. *FIGURINE*

Two warriors, one seated on a low foreground rock and holding a war hammer; the other figure seated on the ground behind him, holding a mace across his right shoulder and looking up at the foreground figure.
Bartsch 48
142 x 93 mm.

44/I*. Etching with drypoint
Not signed. Traces of light to medium drypoint in the shading of the war hammer head, in the plume and turban of the secondary figure, in the shading of the upper left leg armor of the principal figure, and as fill on the ground at the lower left. Lightly and unevenly printed on paper with the watermark a six-pointed star in a circle. Known in only one impression.
Rome, G.N.S. (F.N. 31531)

44/II*. Etching with drypoint
Signed with the monogram *SR*, in drypoint, at the lower right. Otherwise graphically the same as the first state.

Collections

London, B.M. (Chambers Hall volume, 163*-b-20); Rijksmuseum

44/III*. Etching with drypoint
The left foot of the principal figure shortened by about 2 mm. by burnishing out the etched toes of the earlier states and reworking them in medium to deep drypoint. Several light drypoint lines and circles added to the footgear. This reworking was certainly done by Rosa himself since the way the burnishing and drypoint are handled is typical of him and a similar correction of too-long a foot was also made in the *Ceres and Phytalus* [112].
Copperplate: Rome, C.N. (747y, 48B)

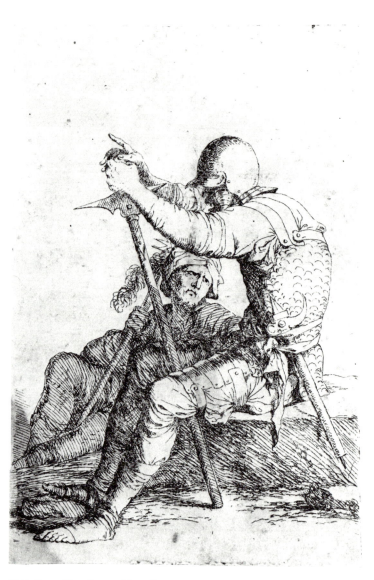

44/I. Rosa, *Figurine*, etching. Rome, Gabinetto Nazionale delle Stampe

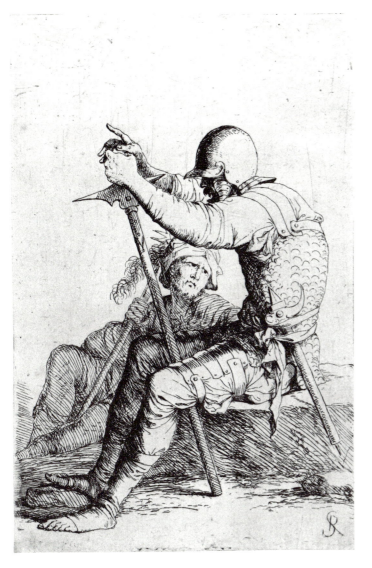

44/II. Rosa, *Figurine*, etching. British Museum

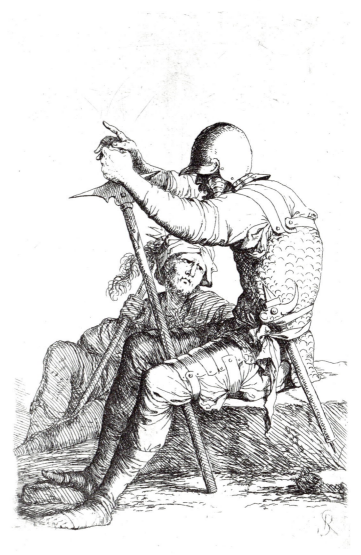

44/III. Rosa, *Figurine*, etching. Boston,
Museum of Fine Arts

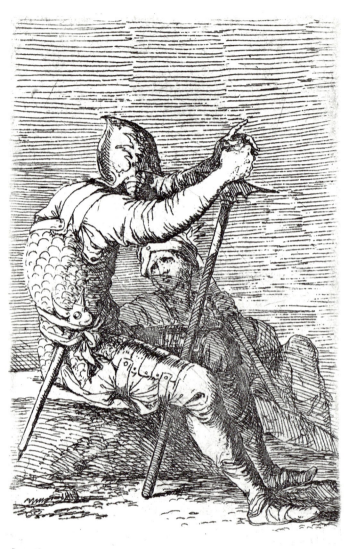

45. Rosa, variant of [44], etching. Author's collection

45*. VARIANT OF [44]

Very similar to [44], in reverse from it, with slight differences in the figures' costumes.

Not listed in Bartsch or Nagler. Rotili, 51.

Etching. 142 x 92 mm.

Not signed

Discovered by the author in 1968 as the *rovescio* of the plate for [11] in Rome, C.N. Probably discarded because of its relative graphic crudeness and heavy, muddy biting.

Because of its coarseness and reversal from [44], it is tempting to think that it might be a copy of [44] by another hand. It might be, but I feel that it is by Rosa himself because of its very close connections to the other canceled *rovesci* and also because the handling of the needle in many passages, especially the lower portions of the principal figure and his rocky seat, is typical of Rosa. Also, the slight changes in costume suggest that it is not simply a copy, especially since yet another solution is given to the foot that was changed in the third state of [44].

Canceled, possibly by Rosa himself. Later "salvaged," by roughly burnishing out the cancellation strokes in the areas where this could be done without affecting the original etching, and re-used.

Impressions as in [23]

Copperplate: Rome, C.N. (747y, 28B *rovescio*)

46*. *FIGURINE*

Two warriors in armor with a figure wearing a turban behind them.
Bartsch 49
Etching. 143 x 95 mm.
Signed *SRosa*, in etching, at the lower left.

Although the print is known in only one state, an impression appears in the bound volume in Rome, G.N.S., which contains all the known first states of the *Figurine*. This impression (F.N. 31528) is somewhat unevenly printed, as are many of the first states, suggesting that Rosa may have pulled an impression as a trial proof and then decided that no changes were needed. Even in early impressions, including this one, the lower right corner of the plate is distinctly beveled.

Copperplate: Rome, C.N. (747y, 49B)

Related drawings

46a. Odescalchi (Berlin, Galerie Gerda Bassenge in 1974)
A study of several warriors, relating both to this print and to [54].
Pen and brown ink, brown wash. 182 x 132 mm. (M. 45.12)

46b. Odescalchi (Berlin, Galerie Gerda Bassenge in 1974)
An early drawing showing a peasant figure seated in a pose very much like that of the foreground figure of [46], in reverse from it, with two gesturing figures behind him. Probably not directly related to the print, but perhaps of some influence on it.
Pen and brown ink, brown wash. 125 x 104 mm. (M. 8.1)

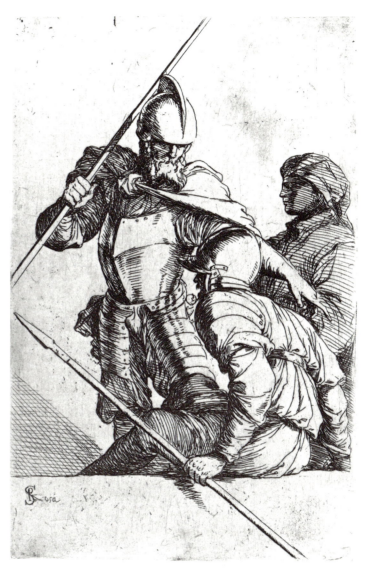

46. Rosa, *Figurine*, etching. British Museum

47*. *FIGURINE*

Two warriors, the seated one leaning against a rock and gesturing; the other seen helmet and shoulders behind him.
Bartsch 50
Etching. 144 x 93 mm.
Signed with the monogram *SR*, in etching, at the lower right.

Although the print is known in only one state, an impression appears in the bound volume in Rome, G.N.S., which contains all the known first states of the *Figurine*. This impression (F.N. 31508) is quite lightly and unevenly printed, as are many of the first states, suggesting that Rosa may have pulled an impression as a trial proof and then decided that no changes were needed.

Copperplate: Rome, C.N. (747y, 50B)

Related drawing

47a*. Windsor, Collection of Her Majesty the Queen (no. 6127)
The final drawing for the print, in reverse from it. Unique among the preparatory drawings for the *Figurine* in being scored for transfer to the plate. Laid down, so that it is impossible to tell whether the verso was rubbed with chalk for transfer.
Pen and brown ink, brown wash, traces of red chalk. 140 x 92 mm. (M. 45.13)

48*. *FIGURINE*

Three warriors, one seated on a foreground rock holding a staff; the second standing behind him and pointing, the third seen as a face behind them.
Bartsch 51
Etching with drypoint. 145 x 95 mm.
Signed with the monogram *SR*, in etching, at the lower left.

Known in only one state.

Touches of light drypoint in the cheek and jowl of the face at the left edge of the print.

Copperplate: Rome, C.N. (747y, 51B)

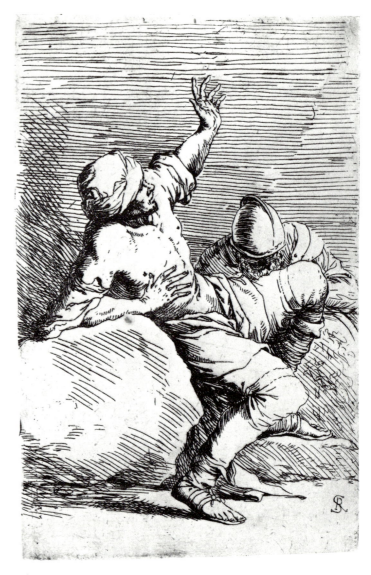

47. Rosa, *Figurine*, etching. British Museum

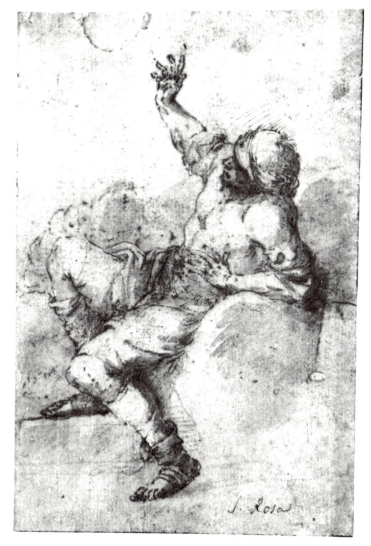

47a. Rosa, final drawing for [47]. Windsor,
 Collection of Her Majesty the Queen

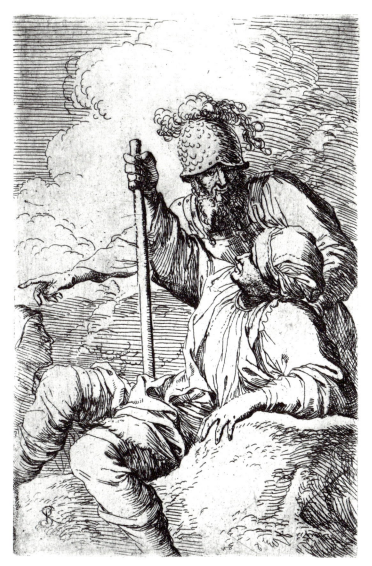

48. Rosa, *Figurine*, etching. British Museum

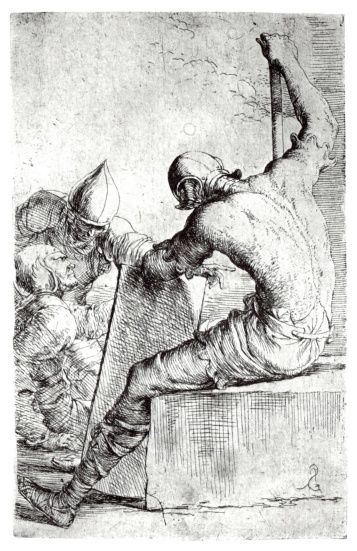

49/II. Rosa, *Figurine*, etching. British Museum

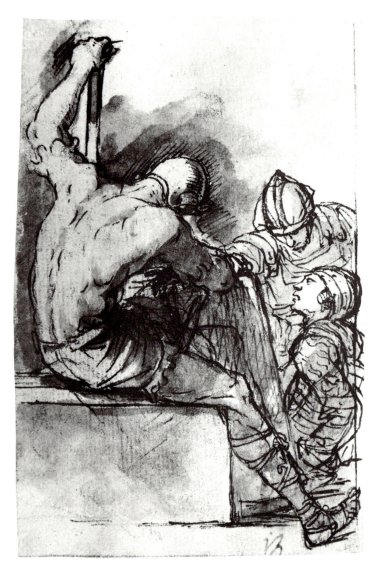

49a. Rosa, final drawing for [49]. Odescalchi

49. *FIGURINE*

A warrior, seated on a foreground block, holds a shield and staff and turns toward two warriors behind him.
Bartsch 52
140 x 91 mm.

49/I. Etching (with drypoint?)
Not signed. There may be a few strokes of medium to deep drypoint added to the shading behind the head of the figure at the left edge of the print. An extremely good impression, much better printed than most of the first states. Known in only one impression.
Rome, G.N.S. (F.N. 31506)

49/II*. Etching (with drypoint?)
Signed with the monogram *SR*, in reverse, in drypoint at the lower right. Otherwise graphically the same as the first state.
Copperplate: Rome, C.N. (747y, 52B)

Related drawing

49a*. Odescalchi
The final drawing for the print, in reverse from it.
Pen and brown ink, brown wash, traces of black chalk. 143 x 90 mm. (M. 45.14)

50. *FIGURINE*

A warrior, seated on a rock, leans on a large shield and turns toward three warriors behind him.
Bartsch 53
140 x 92 mm.

50/I. Etching with drypoint
Not signed. Light to medium drypoint added to the belly of the principal figure and to his skirt at the crotch. Quite well printed, if somewhat lightly. Known in only one impression.
Rome, G.N.S. (F.N. 31535)

50/II*. Etching with drypoint
Signed with two monograms *SR*, both in reverse, in drypoint at the lower left. Burnishing of the left cheek of the figure with the lion cap, burnishing of his left shoulder and his right shoulder next to his cap.
Copperplate: Rome, C.N. (747y, 53B)

Related painting

50a. New Haven, Yale University Art Gallery
Landscape with Bathers
The principal figure of the etching is almost identical in pose, in reverse, with a nude bather in the picture. This is the only instance I know in which one of the *Figurine* is very similar to a figure in a genuine Rosa painting. Illustrated in Salerno, *Rosa*, no. 48a.
.76 x 1.02 m.

Related drawing

50b. Odescalchi
The final drawing for the print, in reverse from it.
Pen and brown ink, brown wash, traces of black chalk. Framed, hung, impossible to measure, but of the same general dimensions as the print.

Copy

Florence, Uffizi (no. 6613)
A drawing, a rather crude copy of the etching, in reverse from it. Accepted by Rotili, 55a.
Pen, ink, wash. Measurements wanting.

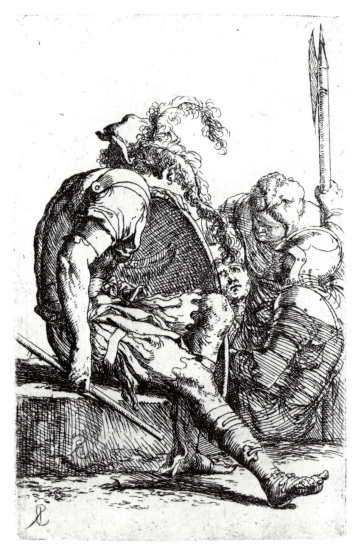

50/II. Rosa, *Figurine*, etching. British Museum

51. *FIGURINE*

A warrior stands in the foreground and points; another leans on a shield with a grotesque face.
Bartsch 54
145 x 95 mm.
Signed with the monogram *SR*, in etching, at the lower left in both states.

51/I. Etching with drypoint
Medium to deep drypoint shading added to the armor of the principal figure's right arm. Light to medium drypoint shading added to his left chest armor next to his left forearm and to his drapery to the right of his left hand. Some medium drypoint shading on the principal figure's upper left leg.

The mouth, nose and left eye of the grotesque face on the shield have been gone over with brown ink, but it is not clear if actual graphic changes were made in these areas in the second state since the ink obscures the etched lines in the first state, making a definitive comparison impossible.

Rather lightly and unevenly printed. Known in only one impression.
Rome, G.N.S. (F.N. 31507)

51/II*. Etching with drypoint
Medium to deep drypoint added to the shaded portions of the drapery that hangs down in front of the left leg of the principal figure and behind his right leg, creating distinct hatching. Light drypoint shading added to the right side of the second figure's face and to his right forearm. Light to medium drypoint added to the hair of the principal figure on the right side of his head. Traces of light drypoint shading added beneath his left ear. Light to medium drypoint added to his upper left leg beyond that seen in the first state. Light to medium drypoint added to **the sh**ading of his upper left foot near the ankle.

Copperplate: Rome, C.N. (747y, 54B)

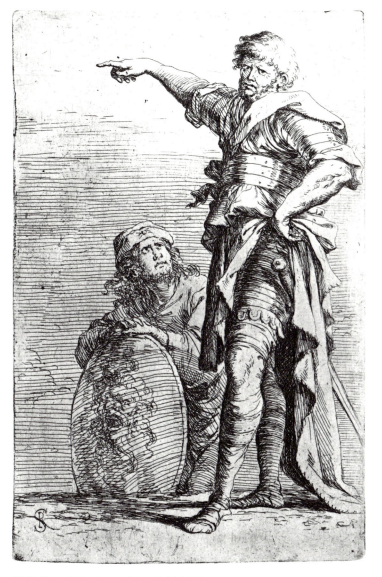

51/II. Rosa, *Figurine*, etching. British Museum

52. *FIGURINE*

Three warriors at a low wall, one seated with his back turned to the viewer.
Bartsch 55
140 x 90 mm.
This is the only one of the *Figurine* prints that is not signed.

52/I. Etching with drypoint

Light drypoint strokes with rich burr added to the shading of the inner right shoulder of the left figure. Light to medium drypoint with rich burr at his lower right hip, filling out the contour. Burnishing of the wall at the left. Rather lightly and unevenly printed on light paper with the watermark six mountains over the letters MA. Known in only one impression.
Rome, G.N.S. (F.N. 31526)

52/II*. Etching with drypoint

Light to deep drypoint added to the shading of the helmet of the left figure. Light to medium drypoint added to the shading of the wall below that figure and above the leg of the principal figure. Light drypoint to complete the contour of the sword tip, with light drypoint shading on the ground next to it. Burnishing of the left sleeve of the right figure around the elbow. Burnishing of his face, hair, and the overlapping parts of the hair of the principal figure. Several strokes of deep drypoint added to the lower right portions of the principal figure's hair. Possibly some drypoint at the right shoulder of the principal figure and in the hair of the right figure.
Copperplate: Rome, C.N. (747y, 55B)

Related drawing

52a*. Rome, Collection of Principe Urbano Barberini
The final drawing for the print, in reverse from it. Until recently part of the Odescalchi collection of Rosa drawings.
Pen and brown ink, brown wash, traces of black chalk. Framed, hung, impossible to measure, but of the same general dimensions as the etching. (M. 45.15)

Copy

Albertina (W. Sc. R. 1100, Inv. 989)
A drawing, a copy of the print in the same direction.
Pen and brown ink, brown wash, traces of black chalk, heightened with white. 143 x 91 mm.

Addendum

[52] also shows interesting similarities to a painting attributed to L. Bramer, signed and dated 1626, and now in the Bredius Museum, The Hague. It seems very unlikely, however, that there is any direct connection between them.

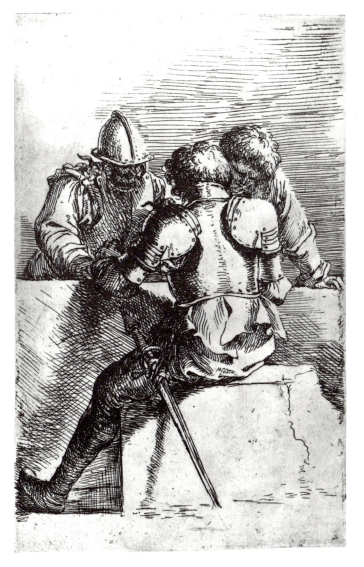

52/II. Rosa, *Figurine*, etching. British Museum

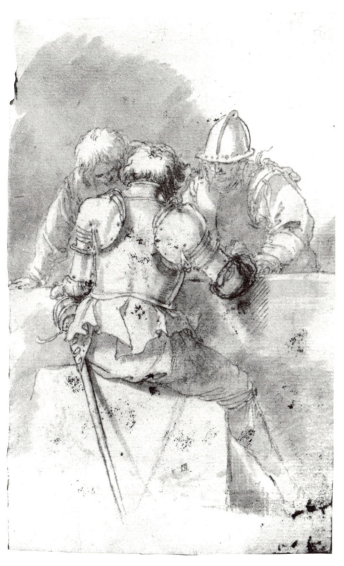

52a. Rosa, final drawing for [52]. Rome,
 Collection of Principe Urbano Barberini

53. *FIGURINE*

Four warriors, one seated on a foreground block and holding a shield, his head turned toward a standing warrior behind him, with two others beyond.
Bartsch 56
144 x 94 mm.
Signed *SRosa*, in etching, at the lower right in both states.

53/I. Etching
No drypoint. An accidental etched line below and parallel to the principal figure's left elbow. A very good impression, more clearly and forcefully printed than most of the first states. Known in only one impression.
Rome, G.N.S. (F.N. 31516)

53/II*. Etching with drypoint
Some light to deep drypoint in a number of places in the print. Burnishing to remove the accidental line beneath the principal figure's left elbow.
Copperplate: Rome, C.N. (747y, 56B)

54. *FIGURINE*

Four warriors, one seated on a foreground rock, his arm raised toward a standing figure who gestures vigorously; two others stand behind them.
Bartsch 57
141 x 90 mm.
Signed with the monogram *SR*, in etching, at the lower left in both states.

54/I. Etching with drypoint
Light drypoint added to the shading of the lower right of the shield and to the adjacent background. Light drypoint added to the shading of the left forearm of the foremost figure, light to medium drypoint shading on his left leg, several light strokes of drypoint at the lower edge of the projecting fold of drapery at his right hip. Light drypoint shading lines with considerable burr on the skirt of the tallest figure. Some drypoint added to the shading of the center shield.

At some time touches of brown ink were added to the holding straps of the round shield and to the fingers of the tallest figure's right hand, but no graphic changes were made in these areas in the second state.
Even in early impressions, including this one, the plate corners, especially the upper left, are slightly rounded. Lightly but well printed. Known in only one impression.
Rome, G.N.S. (F.N. 31509)

54/II*. Etching with drypoint
Light drypoint added to the hair, neck, and armor of the figure farthest left. Light drypoint lines added to the shading of the center shield beyond those already there in the first state. Some light to medium drypoint added to the rock near its left edge. Medium to deep drypoint added to the shading of the drapery on the belly and chest of the seated figure. Medium to deep drypoint added to the shading of the belly and chest of the tallest figure near the contour. Medium drypoint lines running basically vertically added to his skirt opening at the crotch. A few light strokes of drypoint added to the sword handle of the seated figure.
Copperplate: Rome, C.N. (747y, 57B)

Related drawings

54a. Odescalchi (Berlin, Galerie Gerda Bassenge in 1974)
A preliminary study related to both this print and [46], a *Figurine* etching much like this one in basic composition.
Pen and brown ink, brown wash. 182 x 132 mm. (M. 45.12)

54b. New York, Collection of E. Powis Jones
A figure very similar to the foreground figure of the etching, in reverse from it. I know this drawing only from Mahoney.
Pen and brown ink. Dimensions wanting (one of six drawings on a single mat). (M. 82.13c)

Addendum

[54] is clearly based on the *Laocoön* as seen from the side.

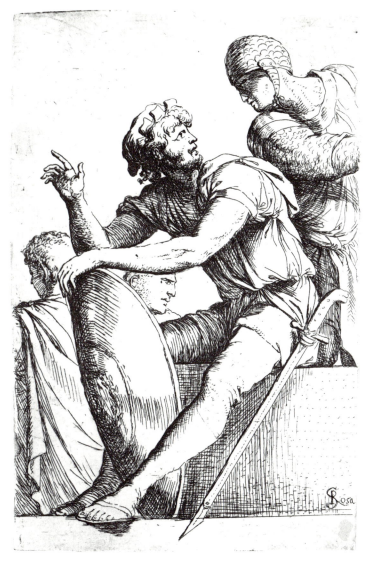

53/II. Rosa, *Figurine*, etching. British Museum

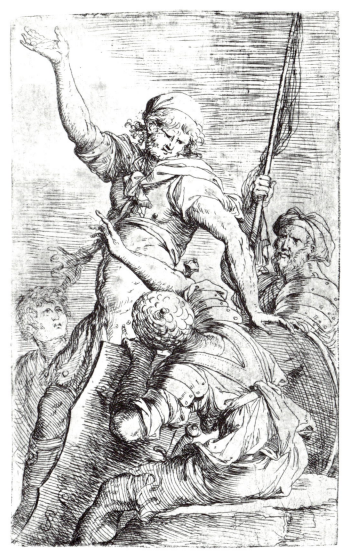

54/II. Rosa, *Figurine*, etching. British Museum

55. *FIGURINE*

A warrior sits on a foreground block and gestures; two genre figures are behind him.
Bartsch 58
145 x 96 mm.
Signed with the monogram *SR*, in etching, at the lower right in both states.

55/I. Etching with drypoint
　　Light to medium drypoint added to the shading of the principal figure's right leg below the knee. Light touches of drypoint between the thumb and forefinger of his left hand and on the toes of his right foot. Light drypoint shading on the block to the left of the drapery and in the second figure's drapery, especially where framed by the principal figure's legs. Traces of light drypoint in the shading of the second figure's neck and cap, and on the sleeve and drapery of the figure farthest in depth. Even in early impressions, including this one, the upper left plate corner is slightly rounded. Rather lightly and unevenly printed. Known in only one impression.
　　Rome, G.N.S. (F.N. 31530)

55/II*. Etching with drypoint
　　Strokes of deep drypoint added to the shading of the trailing drapery where it folds inward from resting on the ground. Medium to deep drypoint to clarify the left knee contour of the principal figure. Traces of light drypoint shading added to his upper right breast just above his armor. Light drypoint added to the hair of the figure farthest in depth, and to complete his shoulder contour.
　　Copperplate: Rome, C.N. (747y, 58B)

Related drawing

55a. Mahoney lists a study (M. 45.16) from the Odescalchi Collection. (Berlin, Galerie Gerda Bassenge in 1974)

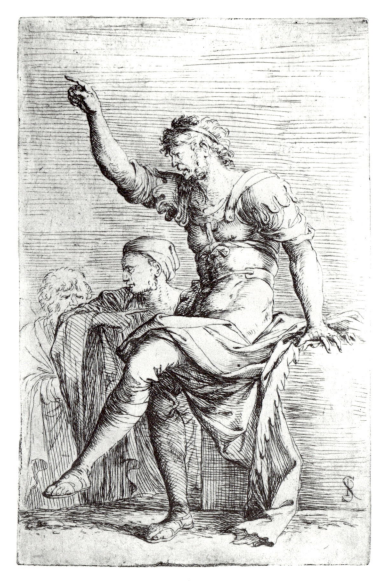

55/II. Rosa, *Figurine*, etching. British Museum

56*. VARIANT OF [55]

A print almost identical with [55], in reverse from it, with the head of an additional figure in the background.
Nagler 96
Etching with drypoint. 141 x 89 mm.
Signed with the monogram *SR*, in etching, at the lower left.

Apparently abandoned because too lightly and unevenly bitten, and because of extensive light false biting over most of the plate surface. A tentative attempt was made to salvage the plate by burnishing out parts of this false biting. Touches of light drypoint added to the sleeve of the figure at the extreme right.

Collections

Boston; Fogg (Gray 3419); Hamburg (no. 2232); London, B.M. (W. 7-28)

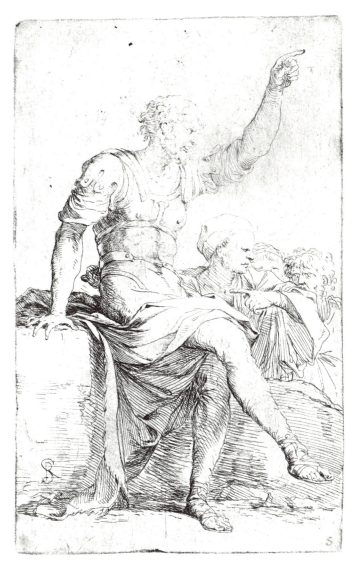

56. Rosa, variant of [55], etching.
Boston, Museum of Fine Arts

57. *FIGURINE*

Two warriors, one seated asleep on a foreground rock.
Bartsch 59
141 x 90 mm.

57/I. Etching

Not signed. No drypoint. Quite well printed. Known in only one impression.
Rome, G.N.S. (F.N. 31514)

57/II*. Etching (with drypoint?)

Signed with the monogram *SR*, in reverse, in drypoint at the lower left. It is difficult to be certain, but a few strokes of medium drypoint may have been added at the principal figure's left knee to compensate for plate breakdown there. This is evident only when comparing a second state impression directly with the first state.
Copperplate: Rome, C.N. (747y, 59B)

Related etching

This print is in many ways a version of [27], graphically less sophisticated.

Related drawings

57a*. Rome, Collection of Principe Urbano Barberini
The final drawing for the print, in reverse from it. Until recently part of the Odescalchi collection of Rosa drawings.
Pen and brown ink, brown wash, traces of black chalk. Framed, hung, impossible to measure, but of the same general dimensions as the print. (M. 45.17)

57b. Uffizi (Santarelli 6592)
A figure almost identical with the principal figure in the etching, in reverse from it. Possibly a copy, but possibly done by Rosa himself as a more detailed study of the figure's armor. Rejected by Mahoney.
Pen and brown ink, brown wash. 140 x 95 mm.

See also M. 45.18.

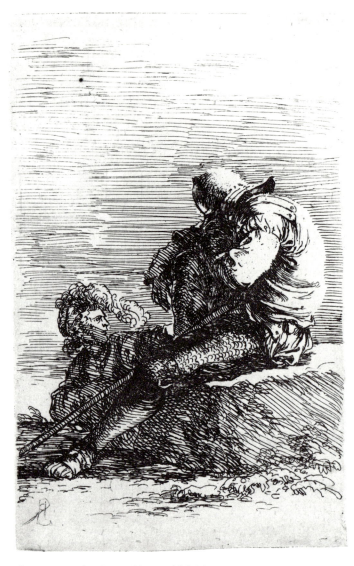

57/II. Rosa, *Figurine*, etching. British Museum

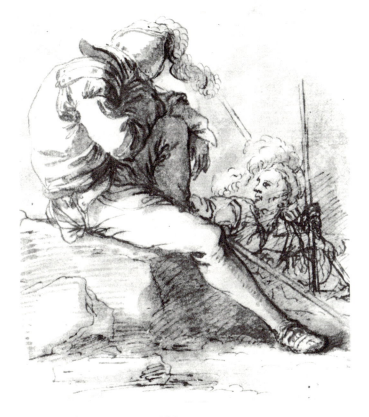

57a. Rosa, final drawing for [57]. Rome,
 Collection of Principe Urbano Barberini

58*. *FIGURINE*

Three warriors, one in chain mail seated on a foreground rock and holding a shield; he looks up at a standing warrior with a sword; a third figure is behind them.
Bartsch 60
Etching with drypoint. 145 x 95 mm.
Signed with the monogram *SR*, in reverse, in etching at the lower right of center.

Known in only one state.

A few strokes of light drypoint added to the shadow to the left of the shield. Even in early impressions the plate corners are slightly rounded.

Copperplate: Rome, C.N. (747y, 60B)

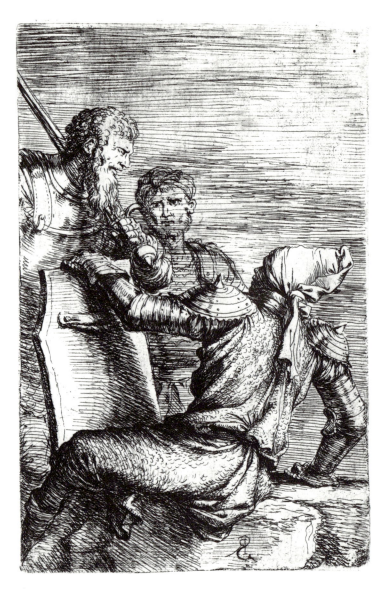

58. Rosa, *Figurine*, etching. British Museum

59. *FIGURINE*

Four warriors and a standing youth, who points down at one of them.
Bartsch 61
147 x 94 mm.
Signed with the monogram *SR*, in etching, at the lower right in both states.

59/I. Etching with drypoint

Light drypoint lines running basically in parallels on the armor of the figure farthest right. His hair lightly burnished and worked over in places with light to medium drypoint. Varying amounts of light to deep drypoint here and there throughout the print. A superb impression, much better printed than most of the first states. Known in only one impression.
Rome, G.N.S. (F.N. 31524)

59/II*. Etching with drypoint

Deep, curving drypoint strokes added to the shading of the right sleeve above the elbow of the foremost figure. Deep, slightly curving drypoint shading strokes added to the drapery of his upper right leg just above the ledge, running generally parallel with the fingers of his right hand.
Copperplate: Rome, C.N. (747y, 61B)

Related drawing

59a. Uffizi (2217F)

An early drawing of a semi-nude youth seated in a pose rather like that of the foremost figure in the print. Earlier than the print and probably not directly related to it, but perhaps of some influence in the evolution of the composition.
Red and black chalk. 85 x 79 mm. (M. 20.3)

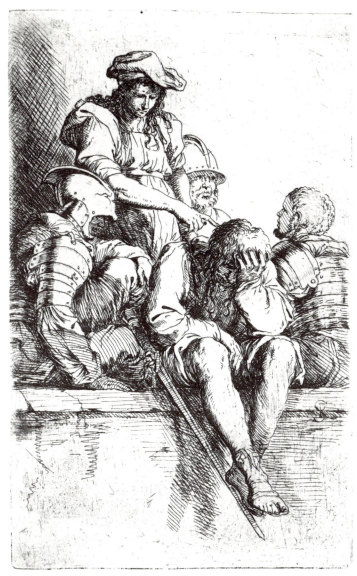

59/II. Rosa, *Figurine*, etching. British Museum

60. *FIGURINE*

Two warriors, one holding a mace and turning to beckon to the other.
Bartsch 62
140 x 91 mm.

60/I. Etching with drypoint
Not signed. Some light to deep drypoint in a number of places in both figures and in the ground shadows. Somewhat lightly and unevenly printed on quite hard, heavy paper so that the finer drypoint lines are often difficult to see. Nevertheless it seems graphically to be the same as the second state. Known in only one impression.
Rome, G.N.S. (F.N. 31510)

60/II*. Etching with drypoint
Signed with the monogram *SR*, in reverse, in drypoint at the lower right.
Copperplate: Rome, C.N. (747y, 62B)

Related drawings

60a. Odescalchi
The final drawing for the print, in reverse from it.
Pen and brown ink, brown wash, traces of black chalk. 146 x 92 mm.

60b. Leipzig (Bd. 25, no. 35A)
A figure group very similar to that of the print, in reverse from it, with slight variations in the poses of the two figures. Probably an early idea for the print.
Pen and brown ink. Cut down around the figures to roughly 135 x 85 mm. (M. 45.19)

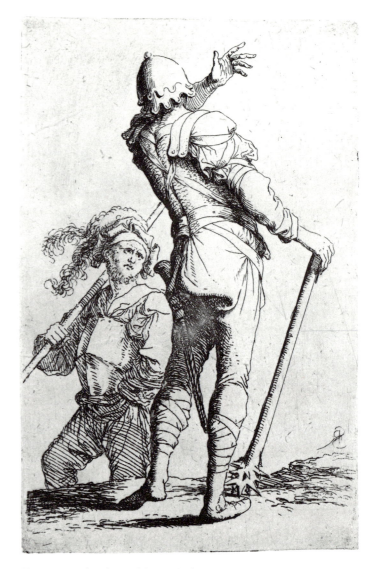

60/II. Rosa, *Figurine*, etching. British Museum

61*. VARIANT OF [60]

A print virtually identical with [60], in the same direction.
Not listed in Bartsch, Nagler, or the other literature.
Etching. 142 x 93 mm.
Not signed

Much too lightly and unevenly bitten to be used.

Collections

Albertina (AL 16); Boston; Fogg (Gray 3424); London, B.M. (W. 7-38)

Related drawing

See [60]

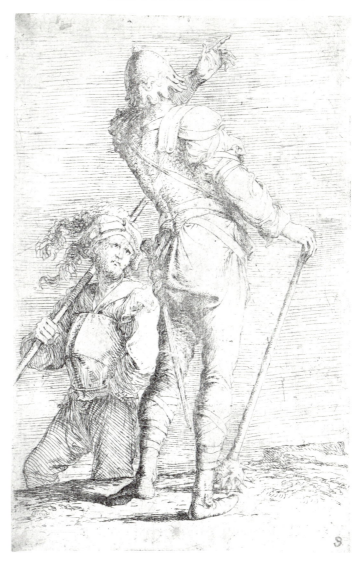

61. Rosa, variant of [60], etching.
Boston, Museum of Fine Arts

62. *FIGURINE*

Two warriors, one holding a shield with a Medusa face and gesturing; the other behind him holding a spear.
Bartsch 63
140 x 92 mm.
Signed with the monogram *SR*, in reverse, in etching at the lower right in both states.

62/I. Etching with drypoint
Light drypoint added to the shading of the principal figure's upper left leg between hip and crotch. Traces of light drypoint shading on the cuff-like fold of drapery above his right knee, and along the lower edge of his left arm and hand. Light drypoint added to the tip of the secondary figure's plume and to his right shoulder and sleeve. Rather lightly but quite clearly printed. Known in only one impression.
Rome, G.N.S. (F.N. 31512)

62/II*. Etching with drypoint
Considerable medium to deep drypoint added to the shading of the shield, especially below the hand of the principal figure. Medium drypoint added around the beard of the face on the shield. Several strokes of deep drypoint added to the principal figure's upper right leg near the crotch, running generally parallel with the curves of the cuff-like fold of drapery and above it. Light drypoint added to the shading of the outer edge of his right arm. Light drypoint added to the shadows on the ground cast by the principal figure's right foot and the shield.
Copperplate: Rome, C.N. (747y, 63B)

Related drawings

62a. Odescalchi
The final drawing for the print, in reverse from it.
Pen and brown ink, brown wash, traces of black chalk. 142 x 90 mm. (M. 45.20)

62b. Odescalchi
A drawing of a gesturing woman almost identical with the principal figure in the drawing above, surrounded by a large group of figures and a donkey. Possibly indirectly related to the print.
Pen and brown ink. 101 x 102 mm. (M. 25.5)

63. *FIGURINE*

Two warriors, one leaning against a foreground rock and turning back toward the other, who is gesturing.
Bartsch 64
144 x 92 mm.

63/I. Etching
Not signed. Known in only one impression.
Rome, G.N.S. (F.N. 31551)

63/II*. Etching
Signed with the monogram *SR*, in drypoint, at the lower left.
Copperplate: Rome, C.N. (747y, 64B)

Copy

Rotili, 66a, accepts and illustrates a drawing in a Roman private collection as a preparatory study for the etching. It is, in my opinion, a crude copy after the print.

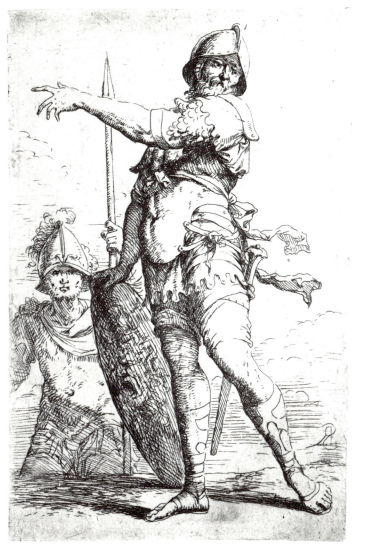

62/II. Rosa, *Figurine*, etching. British Museum

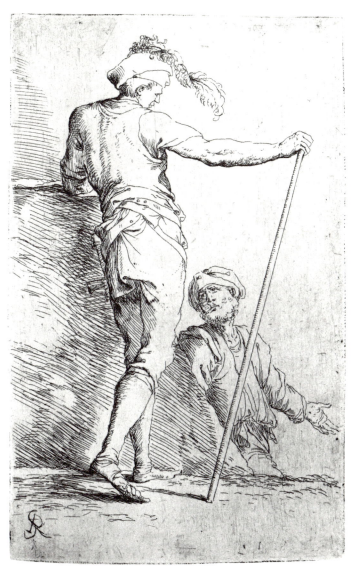

63/II. Rosa, *Figurine*, etching. British Museum

64. *FIGURINE*

Four warriors, one seated on a foreground block, three others behind him.
Bartsch 65
144 x 92 mm.

64/I. Etching

Signed with the monogram *SR*, in drypoint with a very rich burr, at the lower right. No other drypoint. Lightly but quite well printed on paper with the watermark a bird with a star above. Known in only one impression.
Rome, G.N.S. (F.N. 31523)

64/II*. Etching with drypoint

Light to medium drypoint used to reinforce lightly etched or unclear lines and areas in the hair, cap, and right shoulder drapery of the tallest figure, and in the head, cap, left arm and left leg of the foreground figure. These touches tend to read as being darker than the etched lines they reinforce. Light to medium drypoint also added both to the shading of the shield at the right and to the head of the halberd.
Copperplate: Rome, C.N. (747y, 65B)

Related drawing

64a. Odescalchi (Sold: London, Christie's, July 6, 1976, No. 53)
The final drawing for the print. Very unusual in not being in reverse from the print.
Pen and brown ink, brown wash. 150 x 94 (M. 45.21)

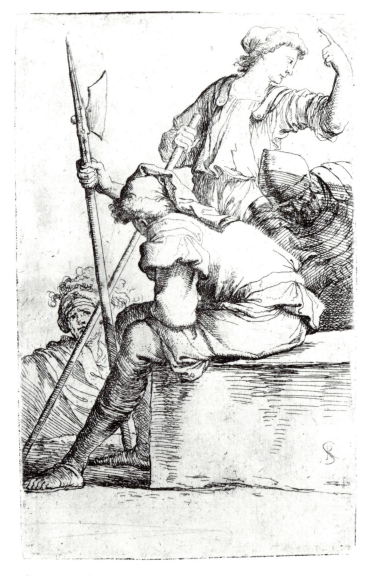

64/II. Rosa, *Figurine*, etching. British Museum

65*. *FIGURINE*

Two warriors, one holding a sword, the other a halberd; an old bearded man behind them.
Nagler 107
Etching. 143 x 91 mm.
Signed with the monogram *SR*, in drypoint, at the lower right.

Known in only one state.

No drypoint. Very lightly bitten and apparently soon quite worn, as evidenced by the worn character of the impressions in Boston, Rome, G.N.S., and Paris, B.N. It was then evidently replaced by [65b], which in my opinion is a copy by another hand. Bartsch accepts [65b], but Nagler, noting its roughness and the superiority of [65], correctly assigns priority to [65]. He does, however, feel that [65b] was done by Rosa himself to replace the too lightly bitten [65].

It is noteworthy that, unlike almost all of the variants, [65] is from a fully finished plate having no significant graphic deficiencies aside from too light biting. Impressions of [65] are also more commonly encountered than are impressions of the variants.

Collections

Boston; Fogg (Gray 3426); Grunwald; Hamburg; London, B.M. (W. 7-15); Paris, B.N. (Be 7, p. 28, no. 66); Rome, G.N.S. (26-M-16, 04555)
Rotili, 69, also cites an impression in Budapest, Museum of Fine Arts, which I have not seen.

Related drawing

65a. Odescalchi (Berlin, Galerie Gerda Bassenge in 1974)
The final drawing for [65], in reverse from it. The fact that it is in reverse from [65] and not from [65b] is another reason for giving priority to [65], since almost all of the drawings for the *Figurine* are in reverse from the etchings.
Pen and brown ink, brown wash, traces of black chalk. 143 x 90 mm. (M. 45.22)

Copy

65b*. A print virtually identical with [65], in reverse from it.
Bartsch 66
Etching. 140 x 90 mm.
Signed with the monogram *SR*, in etching, at the lower left.
This is the only one of the prints attributed to Rosa by Bartsch that, in my opinion, is not by him. It is this print which is commonly encountered in collections and print rooms as a standard Rosa attribution. It is accepted in the literature as being by Rosa (see especially Nagler 107, Bozzolato, 46, and Rotili, 68). However, I feel that the drawing and modeling are too uncertain, choppy, and crude to be by Rosa himself, and the whole print has a general rough sloppiness of handling and harshness of tone which are very atypical of Rosa's production in etching.
Copperplate: Rome, C.N. (747y, 66B)

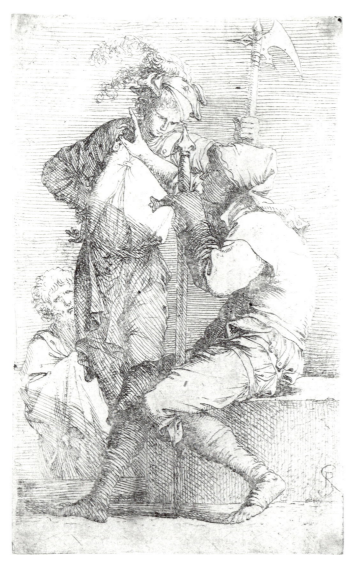

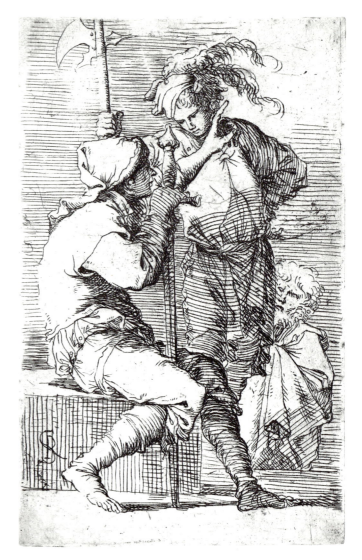

65. Rosa, *Figurine*, etching. Boston,
Museum of Fine Arts

65b. A copy of [65] by another hand, etching.
Boston, Museum of Fine Arts

66. *FIGURINE*

An old man seated on a foreground rock, two men in exotic costume behind him.
Bartsch 67
144 x 93 mm.
Signed *SRosa*, in etching, at the lower right in both states.

66/I. Etching
No drypoint. An excellent impression, lightly but more clearly and evenly printed than most of the first states of the *Figurine*. Known in only one impression.
Rome, G.N.S. (F.N. 31538)

66/II*. Etching with drypoint
Light to medium drypoint added to reinforce etched lines in the beard, cap, right shoulder, sleeves, and knees of the principal figure. These touches tend to read as being darker than the etched lines around them, much as in [64].
Copperplate: Rome, C.N. (747y, 67B)

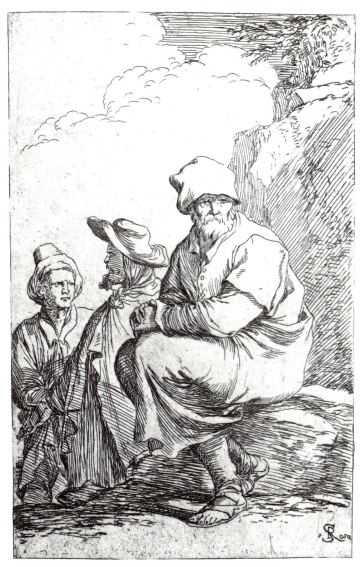

66/II. Rosa, *Figurine*, etching. British Museum

67. *FIGURINE*

Three mendicant-like men, one kneeling on a foreground rock.
Bartsch 68
143 x 94 mm.
Signed with the monogram *SR*, in etching, at the lower left in both states.

67/I. Etching
No drypoint. Lightly and somewhat unevenly printed. Known in only one impression.
Rome, G.N.S. (F.N. 31546)

67/II*. Etching with drypoint
Considerable light to medium drypoint added to the shading of the principal figure's right leg and foot, right biceps, drapery, and turban. Traces of light drypoint shading in the drapery and cap of the figure farthest right. Drypoint to complete parts of the contour line of the center figure's right arm where foiled against his companion's drapery.
Copperplate: Rome, C.N. (747y, 68B)

Related drawing

67a. Haarlem, Teyler Museum (E 15)
The final drawing for the print, in reverse from it.
Pen and brown ink, brown wash, traces of black chalk. 127 x 77 mm. (M. 45.23)

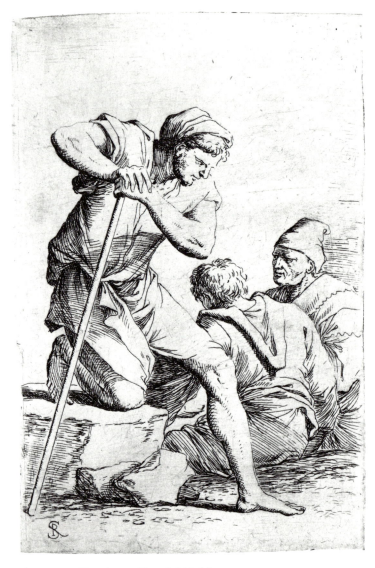

67/II. Rosa, *Figurine*, etching. British Museum

68. *FIGURINA*

A man turned to face a rocky cliff.
Bartsch 69
142 x 93 mm.

68/I. Etching with drypoint
Not signed. Light to deep drypoint in a number of places in
the figure and in the lower right background. Traces of vertical
lines, apparently *pentimenti* related to the staff, near the right
edge of the print. Known in only one impression.
Rome, G.N.S. (F.N. 31543)

68/II*. Etching with drypoint
Signed with the monogram *SR,* in drypoint, at the lower left.
Otherwise graphically the same as the first state.
Copperplate: Rome, C.N. (747y, 69B)

Related drawings

68a. Odescalchi (Sold: London, Christie's, July 6, 1976, No. 54)
The final drawing for the print, in reverse from it.
Pen and brown ink, brown wash, traces of black chalk. 141
x 97 mm. (M. 45.25)

68b. Odescalchi (Berlin, Galerie Gerda Bassenge in 1974)
A figure generally similar to that of the drawing above, in a
more active pose and turned more in profile.
Pen and brown ink, gray wash, traces of black chalk, height-
ened with white. 163 x 109 mm. (M. 45.24)

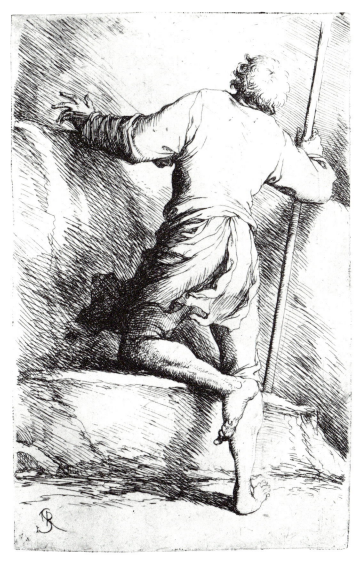

68/II. Rosa, *Figurina*, etching. British Museum

69*. *FIGURINE*

A bearded old man seated on a rock and making a hortatory gesture toward three men opposite him.

Bartsch 70

Etching with drypoint. 145 x 93 mm.

Signed with the monogram *SR*, in etching, at the lower right.

Although the print is known in only one state, an impression appears in the bound volume in Rome, G.N.S., which contains all the known first states of the *Figurine*. This impression (F.N. 31537) is quite lightly and unevenly printed, as are many of the first states, suggesting that Rosa may have pulled an impression as a trial proof and then decided that no changes were needed.

A few strokes of light to medium drypoint added to the upper right edge of the turban of the figure farthest in depth. Light to medium drypoint added above the left shoulder of the youth and in the shaded area beneath his right arm.

Copperplate: Rome, C.N. (747y, 70B)

Related drawings

69a. Chatsworth, Collection of the Duke of Devonshire (617A)
An old man seated in a pose almost identical with that of the principal figure of the print, in reverse, with three figures behind him, generally like those of the print. Possibly an early idea for the etching.
Pen and brown ink, brown wash. 146 x 101 mm. (M. 8.3)

69b. Haarlem, Teyler Museum (E22)
Two figures, the principal one generally like that of the print, in reverse from it.
Pen and brown ink, traces of black chalk. 100 x 153 mm. (M. 68.1)

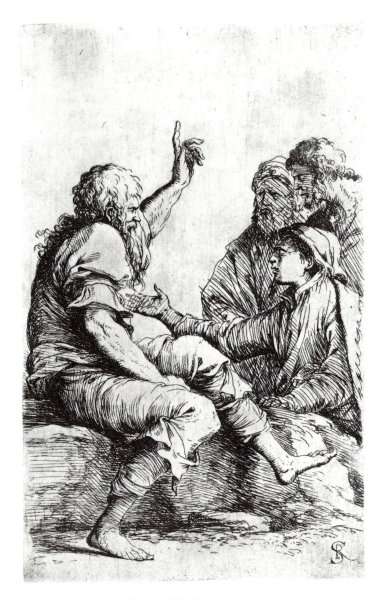

69. Rosa, *Figurine*, etching. British Museum

70*. *FIGURINE*

Three warriors, one wearing a fur cap and seated on a low foreground wall gesturing to the two behind him.
Bartsch 71
Etching with drypoint. 142 x 94 mm.
Signed with the monogram *SR*, in reverse, in drypoint at the lower right.

Known in only one state.

Several strokes of deep drypoint in the principal figure's left foot and sandal. Possibly some medium to deep drypoint shading in his trailing drapery where it breaks at the upper edge, and possibly also as horizontal contour lines in his belly armor. Light to medium drypoint shading on the cap and left shoulder of the second figure. Burnishing to lighten the background behind the principal figure's neck and a spot on his left cheek.

Copperplate: Rome, C.N. (747y, 71B)

Related drawing

70a. Odescalchi (now Washington, D.C., National Gallery of Art)
The final drawing for the print, in reverse from it.
Pen and brown ink, brown wash, traces of black chalk. 149 x 96 mm. (M. 45.26)

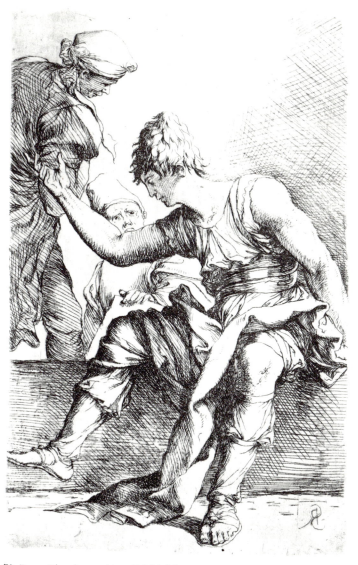

70. Rosa, *Figurine*, etching. British Museum

71*. *FIGURINA*

A standing youth supporting a large tablet with a representation of a herm of Diana of Ephesus.
Bartsch 72
Etching. 146 x 95 mm.
Signed with the monogram *SR*, in reverse, in etching at the bottom of the panel.

Although the print is known in only one state, an impression appears in the bound volume in Rome, G.N.S., which contains all the known first states of the *Figurine*. This impression (F.N. 31542) is quite lightly printed in a way that is typical of many of the first states, suggesting that Rosa may have pulled an impression as a trial proof and then decided that no changes were needed.

Burnishing to lighten the background, especially behind the figure.

Copperplate: Rome, C.N. (747y, 72B)

Copy

Rome, G.N.S. (Inv. 124,292)
A red chalk drawing generally accepted as the final drawing for the print (Bozzolato, 52; Rotili, 83a; Mahoney, 45.27). In reverse from the print. In my opinion it is probably a copy after the print, even though in reverse from it. Not only are there no other known final drawings for any of the *Figurine* in chalk, but the handling of the red chalk is too timid, refined, and characterless to be Rosa's work. The drawing is also much more highly finished and precisely detailed than any other known Rosa drawing for the *Figurine*. In addition, it seems very unlikely that the artist would have bothered with so highly finished a drawing for [71] if he could have worked directly from the variant [72], which must certainly have preceded [71].

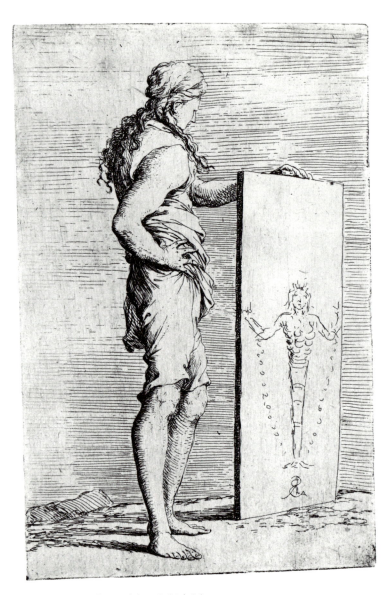

71. Rosa, *Figurina*, etching. British Museum

72*. VARIANT OF [71]

A figure almost identical with that of [71], in reverse from it, with his outstretched right hand resting on a pile of rocks within which a rectangular panel shape is etched.

Not listed in Bartsch or Nagler. Wallace, 1973, 91, Rotili, 82. Etching with drypoint. 142 x 90 mm.

Signed with the monogram SR, in etching, at the lower right.

Some light to medium drypoint strokes in the shading of the rock pile. The fact that the panel within the rock pile is etched indicates that the artist designed several alternative solutions before actually biting the plate, evidently deciding in favor of the panel after rejecting the more fully worked out rock pile.

Collections

Albertina (AL 16); Boston; Fogg (Gray 3451)

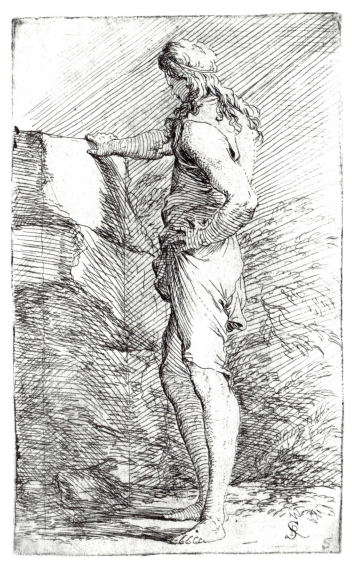

72. Rosa, variant of [71], etching.
Boston, Museum of Fine Arts

73*. *FIGURINE*

A man pulling a net, with two figures behind him.
Bartsch 73
Etching with drypoint. 141 x 90 mm.
Signed with the monogram *SR*, in etching, at the lower right.

Although this print is known in only one state, an impression appears in the bound volume in Rome, G.N.S., which contains all the known first states of the *Figurine*. This impression (F.N. 31545) is an excellent one, much better printed than most of the first states, but the extreme freshness of the drypoint suggests that Rosa may have pulled an impression as a trial proof and then decided that no changes were needed.

Extensive light to deep drypoint added as shading and also occasionally as contour lines throughout the print.

Copperplate: Rome, C.N. (747y, 73B)

Related drawing

73a. Haarlem, Teyler Museum (E 30)
 The final drawing for the print, in reverse from it.
 Pen and brown ink, brown wash, traces of red chalk. 126 x
79 mm. (M. 45.28)

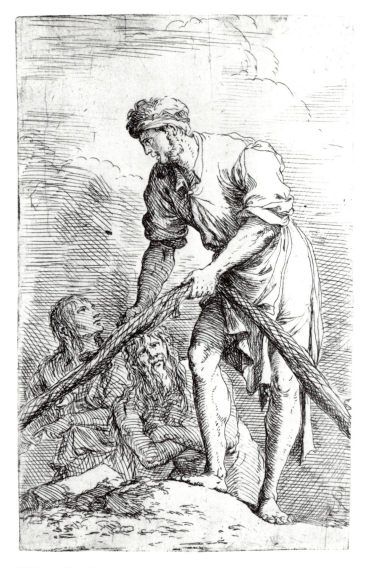

73. Rosa, *Figurine*, etching. British Museum

74*. *FIGURINE*

A standing youth in exotic costume with an older man in a turban behind him.

Bartsch 74

Etching. 142 x 95 mm.

Signed with the monogram *SR*, in etching, at the lower right.

Although this print is known in only one state, an impression appears in the bound volume in Rome, G.N.S., which contains all the known first states of the *Figurine*. This impression (F.N. 31539) is quite lightly and unevenly printed in a way that is typical of many of the first states, suggesting that Rosa may have pulled an impression as a trial proof and then decided that no changes were needed. In even earlier impressions, including this one, the lower left plate corner is distinctly rounded.

Copperplate: Rome, C.N. (747y, 74B)

Related drawing

74a. Odescalchi

A figure quite like the secondary figure of the print, same direction, standing in front of a clump of trees.

Pen and brown ink, brown wash, traces of black chalk. 156 x 98 mm.

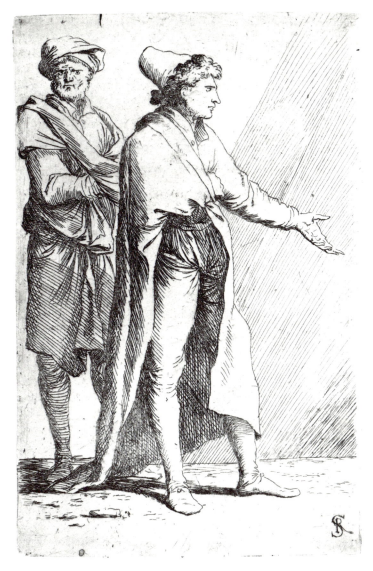

74. Rosa, *Figurine*, etching. British Museum

75. *FIGURINA*

An old, ragged man with a staff and a gourd at his hip.
Bartsch 75
140 x 91 mm.
Signed with the monogram SR, in reverse, in etching at the lower right in both states.

75/I. Etching
No drypoint. A clear, strong impression, distinctly better printed than most of the first states of the *Figurine*. Known in only one impression.
Rome, G.N.S. (F.N. 31547)

75/II*. Etching with drypoint
Light to medium drypoint shading lines added to the drapery at his right hip.
Copperplate: Rome, C.N. (747y, 75B)

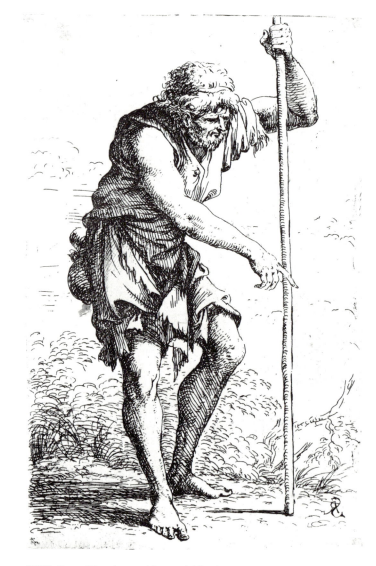

75/II. Rosa, *Figurina*, etching. British Museum

76*. *FIGURINA*

A man in a long outer garment and cap, pointing with up-raised hand.
Bartsch 76
Etching, possibly with a few touches of drypoint. 141 x 89 mm.
Signed with the monogram *SR*, in etching, at the lower right.

Known in only one state.

It is difficult to be certain, but the lines around the toes of his left foot may be reinforced with drypoint. As a rule even in early impressions the lines at the top of his cap are quite thin and the corner at the lower right is slightly beveled.

Copperplate: Rome, C.N. (747y, 76B)

Related drawing

76a. Odescalchi (Sold: London, Christie's, July 6, 1976, No. 55)
The final drawing for the print, in reverse from it.
Pen and brown ink, brown wash, traces of black chalk. 146 x 92 mm. (M. 45.29)

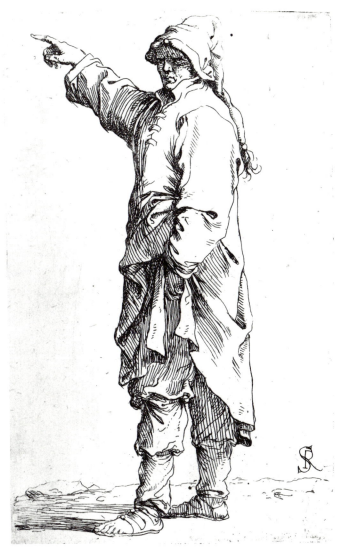

76. Rosa, *Figurina*, etching. British Museum

77. *FIGURINE*

A man in exotic costume with two women behind him.
Bartsch 77
140 x 91 mm.
Signed with the monogram *SR*, in etching, at the lower right in both states.

77/I. Etching

No drypoint. Most of the background lightened by burnishing or by being somehow inhibited in the course of biting. A clear, firm impression. Known in only one impression.
Rome, G.N.S. (F.N. 31540)

77/II*. Etching with drypoint

Light drypoint added to the front of the principal figure's cap, light to medium drypoint added to the drapery at his left shoulder, to his left sleeve, and to the folds below his left sleeve.
Copperplate: Rome, C.N. (747y, 77B)

Related drawing

77a*. Rome, Collection of Principe Urbano Barberini
The final drawing for the print, in reverse from it. Until recently part of the Odescalchi collection of Rosa drawings.
Pen and brown ink, brown wash, traces of black chalk. Framed, hung, impossible to measure, but of the same general dimensions as the etching. (M. 45.30)

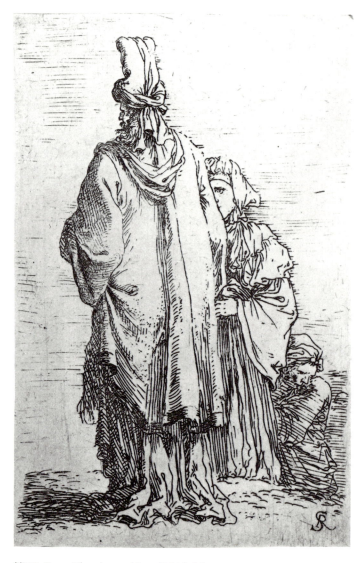

77/II. Rosa, *Figurine*, etching. British Museum

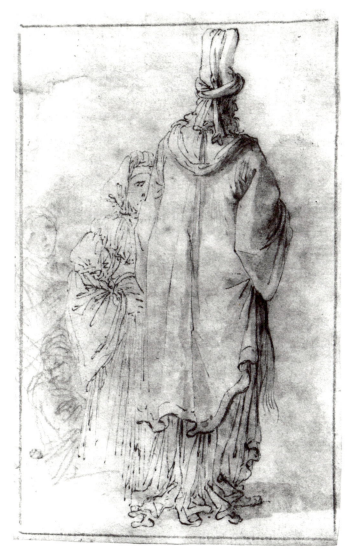

77a. Rosa, final drawing for [77]. Rome,
 Collection of Principe Urbano Barberini

78*. *FIGURINA*

A walking man carrying a large book.
Bartsch 78
Etching. 140 x 91 mm.
Signed with the monogram *SR*, in drypoint, at the lower left.

Known in only one state.

Copperplate: Rome, C.N. (747y, 78B)

Related drawing

78a. New York City, Pierpont Morgan Library (no. 1955.6)
The final drawing for the print, in reverse from it.
Pen and brown ink, brown wash. 136 x 89 mm. (M. 45.31)

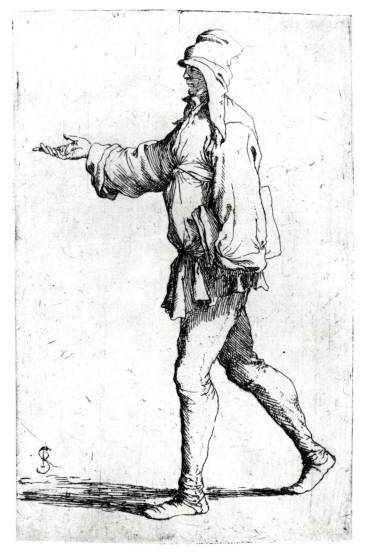

78. Rosa, *Figurina*, etching. British Museum

79*. *FIGURINA*

An exotic warrior with a bow.
Bartsch 79
Etching. 139 x 89 mm.
Signed with the monogram *SR*, in drypoint, at the lower right.

Although this print is known in only one state, an impression appears in the bound volume in Rome, G.N.S., which contains all the known first states of the *Figurine*. This impression (F.N. 31521) is rather carelessly printed and has random smudges of ink, suggesting that Rosa may have pulled an impression as a trial proof and then decided that no changes were needed.

Distinct false biting producing speckled and blurred plate tone in the lower corners, especially the left. In even early impressions the plate corners are slightly rounded or beveled, especially at the top.

Copperplate: Rome, C.N. (747y, 79B)

Related drawings

79a. Odescalchi
The final drawing for the print, in reverse from it. Pen and brown ink, brown wash. Framed, hung, impossible to measure, but of the same general dimensions as the etching. (M. 45.32)

79b. Uffizi (2223F)
An early drawing of a figure in a pose very similar to that of the figure in the print, in the same direction, wearing a different costume.
Pen and brown ink, brown wash. 139 x 90 mm. (M. 6.9)

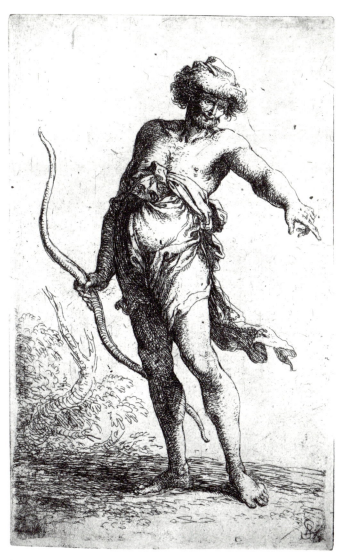

79. Rosa, *Figurina*, etching. British Museum

80. *FIGURINA*

An old man wearing a long cloak and pointing.
Bartsch 80
140 x 91 mm.

80/I*. Etching
Not signed. No drypoint. Rather lightly and unevenly printed.
Known in only one impression.
Rome, G.N.S. (F.N. 31544)

80/II*. Etching with drypoint
Signed with the monogram *SR*, in reverse, in drypoint at the
lower left. Light to medium drypoint shading added to the cen-
ter fold of drapery hanging down in front of the figure.
Copperplate: Rome, C.N. (747y, 80B)

Related drawing

80a*. Rome, Collection of Principe Urbano Barberini
The final drawing for the print, in reverse from it. Until
recently part of the Odescalchi collection.
Pen and brown ink, brown wash. Framed, hung, impossible
to measure, but of the same general dimensions as the etching.
(M. 45.33)

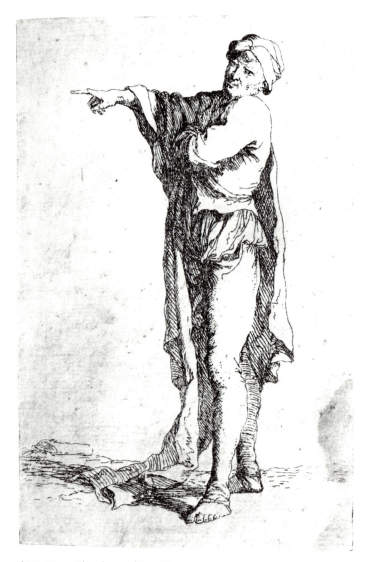

80/I. Rosa, *Figurina*, etching. Rome,
Gabinetto Nazionale delle Stampe

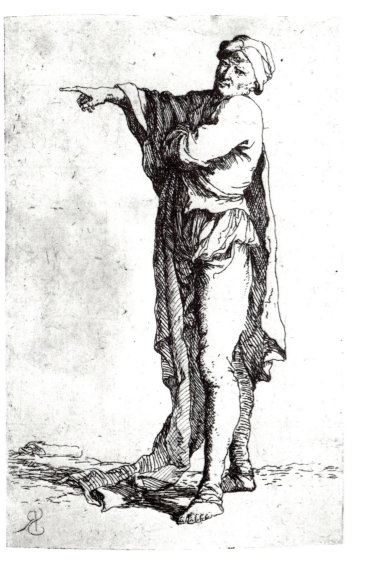

80/II. Rosa, *Figurina*, etching. British Museum

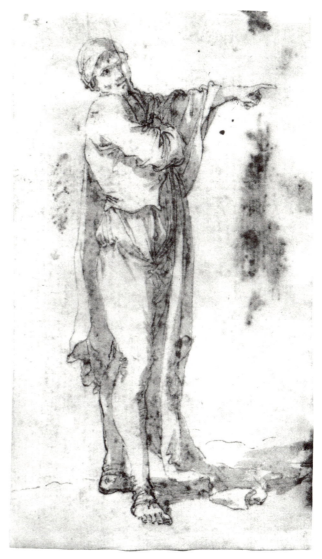

80a. Rosa, final drawing for [80]. Rome,
Collection of Principe Urbano Barberini

81. *FIGURINA*

A seated female nude holding onto a tree trunk.
Bartsch 81
142 x 93 mm.

81/I. Etching with drypoint

Not signed. Touches of light drypoint shading on the tree trunk and in the foliage, in the background between her head and the trunk, and in the shadow cast by her right leg. More extensive light drypoint shading on the rock around the drapery, especially at the left. Very light touches of drypoint near the right edge of the rock. A very good impression, if somewhat light. Known in only one impression.
Rome, G.N.S. (F.N. 31549)

81/II*. Etching with drypoint

Signed with the monogram *SR*, in drypoint, at the lower left. Small amounts of additional drypoint shading in the foliage, tree trunk, and at the lower right. Light drypoint added to the outer edge of her lower right leg.
Copperplate: Rome, C.N. (747y, 81B)

Related drawings

81a. London, B.M. (Payne Knight, Pp. 5-99)
The final drawing for the print, in reverse from it.
Pen and brown ink, brown wash. 132 x 91 mm. (M. 45.34)

81b. Odescalchi (Berlin, Galerie Gerda Bassenge in 1974)
A semi-nude woman seated in a landscape. Generally similar to the figure in the print.
Pen and brown ink, brown wash. 152 x 89 mm. (M. 38.6)

81c. Uffizi (12088F)
An early drawing of a female nude seated in a landscape. Generally similar to the figure in the print. An early idea for the general figure type.
Red chalk, traces of white heightening. 135 x 83 mm. (M. 20.1)

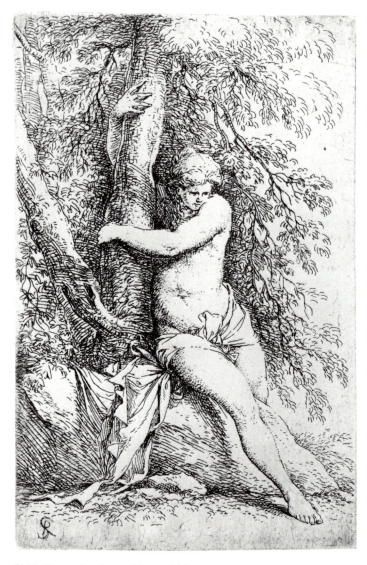

81/II. Rosa, *Figurina*, etching. British Museum

82. *FIGURINA*

A standing, semi-nude woman.
Bartsch 82
141 x 90 mm.

82/I. Etching with drypoint

Not signed. Light to deep drypoint with rich burr added above her left hand, creating a bump of drapery at the contour. Light drypoint shading at the lower edge of her right arm. A good impression on light weight paper with the watermark six concentric ovals with a crown above. Known in only one impression.

Rome, G.N.S. (F.N. 31550)

82/II*. Etching with drypoint

Signed with the monogram *SR*, in drypoint, at the lower right. Light to medium drypoint added to the right side of the figure's head, altering the contour of her turban and adding considerably to her hair at that side. Light touches of drypoint added to the hair at the left side of her neck, to her chin, to the shadow of her neck, and to her right shoulder. Burnishing to lighten the clump of hair above her left temple.

Copperplate: Rome, C.N. (747y, 82B)

Related drawings

82a. Odescalchi

A semi-nude woman generally similar to the figure in the print, in reverse from it, with what seem to be bacchanalian figures in the background. Possibly but not definitely related to the etching.

Pen and brown ink, brown wash. 183 x 128 mm. (M. 38.8)

82b. Odescalchi (Sold: Berlin, Galerie Gerda Bassenge, May 10-15, 1976, No. 286)

A semi-nude woman generally like the figure of the print, in reverse from it, with foliage and a seated satyr behind her. Possibly but not definitely related to the print.

Pen and brown ink, brown wash. 136 x 99 mm. (M. 38.4)

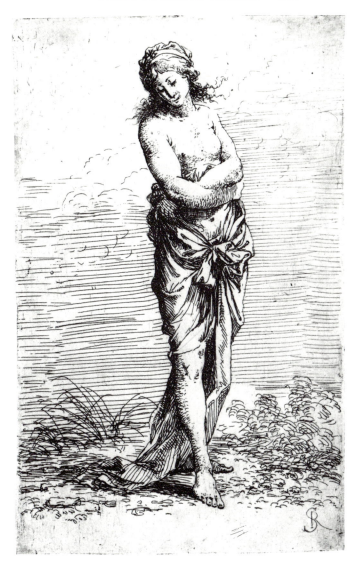

82/II. Rosa, *Figurina*, etching. British Museum

83. *FIGURINA*

A walking woman grasping her skirt and pointing.
Bartsch 83
143 x 93 mm.

83/I. Etching with drypoint

Not signed. Touches of light drypoint at her right shoulder, on her left leg and in the shadow of her skirt at the bottom. Burnishing of her right leg below the knee. Brown ink drawn down most of the length of her left shin, reducing the width of her leg, a reduction carried out in drypoint in the second state. A touch of brown ink added to her left calf where it touches her right leg, but no graphic change made in that area in the second state. A good impression on light-weight paper with the watermark a lion or dragon rampant in an oval. Known in only one impression.

Rome, G.N.S. (F.N. 31554)

83/II*. Etching with drypoint

Signed with the monogram *SR*, in drypoint, at the lower right. Light to medium drypoint added along the contour of much of her left shin, reducing the width of the leg.

Copperplate: Rome, C.N. (747y, 83B)

Related drawings

83a. Haarlem, Teyler Museum (B 15)

Two female figures, one generally like the figure in the print, the other pointing with a gesture much like that of the woman in the print.

Pen and brown ink, brown wash, traces of black chalk. 108 x 75 mm. (M. 37.1)

83b. Odescalchi (Berlin, Galerie Gerda Bassenge in 1974)

A woman wearing a turban, generally similar to the figure in the print, and possibly an early idea for it.

Pen and brown ink, traces of black chalk. 163 x 84 mm. (M. 46.21)

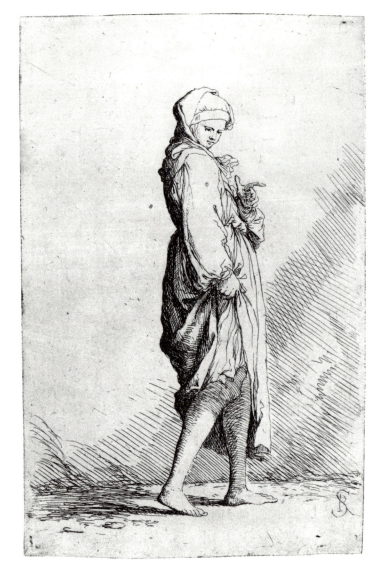

83/II. Rosa, *Figurina*, etching. British Museum

84*. *FIGURINA*

A woman in voluminous drapery, walking to the left, her right hand lifting a portion of her drapery to cover her lower face, her left hand grasping her skirt.
Bartsch 84
Etching with drypoint. 141 x 91 mm.
Signed with the monogram *SR*, in drypoint, at the lower right.

Known in only one state.

A few very light strokes of drypoint added to the ground near the left and right edges of the print.

Copperplate: Rome, C.N. (747y, 84B)

Related drawings

See [85]

85*. VARIANT OF [84]

A figure almost identical with that of [84], in reverse from it, without the fillet in her hair.
Not listed in Bartsch, Nagler, or the other literature.
Etching with drypoint. 142 x 92 mm.
Signed with the monogram *SR*, in etching, at the lower right.

Light drypoint added to the knot of drapery projecting behind the figure's back, to the drapery near her right hand, and to her left leg.

Since the print has no serious technical shortcomings and was worked over with drypoint, Rosa may have at one time considered using it as part of the published *Figurine* series. Perhaps it was rejected because of its relative graphic blandness and lack of expressive force, since in the final version he set the figure off against a rather dramatically darkened sky.

Collections

Boston; Fogg (Randall 1233); London, B.M. (W. 7-56)

Related drawings

85a. Odescalchi (Berlin, Galerie Gerda Bassenge in 1974)
The final drawing for [85], in reverse from it. This would seem to indicate that the final version, [84], was done from the variant, [85], rather than from a drawing.
Pen and brown ink, brown wash over black chalk. 145 x 92 mm. (M. 45.35)

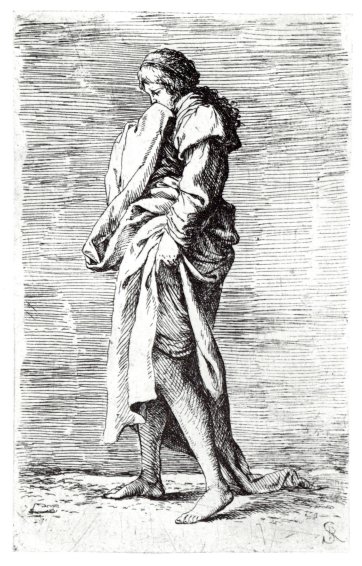

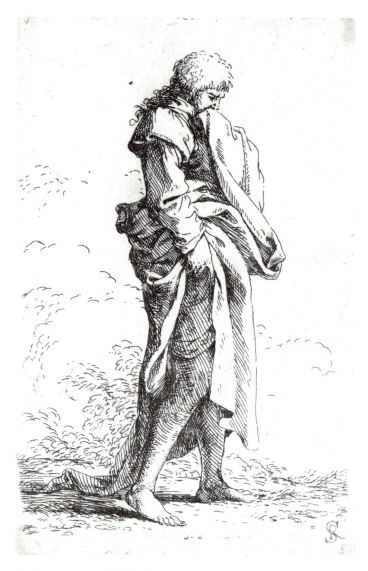

84. Rosa, *Figurina*, etching. British Museum

85. Rosa, variant of [84], etching.
Boston, Museum of Fine Arts

86*. *FIGURINA*

A female nude, seated asleep in a wilderness.
Bartsch 85
Etching with drypoint. 141 x 90 mm.
Signed with the monogram *SR* in reverse, in drypoint, at the lower left.

Known in only one state.

Light drypoint shading added to the figure's lower right leg, right arm, in the shadow on the rock next to her buttocks, and adjacent to the lower right edge of the rock she leans on. Light drypoint used to complete the broken contours of the tree trunks at the upper right. The plate shows distinct false biting around the edges.

Copperplate: Rome, C.N. (747y, 85B)

Copy

Odescalchi

A drawing virtually identical with the print, in the same direction. Badly blurred, possibly as a result of a wetting or something similar, so that attributing it is difficult. Nevertheless I think that it is a copy after the print since, unlike any other authentic Rosa drawing for the *Figurine*, it is finished down to the last detail. The drawing style is also unlike Rosa's, and the drawing is not in reverse from the print, as are almost all of the final drawings for the *Figurine*.

Pen and brown ink, possibly with some brown wash. 143 x 96 mm. (M. 45.36)

Addendum

This Rosa etching shows interesting similarities to the *Sleeping Venus* etching in Oduardo Fialetti's *Scherzi d'Amore* series (Bartsch XVII, 11)

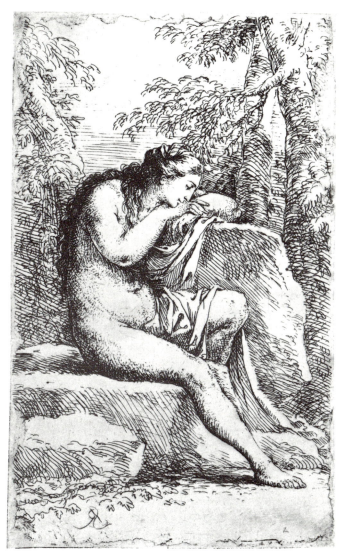

86. Rosa, *Figurina*, etching. British Museum

87. *FIGURINE*

A woman carrying a baby.
Bartsch 86
139 x 91 mm.

87/I. Etching
Not signed. An excellent impression on light-weight paper. Known in only one impression.
Rome, G.N.S. (F.N. 31548)

87/II*. Etching
Signed with the monogram *SR* in reverse, in drypoint, at the lower left.
Copperplate: Rome, C.N. (747y, 86B)

Related drawing

87a. Odescalchi (Sold: London, Christie's, March 30, 1976, No. 57)
The final drawing for the print, in reverse from it.
Pen and brown ink, brown wash, traces of black chalk. Framed, hung, impossible to measure, but of the same general dimensions as the etching. (M. 45.37)

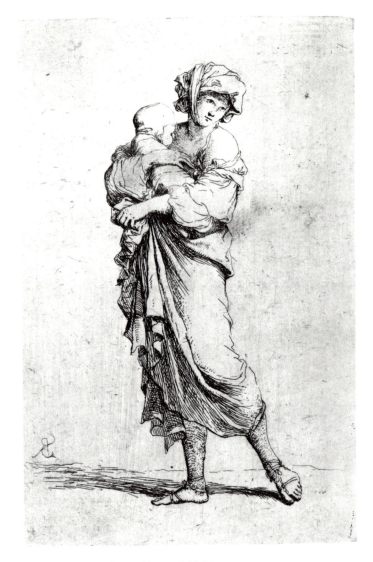

87/II. Rosa, *Figurine*, etching. British Museum

88*. *FIGURINE*

Three exotic warriors, one seated on a low foreground wall and turned to face the two behind him. (Rejected by Rosa for the published series)
Nagler 97
Etching. 148 x 96 mm.
Signed with the monogram *SR*, in etching, at the lower left.

Probably discarded because the biting was very uneven and, in many areas, too light, and possibly also because of its spatial and compositional awkwardness. Known in only one impression.

Hamburg (no. 2233)

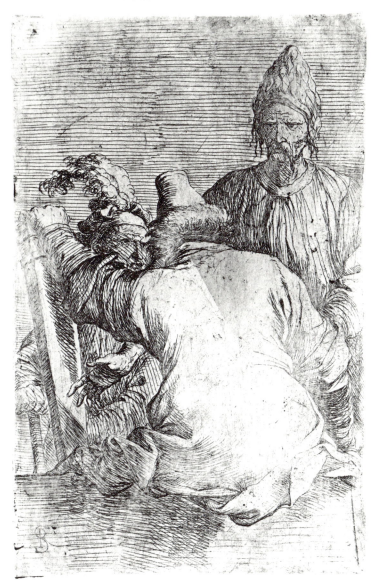

88. Rosa, *Figurine* (rejected by the artist for the published series), etching. Hamburg, Kunsthalle

89*. *FIGURINA*

A standing, pointing man in toga-like robes and a headdress. (Rejected by Rosa for the published series)
Nagler 98
Etching. 141 x 93 mm.
Not signed

Probably discarded because quite unevenly and in many passages unclearly bitten. It is also not a particularly interesting print or figure in comparison with the other *Figurine*.

Collections

Albertina (AL 16); Boston; Fogg (Gray 3429); Grunwald; Hamburg (no. 2234); London, B.M. (W. 7-86)

Related paintings

89a. The figure is quite like that of Phythagoras in the paintings *Pythagoras and the Fishermen* at Chatsworth, Collection of the Duke of Devonshire, and Berlin, Dahlem Museum (Salerno, p. 124, no. 44, p. 97)

Related drawing

89b. Odescalchi (Berlin, Galerie Gerda Bassenge in 1974)
The final drawing for this print and [90], in reverse from them.
Pen and brown ink, brown wash, traces of black chalk. 143 x 90 mm. (M. 33.5)

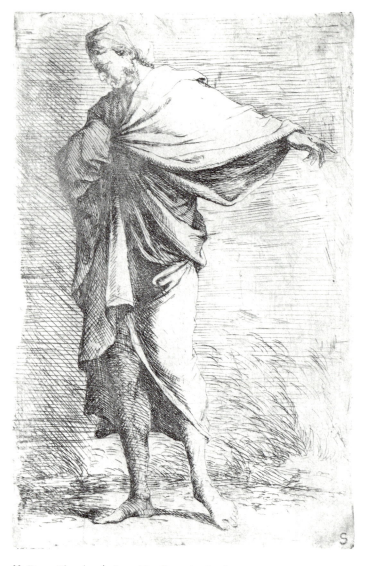

89. Rosa, *Figurina* (rejected by the artist for the published series), etching.
Boston, Museum of Fine Arts

90*. *FIGURINA*

A figure similar to [89], in the same direction, wearing a fillet instead of a headdress. (Rejected by Rosa for the published series)
Nagler 99
Etching. 141 x 90 mm.
Not signed

Too unevenly, deeply, and muddily bitten to be usable. Also, like [89], it is not a particularly interesting figure or print in comparison with the other *Figurine*. Canceled, possibly by Rosa himself. A tentative attempt was apparently made at salvaging the plate by burnishing out some of the cancellation strokes.

Collections

Albertina (AL 16); Boston; Hamburg (no. 2235); London, B.M. (W. 7-87)

Related paintings

See [89a]

Related drawing

See [89b]

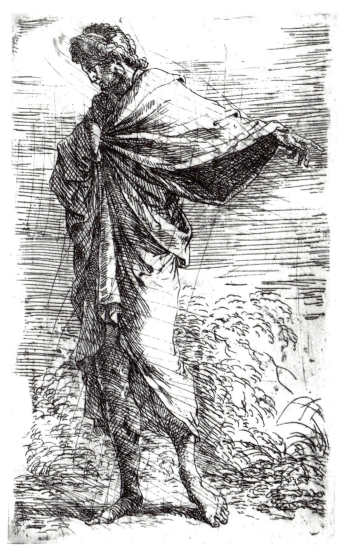

90. Rosa, *Figurina* (rejected by the artist for the published series), etching.
Boston, Mueseum of Fine Arts

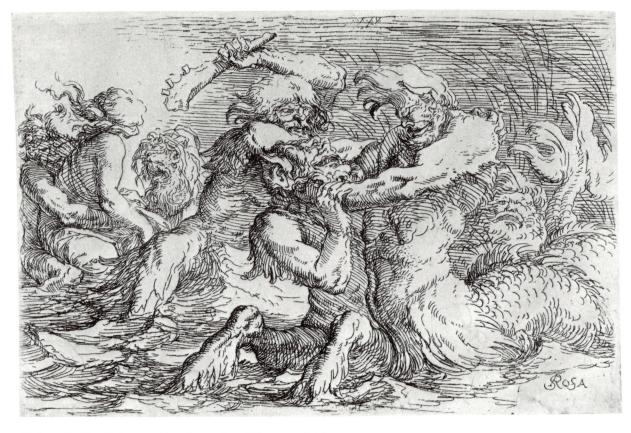

91. Rosa, *Battling Tritons*, etching. Amsterdam, Rijksprentenkabinet

THE TRITON GROUP [91-98], c. 1660-1661
(see Ch. III)

91*. *BATTLING TRITONS*

Bartsch 11
Etching. 108 x 163 mm.
Signed *SRosa*, in etching, at the lower right.
c. 1660-1661

Known in only one state.

Light burnishing at the upper edge of the right wrist of the nymph, and of the forward contour of her upper right arm.

Copperplate: Rome, C.N. (747t)

Related drawing

91a. Mahoney, M. 39.6, mentions a drawing for this print in the Odescalchi Collection. I have not seen it and, to my knowledge, it has not been photographed.

Copies

[138], an etched copy.

An etching by Christian Wilhelm Ernst Dietrich (1712-1784), a variation on the Rosa print. See E. Bock, *Die Deutsche Graphik*, Munich, 1922, p. 262.

The etching by Joseph Goupy (c. 1680-1747) of a two-tailed, triton-like sea monster is very similar to Rosa's *Battling Tritons* prints in general, but according to the inscription on the print it is based on a painting by Rosa, now unknown.

Tomory, 5, 6, 7, cites anonymous etched copies of the *Battling Tritons* prints in both black ink and sanguine.

Bozzolato, 70, cites an anonymous etched copy.

Literature

Huber, iv, p. 27
Bryan, x, p. 321
Joubert, iii, p. 57
Morgan, ii, p. 283
Le Blanc, iii, p. 360
Ozzola, pp. 193, 196, 199
Pettorelli, pp. 28-29
Petrucci, 1934-35, p. 32
Petrucci, 1953, pp. 66, 74-76
C. A. Petrucci, p. 107, no. 747t
Salerno, p. 149
Barricelli, p. 15
Tomory, 5
Colnaghi, 48
Wallace, 1973, pp. 51, 56
Bozzolato, 70
Rotili, 11, and pp. 15-16

92*. VARIANT OF [91]

An etching very similar to [91], same direction, but less fully developed at the bottom and right edges.
Not listed in Bartsch or Nagler. Bozzolato, 70a; Rotili, 12.
Etching. 91 x 145 mm.
Not signed
c. 1660-1661

Ruined in the course of biting and canceled with drypoint strokes, possibly by Rosa himself. Discovered by the author in 1968 as the *rovescio* of the plate for [12]. Impressions as in [7].

Copperplate: Rome, C.N. (747y, 29B *rovescio*)

93*. *BATTLING TRITONS*

Bartsch 12
Etching with drypoint. 109 x 164 mm.
Signed *Rosa*, in etching, at the lower right.
c. 1660-1661

Known in only one state.

Light drypoint in curving strokes on the right side of the grinning, isolated triton face beneath the arm of the hair-pulling triton.

Copperplate: Rome, C.N. (747u)

Copies

[138], an etched copy
Bozzolato, 71, cites an anonymous etched copy.
See also [91].

Literature

Huber, iv, p. 27	Pettorelli, p. 28
Bryan, x, p. 321	Petrucci, 1934-35, pp. 32-33
Joubert, iii, p. 57	Petrucci, 1953, pp. 66, 74-76
Morgan, ii, p. 283	C. A. Petrucci, p. 107, no.
Le Blanc, iii, p. 360	747a
Ozzola, pp. 193, 196, 199	Salerno, p. 149

Barricelli, p. 15	Bozzolato, 71
Tomory, 6	Rotili, 13, and pp. 15-16, 30,
Colnaghi, 45	35, 55, 70-72
Wallace, 1973, pp. 51, 56,	
no. 92	

94*. *BATTLING TRITONS*

Bartsch 13
Etching with drypoint. 94 x 207 mm.
Signed with the monogram *SR*, in drypoint at the lower right.
c. 1660-1661

Known in only one state.

Light to medium drypoint shading on the tail of the triton at the left. Light drypoint at the left edge of the print beneath the tail as fill in an inadequately bitten area.

Copperplate: Rome, C.N. (747s)

Copies

[138], an etched copy.
Bozzolato, 72, cites an anonymous etched copy.
See also [91].

Literature

Huber, iv, p. 27	C. A. Petrucci, p. 107, no. 747s
Bryan, x, p. 321	Salerno, p. 149
Joubert, iii, p. 57	Barricelli, p. 15
Morgan, ii, p. 283	Tomory, 7
Le Blanc, iii, p. 360	Colnaghi, 46
Ozzola, pp. 193, 196, 199	Wallace, 1973, p. 51
Pettorelli, p. 28	Bozzolato, 72
Petrucci, 1934-35, p. 32	Rotili, 14, and pp. 15-16, 30,
Petrucci, 1953, pp. 66, 74-76	35, 55, 70-72

92. Rosa, ruined variant of [91], etching. Author's collection

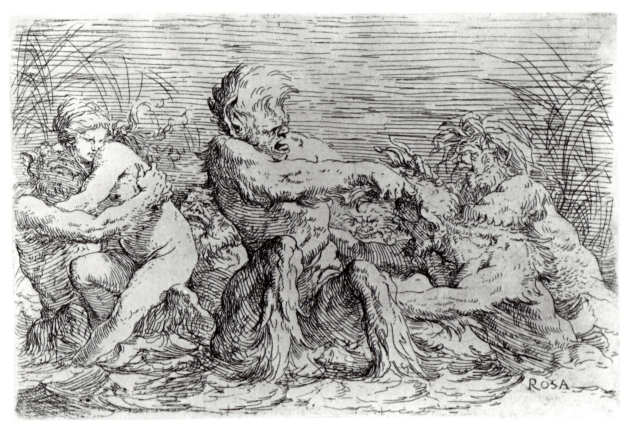

93. Rosa, *Battling Tritons*, etching. Amsterdam, Rijksprentenkabinet

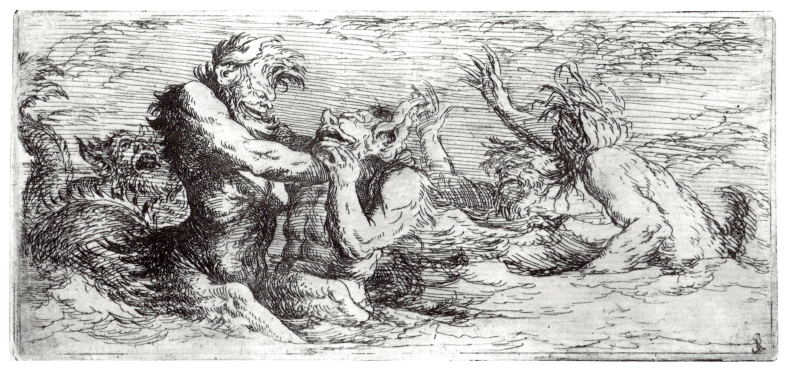

94. Rosa, *Battling Tritons*, etching. London, Collection of Mr. Paul Hollis

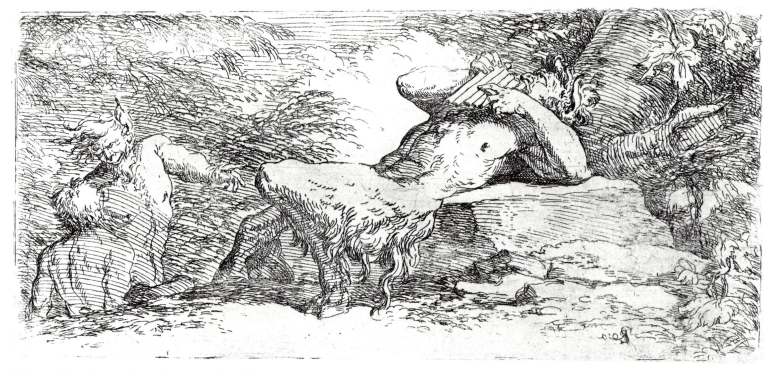

95. Rosa, *Piping Satyr*, etching. Hamburg, Kunsthalle

95*. *PIPING SATYR*

Bartsch 14
Etching with drypoint. 93 x 206 mm.
Signed *SRosa*, in reverse, in drypoint at the lower right.
c. 1660-1661

Known in only one state.

A few light strokes of drypoint on the piping satyr's right hand, on the rock face below him, and in the face and hand of the satyr farthest in depth. Possibly some burnishing of the face of the rock below the piping satyr, although the somewhat uneven biting of the plate in that area makes it difficult to be certain. Even early impressions of this print are often somewhat uneven and blurred, especially in the foliage at the left.

Copperplate: Rome, C.N. (747v)

Related drawings

95a*. Odescalchi (Berlin, Galerie Gerda Bassenge in 1974)
The final drawing for the print, in reverse from it.
Pen and brown ink, brown wash, traces of black chalk. 92 x 213 mm. (M. 39.5)

95b. Odescalchi (Berlin, Galerie Gerda Bassenge in 1974)
A piping satyr seated in a landscape. Generally similar to the figure in the etching, but not apparently directly related to the print, and definitely earlier in date.
Pen and brown ink, brown wash. 153 x 101 mm. (M. 38.1)

95c. London, B.M. (1902-8-22-8)
Three satyrs uncovering a sleeping nymph. Generally similar in basic idea to the *Piping Satyr* and *River Gods* prints [96], [97], and possibly, as Mahoney suggests, an idea for a related print that was never executed.
Red chalk. 200 x 320 mm. (M. 39.7)

Copies

95d*. A print very similar to [95], in reverse from it and somewhat different in dimensions.
Nagler 89
Etching. 112 x 187 mm.
Signed *SRosa*, scrawled in reverse in etching at the lower left.
Quite roughly etched and badly underbitten in many areas.
Known in only one impression.
Hamburg (no. 2225)

[138], an etched copy
Tomory, 3, cites "A copy (?) with the signature *SRosa* (reversed)." Possibly [95d]?

For an important variation on this print, often attributed to Rosa, but in my opinion by another hand see [130].

Literature

Huber, IV, p. 27	C. A. Petrucci, p. 107, no. 747v
Bryan, X, p. 321	Salerno, p. 149
Joubert, III, p. 57	Barricelli, p. 15
Morgan, II, p. 283	Tomory, 3
Meyer, 89	Colnaghi, 44
Le Blanc, III, p. 360	Wallace, 1973, p. 51
Ozzola, p. 199	Bozzolato, 69
Petrucci, 1934-35, p. 32	Rotili, 15, and pp. 35, 73
Petrucci, 1953, p. 68	

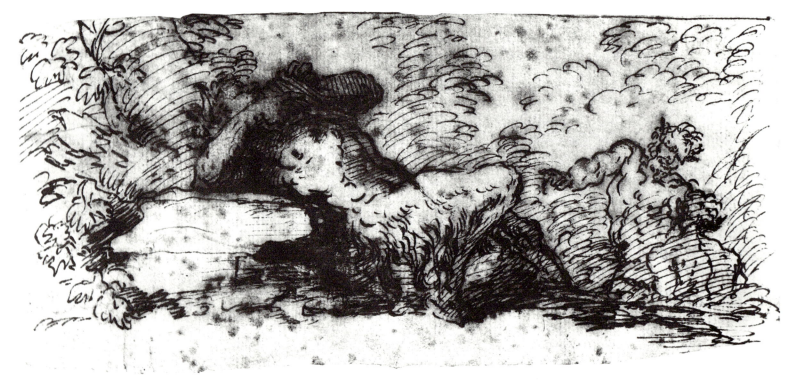

95a. Rosa, final drawing for [95]. Odescalchi

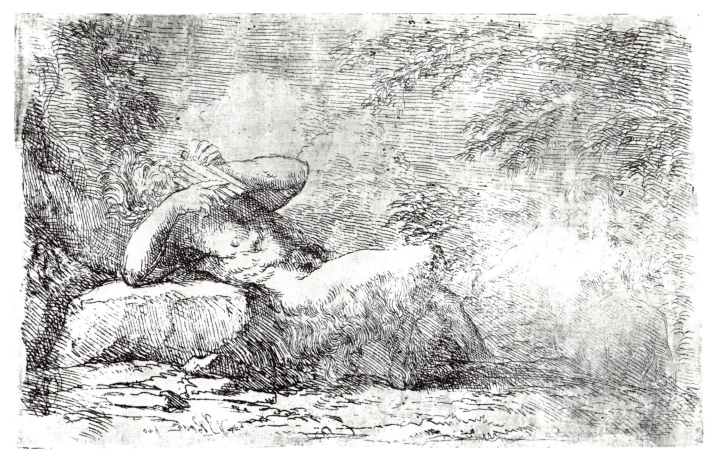

95d. Copy by another hand of [95], etching. Hamburg, Kunsthalle

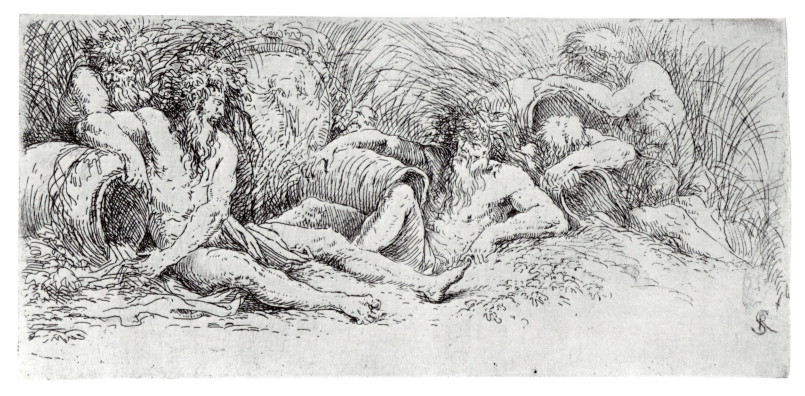

96. Rosa, *River Gods*, etching. London, Collection of **Mr.** Richard Law

96*. *RIVER GODS*

Bartsch 15
Etching with drypoint. 95 x 210 mm.
Signed with the monogram *SR*, in drypoint, at the lower right.
c. 1660-1661

Known in only one state.

Considerable light to medium drypoint as shading throughout much of the print. Light to medium drypoint to delineate a number of leaves on the urn at the left. Traces of false biting at the right edge of the print. Many of the lines tend to be rough and granular, possibly because of irregular biting.

Copperplate: Rome, C.N. (747w)

Related drawings

96a.* Odescalchi
The final drawing for the print, in reverse from it.
Pen and brown ink, brown wash, 102 x 212 mm. (M. 39.4)

96b. Odescalchi (Berlin, Galerie Gerda Bassenge in 1974)
Three river gods. An earlier idea for the print, basically similar to the etching and [96a], with the river god farthest right being very similar to the one seen in the etching and that drawing.
Pen and brown ink. 58 x 110 mm. (M. 39.3)

96c. Leipzig (Bd. 24, no. 7B)
A sleeping river god. Possibly an early idea for the reclining river god at the left of the print.
Pen and brown ink, brown wash over black chalk. 59 x 88 mm. (M. 39.2)

Copies

[138], an etched copy.
Tomory, 8, 9, cites anonymous etched copies in sanguine.

Literature

Huber, IV, p. 27	C. A. Petrucci, p. 107, no. 747w
Bryan, X, p. 321	Salerno, p. 149
Joubert, III, p. 57	Barricelli, p. 15
Morgan, II, p. 283	Tomory, 8
Le Blanc, III, p. 360	Colnaghi, 47
Ozzola, pp. 193, 196, 199	Wallace, 1973, p. 51
Petrucci, 1934-35, p. 32	Bozzolato, 73
Petrucci, 1953, p. 68	Rotili, 16, and pp. 35, 55, 70, 73

97*. *RIVER GODS*

Bartsch 16
Etching with drypoint. 95 x 207 mm.
Signed with the monogram *SR*, in etching, at the lower left.
c. 1660-1661

Known in only one state.

Light to medium drypoint used quite extensively as shading and occasionally for contour lines throughout much of the print. Considerable speckled plate tone at the upper left and more limited amounts in other parts of the print, especially near the right edge, which is irregularly bitten.

Copperplate: Rome, C.N. (747x)

Copies

[138], an etched copy.
Tomory, 8, 9, cites anonymous etched copies in sanguine.

Literature

Huber, IV, p. 27	C. A. Petrucci, p. 107, no. 747x
Bryan, X, p. 321	Salerno, p. 149
Joubert, III, p. 57	Barricelli, p. 15
Morgan, II, p. 283	Tomory, 9
Le Blanc, III, p. 360	Colnaghi, 49
Ozzola, pp. 193, 196, 199	Wallace, 1973, p. 51
Petrucci, 1934-35, p. 32	Bozzolato, 74
Petrucci, 1953, p. 68	Rotili, 17, and pp. 35, 55, 70, 73

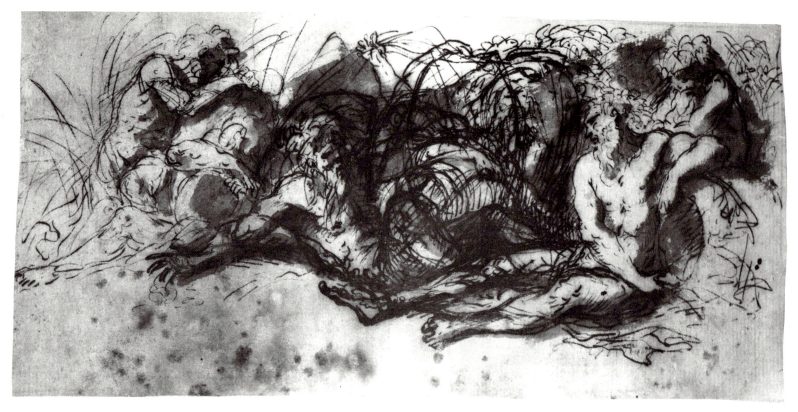

96a. Rosa, final drawing for [96]. Odescalchi

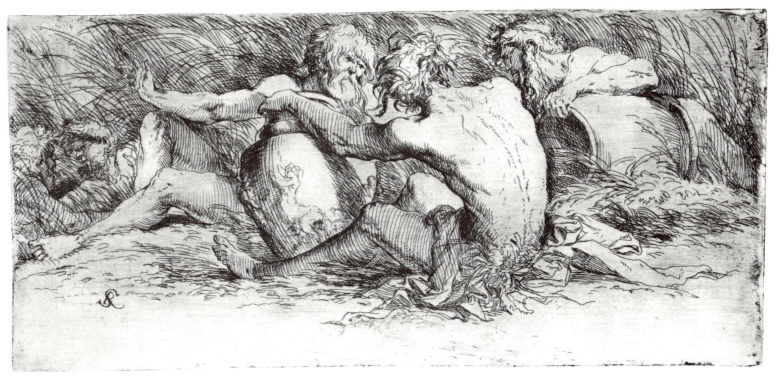

97. Rosa, *River Gods*, etching. London, Collection of Mr. Paul Hollis

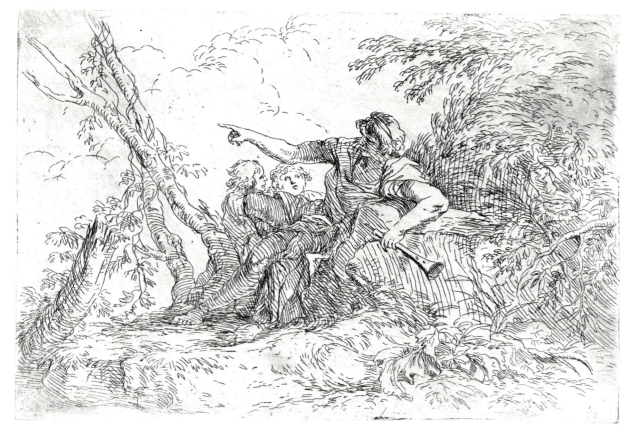

98. Rosa, *Shepherd*, etching. Boston, Museum of Fine Arts

98*. *SHEPHERD*

Bartsch 22
Etching with drypoint. 108 x 163 mm.
Not signed
c. 1660-1661

Known in only one state.

Light drypoint shading lines added to the shepherd's right knee and to the head and shoulders of the child on the left. A few light drypoint strokes at the lower edge of the shepherd's lower left arm and in the shadow on the rock next to it. This print is somewhat rare.

Watermarks seen in this print: Fleur-de-lis in an oval (Fogg); Fleur-de-lis in an oval with a V above (Metropolitan)

Copy

Uffizi (Santarelli 6529)
A drawing, an exact copy by a later hand.
Red chalk. 151 x 206 mm.

Literature

Joubert, III, p. 57; Le Blanc, III, p. 360; Ozzola, p. 200; Petrucci, 1934-35, p. 32; Petrucci, 1953, p. 68; Salerno, p. 149; Tomory, 4; Colnaghi, 57; Bozzolato, 3; Rotili, 6, and pp. 35, 72

THE LARGE PRINTS [99-118], c. 1661 - c. 1663/1664
(See Chs. IV-VI above)

99. *ST. WILLIAM OF MALEVAL*

Bartsch 1
348 x 231 mm.
Signed *S. Rosa*, in etching, on a plaque at the lower right in
both states.
1661

99/I*. Etching with drypoint (* and detail)

Limited amounts of light to medium drypoint shading in
the figure's helmet and armor. Extensive light to deep drypoint
shading in the tree trunk he leans against and in the ground
adjacent to and below it. Some light to medium drypoint in
various portions of the tree trunks and foliage. Irregular, patchy
areas of flawed printing at the lower left corner, especially
around the root, probably caused by corrosion of the plate sur-
face.

Collections

Albertina, two impressions (AL 16, AL 42); Paris, B.N. (Be
7, p. 2, no. 1); Collection of Nancy Ward Neilson, St. Louis,
Mo.; and in the author's collection (watermark: anchor in an
oval with a six-pointed star above).

99/II. Etching with drypoint (* detail only)

Burnishing of the saint's upper right cheek and nose to re-
move the diagonal etched shading lines of state I. Burnishing
to lighten the triangle of shadow at the neck of his breastplate
beneath his beard and portions of his beard. Light to deep dry-
point strands added to his beard. Light drypoint used to add two
circular rivets to his left shoulder armor and two curved lines
to his armor below and generally parallel to the outline of his
beard. Light to medium drypoint shading lines added to the
earflap of his helmet, crossing the drypoint already there in
state I to produce crosshatching. Light to medium drypoint in
addition to that seen in state I in his armor, arms, the tree trunk

he leans against, the ground adjacent to and beneath it, and
the tree trunks and foliage.

Watermarks seen in state II impressions: Anchor in an oval
with a six-pointed star above, as that seen in the first state im-
pression in the author's collection cited above (Rijksmuseum);
Fleur-de-lis in an oval with a V above (Fogg)
Copperplate: Rome, C.N. (7471)

Copies

Genoa, Palazzo Rosso (Inv. 2834)
A drawing, an exact copy, in the same direction.
Pen and brown ink. 400 x 285 mm.

Vienna, Kunsthistorisches Museum
A painting

Goodwood, England
A painting almost identical with the Vienna picture.

[133], [138], [142], etched copies
Tomory, 26, cites two anonymous etched copies, one in san-
guine.

Literature

Huber, IV, p. 27
Füssli, III, p. 186
Joubert, III, p. 57
Morgan, II, p. 283
Le Blanc, III, p. 360
Ozzola, pp. 192, 196, 198
O. Grosso, A. Pettorelli, *Città
di Genova, i disegni di
Palazzo Bianco*, Milan
1910, no. 96
Pettorelli, p. 29

Petrucci, 1934-35, p. 31
Petrucci, 1953, p. 75
C. A. Petrucci, p. 107, no. 7471
Salerno, p. 149
Barricelli, pp. 19-20
Tomory, 26
Colnaghi, 50
Wallace, 1973, pp. 51, 57,
no. 95
Bozzolato, 83
Rotili, 90, and pp. 16, 85-88

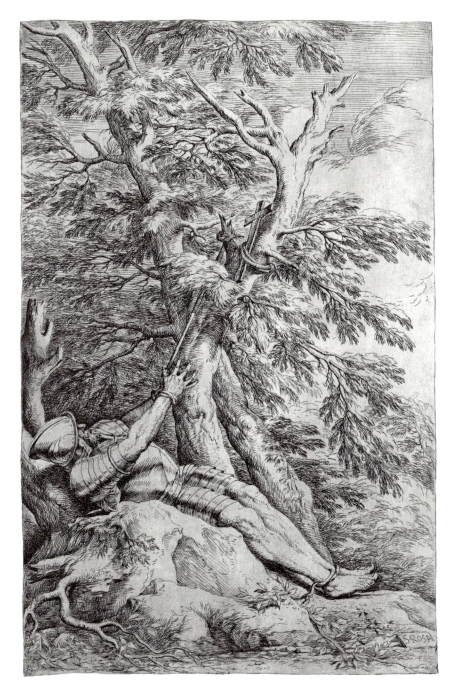

99/I. Detail. Author's collection

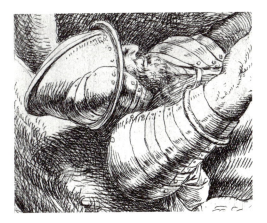

99/II. Detail. Boston, Museum of Fine Arts

99/I. Rosa, *St. William of Maleval*, etching. Author's collection

100*. *ALBERT, COMPANION TO ST. WILLIAM*

Bartsch 2
Etching with drypoint. 347 x 226 mm.
Signed *S.Rosa*, in etching, at the lower left.
1661

Known in only one state.

Some light to deep drypoint in the shaded portions of the figure's body, hands, hair, and drapery. Considerable light to deep drypoint in the tree trunk. Some light to medium drypoint in the background rocks. Burnishing of the figure's upper right thigh and adjacent drapery, lightening contour and shading lines and producing faint zigzag scratches on the thigh.

Copperplate: Rome, C.N. (747m)

Related drawing

100a*. Holkham Hall, Collection of Lord Leicester
A preparatory drawing for the etching, in reverse, with marked differences in the setting. Mahoney calls it a copy of a lost Rosa study.
Pen and brown ink, brown wash. 194 x 133 mm. (M. 39.1)

Copies

[133], [138], etched copies
Tomory, 27, cites three anonymous etched copies, one in sanguine.
Bozzolato, 84, cites an anonymous etched copy, in reverse.

Literature

Huber, IV, p. 27
Füssli, III, pp. 186-187
Joubert, III, p. 57
Morgan, II, p. 283
Le Blanc, III, p. 360
Ozzola, pp. 192, 196, 198
Petrucci, 1934-35, pp. 31-32
Petrucci, 1953, p. 75
C. A. Petrucci, p. 107, no. 747m
Salerno, p. 138, nos. 98, 99
Barricelli, p. 19
Tomory, 27
Colnaghi, 51
Wallace, 1973, pp. 51, 57-58, no. 96
Bozzolato, 84
Rotili, 91, and pp. 16, 30, 85-86

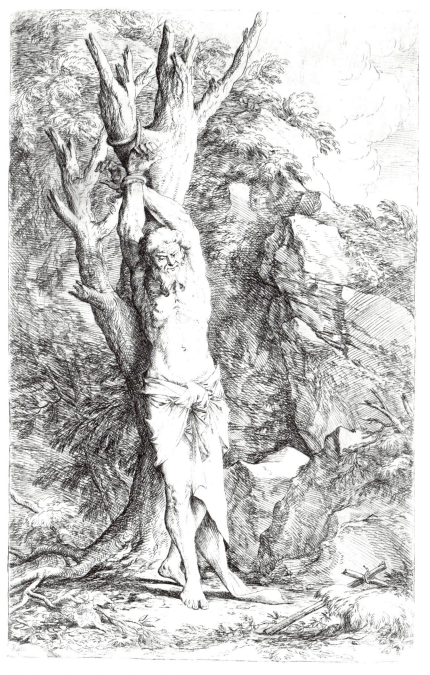

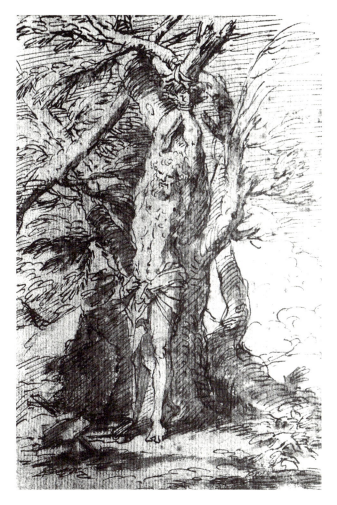

100a. Rosa, preparatory drawing for [100].
Holkham Hall, Collection of
Lord Leicester

100. Rosa, *Albert, Companion to St. William*,
etching. Boston, Museum of Fine Arts

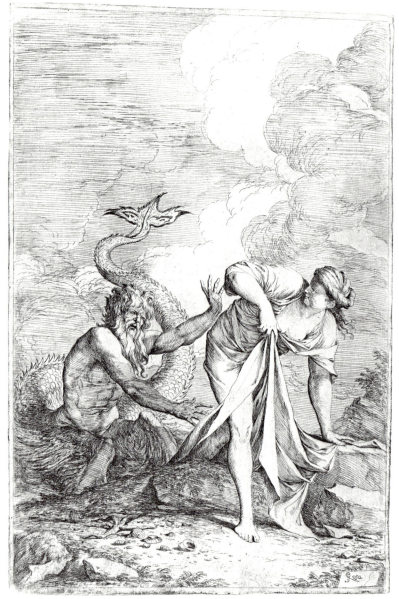

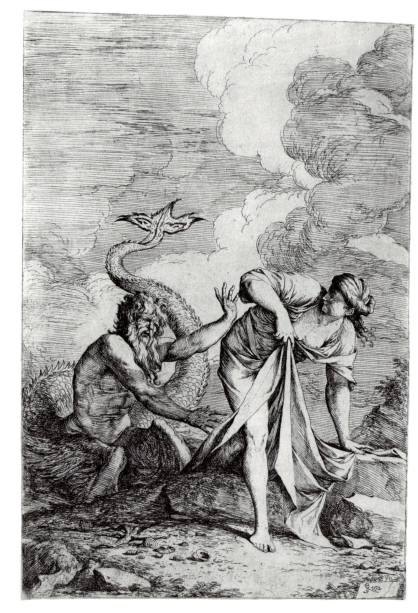

101/I. Rosa, *Glaucus and Scylla*, etching. Boston, Museum of Fine Arts

101/II. Rosa, *Glaucus and Scylla*, etching. Washington, D.C., National Gallery of Art

101. *GLAUCUS AND SCYLLA*

Bartsch 20
356 x 234 mm.
Signed *SRosa*, in etching, on a plaque at the lower right in all three states.
c. 1661

101/I*. Etching with drypoint

Light to deep drypoint shading on the forehead and cheek of Scylla and in the shadow on her neck adjacent to her profile. Light drypoint shading lines on her trailing drapery adjacent to the right hand of Glaucus and adjacent to the inner side of her right knee. Considerable light to deep drypoint shading along the back of Glaucus inside the contour line. Considerable speckled plate tone in the lower left portions of the print. Known in only one impression.

Boston (watermark: Fleur-de-lis in a circle, with possibly something above the circle)

101/II*. Etching with drypoint

Considerable burnishing to lighten the sky behind Glaucus' head and shoulders, above the part of his tail directly above his head, and beneath his left arm pit. Burnishing of his inner left forearm, parts of his right arm, especially near the elbow, and parts of his legs, especially his lower left leg.

Paris, B.N. (Be 7, p. 7, no. 6) (Laid down, so that it is difficult to examine the paper.)
Washington, D.C., National Gallery of Art (B-26, 316)

101/III*. Etching with drypoint

Light to medium drypoint strands of long curling hair added above the etched flowing hair over Scylla's left shoulder. The shaded portion of her lower right leg lightened by burnishing with the outer contour redone in drypoint, making the lower leg thicker. Light to medium curving drypoint lines added inside the etched contour of her inner right ankle. Light drypoint shading added to the rock adjacent to the contour of her inner right leg, and to both her legs near the knees.

Copperplate: Rome, C.N. (747q)

Related painting

101a*. Brussels, Musée des Beaux Arts

The print is almost identical with but in reverse from the painting. Despite this, the evidence indicates that the painting probably follows the print in date (see Ch. IV).
.85 x .70 m.

Another version of this painting, now in St. Louis, Collection of Washington University, is in my opinion a copy, of very high quality, of the Brussels picture and not by Rosa's hand.

Related drawing

101b. Odescalchi

A study of Scylla, almost identical with the figure in the print, in reverse from it.
Pen and brown ink, brown wash. 165 x 108 mm.

Copies

[133], [138], etched copies

The etching of this subject by Joseph Goupy (c. 1680-1747) which is very like the Rosa etching is, according to the inscription on the print, a copy of the painting.

Literature

Huber, IV, p. 27
Füssli, III, pp. 189-190
Bryan, X, p. 320
Joubert, III, p. 57
Morgan, II, p. 283
Le Blanc, III, p. 360
Ozzola, pp. 196, 200
Pettorelli, p. 29, no. 44
Bodkin, pp. 91-97
Petrucci, 1934-35, p. 32

Petrucci, 1953, p. 75
C. A. Petrucci, p. 107, no. 747q
Salerno, p. 128, no. 61, p. 149
Barricelli, p. 19
Tomory, 21
Colnaghi, 54
Wallace, 1973, no. 97
Bozzolato, 86
Rotili, 92 and p. 88

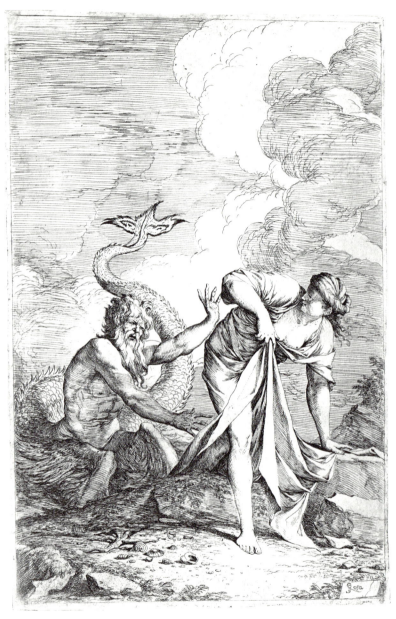

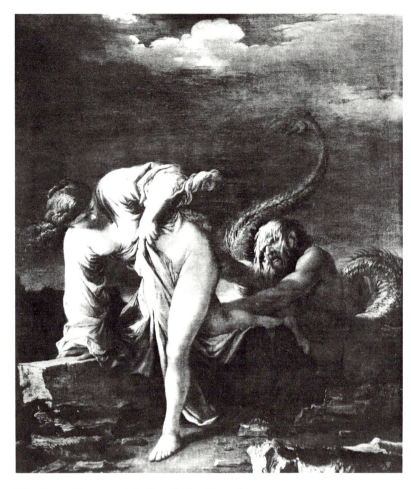

101a. Rosa, *Glaucus and Scylla*, painting. Brussels, Musée des Beaux-Arts

101/III. Rosa, *Glaucus and Scylla*, etching. Boston, Museum of Fine Arts

102. *APOLLO AND THE CUMAEAN SIBYL*

Bartsch 17
343 x 217 mm.
Signed *Rosa*, in etching, on the lyre at the lower right in all three states.
c. 1661

102/I*. Etching with drypoint

Varying amounts of light to deep drypoint as shading and also rarely as contour lines throughout much of the print. Clusters of leaves in light to medium drypoint added to the foliage above Apollo's left shoulder and to the topmost branch.

It is quite likely that the print may originally have been slightly larger since its dimensions are significantly smaller than those of the *Glaucus and Scylla* [101], which was certainly intended to be its companion piece but measures 356 x 234 mm. It also lacks the framing lines inside the plate mark that appear in all of Rosa's other large etchings except the *Jason* (which in my opinion was also probably cut down, see [118]), and the *Oedipus* [116]. Known in only one impression.

Paris, B.N. (Be 7, p. 4, no. 3) (Laid down, so that it is difficult to examine the paper.)

102/II*. Etching with drypoint

The figure in the background to the left of the sibyl is burnished out and replaced by a tree trunk done in light to deep drypoint. Considerable light to medium drypoint shading in addition to that seen in state I throughout much of the print.

Collections

Albertina (two impressions, AL 42, AL 16); Budapest, National Museum (no. 46-505); Paris, B.N. (Be 7, p. 5, no. 4); Rome, G.N.S. (26-M-16, 04490); Uffizi (no. 1716); San Francisco, formerly in the possession of R. E. Lewis, Inc.; Collection of Mrs. Arthur Solomon, Cambridge, Mass.

102/III. Etching with drypoint (* detail only)

The eye, eyebrow, forehead, and nose profile of the sibyl burnished and reworked in light to deep drypoint. Light to deep drypoint added to her hair, ear, and cap, especially to define the folds of the cap. The clusters of leaves in drypoint above Apollo's left shoulder removed by being burnished out. Some medium to deep drypoint in addition to that seen in state II.

In most third-state impressions the area around the sibyl's eye shows wear and loss where altered. In later impressions this is very pronounced.

Copperplate: Rome, C.N. (747n)

Related painting

102a*. London, Wallace Collection

A generally similar Apollo and sibyl group with subsidiary figures set in one of Rosa's largest and most magnificent landscapes. Salerno, p. 58, calls it a late work, possibly after the print, but I feel it can most reasonably date to the 1650s. It is certainly earlier in date than the print, as the state I to state II change in the secondary figure indicates (see Ch. IV).

1.71 x 2.58 m.

Related drawing

102b*. Paris, Louvre, Cabinet des Dessins (9747)

A study for the sibyl. Cut out of the original sheet and mounted on another sheet with the trailing drapery filled out by another hand.

Pen and brown ink, brown wash, traces of red chalk. The dimensions of the cut out portion are roughly 236 x 84 mm. (M. 68.8)

Copies

London, B.M. (286/36) (20)
A drawing.
Pen and brown ink, brown wash. 340 x 320 mm.

[133], [138], [142], etched copies
Tomory, 19, cites an anonymous etched copy.

Literature

Huber, IV, p. 27

Füssli, III, p. 190

Bryan, X, p. 320

Joubert, III, p. 57

Morgan, II, p. 283

Le Blanc, III, p. 360

Ozzola, pp. 195, 200

Bodkin, pp. 91-97

Petrucci, 1934-35, p. 31

Petrucci, 1953, p. 75

C. A. Petrucci, p. 107, no. 747n

Salerno, pp. 134-35, nos. 83a, 83b, 83c

R. A. Cecil, "*Apollo and the Sibyl of Cumae* by Salvator Rosa," *Apollo*, LXXXI, 1965, pp. 464-69

Barricelli, p. 18

Tomory, 19

Colnaghi, 52

Bozzolato, 81

Rotili, 93 and pp. 88-89

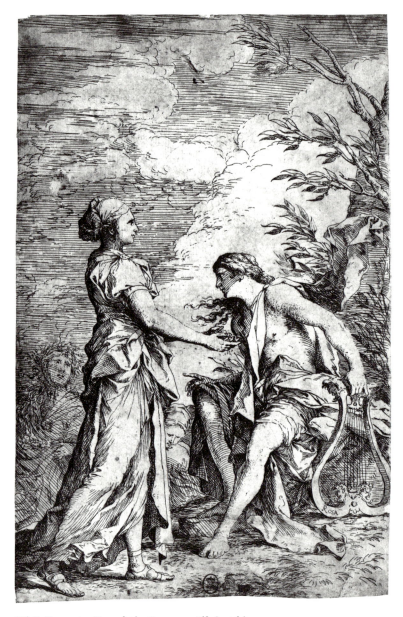

102/I. Rosa, *Apollo and the Cumaean Sibyl*, etching. Paris, Bibliothèque Nationale

102/III. Detail. Boston,
Museum of Fine Arts

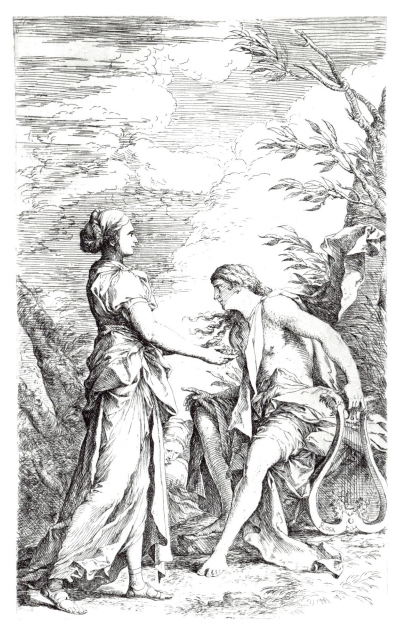

102/II. Rosa, *Apollo and the Cumaean Sibyl*, etching. Cambridge, Mass.,
Collection of Mrs. Arthur Solomon

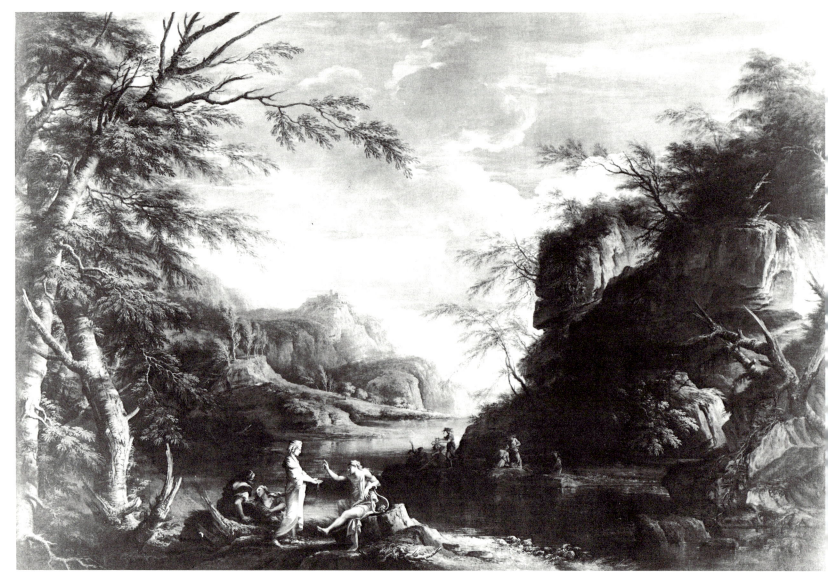

102a. Rosa, *Apollo and the Cumaean Sibyl*, painting.
London, Wallace Collection

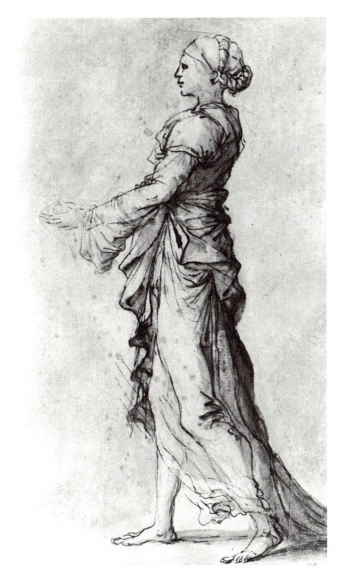

102b. Rosa, drawing for the sibyl of the *Apollo and the Cumaean Sibyl* etching [102]. Paris, Louvre, Cabinet des Dessins

103. *DIOGENES CASTING AWAY HIS BOWL*

Bartsch 5
453 x 274 mm.
1661-1662

103/I*. Etching

Signed and inscribed in etching at the lower left: *Diogenes Adolescentem manu bibentem | intuitus Scyphum projicit | Salva. Rosa.* (Diogenes, seeing a youth drinking from his hand, throws away his bowl.) The inscription is roughly and carelessly lettered with a number of the letters reversed. Traces of this inscription are very faintly legible in many state II impressions.

In poor condition, and originally quite carelessly inked, wiped, and printed, indicating that it was used as a trial proof. Apparently no drypoint, although it is difficult to be certain because of the roughness of the impression. Known in only one impression.

Paris, B.N. (Be 7, p. 13, no. 16) (Laid down, so that no watermark can be seen.)

103/II*. Etching with drypoint

The inscription is identical but much more carefully lettered. Signed *Salvator Rosa Inv. scul.*

Some light to medium drypoint shading in the figure of Diogenes and considerable amounts of it in the figure seated behind him. Some light to deep drypoint shading added to the trees behind the seated figure. Limited light drypoint shading on the left edge of the rock the seated figure leans on. Some deep drypoint in the foreground foliage immediately to the right of the inscription.

Watermarks seen in state II impressions: Fleur-de-lis in a double oval, two impressions (Fogg)

Copperplate: Rome, C.N. (747j)

Related paintings

103a*. Copenhagen, Statens Museum for Kunst

The etching is an exact reproduction, in reverse, of this painting, which was done probably in 1651-1652 and exhibited in 1652. It is a companion piece to the *Democritus* [104a].

3.44 x 2.14 m.

103b*. Florence, Pitti Palace, Galleria Palatina
Also called *The Philosophers' Grove* (*La Selva dei Filosofi*)
An earlier version, done in Florence probably in the early 1640s. It has a figure group generally like that of the Copenhagen painting [103a], set in a broad landscape.
1.49 x 2.23 m.

Related drawings

103c. Princeton University, The Art Museum (Acc. no. 48-610 verso)
A study of the figure of Diogenes for the Copenhagen painting [103a].
Pen and brown ink. 253 x 203 mm. (M. 33.2)

See also M. 33.1, 33.3, 33.4, 33.5 and 33.6.
In addition there are two drawings for the Pitti Palace painting [103b] which do not call for complete catalogue listing here: Oxford, Ashmolean Museum (939A) (M. 26.2); Odescalchi (now Stockholm, Nationalmuseum (M. 26.1)

Copies

[138], [142], etched copies

Literature

Basan, ii, p. 419
Gori Gandinelli, iii, p. 166
Strutt, i, p. 275
Huber, iv, p. 28
Füssli, iii, p. 187
Bryan, x, p. 320
Joubert, iii, p. 57
Morgan, ii, p. 283
Le Blanc, iii, p. 360
Ozzola, pp. 190, 191, 196, 199
Pettorelli, p. 27
Petrucci, 1934-35, p. 31
De Rinaldis, p. 130, no. 99, pp. 131-32, no. 100 bis
Petrucci, 1953, p. 69

C. A. Petrucci, p. 106, no. 747j
Olsen, pp. 85-86
Salerno, p. 109, no. ix, p. 121, no. 31, pp. 38, 43, 52
Barricelli, p. 17
Tomory, 16
Colnaghi, 2
Langdon, "Rosa: Paintings," 12
Mahoney, "Rosa: Drawings," 1973, 58
Wallace, 1973, p. 59
Bozzolato, 89
Rotili, 97, and p. 91

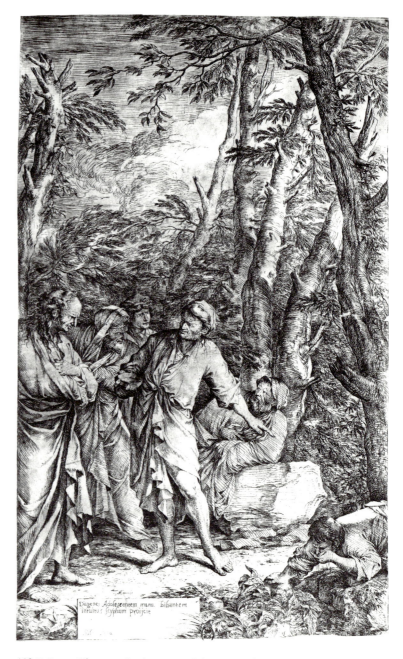

103/I. Rosa, *Diogenes Casting Away His Bowl*, etching. Paris, Bibliothèque Nationale

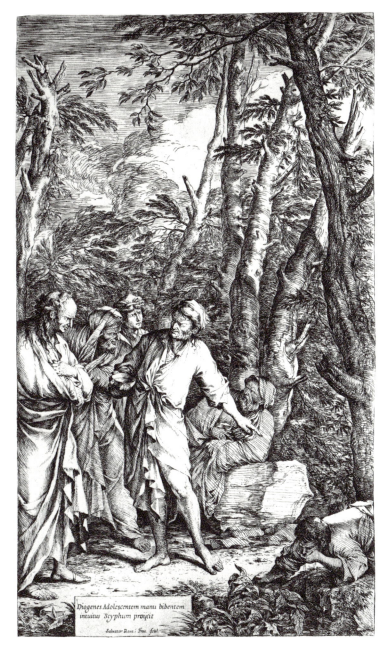

Diogenes Adolescentem manu bibentem
intuitus Scyphum proycit

Salvator Rosa: Inu. scul.

103/II. Rosa, *Diogenes Casting Away His Bowl*, etching. By Courtesy of
the Victoria and Albert Museum, London

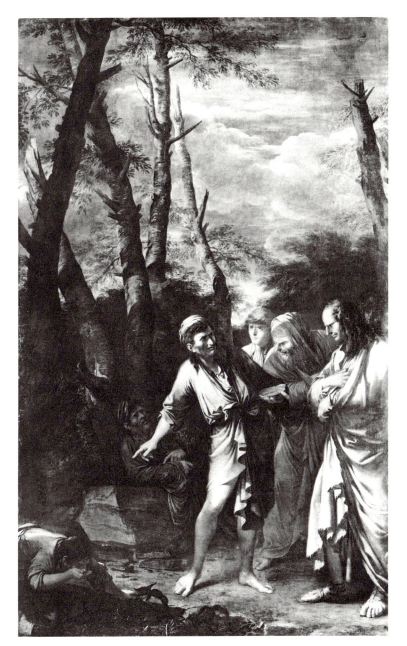

103a. Rosa, *Diogenes Casting Away His Bowl*, painting.
Copenhagen, Statens Museum for Kunst

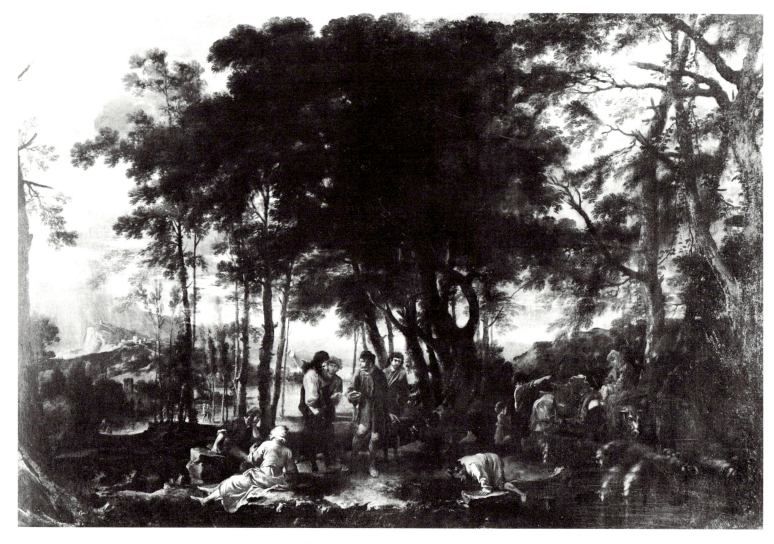

103b. Rosa, *Diogenes Casting Away His Bowl* (*La Selva dei Filosofi*), painting.
Florence, Pitti Palace, Galleria Palatina

104. *DEMOCRITUS IN MEDITATION*

Bartsch 7
456 x 276 mm.
Signed and inscribed in etching on a scroll at the lower left in both states: *Democritus omnium derisor / in omnium fine defigitur / Salvator Rosa Inv. scul.* (Democritus, the mocker of all things, is here stopped by the ending of all things.)
1662

104/I*. Etching with drypoint (* and detail)
Medium to deep drypoint in a number of places in the tree trunks and foliage. Medium to deep drypoint shading in the shadow at the curled right end of the inscription scroll. A few deep drypoint strokes in the ground to the right of the scroll and in the fish skeleton above. Burnishing to lighten the sky in several places behind the tree trunks and behind Democritus. Burnishing of the triangular fold of drapery to the right of Democritus' right hand and of his lower left leg.

Collections

Albertina (AL 42) (watermark: an anchor in an oval with a six-pointed star above); Boston (watermark: Fleur-de-lis in an oval); Paris, B.N. (Be 7, p. 15, no. 18); Paris, Louvre, Collection Rothschild; Providence, Rhode Island, Rhode Island School of Design; Rijksmuseum; Washington, D.C., National Gallery of Art (watermark: Fleur-de-lis in a circle with a crown above)

104/II. Etching with drypoint (* detail only)
Burnishing of the upper right edge of the sarcophagus base above Democritus' right knee and below the molding so that the rather dark, vertical etched lines of state I are erased, producing a light area inside and adjacent to the edge of the base. The edge contour line at that point is usually quite blurred in most impressions of state II. Burnishing of the curved strokes of the background sky to the left of Democritus' right elbow, above his right leg.

Watermarks seen in state II impressions: Fleur-de-lis in a double oval with a V above (Fogg)
Copperplate: Rome, C.N. (747i)

Related painting

104a*. Copenhagen, Statens Museum for Kunst
The etching is an almost exact reproduction, in reverse with a few slight changes, of this painting which was done in 1650 and exhibited in 1651. It is a companion piece to the *Diogenes Casting Away His Bowl* [103a], now also in Copenhagen.
3.44 x 2.14 m.

Copies

[138], [142], etched copies
Tomory, 15, cites an anonymous etched copy in sanguine.

Literature

Basan, II, p. 419
Gori Gandinelli, III, 166
Strutt, I, p. 275
Huber, IV, p. 28
Füssli, III, p. 184
Bryan, X, p. 320
Joubert, III, p. 57
Morgan, II, p. 283
Le Blanc, III, p. 360
Ozzola, pp. 190, 191, 196, 199
Pettorelli, pp. 27, 29
Petrucci, 1934-35, p. 31
De Rinaldis, p. 130, no. 99, pp. 131-132, no. 100 bis
C. A. Petrucci, p. 107, no. 747i
Olsen, p. 85
Salerno, p. 110, no. XIII, pp. 43-44
Wallace, 1968, pp. 21-32
Barricelli, pp. 16-17
Tomory, 15
Colnaghi, 5
Wallace, 1973, pp. 51, 58-59, no. 98
Bozzolato, 93
Rotili, 98, and pp. 91-92

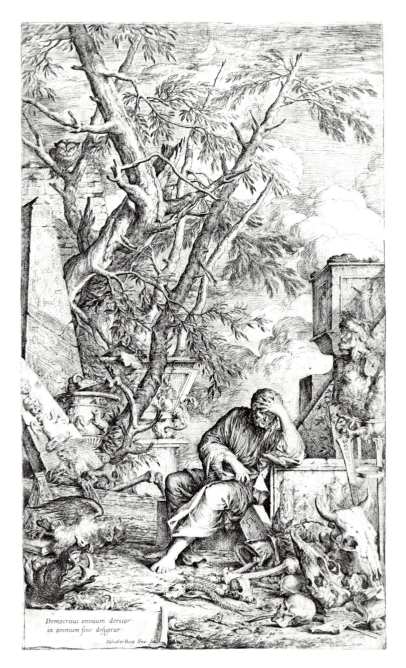

104/I. Rosa, *Democritus in Meditation*, etching. Boston,
 Museum of Fine Arts

104/I. Detail. Boston,
 Museum of Fine Arts

104/II. Detail. Boston,
 Museum of Fine Arts

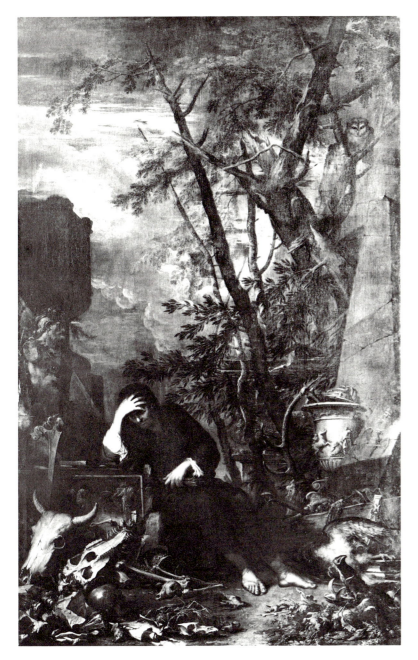

104a. Rosa, *Democritus in Meditation*, painting. Copenhagen,
Statens Museum for Kunst

105*. STUDY FOR *DEMOCRITUS IN MEDITATION* [104]

Three human skulls, one of them virtually identical with the
skull in the lower right of the *Democritus* print, in reverse
from it.
Nagler 108
Etching. 142 x 92 mm.
Signed with the monogram *SR*, in reverse, in etching at the
lower right.
1662

Known in only one state.

Collections

Boston; Grunwald; Hamburg (no. 2243); London, B.M.
(W. 7-109); Metropolitan (Acc. no. 53.509.7)

Literature

Meyer, 108; Le Blanc, III, p. 360; Ozzola, p. 206; Salerno, p.
149; Tomory, 12; Wallace, 1973, p. 59; Bozzolato, 75; Rotili, 99

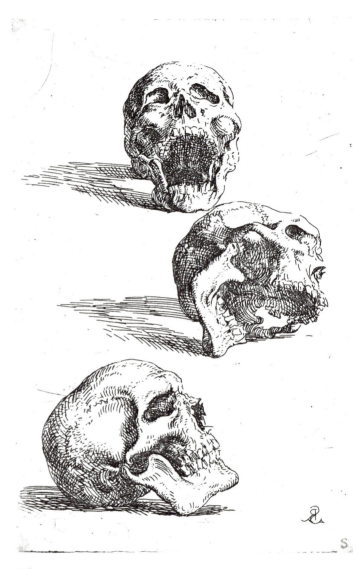

105. Rosa, study of skulls for the *Democritus* etching [104],
etching. Boston, Museum of Fine Arts

106*. STUDY FOR *DEMOCRITUS IN MEDITATION* [104]

Two ox skulls and a portion of a third, one of them quite like the skull at the lower right of the *Democritus* print, in the same direction.
Nagler 109
Etching. 142 x 92 mm.
Signed with the monogram *SR*, in etching, at the lower right.
1662

Known in only one state.

Collections

Boston (two impressions); Grunwald; Hamburg (no. 2244); London, B.M. (W. 7-111); Metropolitan (Acc. no. 53.509.6)

Literature

Meyer, 109; Le Blanc, III, p. 360; Ozzola, p. 206; Salerno, p. 149; Tomory, 13; Wallace, 1973, p. 59; Bozzolato, 76; Rotili, 100

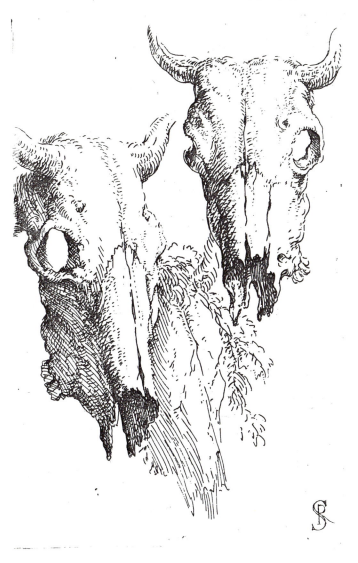

106. Rosa, study of skulls for the *Democritus* etching [104], etching. Boston, Museum of Fine Arts

107*. STUDY FOR *DEMOCRITUS IN MEDITATION* [104]

Three ox skulls, two horse skulls, and a grotesque face, one of the ox skulls and one of the horse skulls resembling those in the lower right of the *Democritus* etching.
Nagler 110
Etching with drypoint. 142 x 91 mm.
Signed with the monogram *SR*, in drypoint, at the lower left.
1662

Known in only one state.

Light to medium drypoint to complete the contour lines and shading of the horns of the ox skull at the left.

Collections

Boston (two impressions); Grunwald; Hamburg (no. 2245); London, B.M. (W. 7-110); Metropolitan (Acc. no. 53.509.5)

Literature

Meyer, 110; Le Blanc, III, p. 360; Ozzola, p. 206; Salerno, p. 149; Tomory, 14; Wallace, 1973, p. 59; Bozzolato, 77; Rotili, 101

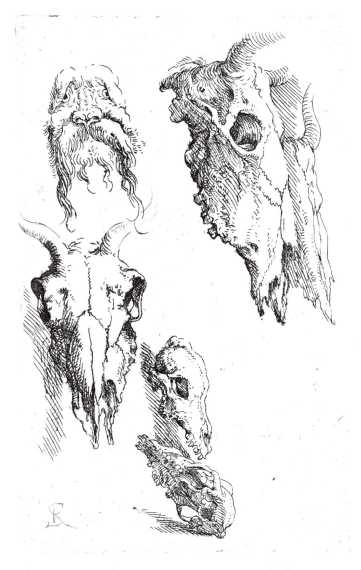

107. Rosa, study of skulls for the *Democritus* etching [104], etching. Boston, Museum of Fine Arts

108. *DIOGENES AND ALEXANDER*

Bartsch 6
458 x 276 mm.
Signed and inscribed in etching on a scroll at the bottom center of both states: *Sensit Alexander, testa quum vidit in illa / Magnum habitatorem, quantò felicior hic, qui / Nil cuperet, quam qui totum sibi posceret orbem / Salvator Rosa Inv. scul.* (Alexander felt, when he saw the great inhabitant of that tub, how much more fortunate he was who would desire nothing, than he who would demand the whole earth for himself.) The inscription is taken directly from Juvenal, *Satires* 14. 311-314.
1662

108/I*. Etching with drypoint
Varying amounts of light to deep drypoint, principally as shading, but also very rarely as contour lines, throughout most of the print. Light burnishing of the lower edge of the drapery that crosses Alexander's chest. Light burnishing of the soldier's ankle closest to Alexander's left knee. Burnishing of the leg drapery of the figure farthest in depth behind Diogenes' outstretched finger tips.

Collections

Albertina (AL 42); Boston (watermark: an anchor in an oval); London, B.M. (W. 7-107) (watermark: an anchor in a double oval); Paris, B.N. (Be 7, p. 9, no. 13)

108/II. Etching with drypoint (* detail only)
Most of Diogenes' left ear and the dark patch of shading on his left cheek removed by being burnished out. A few light to medium drypoint strokes added to his hair and neck near the ear. Light drypoint shading lines running diagonally added to the face of the boy at the left. Similar lines added to his left forearm and hand.
Watermarks seen in state II impressions: Fleur-de-lis in a double oval (Fogg)
Copperplate: Rome, C.N. (747g)

Related painting

108a*. Northampton, Althorp

The painting has a generally similar but larger figure group than the etching, set in an extensive landscape. Intended by the artist to be a companion piece to the *Cincinnatus*, now also at Althorp. Salerno (p. 109, no. VIII, p. 118, no. 22) dates them both c. 1640-1645. Langdon, "Rosa and Claude," pp. 784-85, considers them to be post 1649 and dates this picture to the 1650s. I think that they must have been done in the late 1640s.

2.31 x 2.60 m.

Related drawings

108b*. London, B.M. (Cracherode Ff. 2-180)

A study of Alexander confronting Diogenes. As Salerno observes (1963, p. 52), the drawing is clearly an intermediate step between the painting and the etching. In it Rosa reduced and concentrated the setting and composition and experimented with two postures for Diogenes that are much like the energetic pose seen in the etching.

Pen and brown ink with considerable black chalk and traces of red chalk.

Cancellation in white chalk of a *pentimento* at Alexander's left hand.

305 x 200 mm. (M. 65.10)

108c*. Leipzig, (7456.24.2)

A summary sketch which probably follows the British Museum drawing above since it shows Diogenes seated in a pose more like that of the etching than either of those seen in the drawing.

Pen and brown ink, brown wash. 85 x 45 mm. (M. 65.12)

108d. Leipzig (7457.25.45C)

A standing figure in armor generally like Alexander in the etching and in the British Museum drawing above.

Pen and brown ink. 140 x 76 mm. (M. 65.11)

In addition, there are four drawings for the Althorp painting which do not call for complete catalogue listing here:
Uffizi, nos. 2240F, 2234F, 872E, (M. 14.1, M. 14.2, M. 14.3)
Leipzig, Bd. 25, no. 54b (M. 65.13)

Copies

[138], an etched copy

An undated etching by Lorenzo Loli (Bartsch XIX, 16) is very like the Rosa print and probably follows it.

Literature

Basan, II, p. 419
Strutt, I, p. 275
Huber, IV, p. 28
Füssli, III, p. 188
Bryan, X, p. 320
Joubert, III, p. 57
Morgan, II, p. 283
Le Blanc, III, p. 360
Ozzola, pp. 190, 199
Pettorelli, p. 27
Petrucci, 1934-35, p. 31
De Rinaldis, p. 130, no. 99, pp. 131-32, no. 100 bis
Petrucci, 1953, p. 75
C. A. Petrucci, p. 106, no. 747g
Salerno, p. 109, no. VIII, p. 118, no. 22, pp. 126-27, nos. 53a, 53b
Barricelli, pp. 17-18
Tomory, 17
Colnaghi, 3
Mahoney, "Rosa: Drawings," 1973, 71
Wallace, 1973, pp. 59-60, no. 99
Bozzolato, 90
Langdon, "Rosa and Claude," pp. 784-85
Rotili, 96, and pp. 90-91

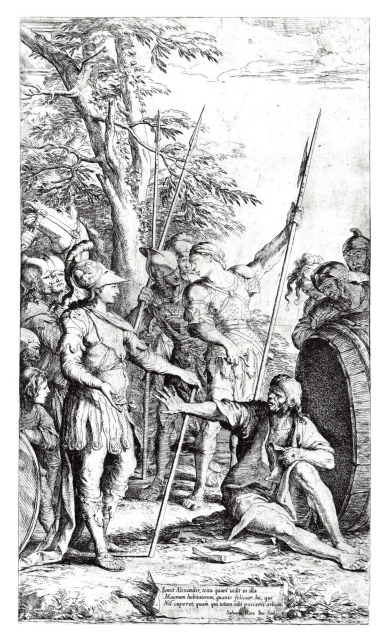

108/I. Rosa, *Diogenes and Alexander*, etching.
Boston, Museum of Fine Arts

108/II. Detail. Boston,
Museum of Fine Arts

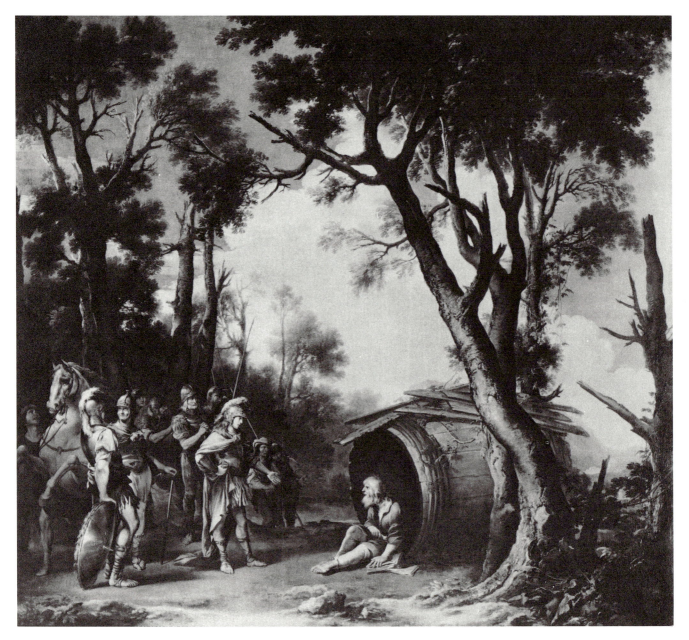

108a. Rosa, *Diogenes and Alexander*, painting. Northampton, Althorp

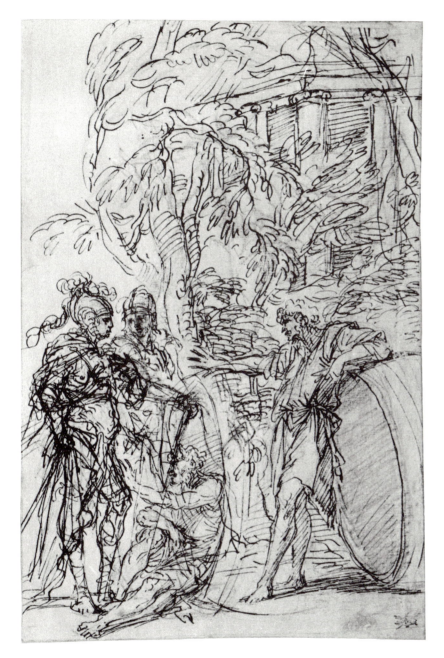

108c. Rosa, *Diogenes and Alexander*,
drawing. Leipzig, Museum der
Bildenden Künste

108b. Rosa, preparatory drawing for the *Diogenes and Alexander*
etching [108]. British Museum

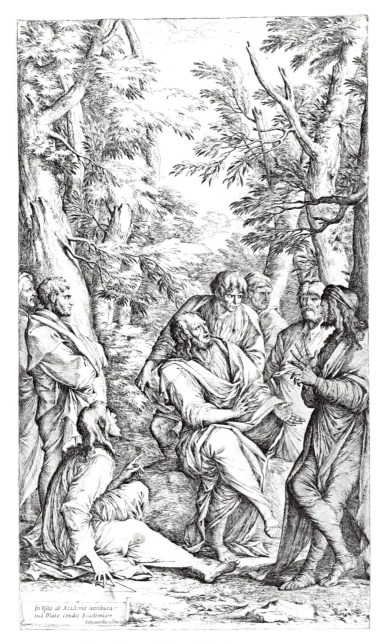

109/I. Rosa, *The Academy of Plato*, etching. Boston,
Museum of Fine Arts

109/II. Detail. Boston,
Museum of Fine Arts

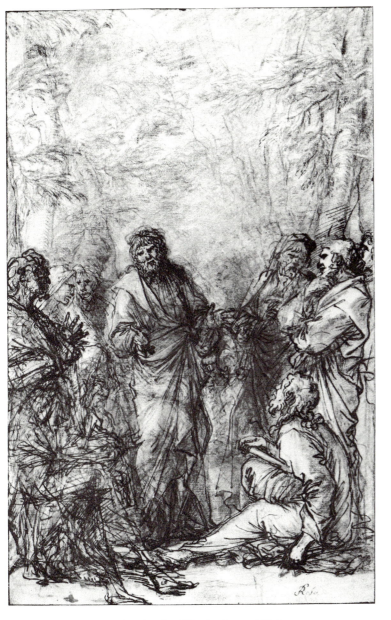

109a. Rosa, preparatory drawing for *The Academy of Plato*
etching [109]. British Museum

109. *THE ACADEMY OF PLATO*

Bartsch 3
458 x 274 mm.
Signed and inscribed in etching on a scroll at the lower left
in both states: *In Villa ab Academo attributa / Sua Plato
condit Academiam / Salvator Rosa Inv. scul.* (In the villa
given by Academus Plato founds his Academy.)
1662

109/I*. Etching with drypoint
Traces of light to deep drypoint in the shading of Plato's
drapery near his left ankle, in the right sleeve of the figure di-
rectly behind him, on the face and left hand of the figure seated
in the left foreground, and in several parts of the setting. Bur-
nishing to lighten modeling lines in parts of all of the above
figures, in the figure farthest in depth at the right, and in several
parts of the setting.

Collections

Albertina (AL 42); Boston (watermark: Fleur-de-lis in an
oval with a crown above); Hamburg (watermark: Fleur-de-lis
in a double oval); Paris, B.N. (Be 7, p. 12, no. 15); Paris, Louvre,
Collection Rothschild; Rome, G.N.S. (26-M-16, 04481); Wash-
ington, D.C., National Gallery of Art

109/II. Etching with drypoint (* detail only)
The ear of the figure seated in the left foreground removed by
being burnished out. His hair worked over with light drypoint.
Light drypoint shading added to the tree trunk behind his head.
Small amounts of light drypoint shading added to Plato's dra-
pery at his right shoulder, to the cap and drapery of the figure
farthest in depth at the right, and to the drapery of the figure
in the foreground at the extreme right. Light drypoint added to
several portions of the background foliage especially near Plato.
Some additional burnishing of the ground and background
foliage.
Watermarks seen in state II impressions: Fleur-de-lis with the

letters A and N below, all within a double oval (London, B.M.);
Fleur-de-lis in a double oval with a circle above (Boston)
Copperplate: Rome, C.N. (747d)

Related drawings

109a*. London, B.M. (1855-7-14-54)
A highly finished drawing, similar to the print with several
identical figures, in reverse from the print. It is like the cartoons
used by Rosa for the *Alexander in the Studio of Apelles* [114a],
Genius of Rosa [113a], *Regulus* [110b], and *Polycrates* [111b],
but clearly not a cartoon since it differs significantly from the
print and is not scored for transfer to the plate. Probably, how-
ever, the final study from which the print was made.
Black chalk, red chalk, considerable pen and brown ink. 421
x 271 mm. (M. 65.20)

In addition, the following drawings show some resemblances
to the print and may be related to it:

109b. Leipzig (7457.25.88A)
A study of the upper half of a figure much like the Plato of
the etching and the British Museum drawing [109a] above.
Pen and brown ink. 130 x 98 mm. (M. 65.21)

109c. Houston, Museum of Fine Arts (69-14)
A study of a figure quite like the one on the extreme right of
the print.
Pen and brown ink. 202 x 95 mm. (M. 65.28)

109d. Rome, G.N.S. (124, 812)
A standing philosopher type, somewhat like the Plato in the
British Museum drawing above.
Black chalk with brown wash. 325 x 215 mm. (M. 20.33)

109e. Odescalchi (Berlin, Galerie Gerda Bassenge in 1974)
A standing philosopher type, rather like the Rome drawing
above.
Pen and brown ink, brown wash, traces of red chalk. 138 x 69
mm. (M. 69.10)

109f. Odescalchi
A group of philosophers in a wood.
Pen and brown ink, brown wash. 240 x 202 mm. (M. 33.1)

109g. Leipzig (7457.25.19D)
A fragment, with what appears to be a study for one of the
figures in the etching.
Pen and brown ink. 91 x 38 mm. (M. 65.22)

See also M. 65.23, 65.24, 65.25, 65.26, 65.27.

Copies

London, Sotheby's Sale, 7-10 December 1920
A drawing from the De Clementi Collection, Florence.
Pen and bistre washed with gray. 450 x 285 mm.

[138], an etched copy
Tomory, 18, cites a copy in reverse by Sandrart, and another
copy, same direction, both etchings.
Bozzolato, 82, cites an anonymous etched copy.

Literature

Basan, ii, p. 419
Strutt, i, p. 275
Huber, iv, p. 28
Füssli, iii, pp. 187-88
Bryan, x, p. 320
Joubert, iii, p. 57
Morgan, ii, p. 283
Le Blanc, iii, p. 360
Ozzola, pp. 198-99
Petrucci, 1934-35, p. 31
Petrucci, 1953, p. 75
C. A. Petrucci, p. 106, no. 747d
Salerno, p. 128, nos. 58, 59
Barricelli, p. 18
Tomory, 18
Colnaghi, 4
Bozzolato, 82
Rotili, 95, and pp. 89-90

110*. *DEATH OF ATILIUS REGULUS*

Bartsch 9
461 x 719 mm.
c. 1662

110/I. Etching with drypoint

Signed and inscribed in etching at the bottom center: *Io: Bapte. Ricciardo Amico Singular.ᵐᵒ* / *Attilium Regulum in praecipitis Fortunae vertigine tot inter clavos firmioris constantiae centrum.* / *Salvator Rosa Inv. pinx. Scul.* (To Giovanni Battista Ricciardi special friend. Atilius Regulus in the change of headlong Fortune remains a firm center in the midst of so many nails.) Ricciardi was Rosa's closest friend.

Extensive light to deep drypoint shading in a number of places throughout the figure group, on the barrel, and in the foreground setting. Burnishing of the left shoulder armor of the standing warrior at the right holding a shield and halberd. What appears to be burnishing of the left cheek of the figure holding the barrel lid, with blurred inking in that area. Possibly some burnishing of the sky above the standing hammerers at the right of the barrel. Burnishing of the right wrist of the standing hammerer farthest left. Light burnishing of the helmet and forehead of the pointing horsemen at the left.

The only impression of this state I have seen is in Paris, Bibliothèque Nationale (AA5), and is closely related to the rare first states of *Polycrates* [111/I] and the *Giants* [115/I] and the unique first state of the *Oedipus* [116/I], all in the Bibliothèque Nationale. Like them the *Regulus* is done on paper which is considerably lighter than that seen in the usual impressions of this print. The watermark is also like that seen in the state I impressions of the *Giants* and *Polycrates*, a shield with a schematized warrior or figure in armor holding a small fleur-de-lis. The paper has the line suggesting a fold across the center usually seen in impressions of Rosa's four largest prints.

110/II*. Etching with drypoint

The *Singular.ᵐᵒ* of the inscription has been burnished out and changed to *Unico*. Otherwise graphically the same as state I.

As in the case of the three other very large prints, most impressions are done on rather heavy paper, often with a line suggesting a fold across the center, frequently with a guard attached to the verso at the center for binding in a volume. Occasionally an impression is cut at the center, probably the result of being cut from a bound volume.

Watermarks seen in state II impressions: Fleur-de-lis in an oval with a B above (Colnaghi); Fleur-de-lis in a double oval (Fogg); A lion rampant on a shield surrounded with scrolls and a crown above (Fogg)

Copperplate: Rome, C.N. (747b)

Related paintings

110a*. Richmond, Virginia Museum of Fine Arts
The etching is an exact reproduction, in the same direction, of this splendid painting, which is datable about 1652.
1.52 x 2.16 m.

Related drawings

110b*. Uffizi (6599S)
The cartoon for the print, in reverse from it. Scored for transfer to the plate.
Black chalk heightened with white, with cancellations in white chalk and corrections. Gone over with pen and brown ink, brown wash, in my opinion by another hand. 470 x 750 mm. (M. 65.8)

110c. Princeton University, The Art Museum (Acc. No. 48-610)
A study for the painting of five figures grouped around the barrel.
Pen and brown ink, brown wash. 203 x 253 mm. (M. 42.1)

110d*. Paris, Louvre, Cabinet des Dessins (Inv. 9746)
A study for the painting of the figure seated on the column at the left of the picture.
Black chalk. 183 x 269 mm. (M. 65.9)

110e. Odescalchi
A large group of warriors in classical armor gathered around a semi-nude old man who is being held and beaten. Possibly an

early idea for the *Regulus* composition. Although it is in many ways different from the final solution of the painting and etching, it does have some important features in common with them, and also with the *Polycrates* etching [111] to a lesser degree.

Pen and brown ink, brown wash over red chalk. 204 x 350 mm. (M. 42.3)

Copies

Paris, Louvre, Cabinet des Dessins (Grand Format 9733) A drawing, an exact copy of the etching. Pen and brown ink, brown wash. 300 x 570 mm.

[138], an etched copy Tomory, 22, cites an anonymous copy in sanguine.

Literature

Basan, II, p. 419
Gori Gandinelli, III, p. 166
Huber, IV, p. 28
Füssli, III, pp. 182-83
Bryan, X, p. 320
Joubert, III, p. 57
Morgan, II, p. 283
Le Blanc, III, p. 360
Ozzola, pp. 190, 191, 195, 196, 199
Pettorelli, p. 27
Petrucci, 1934-35, p. 30
D Rinaldis, p. 140, no. 106, p. 145, no. 110 bis, p. 146, no. 113
Limentani, 1950, p. 25, no. 32
Petrucci, 1953, p. 70
C. A. Petrucci, p. 106, no. 747b
Salerno, pp. 121-22, no. 33 24

J. Bean, *Dessins romains du XVII^e siècle, artistes italiens contemporaines de Poussin*, XXIII^e Exposition du Cabinet des Dessins, Musée du Louvre, Paris, 1959, p. 37, no. 62
W. Vitzhum, "Seicento Drawings at the Cabinet des Dessins," *Burlington Magazine*, CII, 1960, p. 76, figs. 37, 38
Wallace, "Regulus," pp. 395-97
Barricelli, p. 11
Tomory, 22
Colnaghi, 40
Langdon, "Rosa: Paintings," 24
Wallace, 1973, p. 62
Bozzolato, 92
Rotili, 105, and pp. 96, 100, 103

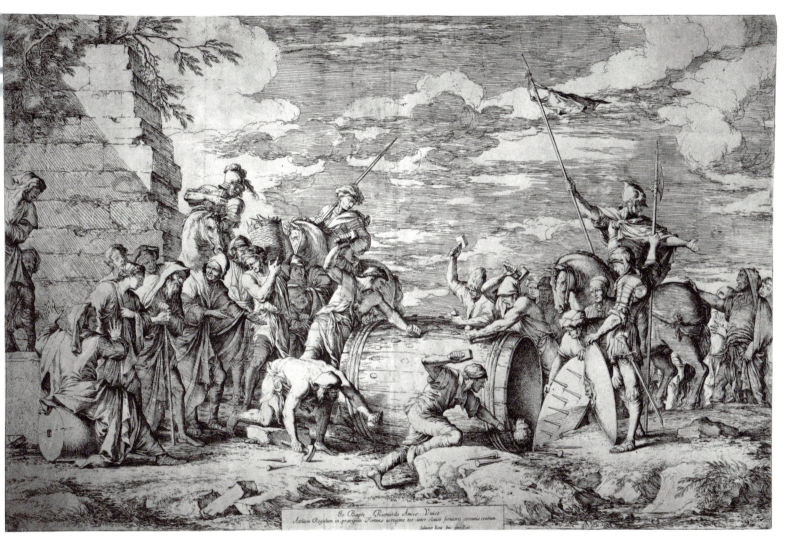

110/II. Rosa, *Death of Atilius Regulus*, etching. British Museum

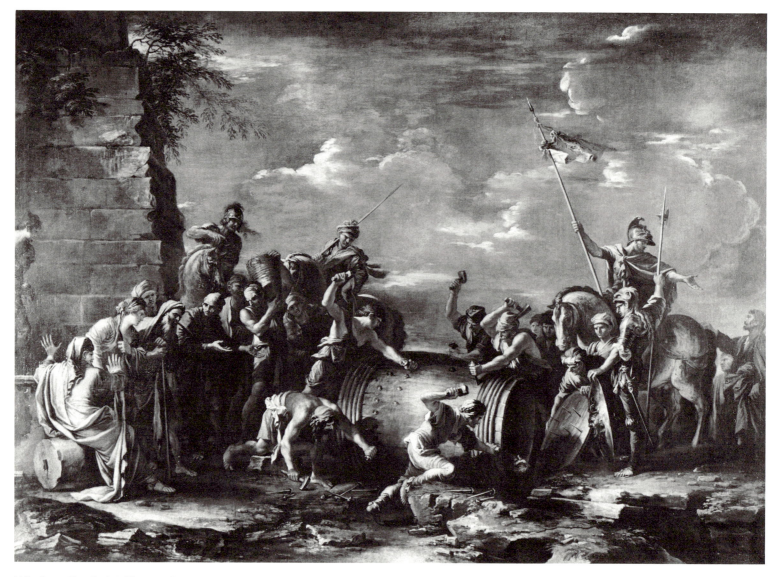

110a. Rosa, *Death of Atilius Regulus*, painting. Richmond, Virginia Museum of Fine Arts

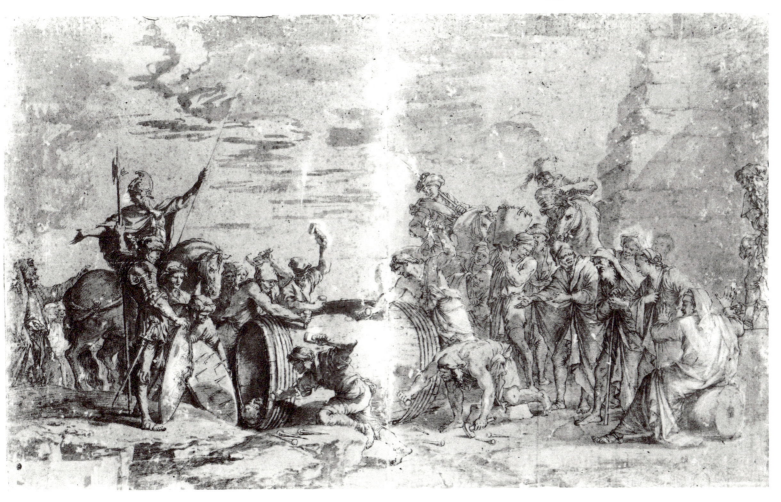

110b. Rosa, cartoon for the *Death of Atilius Regulus* etching [110]. Florence, Uffizi

110d. Rosa, preparatory drawing for the *Death of Atilius Regulus* painting [110a].
Paris, Louvre, Cabinet des Dessins

111. *THE CRUCIFIXION OF POLYCRATES*

Bartsch 10

475 x 723 mm.

Signed and inscribed in etching at the bottom center in both states: *Polycrates Sami Tyrannus, opibus et felicitate inclytus, ab Orete Persarum Satrapa captus, ac cruci / affixus docuit, neminem ante obitum merito dici posse felicem. / Salvator Rosa Inv. pinx. Scul.* (Polycrates, tyrant of Samos, famous for his wealth and good fortune, when he was captured by Oretes, Satrap of the Persians, and fastened on a cross, showed that no man can truly be called happy until he is dead.)

c. 1662

111/I. Etching with drypoint (*detail only)

Varying amounts of light to medium drypoint as shading, and also very rarely as contour lines, in many of the figures, especially those in the foreground. Some light to medium drypoint shading in the figure of Polycrates and the tree to which he is fastened. Burnishing of the back of the head of the pointing figure in the left background behind the horse's head. Burnishing of the sky to the viewer's left of Polycrates' right knee.

This first state is known to me only in a single impression in Paris, Bibliothèque Nationale (AA5). It is done on paper considerably lighter in weight than is usually found in impressions of this print, paper resembling that used for the first states of the *Oedipus* [116/I], *Giants* [115/I], and the first state of the *Regulus* [100/I], all in the Bibliothèque Nationale. The paper has the line suggesting a fold across the center usually seen in impressions of Rosa's four largest prints. The watermark is a shield with a schematized warrior or man in armor holding out a fleur-de-lis.

111/II*. Etching with drypoint (* and detail)

Small amounts of light to medium drypoint shading in addition to that seen in state I, most notably: Light to medium drypoint added to the hair of the climbing figure in the left foreground, to the shading of his left sleeve and left side, and to the shadow he casts on the rock. Light drypoint shading added along the edge of the cap of the horseman second from the left

and to the shading of his chin. Light to medium drypoint added to the shadow of Polycrates' neck at lower left, and to his chest, belly, and drapery. Light to medium drypoint added to the tip of the stub leaning to the viewer's left from the base of the tree.

As in Rosa's other very large prints, state II impressions of the *Polycrates* are usually printed on quite heavy paper, often with the fold-like line across the center, frequently with a guard attached to the verso at the center for binding in a volume. Occasionally the print is cut at the center, probably the result of cutting the print from a bound volume.

Watermarks seen in state II impressions: One identical with that seen in state I (Albertina, Fogg, Colnaghi); Fleur-de-lis in an oval (Boston, Colnaghi); Fleur-de-lis in a double oval with a B above (Colnaghi); A large cluster of grapes (Colnaghi)

Copperplate: Rome, C.N. (747c)

Related painting

111a*. Chicago, The Art Institute

The Crucifixion of Polycrates

Basically quite similar to the print, but with fewer figures and reversed from it. Rosa's letters indicate that the painting was done after the print since he said in a letter of March 11, 1662, that the cartoon for the print was done, but in a letter of October 21, 1663, that among his etchings only the *Democritus* [104], *Diogenes Casting Away His Bowl* [103], and the *Regulus* [110], existed in painted versions (De Rinaldis, pp. 131-32, no. 100 bis, and p. 157, no. 124).

Related drawings

111b*. Florence, Uffizi (6598S)

The cartoon for the print, identical with it in almost every detail and in reverse from it. Scored for transfer to the plate. Laid down, so that it is not possible to see the verso.

Black chalk heightened with white. Cancellations in white chalk with corrections. 470 x 750 mm. (M. 65.1)

111c. Location unknown

A study of a crucified figure seen twice with a group of gesturing soldiers beneath. Almost certainly for the etching.

Pen and brown ink. Measurements wanting. (M. 65.3)

111d. London, Collection of Joseph McCrindle

Studies of four soldiers in poses reminiscent of several of the figures in the etching.

Pen and brown ink. 220 x 210 mm. (M. 65.2)

111e. Berlin, Dahlem Museum, Kupferstichkabinett (601)

A drawing very close to the figure group to the left of the foot of the tree and possibly an early idea for it.

Pen and brown ink, brown wash. 189 x 190 mm. (M. 65.4)

111f. Leipzig (7434.2.41)

A study of several figures for the Chicago painting.

Pen and brown ink, brown wash, traces of black chalk. 201 x 177 mm. (M. 65.6)

See also M. 65.5, 65.7.

Copies

Albertina (1016, R 1000)

A drawing, a full size copy of the entire print.

Pen and gray ink, gray wash.

Paris, Louvre, Cabinet des Dessins (Inv. 9739)

A drawing, a copy of the figure group in the right foreground.

Pen and brown ink, brown wash, traces of black chalk. 240 x 228 mm.

[138], an etched copy

Tomory, 23, cites an anonymous etched copy in sanguine.

Literature

Basan, II, p. 419
Gilpin, *Essay*, pp. 131-33
Gori Gandinelli, III, p. 166
Huber, IV, p. 28
Füssli, III, pp. 181-82
Bryan, X, p. 320
Joubert, III, p. 57
Morgan, II, p. 283
Le Blanc, III, p. 360
Ozzola, pp. 190, 195, 196, 199
Pettorelli, p. 27
Petrucci, 1934-35, p. 30
De Rinaldis, p. 130, no. 99, pp. 131-32, no. 100 bis, p. 140, no. 106, p. 145, no. 110 bis, p. 147, no. 113, p. 157, no. 124
Limentani, 1950, p. 125, no. 32
Petrucci, 1953, pp. 69-70
C. A. Petrucci, p. 106, no. 747c
Salerno, pp. 112-13, no. XX, p. 127, no. 53c
Barricelli, p. 11
Tomory, 23
Colnaghi, 42
Wallace, 1973, pp. 51, 62, no. 102
Bozzolato, 91
Rotili, 104, and pp. 100-101

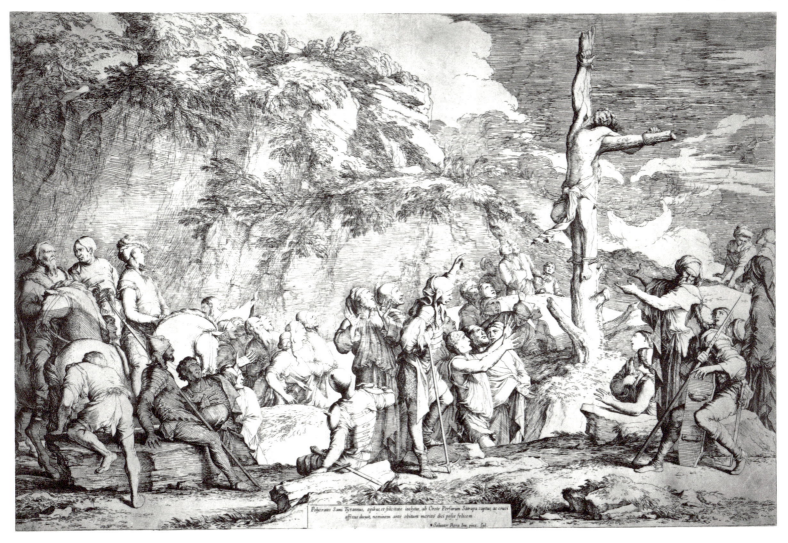

Polycrates Sami Tyrannus, opibus et felicitate inclytus, ab Orete Persarum Satrapa captus, ac cruci
affixus docuit, neminem ante obitum merito dici posse felicem
• Salvator Rosa Inv. pinx. Sul.

111/II. Rosa, *The Crucifixion of Polycrates*, etching. British Museum

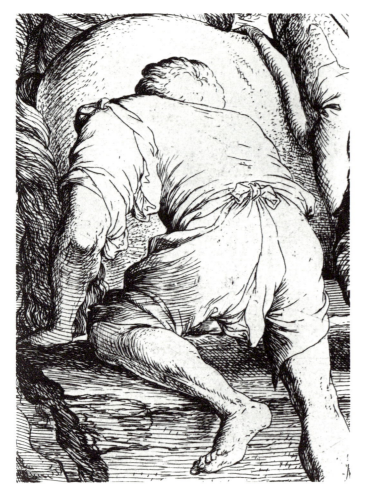

111/I. Detail. Paris, Bibliothèque Nationale

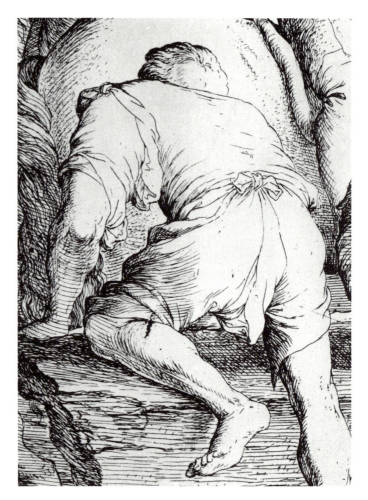

111/II. Detail. British Museum

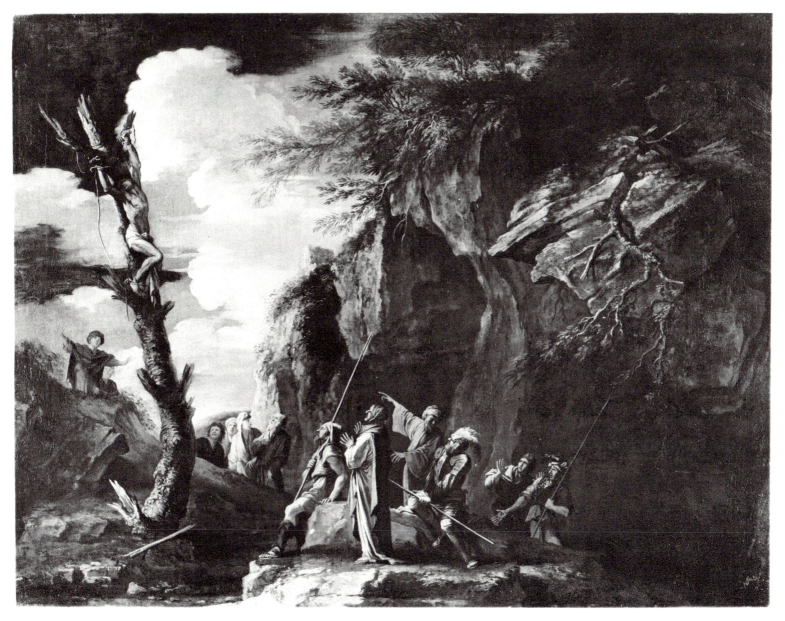

111a. Rosa, *The Crucifixion of Polycrates*, painting. Chicago, The Art Institute

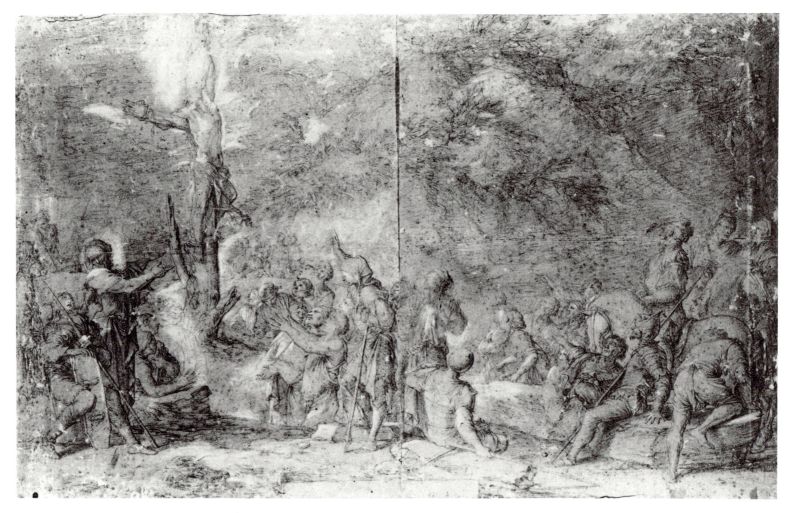

111b. Rosa, cartoon for *The Crucifixion of Polycrates* etching [111]. Florence, Uffizi

112. *CERES AND PHYTALUS*

Bartsch 19

355 x 233 mm.

Signed and inscribed in etching at the bottom center in both states: *Hic Cererem tectis Phytalus susceperat Heros, / Cui primum sacri largita est semina pomi, / Quod mortale genus FICUM vocat. / Salvator Rosa Inv. scul.* (Here the hero Phytalus had received Ceres into his house, on whom she first bestowed the seeds of the sacred fruit which mortals call the fig.) The inscription is a direct translation from Pausanias, *Description of Greece*, 1.37.2.

c. 1662

112/I*. Etching with drypoint

Extensive light to deep drypoint as shading and also very rarely as contour lines throughout much of the print.

Even state I impressions tend to be lighter and more delicate than most of Rosa's prints, especially the figure of Ceres. Light speckled plate tone is seen in many areas of these impressions.

Collections

Albertina (AL 42); London, Collection of Mrs. E.G. Stanley; Paris, B.N. (Be 7, p. 6, no. 5); and the author's collection

112/II*. Etching with drypoint

The toes of Phytalus' right foot and the top edge of his left foot burnished out and reworked in light to deep drypoint, shortening his right foot. Burnishing to lighten the shading lines of his lower right leg. Ceres' profile strengthened and altered slightly at the forehead and nose with medium to deep drypoint. A similar strengthening of her eyebrow, the line above her eyelid, and her upper lip with medium to deep drypoint. Light drypoint shading dots and hatching added to the modeling of her face in several places. Light to deep drypoint in addition to that seen in state I added to her hair at her temple and to create long, flowing strands at her right shoulder just below her profile. Extensive light to medium drypoint shading in addition to that seen in state I in a number of places throughout the print, especially in the background.

State II impressions often show considerable lightening and loss of definition in many areas, especially in the Ceres figure, owing to wear of the lightly etched portions of the plate. Speckled plate tone is evident in many state II impressions.

Watermarks seen in state II impressions: Fleur-de-lis in an oval with a V above (Fogg)

Copperplate: Rome, C.N. (747p)

Copies

[133], [138], etched copies

Tomory, 20, cites an anonymous etched copy.

Literature

Huber, IV, p. 27

Füssli, III, p. 190

Joubert, III, p. 57

Le Blanc, III, p. 360

Ozzola, pp. 190, 196, 200

Pettorelli, p. 27

Petrucci, 1934-35, p. 31

De Rinaldis, p. 130, no. 99, pp. 131-32, no. 100 bis

Petrucci, 1953, p. 75

C. A. Petrucci, p. 107, no. 747p

Salerno, p. 128, no. 60

Barricelli, p. 19

Tomory, 20

Colnaghi, 53

Bozzolato, 94

Rotili, 94, and pp. 89-90

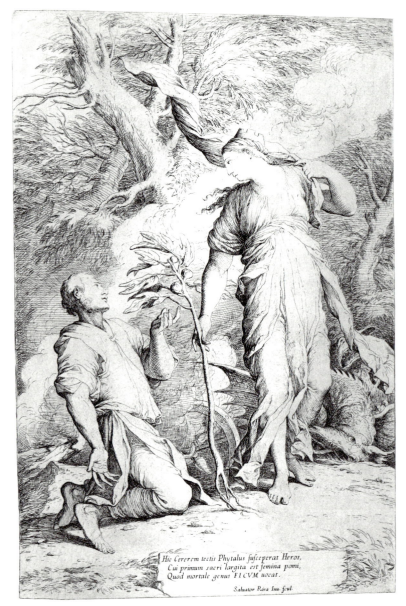

112/I. Rosa, *Ceres and Phytalus*, etching.
Author's collection

112/II. Rosa, *Ceres and Phytalus*, etching. Boston,
Museum of Fine Arts

113. *THE GENIUS OF SALVATOR ROSA*

Bartsch 24
457 x 275 mm.
Signed and inscribed in etching on a scroll at the bottom right in all three states: *Ingenuus, Liber, Pictor Succensor, et Aequus, / Spretor Opum, Mortisque: hic meus est Genius. / Salvator Rosa* (Sincere, free, fiery painter and equable, despiser of wealth and death, this is my genius. / Salvator Rosa)
c. 1662

113/I*. Etching with drypoint

Light to medium drypoint lines running horizontally in the background behind the satyr's hand, diagonally across the nude figure on the panel held by Pittura, and as shading in the drapery behind Pittura's right hand. Light to medium drypoint strokes across the dove held by Sincerità (the central figure), light drypoint shading at the lower part of her skirt and on the urn behind her head. Light drypoint shading along the profile of the genius figure and in the background adjacent to his profile. Light to medium drypoint shading in the face and hair of Libertà (the figure farthest right). Light to deep drypoint shading lines at her bosom and in her drapery. Some light drypoint shading in various places in the background. Extensive burnishing in parts of the smoke, and some on the tomb, urn, and in the drapery of the figure in a toga below the balance weight. Light burnishing of the cheek of the genius figure and that of Libertà. Light burnishing of the back of Libertà's left hand and in the background near the end of the staff she holds. Known in only one impression.

Author's collection (watermark: Fleur-de-lis in an oval with what appears to be a crown above)

113/II*. Etching with drypoint

Light diagonal drypoint strokes added as shading to the curled left end of the inscription scroll. Medium to deep drypoint added to the crown of the genius figure at his forehead, with the two lowest leaves being done chiefly in medium to deep drypoint. Burnishing of the background adjacent to the

profile of the genius figure, the background beneath the left forearm of Sincerità (the central figure), and of Sincerità's neck at the lower right.

Collections

Albertina (AL 42); Boston (watermark; Fleur-de-lis in an oval); London, Collection of Christopher White; Paris, Louvre, Rothschild Collection; Paris B.N. (Be7, p. 18, no. 21); Rijksmuseum (watermark: an anchor in an oval); Washington, D.C., National Gallery of Art

113/III. Etching with drypoint (* detail only)

Burnishing along the upper profile and in front of the eye of Libertà (the figure farthest right). Deep drypoint lines added to her forehead contour, altering it. Deep drypoint added to strengthen the shadow beneath her upper eyelid and to enlarge the dark iris of her eye. Light to medium drypoint strands of hair added at the lower edge of her hair in front and behind her ear. Pronounced burnishing of the left side of the nose of the genius figure and lighter burnishing of his left cheek and upper lip. Light burnishing of the upper right arm of Sincerità (the center figure) and of the left ankle of the genius figure. Light drypoint added to the fall of hair at the right shoulder of the genius figure with a few strands added in front of his ear. Traces of light drypoint added to the hair of Sincerità above her left forehead. Light drypoint shading lines added to the hole in the center of the smoke above the urn, and to the pomegranate directly above the smoke.

Watermarks seen in state III impressions: An anchor in an oval with an inverted V above (Rijksmuseum)

Copperplate: Rome, C.N. (747h)

Related drawings

113a*. Rome, G.N.S. (F.N. 124795)

The cartoon for the etching, in reverse from it. Cancellations in white of *pentimenti* in the head and left hand of Libertà, in the right arm of the genius figure, and in the left arm of the satyr. Scored for transfer. Laid down so that the verso cannot be seen.

Black chalk and red chalk, heightening with white chalk, cancellations in white chalk. 432 x 280 mm. (M. 65.14)

113b*. Paris, Louvre, Cabinet des Dessins (no. 9736)

A compositional and iconographical study, essentially the same as the etching, although quite freely and roughly done. In reverse from the etching.

Pen and brown ink, black chalk and traces of red chalk. 230 x 165 mm. (M. 65.18)

113c. Uffizi (no. 20094F)

A study of the head and shoulders of the male philosopher figure of the print.

Pen and brown ink. 108 x 90 mm. (M. 65.16)

113d. Odescalchi (Berlin, Galerie Gerda Bassenge in 1974)

A seated male nude crowned with leaves, a female figure behind him. Possibly an early idea for the figures of Genius and Libertà.

Pen and brown ink, brown wash, traces of black chalk. 148 x 95 mm. (M. 38.3)

See also M. 65.15, 65.17.

Copies

Uffizi (Santarelli 6609)
A drawing, an exact copy of the print, in the same direction.
Red chalk. Dimensions wanting.

[138], an etched copy.

Literature

Huber, iv, p. 28
Bryan, x, p. 321
Joubert, iii, p. 58
Morgan, ii, p. 283
Le Blanc, iii, p. 360
Ozzola, pp. 195, 196, 200
Pettorelli, p. 30
Petrucci, 1934-35, pp. 29-30
Petrucci, 1953, p. 71
C. A. Petrucci, p. 107, no. 747h

Salerno, p. 138, nos. 96, 97
Wallace, 1965, pp. 471-80
Barricelli, p. 16
Tomory, 29
Colnaghi, 6
Wallace, 1973, pp. 51, 60-61, no. 100
Bozzolato, 87
Rotili, 103, and pp. 97-98

113/I. Rosa, *The Genius of Salvator Rosa*, etching.
Author's collection

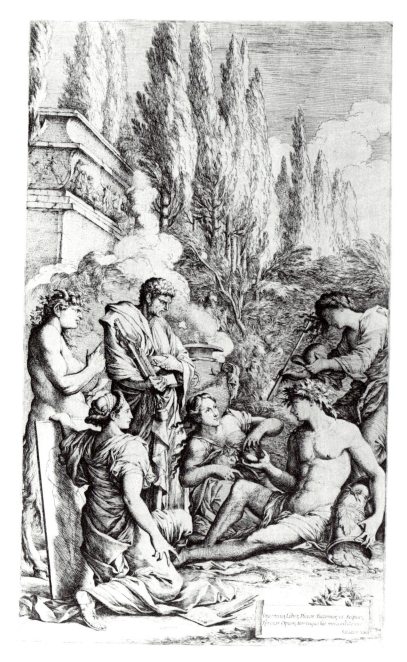

113/III. Detail. Boston, Museum of
Fine Arts

113/II. Rosa, *The Genius of Salvator Rosa*, etching.
Washington, D.C., National Gallery of Art

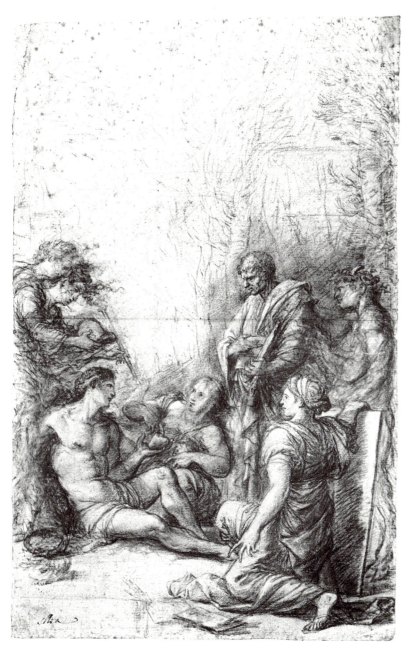

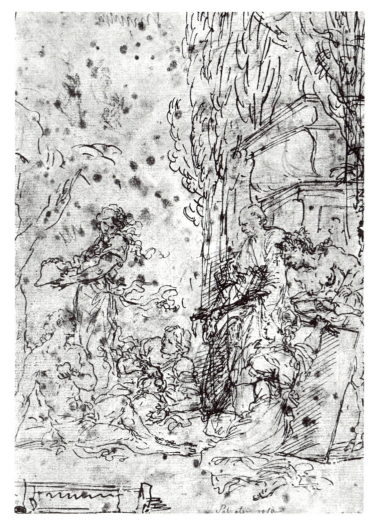

113b. Rosa, preparatory drawing for *The Genius of
Salvator Rosa* etching [113]. Paris,
Louvre, Cabinet des Dessins

113a. Rosa, cartoon for *The Genius of Salvator Rosa* etching [113].
Rome, Gabinetto Nazionale delle Stampe

114. *ALEXANDER IN THE STUDIO OF APELLES*

Bartsch 4

459 x 275 mm.

Signed and inscribed in etching at the bottom center in both states: *Alexandro M. multa imperite in officina disserenti / silentium comiter suadebat Apelles, rideri eum dicens / a pueris, qui colores tererent. / Salvator Rosa Inv. scul.* (In the studio Alexander used to talk a great deal about many things without any real knowledge of them, and Apelles would politely advise him to be silent, saying that the boys engaged in grinding colors were laughing at him.) The incident is taken from Pliny, and the inscription is an almost exact quotation from that source (25. 85-86).

c. 1662

114/I*. Etching with drypoint (* and detail)

Varying amounts of light to deep drypoint, principally as shading lines, but also very rarely as contour lines, in all of the figures of the print. It is difficult to be certain, but many of the fine lines shading the background wall appear to be light drypoint with no burr. Burnishing and some reworking in drypoint of the corner of the tablet held by the seated boy where it overlaps the panel.

Collections

Albertina (AL 42); Boston (watermark: an anchor with the letter M and another letter above the anchor, all within an oval, with a six-pointed star above the oval); London, Collection of Mr. Jack Baer; Paris, B.N. (Be 7, p. 10, no. 14)

114/II. Etching with drypoint (* detail only)

Light drypoint shading added to the top of the stool at the corner nearest Apelles and in curving lines to the leg beneath. Light drypoint shading that runs in lines basically horizontal added to the bottom portions of the hanging curtain. The helmet of the gesturing soldier behind Alexander reworked in drypoint to give it a bulging contour just above his forehead. The light drypoint line parallel to the chin strap of this helmet in state I is usually quite worn in state II impressions and is replaced by a similar light drypoint line further away from the chin strap. The bottom portion of this figure's belly armor is reworked in drypoint to change the lowest band of metal of state I into drapery in state II. A light semicircle added in drypoint to the chest armor of this figure. Light drypoint used to add two rivets, in profile, to the right shoulder armor of the figure farthest right. Additional light drypoint shading in the armor and costumes of Alexander and his soldiers.

State II prints are usually quite light and often show considerable wear of the light drypoint lines.

Watermarks seen in state II impressions: A donkey or horse in an oval (Fogg); Fleur-de-lis in an oval with a crown above (Rijksmuseum)

Copperplate: Rome, C.N. (747e)

Related drawing

114a*. Rome, G.N.S. (F.N. 125794)

The cartoon for the print, in reverse from it and scored for transfer to the plate. Laid down, but clear traces of red chalk rubbing on the verso for transfer can be seen at the edges. *Pentimenti* associated with the easel, hanging curtain, and background wall. Cancellations with white chalk and corrections in Apelles' legs, skirt, right shoulder, the legs of the stool, and around Alexander's sword.

Black chalk heightened with white. 419 x 283 mm. (M. 65.19)

Copies

London, Christie's Sale, July 6, 1965, lot 140

A drawing, same direction.

Pen and brown ink with gray wash. Measurements wanting.

[138], an etched copy

Literature

Basan, II, p. 419

Gori Gandinelli, III, p. 166

Strutt, I, p. 275

Huber, IV, p. 28

Füssli, III, pp. 188-89

Bryan, x, p. 320

Joubert, III, p. 57

Morgan, II, p. 283

Le Blanc, III, p. 360

Ozzola, pp. 196, 197, 199

Pettorelli, p. 29

Petrucci, 1934-35, p. 31

Petrucci, 1953, p. 75

C. A. Petrucci, 106, no. 747e

Salerno, p. 149

Barricelli, p. 18

Tomory, 11

Colnaghi, 1

Wallace, 1973, pp. 51, 61-62, no. 101

Bozzolato, 80

Rotili, 102, and p. 96

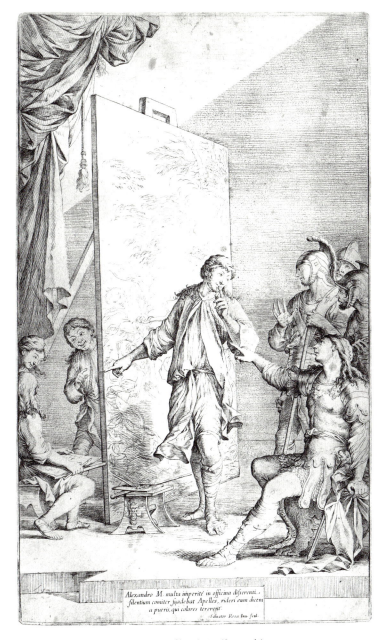

114/I. Rosa, *Alexander in the Studio of Apelles*, etching.
Boston, Museum of Fine Arts

114/I. Detail. Boston, Museum of Fine Arts

114/II. Detail. Boston, Museum of Fine Arts

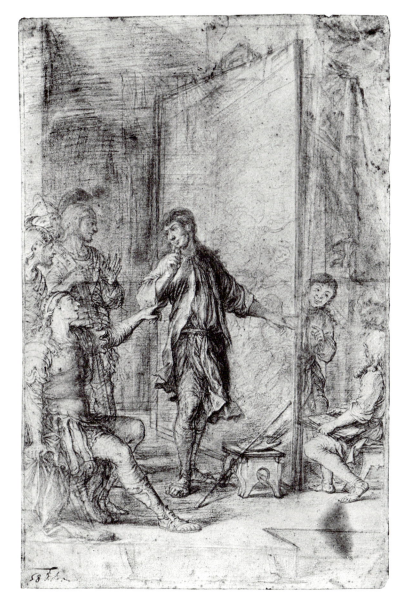

114a. Rosa, cartoon for the *Alexander in the Studio of Apelles* etching [114]. Rome, Gabinetto Nazionale delle Stampe

115. *THE FALL OF THE GIANTS*

Bartsch 21
720 x 475 mm.
Signed and inscribed in etching at the bottom center in both states: *Horatio Quaranta Amico Homogeneo / Tolluntur in altum, / Ut lapsu graviore ruant. / Salvator Rosa Inv. pinx. Scul.* (To Horatio Quaranta, very close friend. They are raised up high that they may be hurled down in more terrible ruin.) Quaranta was a Florentine poet, the author of sonnets and religious verse. Nothing seems to be known about his friendship with Rosa. The inscription itself is taken directly from Claudian Claudianus, *In Rufinum*, 1. 22-23.
1663

115/I. Etching with drypoint (* detail only)
Extensive light to deep drypoint shading in varying arrangements and varying degrees of density throughout the print. All of the lightest lines are drypoint. Burnishing of the projection of the lower left boulder where it is foiled against the left forearm of the figure crouched above it.

Collections

Rijksmuseum
Paris, B.N. (AA5). This is done on paper considerably lighter in weight than in the usual impressions of this print, with the watermark a shield with a schematized figure of a warrior or man in armor holding a small fleur-de-lis. The paper has the fold-like line down the center usually seen in impressions of Rosa's four very large prints.

115/II*. Etching with drypoint (* and detail)
The face (1) with the open mouth near the center of the print has crosshatching of light drypoint on its left side, created by adding diagonal strokes parallel to the main axis of the head over the parallel strokes running across the face in state I. On the right side of this face light to medium drypoint strokes have been added, running chiefly vertically, over the horizontal etched shading lines of state I. Rather dense light to medium drypoint

crosshatching and shading added to the right sleeve of this figure over the parallel horizontal strokes of light drypoint of the first state. Extensive light to medium drypoint shading lines added to the background rocks around this face. In the isolated face (2) partially seen in profile just below the first-mentioned face light parallel drypoint strokes running basically vertically have been added over the very light drypoint crosshatching of state I. Quite dense light drypoint shading added to the upper portions of the arm (3) which overlaps this last-mentioned face. In the figure (4) immediately to the right of this arm light drypoint shading has been added to the drapery. In the figure (5) seen bust length at the center of the print light drypoint shading has been added to his right shoulder and chest, to his left inner arm, and to his belly. Light drypoint crosshatching and shading lines added to the upper part of the leg (6) at the left center over the light drypoint shading lines that are roughly vertical in state I. Light drypoint shading lines that are roughly vertical added to the lower portions of this leg, producing crosshatchings with the light drypoint lines of state I.

Early state II impressions, such as one in the Rijksmuseum and one in the Albertina (AL 42) are very fresh and show pronounced drypoint burr, especially in the areas reworked for the state change.

As in the other of Rosa's very large prints, second state impressions of the *Giants* are usually printed on quite heavy paper, often with a center fold-like line, sometimes with a guard attached to the verso at the center for binding in a volume. Occasionally the print is cut at the center, probably the result of cutting the print from a bound volume.

Watermarks seen in state II impressions: A shield with a schematized figure of a warrior or man in armor holding a small fleur-de-lis (Boston, Albertina); Fleur-de-lis in an oval (Fogg, Colnaghi); Fleur-de-lis in an oval with a B above (Colnaghi); A bunch of grapes (Colnaghi)

Copperplate: Rome, C.N. (747a)

Related drawings

115a*. Dijon, Musée des Beaux-Arts (no. 811)

The cartoon for the etching, in reverse from it. Not having seen the drawing in the original, I do not know whether it is scored for transfer. It is laid down so that the verso cannot be seen to determine whether it was rubbed with chalk for transfer. Enlarged along the right edge by Rosa himself.

Pen and brown ink over black and red chalk, with traces of corrections in white chalk. 711 x 465 mm. (M. 70.3)

115b*. London, B.M. (O.o. 3-8)

A study for the entire composition, much as seen in the print, with a few differences. Much cut up and patched together, approximately the size as the etching and in reverse from it. It was clearly not cut up after the drawing was finished since in a number of areas inserts were made for alterations or corrections and portions of the drawing were continued on these different kinds of paper.

Pen and brown ink with brown wash, traces of black chalk and white chalk. 675 x 453 mm. (M. 70.4)

115c*. Metropolitan (Acc. No. 64.197.6)

A study, with bold alterations, of a portion of the composition. Probably an earlier idea for the print than the British Museum drawing above. None of the figures is identical with those of the etching or the British Museum drawing, although they are very similar to them.

Pen and brown ink over black chalk. 262 x 198 mm. (M. 70.5)

115d. Rome, G.N.S. (Inv. F.C. 124793, Colloc. 157-G-3)

A highly finished chalk drawing of a portion of the composition much like that seen in the Metropolitan drawing above and possibly a more detailed study based on that drawing. It contains a fallen figure resembling one seen in the British Museum drawing above.

Red chalk with traces of black chalk. 523 x 370 mm. (M. 70.2)

115e. Uffizi (13997F)

An early study for a *Fall of the Giants*, probably from the 1640's. Similar in basic conception to the etching but much less grand and not directly related to it.

Pen and brown ink with brown wash. 171 x 110 mm. (M. 24.18)

115f. Uffizi (2219F)

Three fallen male nudes. An early idea for a *Fall of the Giants*, or possibly a battle picture, probably from the 1640's. Although it apparently has no direct connection to the etching, one of its figures is very similar to a fallen figure in both the British Museum and Rome drawings above.

Red chalk with red wash. 91 x 75 mm. (M. 20.4)

115g. Rome, Istituto Nazionale di Archeologia e Storia dell'Arte (MSS. 77)

A slight sketch on a manuscript page of the figure of Zeus hurling thunderbolts, very similar to the Zeus of the Dijon and British Museum drawings and the final print.

Pen and brown ink.

115h. Edinburgh, National Gallery of Scotland (D. 1568)

Two giants, very similar to those of the etching but not identical with any of them.

Pen and brown ink over red chalk. 150 x 152 mm. (M. 70.6)

115i. Leipzig (Bd. 24, no. 25)

A giant kneeling and supporting himself on a boulder. Generally similar to a fallen figure seen in the British Museum, Rome, and Uffizi 2219F drawings above.

Pen and brown ink over black chalk. 171 x 184 mm. (M. 70.7)

115j. Odescalchi (Berlin, Galerie Gerda Bassenge in 1974)

A giant clinging to a rock face. Similar in basic feeling to the giants of the print but not directly related to any of them.

Pen and brown ink, brown wash, black chalk. 173 x 117 mm. (M. 70.13)

115k. Leipzig (Bd. 25, no. 74B)

Two falling male nudes, one of them quite similar to the upside-down Titian *Prometheus* type at the upper center of the print.

Pen and brown ink. 119 x 132 mm. (cut out, irregular in form). (M. 70.8)

115l. Paris, Louvre, Cabinet des Dessins (Inv. 15422v.)

A giant carrying a boulder. Not directly related to any of the figures in the etching.

Pen and brown ink. 197 x 236 mm. (M. 70.12)

115m. Leipzig (7434.2.34)

A fallen male nude with one arm outstretched, a little like the figure with both arms outflung at the upper right of the print. Possibly but not definitely a study for the print.

Pen and brown ink, brown wash. 167 x 148 mm. (M. 70.11)

See also M. 70.9, 70.10.

Copies

Albertina (W. Sc. R. 1097 suppl. 4)

A drawing, an exact copy of the etching without the inscription.

Pen and brown ink, brown wash, gray wash. 619 x 467 mm.

[138], an etched copy

An anonymous etched copy, same direction, of high quality. Tomory, 24, cites an anonymous etched copy in sanguine.

Literature

Basan, II, p. 419
Huber, IV, p. 28
Füssli, III, pp. 185-86
Bryan, X, p. 320
Joubert, III, p. 57
Morgan, II, p. 283
Le Blanc, III, p. 360
Ozzola, pp. 190, 191, 195, 200
Petrucci, 1934-35, pp. 30-31
De Rinaldis, p. 140, no. 106; p. 145, no. 110 bis; p. 153, no. 120; p. 154, no. 121; p. 156, no. 123; p. 157, no. 124; p. 193, no. 157
Limentani, 1950, p. 130, no. 35
Petrucci, 1953, pp. 72-73

C. A. Petrucci, p. 106, no. 747a

Salerno, p. 149

F. Stampfle, J. Bean, *Drawings from New York Collections*, II, *The Seventeenth Century in Italy*, New York, 1967, pp. 71-72, no. 108

K. Andrews, *National Gallery of Scotland Catalogue of Italian Drawings*, Cambridge, 1968, I, p. 108, II, fig. 732

Tomory, 24

Colnaghi, 43

Mahoney, "Rosa: Drawings," 1973, 73

Wallace, 1973, pp. 51, 62-63, no. 103

Bozzolato, 95

Rotili, 106, and pp. 102, 104

Addendum

Despite the "pinx." of the inscription, there is in fact no known painting related to the etching, and apparently none was ever done. See Ch. VI, n. 1.

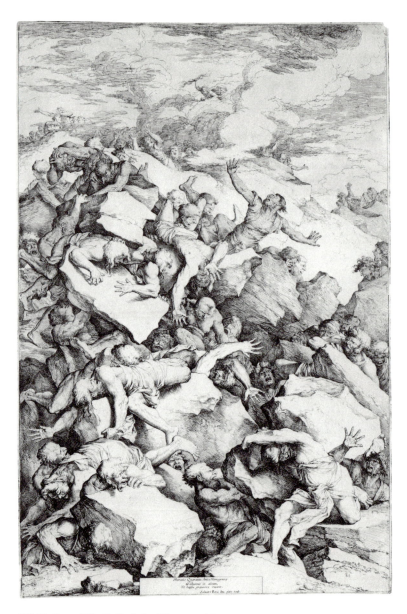

115/II. Rosa, *The Fall of the Giants*, etching. Amsterdam, Rijksprentenkabinet

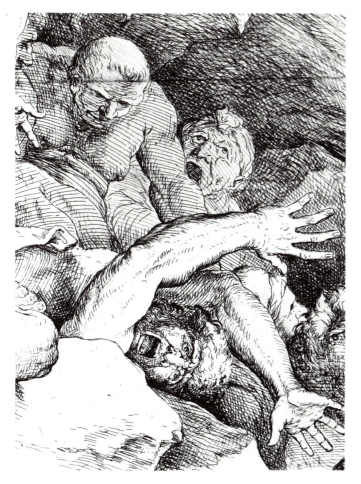

115/I. Detail. Paris, Bibliothèque Nationale

115/II. Detail. Amsterdam, Rijksprentenkabinet

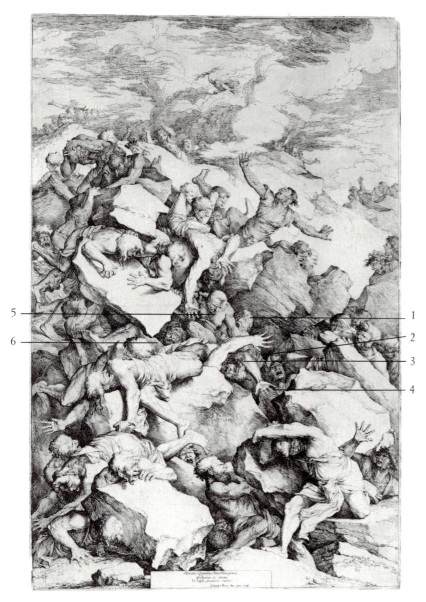

115/II. Keyed to drypoint locations
described in catalogue entry

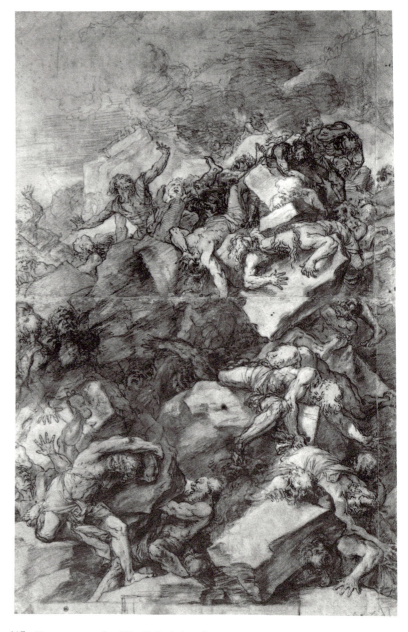

115a. Rosa, cartoon for *The Fall of the Giants* etching [115].
Dijon, Musée des Beaux-Arts

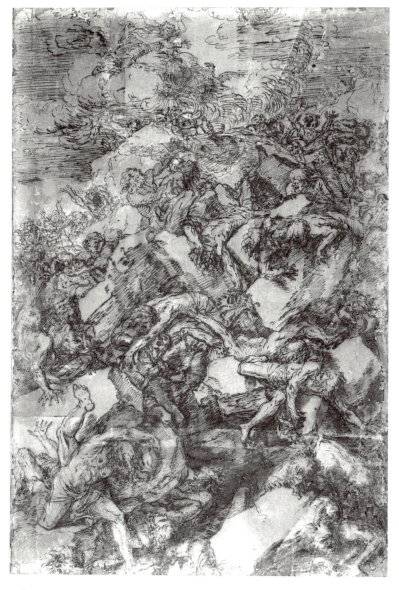

115b. Rosa, preparatory drawing for *The Fall of the Giants*
etching [115]. British Museum

115c. Rosa, preparatory drawing for *The Fall of the Giants*
etching [115]. New York, Metropolitan Museum of Art,
Rogers Fund, 1964

116. *THE RESCUE OF THE INFANT OEDIPUS*

Bartsch 8
724 x 472 mm.
1663

116/I. Etching with drypoint (* detail only)

Signed and inscribed in etching at the bottom center: *Al Sig.^re Giulio Martinelli Amico Cariss.^mo / Oedipus hic fixis, verfisque ad sidera plantis / Edocet ad sortem quemlibet ire suam. / Salvator Rosa Inv. pinx. Scul.* (Oedipus here, with his pierced feet upturned to the stars, shows that each man goes to his own fate.) Giulio Martinelli was a Florentine friend of Rosa's. His name appears occasionally in Rosa's letters, but very little is known about him.

Considerable light to deep drypoint as shading, and also occasionally as contour lines, throughout much of the print. Burnishing of the background areas framed by the two principal crotches of the main tree trunk.

This state I impression was apparently used as a working trial proof since it has black chalk shading in a number of places along the edges of the trunk, in several of the branches of the limb leaning farthest to the right in the principal tree, and in the background around the shepherd's head. In state II this was translated into drypoint shading.

Known only in the unique impression in Paris, Bibliothèque Nationale (AA5). It is done on paper considerably lighter in weight than is usually found in impressions of this print, paper which is much like that used for the first states of the *Polycrates* [111/I], and *Giants* [115/I], and the first state of the *Regulus* [100/I], all in the Bibliothèque Nationale. The paper has the line resembling a fold at the center usually seen in impressions of Rosa's four largest prints. The watermark is not legible.

116/II*. Etching with drypoint (* and detail)

The inscription begins *Julio Martinello* but is otherwise the same as in state I.

The contour line of the shepherd's left side between his arm and hip is reworked with deep drypoint adding two contour lines parallel to each other outside the etched contour of state I. Light to medium drypoint shading added to the places shaded with black chalk in state I. More extensive drypoint than in state I, both as shading and also occasionally as contour lines, especially in adding clusters of leaves in several places at the upper right and left edges of the tree group. Burnishing of portions of the shepherd's lower left leg, neck, and right shoulder drapery. Burnishing of the tree trunks and stubs in a number of places, especially where one overlaps another. Burnishing of the clouds at the middle right edge of the print.

As in Rosa's other very large prints, state II impressions are usually printed on quite heavy paper, often with the line resembling a fold at the center and frequently with a guard attached to the verso at the center for binding in a volume. Occasionally a print is cut at the center, probably the result of cutting it from a bound volume.

Watermarks seen in state II impressions: A large bunch of grapes (Colnaghi)
Copperplate: Rome, C.N. (747)

Related drawing

116a*. Milan, Brera (no. 304)
A study for the figure group of the etching as seen from the back.
Red chalk. 200 x 105 mm. (M. 70.1)

Copies

[138], [142] (a detail of the figure group), etched copies.

Literature

Basan, II, p. 419
Huber, IV, p. 28
Füssli, III, pp. 183-84
Bryan, x, p. 320
Joubert, III, p. 57
Morgan, II, p. 283
Le Blanc, III, p. 360
Ozzola, pp. 190, 196, 199
Pettorelli, p. 29
Petrucci, 1934-35, p. 30
De Rinaldis, p. 140, no. 106;
 p. 145, no. 110 bis; p. 153,
 no. 120; p. 154, no. 121; p.
156, no. 123; p. 157, no.
 124; p. 193, no. 157
Petrucci, 1953, pp. 70, 97
C. A. Petrucci, p. 106, no. 747
Salerno, p. 149
Barricelli, p. 13
Tomory, 25
Colnaghi, 41
Wallace, 1973, pp. 51, 63-64,
 no. 104
Bozzolato, 96
Rotili, 107, and pp. 107-8

Addendum

Despite the "pinx." of the inscription, there is in fact no known painting related to the etching, and apparently none was ever done. See Ch. VI, n. 1.

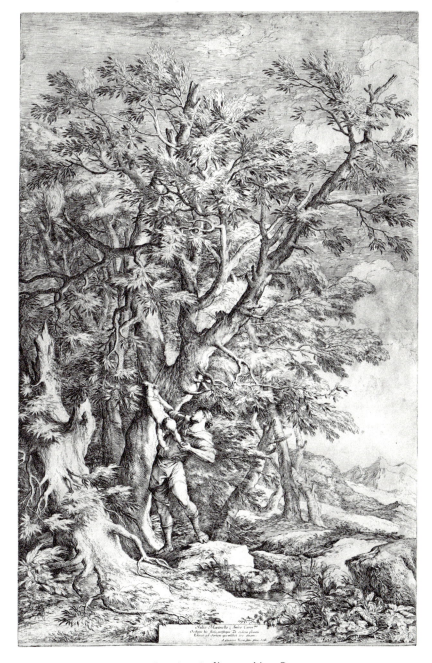

116/II. Rosa, *The Rescue of the Infant Oedipus*, etching. Boston, Museum of Fine Arts

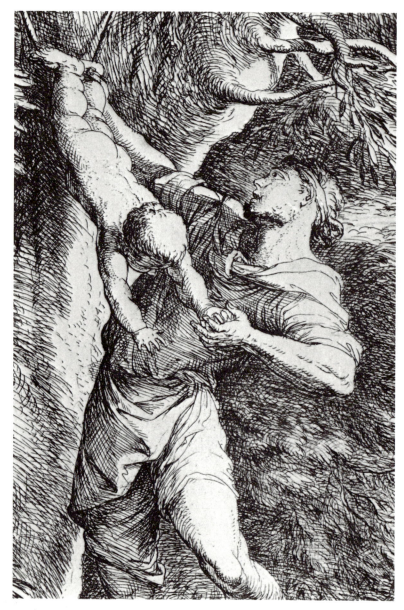

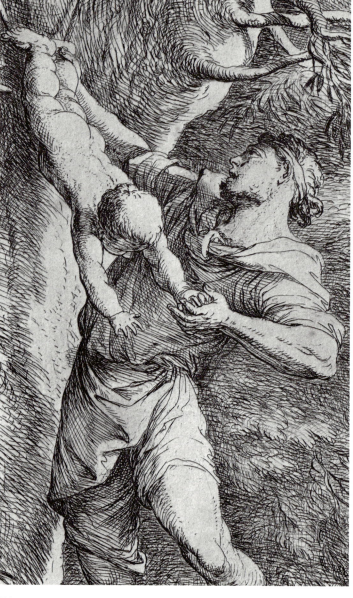

116/I. Detail. Paris, Bibliothèque Nationale

116/II. Detail. Boston, Museum of Fine Arts

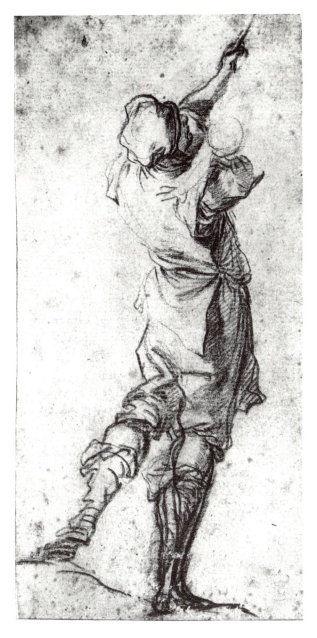

116a. Rosa, drawing study for the figure group in
The Rescue of the Infant Oedipus etching [116].
Milan, Brera

117*. *THE DREAM OF AENEAS*

Bartsch 23
Etching with drypoint. 349 x 237 mm.
Signed *SRosa*, in etching, at the lower left.
c. 1663-1664

Known in only one state.

Some light to deep drypoint as shading and also occasionally as contour lines in a number of places in both figures and in the setting. Burnishing of portions of the river god's beard, part of his reed crown at his left and the adjacent background, of his left groin with some drypoint added, of part of his trailing drapery above the head of Aeneas, and of one flap of Aeneas' skirt.

Later impressions have accidental zigzag scratches at Aeneas' upper left arm and left chest armor.

Copperplate: Rome, C.N. (737r)

Related painting

117a*. Metropolitan (Acc. no. 65.118)
 The etching is almost identical with this magnificent painting, in reverse from it with some variations. Salerno, p. 57, feels that the painting is later in date than the etching. Langdon, "Rosa: Paintings," 39, is undecided, but leans in the direction of a later date for the painting. I feel that the print follows the painting, for the reasons adduced in Ch. VI.
 1.95 x 1.18 m.

Related drawings

117b*. Leipzig (Bd. 25, no. 87A)
 A rather rough, early idea for the composition, showing Aeneas asleep in the right foreground and the river god Tiber peering in from the left background.
 Pen and brown ink. 104 x 124 mm. (M. 74.6)

117c. Berlin, Dahlem Museum (no. 15218)

A sketch of a shepherd-like figure asleep in a pose much like that of Aeneas in the above drawing. Not clearly identifiable as Aeneas but perhaps related to the development of the *Aeneas* composition.

Pen and brown ink, brown wash, traces of black chalk. 132 x 112 mm. (M. 74.4)

117d. Leipzig (Bd. 25, no. 39B)

A sketchy drawing of a warrior in armor, asleep in a pose much like those seen in the drawings above.

Pen and brown ink. 94 x 91 mm. (M. 74.3)

117e*. Paris, Louvre, Cabinet des Dessins (Inv. 9741)

A quite complete study of the basic composition—done first, in my opinion—for the painting, but also returned to by Rosa in order to introduce variations from the painting into the etching.

Pen and brown ink, brown wash, traces of black chalk. 188 x 135 mm. (M. 74.1)

117f. London, B.M. (Cracherode Ff 2-176)

A fluent, free drawing of Aeneas very similar to the Aeneas of the Louvre drawing above.

Pen and brown ink, brown wash, traces of red chalk. 90 x 101 mm. (M. 74.7)

117g*. Leipzig (Bd. 25, no. 19B)

A study of the figure of Aeneas, much like the Aeneas of the Louvre and British Museum drawings above, but with the position of his legs changed to that seen in the painting and etching.

Pen and brown ink. 70 x 75 mm. (M. 74.5)

117h*. New York, Pierpont Morgan Library

The drawing also catalogued in connection with the *Jason* [118], showing a warrior much like the Jason of the etching bestriding and raising a weapon against a sleeping figure in armor much like the Aeneas.

Pen and brown ink, brown wash. 153 x 140 mm. (M. 84.1)

117i. Princeton University, The Art Museum (no. 48-814)

A male figure lying asleep in the foreground of a landscape with another figure behind him, stretching his arms down toward the first figure. Possibly an early idea for the *Aeneas*.

Pen and brown ink, brown wash. 351 x 247 mm. (M.74.2)

Copies

[138], an etched copy

Literature

Huber, IV, p. 27
Joubert, III, p. 57
Le Blanc, III, p. 360
Ozzola, pp. 196, 200
Pettorelli, p. 29
Petrucci, 1934-35, p. 32
Petrucci, 1953, p. 75
C. A. Petrucci, p. 107, no. 747r
Salerno p. 130, nos. 67a, 67b, 67c, p. 54
W. Vitzhum, C. Monbeig-Goguel, *Le dessin à Naples du XVI^e siècle au XVIII^e siècle*, Cabinet des Dessins, Musée du Louvre, 1967, 43

Barricelli, p. 20
Tomory, 28
Colnaghi, 56
Langdon, "Rosa: Paintings," 39
Mahoney, "Rosa: Drawings," 1973, 74, 75, 76
Wallace, 1973, pp. 51, 63, no. 105
Bozzolato, 85
Rotili, 108 and p. 108

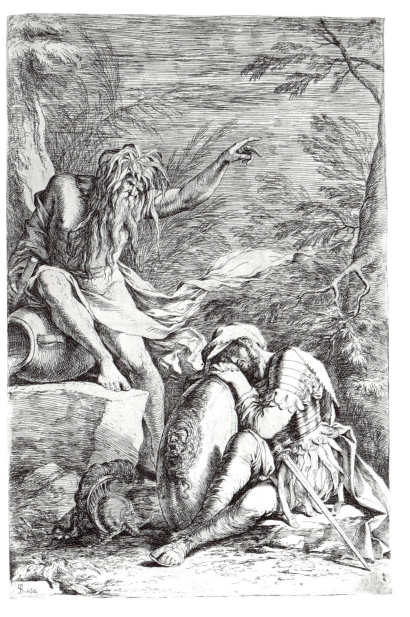

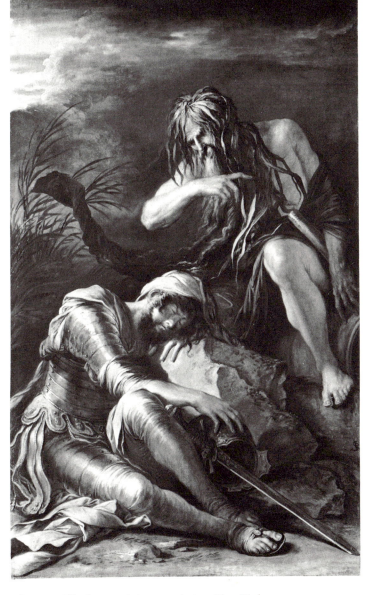

117. Rosa, *The Dream of Aeneas*, etching. Cambridge, Mass.,
Collection of Mrs. Arthur Solomon

117a. Rosa, *The Dream of Aeneas*, painting. New York,
Metropolitan Museum of Art, Rogers Fund, 1965

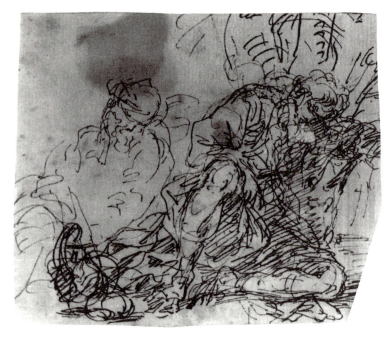

117b. Rosa, drawing study related to *The Dream of Aeneas*
etching [117], and painting [117a].
Leipzig, Museum der Bildenden Künste

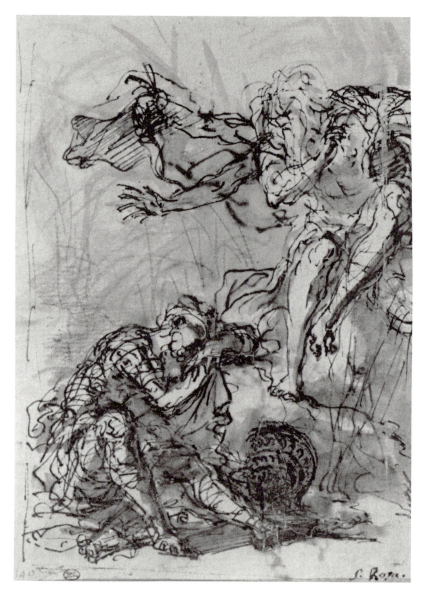

117e. Rosa, drawing study related to *The Dream of Aeneas* etching [117],
and painting [117a]. Paris, Louvre, Cabinet des Dessins

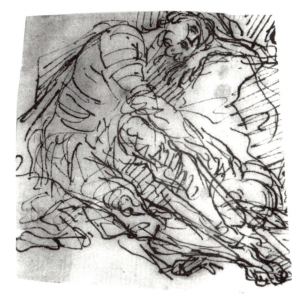

117g. Rosa, drawing study for *The Dream of Aeneas*
painting [117a]. Leipzig, Museum der
Bildenden Künste

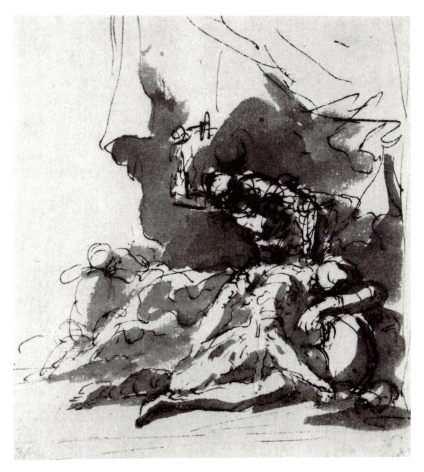

117h. Rosa, drawing related to the *Dream of Aeneas* composition and to
the *Jason and the Dragon* etching [118].
New York, The Pierpont Morgan Library

118*. *JASON AND THE DRAGON*

Bartsch 18
Etching with drypoint. 341 x 216 mm.
Signed *Rosa*, in etching, on a plaque at the lower left.
c. 1663-1664

Known in only one state.

Extensive light to deep drypoint as shading and also occa-
sionally as contour lines throughout much of the print. There
are indications of burnishing and correction in the signature
plaque. The light area immediately to the left of Jason's
right arm may have been lightened by burnishing, as may
also the patch of sky with parallel horizontal lines at the top
center.

It is possible that the print might originally have been larger
since it lacks the framing lines inside the plate mark that
appear in all of Rosa's other large etchings except the *Apollo
and the Cumaean Sibyl* [102], which was in my opinion
probably also cut down, and the *Oedipus* [116].

Copperplate: Rome, C.N. (7470)

Related paintings

118a*. Montreal, Museum of Fine Arts
The painting is closely related to the etching but has a some-
what different composition. It was almost certainly done after
the etching (see Ch. VI).
.77 x 65 m.

118b. England, Collection of the Earl of Harrowby
A replica of [118a], probably by Rosa's own hand.
Measurements wanting

Related drawings

118c*. Stockholm, Nationalmuseum (Anckarsvärd 400)
The cartoon for the print, in reverse from it. I have not seen
the drawing in the original, but Mr. P. Bjurström informs me
that it appears to be scored for transfer, although it is laid down

so that there are no traces of chalk rubbing to be seen on the
verso. It is very unusual among the known cartoons for the
etchings in being completely and flawlessly finished in pen,
ink, and wash, with no evident *pentimenti* or chalk under-
drawing.
Pen and brown ink, brown wash. 310 x 198 mm. (M. 75.1)

118d. New York, Pierpont Morgan Library
The drawing already catalogued and illustrated in connection
with the *Aeneas* as [117h], showing a man in armor in a pose
very much like that of Jason in the etching, bestriding and rais-
ing a weapon against a sleeping warrior in a pose very much
like that of Aeneas in the *Aeneas* etching [117].
Pen and brown ink, brown wash. 153 x 140 mm. (M. 84.1)

118e*. Paris, École des Beaux-Arts (no. 335)
Saint George and the Dragon
The saint in armor standing over and thrusting a lance down
into a dragon almost identical with the one in the etching.
Ozzola ("Pitture di Salvator Rosa sconosciute o inedite," *Bol-
lettino d'Arte*, v, 1925, pp. 29, 36) considers it a first idea for a
picture then in the Giovanelli Collection, Venice, which he
associates with the painting Rosa exhibited in 1668. Salerno
(p. 149) thinks the drawing is a first idea for the *Jason* etching.
Mahoney, "Rosa: Drawings," 1973, 79, considers it a work of
the later 1660's but does not think it can be associated with the
Giovanelli picture. I am inclined to feel that the drawing may
have preceded the *Jason* print, and then possibly played a role
in a later *Saint George* picture, the identity of which remains
unclear.
Pen and brown ink, brown wash. 223 x 148 mm. (M. 84.2)

118f. Leipzig (7434.2.18)
A free, loose sketch of *Jason and the Dragon*, almost identical
in composition to the print, superimposed over the figures of a
warrior and a woman leading him (Jason and Medea?)
Pen and brown ink, brown wash over black chalk. 230 x
184 mm. (M. 61.7)

118g. Leipzig (7434.2.20)

A free, loose sketch of a warrior and a woman leading him, much like the group in Leipzig 7434.2.18 above, seen from behind.

Pen and brown ink, brown wash, traces of black chalk. 210 x 152 mm. (M. 61.8)

118h. Leipzig (Bd. 25, no. 75)

A free sketch of a *Jason and the Dragon* group quite like that of the etching, with a hovering female figure holding what seems to be a crown, and several putti in the sky above. Enclosed within a pendentive-shaped border done as part of the drawing.

Pen and brown ink. 179 x 117 mm. (M. 61.5)

118i. Leipzig (Bd. 25, no. 81A)

A free sketch of a *Jason and the Dragon* group with what seems to be portions of a hovering figure above, all within a pendentive-shaped border done as part of the drawing. Four other figures to the right of this group.

Pen and brown ink. 95 x 149 mm. (M. 61.6)

118j. Leipzig (7434.2.22)

A free sketch of a warrior in a pose generally like Jason's in the etching. Possibly but not definitely related to the print.

Pen and brown ink, traces of red chalk. 106 x 90 mm. (M. 61.10)

118k. Location unknown

A bold, sketchy compositional study for the painting, virtually identical with it in all essentials. Published by W. Vitzhum, "Drawings from Stockholm," *Revue de l'Arte*, v, 1969, p. 93, fig. 6, and incorrectly identified as being number 35 in the exhibition catalogue by P. Bjurström, *Drawings from Stockholm*, New York, 1969. Number 35 in that catalogue is in fact the Anckarvärd 400 drawing cited above.

Pen and brown ink, brown wash. Measurements wanting.

Copies

118l. A print almost identical with the original, smaller, and in reverse from it.

Nagler 87
224 x 154 mm.
Signed *SRosa*, in etching, at the lower left

118l/I. Etching with burin work

Some burin work in the shading of the figure's helmet, skirt, and the background.

Collections

Berlin, Dahlem Museum, Kupferstichkabinett; Boston; Hamburg (no. 2223) with a counterproof; London, B.M. (W. 7-96); Rijksmuseum; Rotili, 110, cites an impression in Brussels, Royal Library Albert I

118l/II*. Etching with burin work

Additional burin work in the figure's helmet, chest, face, cloak, and stream of moly.

Hamburg (no. 2223b)

This print is accepted by Rotili, 110, who describes the burin work as drypoint. In my opinion it is much too crude to be by Rosa himself, who moreover never used the burin in any other print.

[133], [138], [142], etched copies

Tomory, 30, cites two anonymous etched copies, one in sanguine.

Literature

Huber, iv, p. 27
Füssli, iii, p. 189
Bryan, x, p. 320
Joubert, iii, p. 57
Morgan, ii, p. 283
Meyer, 87
Le Blanc, iii, p. 360

Ozzola, pp. 196, 200
Pettorelli, p. 29
L. Ozzola, "Pitture di Salvator Rosa sconosciute o inedite," *Bollettino d'Arte*, v, 1925-26, pp. 29, 36
Petrucci, 1934-35, p. 31

Petrucci, 1953, p. 74
C. A. Petrucci, p. 107, no. 747o
Salerno, p. 136, no. 89; pp. 57, 149
Wallace, 1965, p. 471
Barricelli, p. 20
P. Bjurström, *Drawings from Stockholm*, New York, 1969, 35
W. Vitzhum, "Drawings from Stockholm," *Revue de l'Arte*, v, 1969, p. 93, fig. 6

Tomory, 30
Colnaghi, 55
Langdon, "Rosa: Paintings," 43
Mahoney, "Rosa: Drawings," 1973, 79
Wallace, 1973, pp. 51, 65, no. 106
Bozzolato, 88
Rotili, 109, 110, pp. 108-9

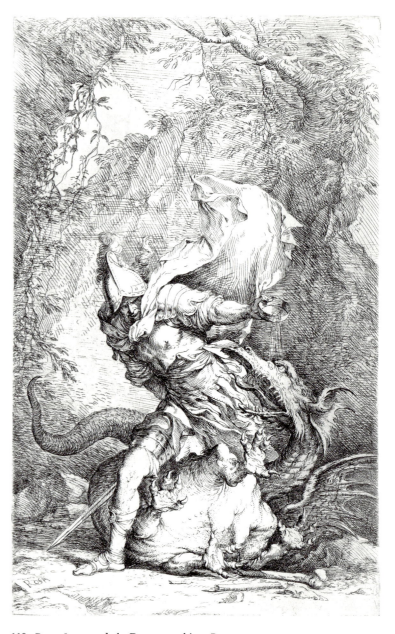

118. Rosa, *Jason and the Dragon*, etching. Boston, Museum of Fine Arts

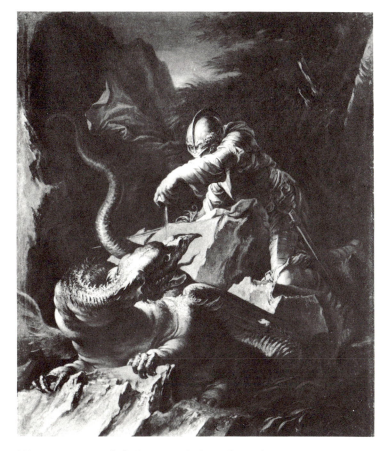

118a. Rosa, *Jason and the Dragon*, painting. Montreal,
Museum of Fine Arts

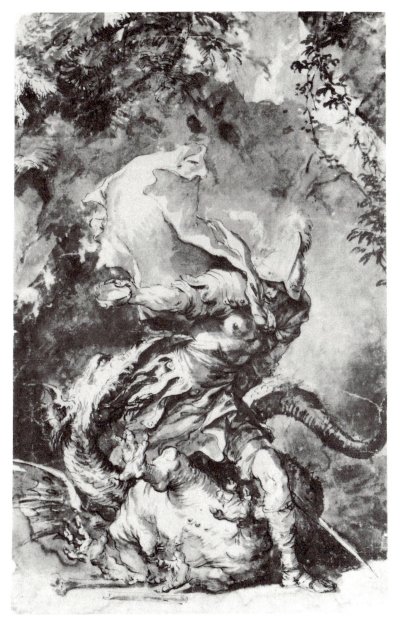

118c. Rosa, cartoon for the *Jason and the Dragon* etching [118].
Stockholm, Nationalmuseum

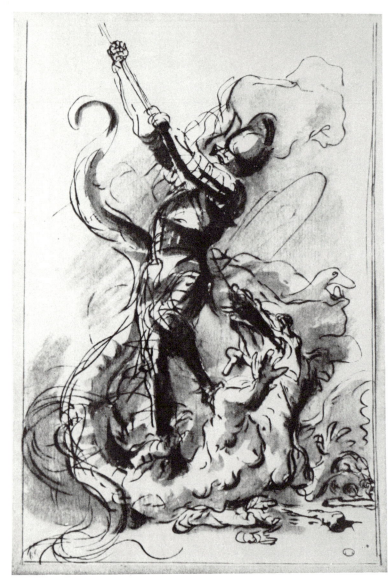

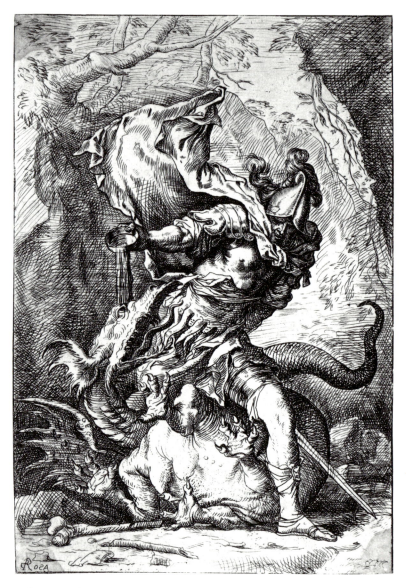

118e. Rosa, *Saint George and the Dragon*, drawing. Paris,
École des Beaux-Arts

118l/II. Copy by another hand of Rosa's *Jason and the Dragon*
etching [118], etching. Hamburg, Kunsthalle

OTHER ATTRIBUTIONS [119-121]

119*. *PUTTI WITH A PLAQUE*

Not listed in Bartsch or Nagler. Bozzolato, 4a, Rotili, 18
Etching. 144 x 90 mm.
Not signed
c. 1656-1657

Ruined in the course of biting by extensive false biting. The sketchy, careless execution of a number of passages, particularly the hands of the two principal putti and the head of the putto farthest in depth suggests that the print may have been intended only as a sketch. Although it is closely associated with the *Figurine* series as the *rovescio* of one of those plates, is the same general size, and may even at one time have been considered as a frontispiece to the series, it is hard to see how it would have fitted into the *Figurine* series. Perhaps that is why this print and [120] were never used. Canceled, possibly by Rosa himself.

Discovered by the author in 1968 as the *rovescio* of the plate for [25]. Impressions as in [7].

Copperplate: Rome, C.N. (747y, 35B *rovescio*)

119. Rosa, *Putti with a Plaque*, etching.
 Author's collection

120*. *PUTTI WITH A GARLAND*

Not listed in Bartsch or Nagler. Ozzola, p. 206, Bozzolato, 67, Rotili, 3
Etching. 146 x 95 mm.
Signed with the monogram *SR*, in reverse, in etching at the lower left.
c. 1656-1657

Somewhat unevenly bitten with some areas of incomplete biting, especially at the right edge, but not flawed enough to preclude use. Possibly discarded because, like [119], it may originally have been intended to be associated with the *Figurine* series but had little connection with that series as finally published or with any other of Rosa's etchings. The plate was canceled, possibly by Rosa himself, and then later salvaged, by burnishing out the cancellation strokes quite thoroughly, and reused.

Discovered by the author in 1968 as the *rovescio* of the plate for [65b]. Impressions as in [23].

Copperplate: Rome, C.N. (747y, 66B *rovescio*)

Related drawings

120a. Princeton University, The Art Museum (48-801)
A group of putti generally similar to those of the print.
Pen and brown ink, brown wash. 164 x 96 mm. (M. 63.6)

120b. Princeton University, The Art Museum (48-808)
A group of putti generally similar to those of the print.
Pen and brown ink, brown wash. 98 x 88 mm. (M. 63. 5)

See also M. 63.7, 63.8.

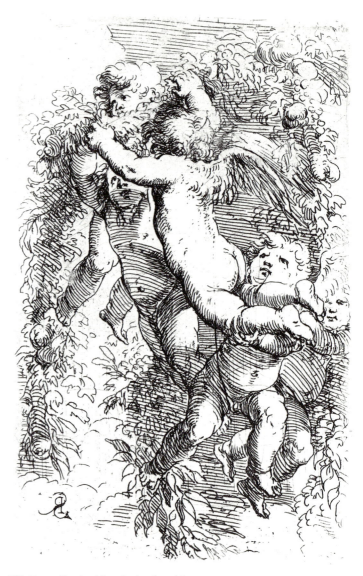

120. Rosa, *Putti with a Garland*, etching.
Author's collection

121*. *ADORATION OF THE SHEPHERDS*

Not listed in Bartsch or Nagler. Rotili, 10.
Etching. 121 x 80 mm.
Not signed.
c. 1664?

Much of the plate surface lightly abraded and speckled with false biting.

London, B.M. (W. 7-121)

Grunwald

Related drawing

121a*. Princeton University, The Art Museum (Acc. No. 48-810)

A drawing very similar to the print, in reverse from it, with minor variations. Clearly the drawing on which the print was based.

Black chalk. 243 x 191. (M. 56.4)

See also M. 56.1, 56.2, 56.3.

Although Rotili, 10, dates this print quite early, about 1651, I think it may be the last print Rosa ever did and datable after the *Aeneas* [117], and *Jason* [118], of c. 1663-1664. Its peculiarly rough execution may very well be the result of the difficulties he had with his eyesight and with working with "cose piccole" during the last year of his work in etching (see Ch. VI, n. 20). The Princeton drawing upon which the etching is based can also be reasonably dated on the basis of its style to the mid 1660's, in my opinion. In addition, the composition of the etching and drawing is quite similar to Rosa's *Jonah Preaching to the Ninevites* now in Copenhagen, a picture which is known to have been sold to the king of Denmark in 1661 and was probably painted just shortly before (Salerno, p. 112, no. xix). The Virgin and the kneeling figure in the *Adoration* print and especially the drawing for it are also strikingly like the figures in the *Ceres and Phytalus* etching of c. 1662 [112].

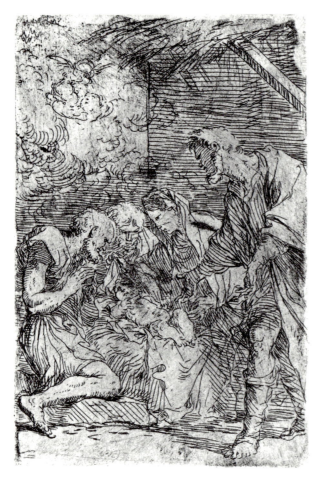

121. Rosa, *Adoration of the Shepherds*, etching.
Los Angeles, University of California,
Grunwald Center for the Graphic Arts

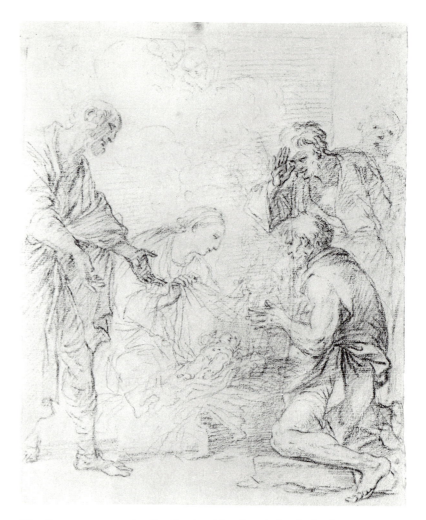

121a. Rosa, preparatory drawing for the *Adoration of the Shepherds*
etching [121]. Princeton University, The Art Museum

DESIGNS FOR PRINTS BY OTHERS
[122-125]

122. A DESIGN BY ROSA for the frontispiece to the book *Il Constantino Tragedia di Gio. Battista Filippo Ghirardelli*, Rome, 1653

Constantine and two other figures are shown in tragic poses. All three are very Rosa-like.
Rotili, 111; Langdon, 1976, pp. 698-99
Engraving. 116 x 67 mm.
Inscribed *F.p.Sc.* at the lower right.

Although the page does not acknowledge Rosa in any way, the artist in a letter to Ricciardi mentions doing the design for the frontispiece (De Rinaldis, p. 70, no. 46, dated May, 1654).

123. A DESIGN BY ROSA for the frontispiece to the book *Sena Civitas Virginis Carmen Petri Jacobi Favillae*, Rome, 1655

Two female figures, possibly personifications of Justice and Faith, are shown holding up a papal tiara.
Engraving. Measurements wanting.
Inscribed at the bottom *Salvator Rosa delin.*

124. A DESIGN BY ROSA for the frontispiece to the book *Carminum Iacobi Albani Ghibbesii Poetae Laureati Caesarei, Pars Lyrica: ad exemplum Q. Horatii Flacci*, Rome, 1668

A classical poet holding a lyre is shown seated at the foot of Mount Parnassus, with Pegasus behind.
Langdon, 1976, pp. 698-99
Engraving. Measurements wanting.
Inscribed at the bottom *Salv. Rosa delin., Alb. Clouvet sculp.*

The same frontispiece with the title inscription changed is used for another book *Romana Pictura et Sculptura. Auctore Io: Michaele Silos*, Rome, 1673.

Rotili, 112

125. A DESIGN BY ROSA for a print which bears the title *Synonymorum Apparatus Auth. Francisco Serra.*

A figure of Mercury is shown hovering over the earth, holding an overturned cornucopia from which a banderole with the title spills.
Engraving. Measurements wanting
Inscribed at the bottom *Salvator Rosa in., F. Poilly esculp.*

Collections

London, B.M. (W. 7-221); Paris, B.N. (Be7a, p. 26)

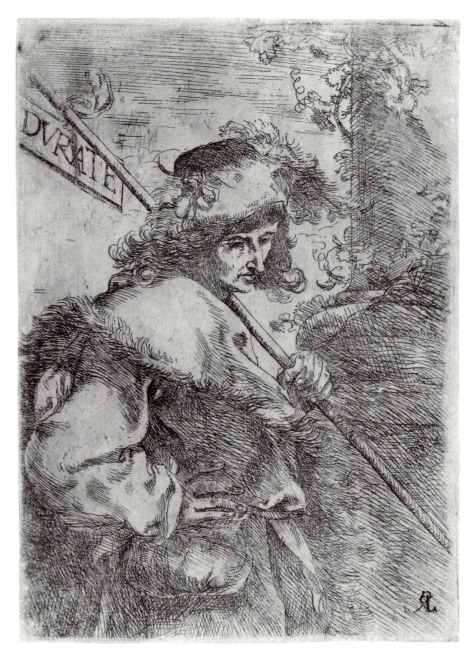

126/II. *Pilgrim*, etching. Berlin, Dahlen Museum, Kupferstichkabinett

REJECTED ATTRIBUTIONS [126-130]

126. *PILGRIM*

A standing young man in a fur-trimmed cap and coat seen half length, turned to the right, holding a staff over his left shoulder with a plaque bearing the word DURATE.
Nagler 88
206 x 150 mm.
The monogram *SR*, in reverse, in drypoint at the lower right.

126/I. Etching
The word DURATE in reverse and upside down.
Hamburg (no. 2224)

126/II*. Etching with burin work
The word DURATE corrected by burnishing of the plaque and the area around it, with burin work used to rework the inscription, the plaque, and portions of the staff, ribbon, and sky above it.

Collections

Berlin, Dahlem Museum, Kupferstichkabinett; Hamburg (no. 2224a)

This print, which is accepted by Petrucci (1953, p. 68) and Rotili (5) is, in my opinion, not by Rosa himself but an imitation by another hand. The basic composition, facial type, and use of a motto-like inscription do have something in common with Rosa's portraiture, but the actual execution, the drawing, modeling, and handling of the needle are not typical of his work in etching. This is seen most notably in the broadly and roughly handled shading of the figure and the column base, and in the often careless, tangled hatching and awkward patches and planes of shading and modeling.

In addition, in the first state the word DURATE is not only in reverse but upside down, something that occurs in no other inscription of a genuine Rosa etching, even the first state of *Diogenes Casting Away His Bowl* [103/I] with its quickly and carelessly lettered inscription. This scrambling of DURATE

was then corrected, presumably immediately by the author of the print himself since only one impression of the incorrectly inscribed first state is known. The correction was done by burnishing out the original inscription and redoing it with the burin, a technique that Rosa never used in any of the other prints that can be attributed to him.

Literature

Meyer, 88; Le Blanc, III, p. 360; Ozzola, p. 204; Petrucci, 1953, p. 68; Rotili, 5

127. *Landscape*, etching. Boston, Museum of Fine Arts

127*. LANDSCAPE

A small landscape with water in the foreground, a tree with a broken stub in the left foreground, and mountains in the distance.
Nagler 90
Etching. 91 x 116 mm.
Not signed

Quite deeply and harshly bitten, with some speckled plate tone caused by false biting.

Collections

Boston; Grunwald; Hamburg (no. 2226); London, B.M. (W. 7-122); Metropolitan (Acc. No. 53.509.11)

This print is, in my opinion, much too crude to be by Rosa or by Mola, as Tomory, 14 bis, and Rotili, p. 54, fig. 22, tentatively propose. R. Cocke, *Pier Francesco Mola*, Oxford, 1972, does not list it.

Literature

Meyer, 90; Le Blanc, III, p. 360; Ozzola, p. 205; Tomory, 14 bis; Rotili, p. 54, fig. 22

128*. LANDSCAPE WITH TWO FIGURES

A small, broad landscape with an expanse of water, broken trees in the left foreground, two figures in the left middle ground, mountains and some buildings.
Nagler 91
Etching. 95 x 206 mm.
Not signed.

Lightly and unevenly bitten around the edges, especially at the left. Lightly abraded in several places on the right side.

Collections

Boston; Grunwald; Hamburg (no. 2227); London, B.M. (W. 7-128)

This print is, in my opinion, much too crude to be by Rosa.

Literature

Meyer, 91; Le Blanc, III, p. 360; Ozzola, p. 205; Tomory, 14 bis; Rotili, p. 54

128. *Landscape*, etching. Boston, Museum of Fine Arts

129*. *FIGURINE* IMITATION

A figure in a plumed cap seated on a low rise of ground in the right foreground, seen from the back, turned to the left, pointing to the left with his left hand and speaking to two monks in the background.

Nagler 94

Etching. 68 x 106 mm.

Not signed.

Known in only one impression.

Hamburg (no. 2230)

This print is almost certainly based on the *Figurine* but is clearly not by Rosa. The composition and free, scribbly execution are not typical of his work in etching.

Literature

Meyer, 94; Ozzola, p. 205

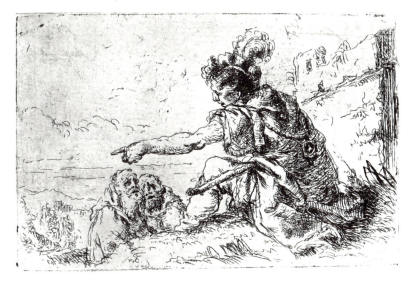

129. *Figurine* imitation, etching. Hamburg, Kunsthalle

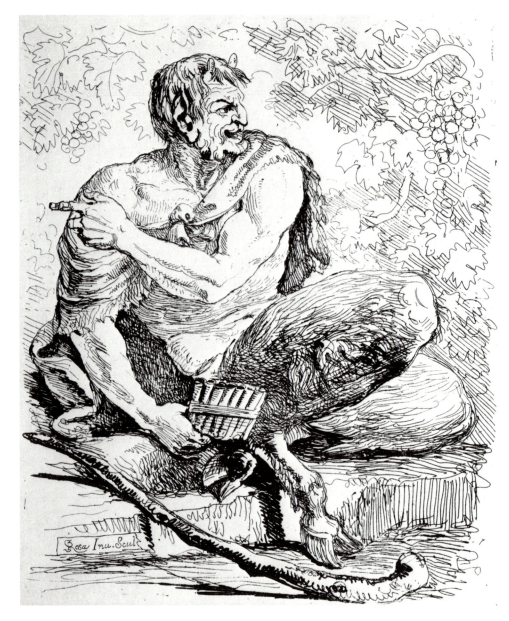

130. *Pan*, etching. Rome, Gabinetto Nazionale delle Stampe

130*. *PAN*

Pan seated, turned to the right, pointing left with his left hand, holding a syrinx with his right hand.
Not listed in Bartsch or Nagler. Petrucci, 1934-35, pp. 36-37.
Etching. 260 x 203 mm.
Signed *SRosa Inv. Scul.*, in etching, at the lower left.

Known in only one state.

Collections

Rome, G.N.S. (F.N. 26721); Turin, Galleria Sabauda
Rotili, 1, cites an impression in Brussels, Royal Library Albert I

This is the most interesting and most persistently endorsed of the questionable attributions to Rosa. It was first published and accepted as a genuine early work by Petrucci (1934-35, pp. 36-37). Barricelli (p. 11) follows Petrucci but Salerno ("Il dissenso" p. 63) does not. Bozzolato (68) accepts it and dates it quite late, 1656-57, and Rotili (1) considers it Rosa's earliest etching.

In my opinion it is not by Rosa himself, but is probably a later imitation based chiefly on the *Piping Satyr* [95]. In facial type and gesture the figure does have something in common with Rosa's figures, but the peculiarly disproportionate anatomy, the extreme flattening out of forms into planes, and the awkward and ambiguous rendering of the figure's trunk in relation to his legs and arms are unlike Rosa's work. The etching style and technique also have no parallels in Rosa's etchings—systems of modeling are quite unlike his, and above all the broad areas of deeply etched blacks are completely uncharacteristic of him. This cannot be written off simply as the result of inexperience in an early etching, as Petrucci and Rotili suggest. In fact it is quite difficult to achieve such wide bands of deeply etched black without plate breakdown, and it calls for considerable technical sophistication.

Literature

Petrucci, 1953, pp. 67-68; Barricelli, p. 11; Salerno, "Il dissenso," p. 63; Bozzolato, 68; Rotili, 1, and p. 30

COPIES, IMITATIONS,
DERIVATIONS [131-144]

131. COPIES OF THE *FIGURINE* by Frederick de Wit
(active c. mid seventeenth century)

The title page has inscribed on the block: *OPERA / SALVA-TORIS ROSA / divisa in / Quinque Partes et edita / per / FREDERICUM DE WIT / Amstelodami cum Privilegio / L'OUVRAGE / de SALVATOR ROSA / divisez en cinq Parties / et imprimez par / F. de Wit a Amstelodam / Avec Privil. S.Rosa inv.* appears at the lower left, *Prima Pars* at the bottom center, and *a* at the bottom right. A tree has been added behind the urn at the right and a round temple has been added behind the figure of Envy at the left.
60 engravings (burin), lettered variously a, b, c, d, at the lower right.
145 x 95 mm. (title page slightly larger)
Same direction as the originals.

London, Victoria and Albert Museum (93.C.143)

132. COPIES OF THE *FIGURINE*
by Iacomo Antonio S. Agostino (c. 1675-1683).

The title page has inscribed on the block: *All' Ill.^mo et R.^mo Sig.e/Prone. Col.^mo Mons.:^e /CARLO FRANCESCO/AIROLDI. per la gra. di / DIO e della S.^ta Sede Arciu.^o / de' Edesta Prelato domestico, et / assistente del Sommo Romano/ Pon.^ce et app. la S.R. dei Venezia N. Ap.^co*
In an addition to the dedication on another plate the artist makes lengthy reference to his indebtedness to Rosa.
60 etchings
c. 145 x 95 mm., with variations
In reverse from the originals.

Naples, Museo di Capodimonte (Coll. Firmian 91659-91718)

Rotili, pp. 124, 127, fig. 30

133. COPIES OF THE *FIGURINE* and six of Rosa's
larger etchings by Johann Jakob von Sandrart (1655-1698)

The title page exists in two versions, both with the inscription as in the original, one with: *Norimbergae aput Joannem Jacobum de Sandrart Pictorem et Calcographum*, added to the bottom of the inscription block; the second showing traces of the first inscription but changed to: *Norimbergae apud Ioan. Iacobum de Sandrart.*
60 etchings numbered at the lower right.
c. 145 x 95 mm.
In reverse from the originals.

Collections

Albertina (AL 42 supp.) London, Victoria and Albert Museum (93.D.154, and 93.A.130)
Tomory 10, mentions a set in the Auckland City Art Gallery.

This series also includes copies of *Saint William* [99], *Albert* [100], *Apollo and the Cumaean Sibyl* [102], *Glaucus and Scylla* [101], *Jason* [118], and *Ceres and Phytalus* [112].
Etchings
c. 335 x 230 mm.
In reverse from the originals.

London, Victoria and Albert Museum (93.A.130)

Literature

Tomory, 10; Bozzolato, p. 220; Rotili, pp. 125-26, fig. 29

134. COPIES OF THE *FIGURINE*
 by Henri Bonnart (1642-1711)

The title page has simply *SALVATOR ROSA / Invenit.* on the block and *A Paris Chez H. Bonnart, rue St. Jacques au Coq. avec privil.* at the base of the block.
60 etchings numbered at the lower left.
c. 145 x 95 mm.
Same direction as the originals.

Collections

Leipzig; Parma, Biblioteca Palatina (GG II 20); Paris, B.N. (Be 7a)

135. COPIES OF THE *FIGURINE*
 by Jan Goeree (1670-1731)

The title block inscribed as in the original with *J. Goeree fecit.* at the base of the block.
61 etchings (one of them after a print not by Rosa).
c. 140 x 95 mm.
Same direction as the originals.

Collections

New York, New York Public Library (MEM R788r); Paris, B.N. (Be 7a); Rijksmuseum (328-L-14)

Literature

Tomory, 10; Bozzolato, p. 221; Rotili, p. 126

136. COPIES OF THE *FIGURINE* by De Poilly
 (a member or members of the large family of print makers, probably done in the early eighteenth century.)

The title page has simply *SALVATOR ROSA / Invenit.* on the block with *A Paris chez De Poilly rue St. Jacques a l'image St. Benoist* at the bottom of the block. The title page and series are quite close to the Bonnart copies [134], and were probably based on them (or possibly vice versa).
58 etchings numbered at the lower right
c. 140 x 95 mm.
In reverse from the originals.

Collections

London, B.M. (163*-a-49); Milan, Bertarelli Collection; Paris, B.N. (Be 7a); Vatican Library (Cicognara III 2099)

136a. The same series of prints, with the title page having the same *SALVATOR ROSA / Invenit.* but altered to read *A Paris chez Basan rue St. Jacques* at the base of the block.
 Rijksmuseum (55 B 39)

136b. The same series of prints, with the title page having the same *SALVATOR ROSA / Invenit.* but altered to add *Liber Primus*, with *A Paris chez De Poilly . . .* burnished out. The set is divided into four parts by the addition of *Liber Primus*, as above, and *Liber Secundus*, *Liber Tertius*, and *Liber Quartus* to three other of the prints.

Collections

Albertina; New York, New York Public Library (MEM R788rsh)

Literature

Tomory, 10; Bozzolato, pp. 220-21; Rotili, pp. 126-27, fig. 31

137. COPIES OF SOME OF THE *FIGURINE*
by Elias Boeck (1679-1747) and Aug. Vindel

The title page has inscribed on the block *Diversa Positurae /
â / SALVATORE ROSA PRIMIT, / inventae: / Nunc verò
artis instinctu noviter / Suma cum diligentia curioso ar- / tem
Sculptoriam, pictoriamque avi- / de imitanti mundo dicatae,
et excu-/ sae â me / Elia Boeck, a Held: Calcogr: Aug: Vin-
del.* A palette, brushes, and other implements associated with
the arts are hung in a cluster at the upper left of the print.
19 etchings are known to me, numbered at the upper left.
144 x 98 mm.
In reverse from the originals.

Paris, B.N. (Be 7a, pp. 57-61)

138. COPIES OF ROSA'S ETCHINGS
by Carlo Antonini, 1780

First published in book form although single prints and
groups of prints from the series are the most commonly en-
countered copies of Rosa's prints. The title of the book is
*Serie dei LXXXV disegni in varie grandezze composti dal
celebre pittore Salvator Rosa publicati ed incisi da Carlo
Antonini . . .* , Rome, 1780. The title page of the *Figurine*
series is inscribed on the block *SALVATORIS ROSA VA-
RIA ET CONCINNA DELINEAMENTA*
Etchings reproducing all of the Rosa etchings listed by
Bartsch except Bartsch 22, this catalogue [98]. In both black
ink and sanguine.
Approximately original size, with some variations.
Same direction as the originals.

Collections

Florence, Biblioteca Marucellana; London, B.M. (163-C-9);
Rome, Istituto Nazionale di Archeologia e Storia dell'Arte
(S. Rari 691-C)
Tomory, 10, cites a set in the Metropolitan
Quite commonly encountered.

Literature

Tomory, 10; Bozzolato, p. 222; Rotili, p. 128

139. COPIES OF SOME OF THE *FIGURINE*
by Benjamin Green (1736-1800) and Sarah Green

I know only fourteen prints, in etching and acquatint, by
Benjamin, and three by Sarah. The title page is not among
them. Variously signed. Two prints dated 1787 on the plate.
c. 140 x 93 mm.
Some in reverse from the originals, some same direction.

Christie's Sale Catalog, October 16, 1973, p. 15, no. 53.

140. COPIES OF SOME OF THE *FIGURINE*
by Müller (not further identifiable)

The title page as in the original with *Müller fecit.* at the base
of the block.
12 etchings are known to me, numbered at the upper right.
c. 147 x 102 mm.
In reverse from the originals.

Hamburg

141. ANONYMOUS COPIES of a number of Rosa's
etchings, *Figurine* and larger prints

Published by M. Mussini, *Salvator Rosa le incisioni*, Parma,
1972, 1-52. The prints illustrated, 19 in number, are all copies.
The *Figurine* title page as in the original.
Etchings
Approximately original size
Same direction as the originals.

142. COPIES OF SIX OF ROSA'S larger prints
 by Jeremiah Wolff (Augsburg, c. 1663/73-1724)

Copies of the *Saint William* [99], *Diogenes Casting Away His Bowl* [103], *Democritus* [104], *Oedipus* [116], *Apollo and the Cumaean Sibyl* [102], and *Jason* [118].
Etchings, numbered at the lower right. The *Jason* signed *Jerem. Wolff exc.*
c. 153 x 105 mm.
In reverse from the originals.

Düsseldorf, Kunstmuseum (Inv. Nr. F.P. 6948, 6949, 6956-6959)

143. DERIVATIONS FROM THE *FIGURINE*:
 Reitres et Lansquenets prints by Jean Georges Wille
 (1717-1807) after drawings by Charles Parrocel (1688-1752)

12 etchings
173 x 121 mm.
1753

London, B.M. (45-9-6-104, 105, 106, 109, 114, 115, 116, 118, 119)

Sunderland, "Works by Other Artists," 131

144. DERIVATIONS FROM THE *FIGURINE*:
 1^{ere} Suite de Soldats dessinés et gravés par
 P.J. Loutherbourg . . .

6 etchings
107 x 72 mm.
c. 1763-1766

London, B.M. (1868-12-12-169-172; 1857-2-28-254-255)

Sunderland, "Works by Other Artists," 132

CONCORDANCE

Catalogue	Bartsch	Nagler	Wallace 1973	Bozzolato	Rotili
1	—	—	—	—	2
2	—	93	80	2	4
3	—	92	—	1	7
4	—	—	93	78	9
5	—	—	94	79	8
6	25	—	81	4	21a
7	—	—	81	4b	19
8	—	—	81	4c	20
9	26	—	—	5*	25
10	27	—	—	6*	26
11	28	—	—	7	27
12	29	—	—	8	28
13	30	—	—	9	29
14	31	—	—	10	30
15	—	100	—	10**	—
16	32	—	—	11	31
17	—	102	—	11**	—
18	—	103	—	—	32
18a	—	—	—	—	—
19	—	104	—	—	—
20	—	—	—	—	—
21	33	—	87	13*	33
22	—	101	—	—	—
23	—	—	88	12*	34
24	34	—	89	14	35
25	35	—	—	15	36
26	36	—	—	16	37
27	37	—	—	17	38
28	—	—	—	17a	39
29	38	—	—	18	24
30	39	—	—	19	40
31	—	—	—	—	—
32	40	—	—	20	41
33	41	—	—	21	42
34	—	—	—	—	43
35	42	—	—	22	44
36	43	—	—	23*	45
37	44	—	—	24	46
38	—	105	—	24**	—
39	45	—	—	25	47
40	46	—	—	26	48
41	47	—	—	27	49
42	—	95	—	27**	—

* Error in print identification, numbering, or illustration
** Variant incorrectly identified as different state

Catalogue	Bartsch	Nagler	Wallace 1973	Bozzolato	Rotili	Catalogue	Bartsch	Nagler	Wallace 1973	Bozzolato	Rotili
43	—	106	—	—	—	86	85	—	—	65	88
44	48	—	—	28	50	87	86	—	—	66	89
45	—	—	—	—	51	88	—	97	—	—	—
46	49	—	—	29	52	89	—	98	—	—	—
47	50	—	82	30	22	90	—	99	—	—	—
48	51	—	—	31	53	91	11	—	—	70	11
49	52	—	84	32	54	92	—	—	—	70a	12
50	53	—	—	33	55	93	12	—	92	71	13
51	54	—	—	34	56	94	13	—	—	72	14
52	55	—	—	35	57	95	14	—	—	69	15
53	56	—	—	36	58	95d	—	89	—	69	15
54	57	—	86	37	59	96	15	—	—	73	16
55	58	—	—	38	60	97	16	—	—	74	17
56	—	96	—	38	—	98	22	—	—	3	6
57	59	—	—	39	61	99	1	—	95	83	90
58	60	—	—	40	62	100	2	—	96	84	91
59	61	—	90	41	63	101	20	—	97	86	92
60	62	—	—	42	64	102	17	—	—	81	93
61	—	—	—	—	—	103	5	—	—	89	97
62	63	—	—	43	65	104	7	—	98	93	98
63	64	—	—	44	66	105	—	108	98	75	99
64	65	—	—	45	67	106	—	109	98	76	100
65	—	107	—	—	69	107	—	110	98	77	101
65b	66	—	—	46	68	108	6	—	99	90	96
66	67	—	—	47	70	109	3	—	—	82	95
67	68	—	—	48	71	110	9	—	—	92	105
68	69	—	—	49*	72	111	10	—	102	91	104
69	70	—	—	50	73	112	19	—	—	94	94
70	71	—	—	51	74	113	24	—	100	87	103
71	72	—	91	52	83	114	4	—	101	80	102
72	—	—	91	—	82	115	21	—	103	95	106
73	73	—	—	53	75	116	8	—	104	96	107
74	74	—	—	54	76	117	23	—	105	85	108
75	75	—	—	55	77	118	18	—	106	88	109
76	76	—	—	56	78	118l	—	87	—	88	110
77	77	—	—	57	79	119	—	—	—	4a	18
78	78	—	—	58	80	120	—	—	—	67	3
79	79	—	—	59	81	121	—	—	—	—	10
80	80	—	83	60	23						
81	81	—	85	61	84			*Designs by Rosa for prints by others*			
82	82	—	—	62	85	122	—	—	—	—	111
83	83	—	—	63	86	123	—	—	—	—	—
84	84	—	—	64	87	124	—	—	—	—	112
85	—	—	—	—	—	125	—	—	—	—	—

Catalogue	Bartsch	Nagler	Wallace 1973	Bozzolato	Rotili
			Prints rejected as attributions to Rosa		
126	—	88	—	—	5
127	—	90	—	—	—
128	—	91	—	—	—
129	—	94	—	—	—
130	—	—	—	68	1
18a above					
65b above					
95d above					
118l above					

GENERAL BIBLIOGRAPHY

In the footnotes and Catalogue, an item listed here is referred to only by the author's name unless further data is needed to distinguish the publication from others by the same author.

For a comprehensive bibliographical survey of the vast literature on Rosa, see U. Limentani, *Bibliografia della vita a delle opere di Salvator Rosa*, Florence, 1955, and the same author's "Salvator Rosa: Supplemento alla bibliografia," *Forum Italicum*, VII, 1973, pp. 268-79. See also M. Rotili, *Salvator Rosa incisore*, Naples, 1974, pp. 249-53.

Alciati, A. *Emblemata*, Lyons, 1593.

Arnold, E. V. *Roman Stoicism*, London, 1911, reissued 1958.

Baldinucci, F. *Delle notizie de' professori del disegno da Cimabue in quà*, G. B. Stecchi e A. G. Pagani, Florence, 1773.

————. *Cominciamento e progresso dell'arte dell'intagliare in rame*, Società Tipografica de' Classici Italiani, Milan, 1808.

Barricelli, A. *Mostra delle incisioni di Salvator Rosa*, Galleria Sabauda, Turin, 1969.

Bartsch, A. *Le peintre graveur*, Vienna, 1802-1821.

Basan, F. *Dictionnaire des graveurs anciens et modernes depuis l'origine de la gravure*, II, Paris, 1767.

Blunt, A. *The Drawings of G. B. Castiglione and Stefano della Bella in the Collection of Her Majesty the Queen at Windsor Castle*, London, 1954.

Boas, G. *The Hieroglyphics of Horapollo*, New York, 1950.

Bodkin, T. "A Note on Salvator Rosa," *Burlington Magazine*, LVIII, 1931, pp. 91-97.

Bozzolato, G. *Le incisioni di Salvator Rosa*, Padua, 1973.

Brown, J. *Jusepe de Ribera: Prints and Drawings*, The Art Museum, Princeton University, October-November 1973; Fogg Art Museum, Harvard University, December 1973-January 1974.

Bryan, M. *A Biographical and Critical Dictionary of Painters and Engravers*, X, London, 1816.

Calabi, A. *Saggi sull'incisione del sec. XVII*, Milan, 1962.

Cesareo, G. A. *Poesie e lettere di Salvator Rosa*, Naples, 1892.

Claudian, *In Rufinum*, Loeb Classical Library Edition by M. Platnauer, London, New York, I, 1932.

Colnaghi and Co. *Etchings by Salvator Rosa and His Contemporaries*, London, October 11-November 2, 1973.

Crispolti, E. "Capriccio," *Encyclopedia Universale dell'Arte*, Venice, Rome, 1958, III, cols. 103-10.

De Dominici, B. *Vite de' pittori, scultori, ed architetti Napoletani*, Naples, 1742-1743.

De Rinaldis, A. *Lettere inedite di Salvator Rosa a G. B. Ricciardi*, Rome, 1939.

Diogenes Laertius, *Lives of Eminent Philosophers*, Loeb Classical Library Edition by R. D. Hicks, London, New York, 1923-1925.

Disertori, B. "La Regia Calcografia. II. Il primo secolo dell'incisione all'acquaforte," *Emporium*, LV, 1922, pp. 131-48.

Dudley, D. R. *A History of Cynicism*, London, 1938.

Epictetus, *Discourses*, Loeb Classical Library Edition by W. A. Oldfather, London, New York, Cambridge, Mass., 1928-1946.

Fabbri, N. R. "Salvator Rosa's Engraving for Carlo de' Rossi and his Satire *Invidia*," *Journal of the Warburg and Courtauld Institutes*, XXXIII, 1970, pp. 328-30.

Füssli, H. R. *Kritisches Verzeichnis der besten, nach den berühmtesten Malern aller Schulen vorhandenen Kupferstiche*, III, Zürich, 1802.

Gilpin, W. *An Essay on Prints*, London, 1792. First published in 1768.

Gori Gandinelli, G. *Notizie istoriche degl'intagliatori*, III, Siena, 1771.

Haskell, F. *Patrons and Painters*, New York, 1963.

Highet, G. *Juvenal the Satirist*, Oxford, 1954.

Hind, A. M. *A Short History of Engraving and Etching*, London, 1908.

——. *Early Italian Engraving*, New York, London, 1938-1948.

Huber, M. *Manuel des curieux et des amateurs de l'art*, IV, Zürich, 1800.

John Hamilton Mortimer A.R.A. 1740-1779, Paintings, Drawings and Prints, Towner Art Gallery, Eastbourne, July 6-September 3, Iveagh Bequest, Kenwood, September 10-October 8, 1968, introduction by B. Nicolson.

Joubert, F. E. *Manuel de l'amateur d'estampes*, III, Paris, 1821.

Juvenal, *Satires*, Loeb Classical Library Edition by G. G. Ramsey, London, New York, 1924.

Kitson, M. "Works by Other Artists, 17th Century," *Salvator Rosa*, Exhibition Catalogue, Arts Council of Great Britain, Hayward Gallery, London, October 17-December 23, 1973.

Kristeller, P. *Kupferstich und Holzschnitt in vier Jahrhunderten*, Berlin, 1905.

Langdon, H. "Salvator Rosa: Paintings," *Salvator Rosa*, Exhibition Catalogue, Arts Council of Great Britain, London, October 17-December 23, 1973.

——. "Salvator Rosa and Claude," *Burlington Magazine*, CXV, 1973, pp. 779-85.

——. "Salvator Rosa in Florence 1640-49," *Apollo*, C, 1974, pp. 190-97.

——. "Two Book Illustrations by Salvator Rosa," *Burlington Magazine*, 118, 1976, pp. 698-99.

Le Blanc, C. *Manuel de l'amateur d'estampes*, III, Paris, 1854-1889.

Limentani, U. *Poesie e lettere inedite di Salvator Rosa*, Florence, 1950.

——. "Salvator Rosa nuovi studi e ricerche," *Italian Studies*, VIII, 1953, pp. 29-58; IX, 1954, pp. 46-55.

——. "La satira dell'Invidia," *Giornale Storico della Letteratura Italiana*, CXXXIV, 1957, pp. 570-85.

——. *La satira nel seicento*, Milan, Naples, 1961.

Mahoney, M. *The Drawings of Salvator Rosa*. Doctoral Thesis, University of London, 1965. Published in a revised form by Garland Press, New York, 1977.

——. "Salvator Rosa Provenance Studies, Prince Livio Odescalchi and Queen Christina," *Master Drawings*, III, 1965, pp. 383-89.

——. "Salvator Rosa: Drawings," *Salvator Rosa*, Exhibition Catalogue, Arts Council of Great Britain, Hayward Gallery, London, October 17-December 23, 1973.

Manwaring, E. *Italian Landscape in Eighteenth Century England*, New York, 1925.

Meyer, C. "Nachtrag zum Verzeichniss der Radirungen Salvator Rosa's," *Jahrbücher für Kunstwissenschaft (Zahn)*, Leipzig, III, 1879, pp. 220-23.

Morgan, Lady. *The Life and Times of Salvator Rosa*, Paris, 1824.

Mussini, M. *Salvator Rosa. Le incisioni*, Galleria della Rocchetta, Parma, 1972.

Nagler, G. K. *Die Monogrammisten*, V, Munich, Leipzig, 1879.

Oertel, R. "Die Vergänglichkeit der Künste," *Münchner Jahrbuch der Bildenden Kunst*, 1963, pp. 105-20.

Olsen, H. *Italian Paintings and Sculpture in Denmark*, Copenhagen, 1961.

Ozzola, L. *Vita e opere di Salvator Rosa*, Strassburg, 1908.

Panofsky, E. *Meaning in the Visual Arts*, New York, 1957.

Panofsky E. and F. Saxl. *Dürer's Melencolia I*, Leipzig, Berlin, 1923.

Pascoli, L. *Vite de' pittori, scultori ed architetti moderni*, Rome, 1730.

Passeri, G. B. *Vite de pittori, scultori, et architetti*, ed. by J. Hess, *Die Künstlerbiographien von Giovanni Battista Passeri*, Leipzig and Vienna, 1934.

Percy, A. *Giovanni Benedetto Castiglione, Master Draughtsman of the Italian Baroque*. Foreword by Sir Anthony Blunt, Philadelphia Museum of Art, September 17 to November 28, 1971.

Petrucci, A. "Salvator Rosa acquafortista," *Bollettino d'Arte*, XXVIII, 1934-1935, pp. 28-37.

———. "Poesia e superbia di Salvatoriello acquafortista," *Nuova Antologia*, CDXLIII, July, 1948, pp. 267-75.

———. *Maestri incisori*, Novara, 1953.

———. *Il Caravaggio acquafortista e il mondo calcografico romano*, Rome, 1956.

Petrucci, C. A. *Catalogo generale delle stampe tratte dai rami incisi posseduti dalla Calcografia Nazionale*, Rome, 1953.

Pettorelli, A. *Salvator Rosa, pittore, incisore, musicista, poeta*, Turin, 1924.

Pigler, A. *Barockthemen*, Budapest, Berlin, 1956.

Price, U. *Essays on the Picturesque as Compared with the Sublime and Beautiful*, London, 1810.

Ripa, C. *Iconologia*, Siena, 1613; Padua, 1630.

Rotili, M. *Salvator Rosa incisore*, Naples, 1974.

Ruffo, V. "Galleria Ruffo nel secolo XVII in Messina," *Bollettino d'Arte*, X, 1916, pp. 21-64, 95-128, 165-92, 237-56, 284-320, 369-88.

Salerno, L. *Salvator Rosa*, Milan, 1963.

———. "Il dissenso nella pittura intorno a Filippo Napoletano, Caroselli, Salvator Rosa e altri," *Storia dell'Arte*, V, 1970, pp. 34-65.

———. *L'opera completa di Salvator Rosa*, Classici dell'Arte Rizzoli, Milan, 1975.

Seneca, *Ad Lucilium Epistulae Morales*, Loeb Classical Library Edition by R. M. Gummere, New York, London, Cambridge, Mass., 1920-1939.

———, *Moral Essays*, Loeb Classical Library Edition by J. W. Basore, London, New York, 1928-1935.

Strutt, J. *A Biographical Dictionary Containing an Historical Account of all the Engravers . . .* , I, London, 1785.

Sunderland, J. "John Hamilton Mortimer and Salvator Rosa," *Burlington Magazine*, CXII, 1970, pp. 520-31.

———. "Works by Other Artists, 18th and 19th Centuries," *Salvator Rosa*, Exhibition Catalogue, Arts Council of Great Britain, Hayward Gallery, London, October 17-December 23, 1973.

———. "The Legend and Influence of Salvator Rosa in England in the Eighteenth Century," *Burlington Magazine*, CXV, 1973, pp. 785-89.

Terzo centenario di Salvator Rosa, Galleria 1 +1, Libreria Marsilio da Padova, Padua, November 24-December 30, 1973.

Tomory, P. A. *Salvator Rosa, His Etchings and Engravings after His Work*, John and Mable Ringling Museum of Art, Sarasota, Florida, November 4-December 5, 1971.

Valeriano, G. P. *Hieroglyphica*, Basel, 1567.

Wallace, R. W. *The Figure Paintings of Salvator Rosa*, Unpublished Ph.D. dissertation, Princeton University, 1965.

———. "The Genius of Salvator Rosa," *Art Bulletin*, XLVII, 1965, pp. 471-80.

———. "Salvator Rosa's *Death of Atilius Regulus*," *Burlington Magazine*, CIX, 1967, pp. 395-97.

———. "Salvator Rosa's *Justice Appearing to the Peasants*," *Journal of the Warburg and Courtauld Institutes*, XXX, 1967, pp. 431-34.

———. "Salvator Rosa's *Democritus* and *L'Umana* Fragilità," *Art Bulletin*, L, 1968, pp. 21-31.

———. "Salvator Rosa: Etchings," *Salvator Rosa*, Exhibition Catalogue, Arts Council of Great Britain, Hayward Gallery, London, October 17-December 23, 1973.

Whitley, C. T. *An Attempt to Reproduce by Lithography Etchings by Salvator Rosa, With a Short Notice of His Life and Works*, Dover, 1872.

INDEX